My FAVOURITE Movies

David Stratton AM is an award-winning film critic, film historian and lecturer, television personality and producer. He has served as President of the International Critics Jury for the Cannes and Venice film festivals, and for 28 years co-hosted with Margaret Pomeranz *The Movie Show* on SBS and ABC's *At the Movies*. A former critic for international film-industry magazine *Variety*, he currently writes for *The Australian*.

Other books by David Stratton

The Last New Wave
The Avocado Plantation
I Peed on Fellini
101 Marvellous Movies You May Have Missed

DAVID STRATTON

My
FAVOURITE
Movies

ALLEN&UNWIN

SYDNEY · MELBOURNE · AUCKLAND · LONDON

First published in 2021

Allen & Unwin
83 Alexander Street
Crows Nest NSW 2065
Australia
Phone: (61 2) 8425 0100
Email: info@allenandunwin.com
Web: www.allenandunwin.com

A catalogue record for this
book is available from the
National Library of Australia

ISBN 978 1 76087 838 2

Internal design by Simon Paterson
Index by Puddingburn
Set in 11.25/14.6 pt Minion Pro by Bookhouse, Sydney
Printed in Australia by McPherson's Printing Group

10 9 8 7 6 5 4 3 2 1

The paper in this book is FSC® certified.
FSC® promotes environmentally responsible,
socially beneficial and economically viable
management of the world's forests.

For Austin, Rose and Quinn.
I hope you will one day discover all these
wonderful movies yourselves.

Contents

Introduction

When my publisher originally suggested that I write a book about my favourite movies I hesitated because I knew that it would be fiendishly difficult to reduce the films I would describe as 'favourites' to a manageable number. When I decided to proceed, I made the decision to limit the list to 111 films, ten more than the usual 101 for this sort of thing, but still not really enough.

As I started to consider which titles to include, the difference between making a personal choice of a 'favourite' film and selecting films purely because of their quality or historical importance became clearer. The films in this book are my *favourites*, not only because I love them as films, but sometimes because of the circumstances in which I originally saw them. We probably all remember just when and where we saw certain favourite movies.

The first 30 or so films on the list are, with one exception, films that were made when I was too young to appreciate them; these are films I saw later on, sometimes on television, sometimes at retrospective screenings. The exception is *Duel in the Sun,* which my grandmother took me to see on its initial release in 1946 and which made a lasting impression on me (I was six or seven years old at the time). Four of these early films were made in the 1920s, eight in the 1930s and 16 in the 1940s.

The 1950s is the decade with by far the most favourites—26. These are films I saw when I was a teenager and I was eagerly devouring the world of cinema with a teenager's passion. Some of the films that I've chosen from the 1950s might not be generally considered 'great' or 'important' achievements in cinema history, but they're dear to my heart because in the late 1950s I was living away from home for the first time and so I was free to see anything I wanted to see when I first discovered them.

Later, when I moved from the UK to Australia in 1963 and became Director of the Sydney Film Festival (1966–1983), I started to travel the world in search of movies and to meet the men and women (mostly men in those days) who made them. There are 17 films from the 1960s and 18 from the 1970s. The latter decade saw the Australian film revival, and ten Australian films have been selected (plus an eleventh, *Lorenzo's Oil,* made by an Australian director in the USA).

Since the mid-1980s there have been fewer favourites, perhaps because I've become more demanding and more jaded. But whenever I see a new film I always hope that it will be exciting enough, or challenging enough, or emotionally rewarding enough to enter my personal pantheon.

I also made the important decision to select only one film made by any particular director. This was to avoid loading the list with, for example, half a dozen Hitchcock films. The decision forced me to make more difficult choices. How do you select just one Hitchcock film when he made so many great ones? Again, it came down to a very personal choice, not unconnected with the circumstances in which I saw the film in the first place.

So what follows is not just a celebration of 111 terrific movies; there's also a brief survey of the work of 111 great filmmakers. But I realise I've left out some filmmakers I greatly admire—to name just a few: Raoul Walsh, Paul Cox, Bertrand Tavernier, Carol Reed, Michelangelo Antonioni, Kenji Mizoguchi, Andrzej Wajda, István Szabó, John Boorman; no film by these important and talented filmmakers has made it into the book.

A word about spoilers! The films in this book are discussed in some detail and in many cases the ending is revealed. It is strongly suggested that, if you have never seen one of these films, you try to see it before reading about it here in order to avoid any disappointing revelations.

I should note that the dates of the films listed in this book are the dates included in the credits of the films themselves; these dates might not always accord with information you might find on the internet, but they're more accurate. IMDb, for example, usually lists a film under the year it was first screened, not the copyright date that appears on-screen. A similar caution goes for the running times listed here; all of the films I've listed have been personally timed by me.

I'm most grateful for the support and encouragement I've received from my publisher, Allen & Unwin, and especially from Richard Walsh, Elizabeth Weiss, my watchful and meticulous editors Angela Handley and Jo Lyons, and proofreader Dannielle Viera.

During a global pandemic it's been great fun, and very liberating, to revisit the 111 films you will read about in the following pages. I hope that, if there are films or filmmakers included here with which you are unfamiliar, you will have as much joy as I have had in discovering them.

David Stratton, 2021

1

Metropolis

GERMANY, 1926

UFA. DIRECTOR: Fritz Lang. 148 MINS (APPROX.).
FIRST SEEN: *Projected at home [on 8mm]. 29 May 1961.*

The future. Freder (GUSTAV FRÖLICH) is the son of Joh Fredersen (ALFRED ABEL), ruler of Metropolis, a great city of the future. The workers, identically dressed, who operate giant machines, live in dormitories deep underground while the elite live high above them in the 'Eternal Gardens'. While dallying with ladies chosen to 'entertain' him, Freder glimpses Maria (BRIGITTE HELM), a worker who has stumbled into the gardens surrounded by hungry children. It's love at first sight, and Freder descends into the depths where he discovers that Maria is revered by the workers, who are discontented and restless. She exhorts them to be patient and to await the coming of a Mediator. Observing all this from above, Fredersen instructs Rotwang (RUDOLF KLEIN-ROGGE), his chief scientist, to make the android he is in the process of creating in the spitting image of Maria. Rotwang kidnaps Maria and transfers her looks to his robot (though the robot Maria wears noticeably more eye make-up than does the real woman). The fake Maria incites the workers to revolt, the machines are abandoned, and the city begins to flood. Freder and the real Maria rescue the workers' children. The workers, led by the Foreman (HEINRICH GEORGE), turn on Maria, calling her a witch and threatening to burn her; but they burn the robot Maria by mistake. Freder and Rotwang fight to the death, and Freder is able to bring peace, fulfilling the motto that 'the mediator between the head and the hand must be the heart'.

Fritz Lang's sci-fi epic is one of the great achievements of silent cinema. It originally opened in Berlin in January 1927, a few months before the release of *The Jazz Singer*, the film that would usher in the 'talkie' era. *Metropolis* is a movie with a message—about how important it is for Capital and Labour to work together in harmony for the benefit of all—and it's intriguing in this respect because Lang's socialist views (which would soon get him in trouble with the Nazis) differed markedly from the ultra-conservative opinions of his wife, Thea von Harbou, who wrote the film's screenplay, based on her own novel. (Von Harbou later joined the Nazi Party.)

The film's resolution is its weakest element; after the appalling treatment meted out to the workers by the suave but heartless Fredersen it's hardly likely that their representative would shake his hand and call a truce without some very meaningful negotiations. The film has been attacked for its näiveté, but its strengths far outweigh its weaknesses.

This is truly the forerunner of the science fiction genre, and was a major influence on subsequent films like *Frankenstein* (1931) and *Things to Come* (1936). The enormous sets, designed by Otto Hunte, Erich Kettelhut and Karl Vollbrecht, are immensely impressive; they include Fredersen's art deco office; a nightclub called Yoshiwara; and the skeleton-infested catacombs beneath the city. The intricate machinery churning away doing goodness knows what almost becomes a character in itself—clearly the operation of a huge clock-like Thing is of vital importance, but we never discover quite what it does. With the climactic sequence of the flooding of the city, Lang and his team pull out all the stops. Mass crowds of extras are involved in a very impressive spectacle as the walls of Metropolis start to collapse.

Lang also includes moments of surrealism, for example when the stone statues of the Seven Deadly Sins come to life or when multi-image exposures are used to powerful effect.

Interesting, too, is the fact that Rotwang, the scientist, is the film's true villain, even more so than Fredersen, the oppressive slave-owner and capitalist. Rotwang is one of the first of many mad scientists that cinema has given us over the years, and the film's conception of the ways in which androids might be used in the future is nothing if not intriguing. All this spectacle is beautifully photographed by Karl Freund and Günther Rittau (the former became a director in Hollywood, though he had a modest output in that role).

After its 1927 Berlin premiere, *Metropolis* was shortened by a little over half an hour before it was released for wider distribution in the provinces. This shorter version, about two hours long, became the American release version and was the one widely seen the world over for many years (it's the first version I was able to see when I rented an 8mm copy to watch at home, projected onto my bedroom wall). In 1984 Italian composer Giorgio Moroder recut the film to 83 minutes and attached a newly created music score that involved contributions from Freddie Mercury, Bonnie Tyler and Adam Ant. The result brought the film to a wider audience than ever before, but cinephiles saw it as a travesty of Lang's original. In 2008 a somewhat damaged—but almost complete—16mm copy of the film was discovered

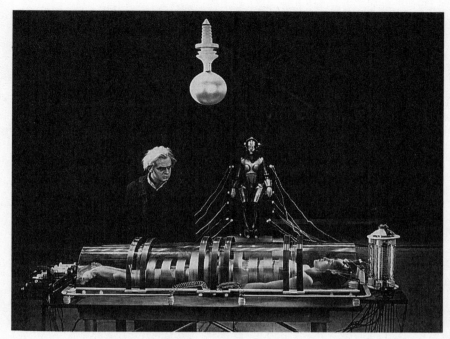

Rotwang (RUDOLF KLEIN-ROGGE) and the kidnapped Maria (BRIGITTE HELM) in Fritz Lang's *Metropolis*.

in Buenos Aires; the version now available on Blu-Ray combines footage from all available sources and, at about 148 minutes, seems to be pretty close to Lang's director's cut.

At the time he made the film, Lang was optimistic that silent cinema could transcend international boundaries and, in effect, play the Mediator role that is the key to *Metropolis*. In an article published in *Die literarische Welt* (1926), he wrote: 'The internationalism of filmic language will become the strongest instrument available for the mutual understanding of peoples who otherwise have such difficulty understanding each other in all too many languages. To bestow upon film the double gift of ideas and soul is the task that lies before us. We will realise it.'

Fritz Lang (1890–1976) was born in Vienna, Austria. He was wounded in World War II, and in the post-war period he studied art, entering the film industry as a screenwriter. He directed his first film, *Halb-blut/Half Blood*, in 1919 and by 1921, when he made *Der müde Tod* (literally, 'The Silent Death', but titled *Destiny* in the USA, where it made something of a splash), he had become one of Germany's leading directors. In 1922 he made the first of three films about Master Criminal Dr Mabuse (*Dr. Mabuse,*

der Spieler/Dr. Mabuse, the Gambler) and in 1923 the spectacular two-part *Die Nibelungen* (*Siegfried* and *Siegfried's Revenge*). His first sound film, *M* (1931), was a powerful drama about a serial killer. He left Germany in 1933 when the Nazis came to power and, after making a film in France (*Liliom*, 1934), directed *Fury* (1936), a thriller about a lynch mob, for MGM. During his American career he excelled at westerns and thrillers; *Western Union* and *Manhunt* (both 1941), *The Woman in the Window* (1944), *Scarlet Street* (1945), *Rancho Notorious* (1952), *The Big Heat* (1953), *Human Desire* (1954) and *While the City Sleeps* (1956) are among his most notable achievements. He returned to Germany in 1958 and made three more films there, ending his career with the further adventures of Dr Mabuse, *The Thousand Eyes of Dr. Mabuse* (1960). Almost all his films share a single theme: the self-destructiveness brought about by hate, revenge and discord.

2

The General

USA, 1927

United Artists. DIRECTORS: Buster Keaton, Clyde Bruckman. 79 MINS.
FIRST SEEN: *Bournville Film Society, Birmingham, UK, 17 December 1957.*

Marietta, Georgia, in the spring of 1861. Johnnie Gray (BUSTER KEATON) is an engineer on the Western and Atlantic line. He has two loves: his engine, The General, and Annabelle Lee (MARION MACK). News arrives that Fort Sumter has been fired on and the Civil War has begun. Johnnie tries in vain to enlist but he is refused not because of his short stature, as he suspects, but because his occupation is too important to the Confederacy. The reason for his rejection is not explained to him by the harassed recruitment officer. Annabelle, believing he's a coward for not enlisting—both her father and brother have signed up—rejects him. A year later Union General Thatcher (JIM FARLEY) and Chief Spy Captain Anderson (GLEN CAVENDER) plot to steal The General and destroy the bridges along the railway track to facilitate the advance of the Union army. Annabelle is the only passenger on the train when it is hijacked. Johnnie pursues the stolen train by commandeering another engine and finds himself behind enemy lines. He succeeds in rescuing Annabelle and retrieves The General, heading back to Confederate territory—with a Union train in hot pursuit. He destroys the Rock River Bridge and becomes a hero.

One of the most elaborate of all silent comedies, *The General* is not only visually beautiful—the photography was by Dev Jennings and Bert Haines—but dramatically exciting—so much so that thirty years later it was remade as a non-comic thriller (*The Great Locomotive Chase*, 1956). The film, loosely inspired by a real incident of the Civil War, is structured around two very elaborate chase sequences in which vintage railway engines speed along the tracks while Keaton, the resourceful Marion Mack and a host of extras perform some obviously dangerous stunts. The first chase sequence, which lasts about 18 minutes, begins after The General has been stolen and Johnnie sets forth after it, first on foot, then on a railway hand-cart and then—briefly—on a wooden penny farthing until he succeeds in commandeering another engine. Scenes like the one in which he clumsily attempts to fire a cannon at the train in front are clearly intricately timed

and appear to be perilous for the actor, but Keaton was accustomed to taking risks—he wasn't named 'Buster' for nothing.

During the central section of the film Johnnie hides under a table as the Northerners are plotting their next moves and then succeeds in rescuing Annabelle, who joins him for the second chase, a longer one at 23 minutes. Prior to this he has stuffed her into a sack and joined a line of Northerners tossing heavy sacks into the freight car; when he later goes looking for her, he accidentally steps all over her. Annabelle is eager to help him, but sometimes not in a good way: as the pair struggle to supply the speeding engine with enough fuel, she rejects a log of wood because it has a hole in it and throws it over the side. Later he ironically hands her a tiny twig, which she dutifully feeds to the engine—he puts his hands around her neck in frustration, then kisses her. It's a magical moment.

In the final battle between the Northern and Southern soldiers beside the riverbank, Johnnie acquires a sabre that repeatedly detaches itself from its handle, but this proves useful when his unruly blade unwittingly spears a Union sharpshooter.

Keaton's reputation relied on two things. He never showed emotion (he was nicknamed 'The Great Stone Face') and he delighted in very elaborate comedy, usually involving machines of one sort or another. The sequence in which Johnnie sets fire to the Rock River Bridge, which spans a gorge across a swiftly flowing river, is one of the most elaborate the film has to offer; when the train crashes into the river the effect is more thrilling than comic, and foreshadows a similar scene in Sam Peckinpah's *The Wild Bunch* 42 years later.

My first viewing of this wonderful film coincided with my discovery of the film society movement. The Bournville Film Society, where I saw it, was connected to the social and cultural activities run by the Cadbury chocolate factory, though non-employees of the company, like myself, were welcome to join.

Keaton's co-director on *The General*, Clyde Bruckman (1894–1955), was a journalist who joined Keaton's team as a gag-man. This was the first film on which he received a director credit, but clearly Keaton was the artistic force behind the film's production. Bruckman went on to work with other comedians, including W.C. Fields, but he directed his last film in 1935. In 1955, after eating a restaurant meal he was unable to pay for, he shot himself with a gun borrowed from Keaton.

Joseph (Buster) Keaton (1895–1966) was, as they say in the theatre, 'born in a trunk'. His parents were vaudeville comedians and he joined their act as a small child (his father, Joe, appeared in several of his son's films and has a small role in *The General* as a Union soldier). Buster entered films in 1917 and worked frequently with Roscoe 'Fatty' Arbuckle in a series of two-reelers (a reel ran for approximately ten minutes) before appearing solo in films like *The Saphead* (1920). He began directing his own material, but unlike fellow silent comedians, such as Charles Chaplin and Harold Lloyd, he was no businessman and he never retained the copyright to his own work. His relatively brief career as a director, or co-director, of feature films began with *The Three Ages* (1923), and several of his subsequent films are masterpieces, including *Our Hospitality* (also 1923), *Sherlock Jr.* and *The Navigator* (both 1924), *Seven Chances* (1925) and *Steamboat Bill Jr.* (1928).

Unfortunately, the coming of talkies at the end of the 20s coincided with Keaton's unwise decision to sign a contract with MGM, a studio that proved unresponsive to his meticulous working methods. He was not allowed to direct the generally unimpressive films that followed, and to add insult to injury he was teamed with Jimmy Durante, a very different kind of comic whose brash overplaying was incompatible with Keaton's minimalism.

Keaton was reduced to working on gag sequences for lesser talents such as Red Skelton. In 1952, Chaplin cast him in a small role in *Limelight*, a nostalgic comedy-drama about the old music halls; the two great comedians share an unforgettable sequence, which is stolen by Keaton. Subsequently Keaton played bit parts and his final screen appearance was in Richard Lester's musical comedy *A Funny Thing Happened on the Way to the Forum* (1966), in which, despite the film's setting in ancient Rome, he still wore a version of his familiar pork-pie hat.

For many years the comedies Keaton made in the 1920s were unavailable (*The General* was an exception), but in 1965, a few months before his death, the Venice Film Festival arranged an almost complete retrospective of his work. Keaton appeared to be amazed and delighted at the rapturous response given to his films—he had thought he was forgotten, but a new generation of film enthusiasts proved otherwise.

3

Wings

USA, 1927

Paramount. DIRECTOR: William A. Wellman. 142 MINS.

FIRST SEEN: *Union Theatre, University of Sydney, 25 January 1976.*

1917. Jack Preston (CHARLES ROGERS) and David Armstrong (RICHARD ARLEN) have grown up in the same small American town. Both are in love with Sylvia (JOBYNA RALSTON), but—although Jack doesn't know it—she prefers David, who comes from a wealthy family. Jack is adored by his next-door neighbour, Mary (CLARA BOW). When America enters the war, both men enlist in the air force and go through basic training; Mary volunteers as a driver for the medical corps. Posted to the same squadron in France, Jack and David put aside their rivalry and become firm friends. They see action and have some hair-raising escapes. On leave in Paris, Jack gets very drunk at the Folies Bergère and doesn't recognise Mary when she locates him there. During the 'Big Push', David is shot down but manages to steal a German plane to fly back to his own lines—but again he is shot down, this time by Jack, and is killed. After the war, David's parents forgive Jack, who is reconciled with Mary.

Both William A. Wellman, the director of this epic, and John Monk Saunders, who wrote the story, had personal knowledge of aerial combat in France during the Great War. Wellman had been a pilot with the Lafayette Escadrille, but was invalided out of the service after he sustained a broken back when his plane was shot down. It's no surprise, then, that the flying scenes in *Wings* seem so authentic, and must have made a powerful impact on audiences in 1927. These 'medieval duels'—as a title describes them— include details that were probably experienced firsthand; the importance of 'having a neck like an owl'—as an officer puts it—so that the pilot is alert to potential enemies coming from any direction, is one such detail. The dogfights are impressively staged, including a scene in which two planes collide and fall blazing to the ground. When David runs out of bullets, the German pilot pursuing him, realising his enemy's predicament, backs away with a salute ('Chivalry among knights of the air' reads the inter-title, or title card). In addition to the aerial combat scenes, the film also contains some astonishing sequences of the battles on the ground, with hand-to-hand

conflict in and around the trenches while explosions rock the shattered landscape and planes fly low overhead. Superbly photographed by Harry Perry, these scenes are still extremely impressive today.

The film opens with a moving statement: 'To the young warriors of the sky, whose wings are folded about them forever, this picture is reverently dedicated.' The early small-town scenes illustrate 'Youth and the dreams of youth' through the relationship between the three main characters, and all three actors are wonderfully expressive. By 1927, silent cinema was at its most sophisticated, and *Wings* is a consummate example of this. The scene in which David farewells his parents, played by Julia Swayne Gordon and Henry B. Walthall—the latter famous for his role in *The Birth of a Nation*, D.W. Griffith's Civil War feature of 1915—is immensely touching. The inter-titles, by Julian Johnson, are occasionally florid ('Like a mighty maelstrom of destruction the War now drew into its center the power and the pride of all of the Earth'), but they can also be simple and direct ('C'est la guerre,' says a French officer, sadly, after the death of another hero).

Apart from some unnecessary comedy involving a German-American recruit named Schwimpf—played by El Brendel, an actor never given to subtlety—the training scenes are handled in a matter-of-fact way; it's quite a while before Jack and David actually get to fly in planes, and it's 36 minutes into the film before the action moves to France.

During the training sequence there's a brief, but affecting, appearance from a superstar to be: Gary Cooper. Jack and David share a tent with Cadet White (Cooper) who, after giving them some prophetic advice ('When your time comes you're going to get it'), leaves to pilot a plane that almost instantly crashes (off-screen), killing him. This was one of Cooper's earliest roles; the previous year he had received his first credit playing a cowboy in Henry King's western, *The Winning of Barbara Worth*.

The 20-minute sequence set in Paris, when the airmen are on leave, is interesting for its authentic location filming on Paris streets. The nightclub scene, in which the hopelessly inebriated Jack sees bubbles everywhere and fails to recognise Mary, who has acquired a low-cut sequined gown from the dressing room of the dancers, again feels authentic—after the horrors and tension of the battlefield the men let down their hair with abandon, or at least as much abandon as the censors of the time would permit.

The moving conclusion, in which Jack accidentally kills his friend believing him to be a German pilot, is beautifully handled, as is the sequence

in which Jack, his hair notably greying as a result of his experiences, visits David's home to apologise to his forgiving parents.

Films about World War I had effectively commenced in 1918 with Griffith's *Hearts of the World,* which was partly shot on the battlefront. Prior to *Wings* the outstanding Hollywood war film had been King Vidor's *The Big Parade* (1925), which quickly became a classic. *Wings* was followed by other films about aerial combat, notably Howard Hawks' *The Dawn Patrol* and Howard Hughes' *Hell's Angels* (both 1930).

The Academy of Motion Picture Arts and Sciences presented its first Academy Awards—Oscars as they became known—at a banquet on 16 May 1929. Awards were given for the best films of the previous two years. The very first Oscar for Best Film was won by *Wings*—though Wellman failed to win the Best Director award, which went to Frank Borzage for *Seventh Heaven.*

William A. Wellman (1896–1975) became a stunt pilot after the war and entered the film industry when he met superstar Douglas Fairbanks. He worked his way up the ranks and directed his first feature, *The Man who Won,* in 1923. Many of his silent films are lost today. In the aftermath of *Wings* he became a contract director at Warner Bros and directed two important early James Cagney films, *Other Men's Women* (1930) and *The Public Enemy* (1931). He was prolific in the early 30s (four features in 1931, five in 1932, an amazing nine in 1933), and—though he was usually assigned his scripts by the studio—he was clearly interested in social issues, as he demonstrated in *Beggars of Life* (1928), *Wild Boys of the Road* (1933) and *The Ox-Bow Incident* (1943). In 1937 he directed the original version of *A Star is Born,* which was filmed in Technicolor, and followed this with another Technicolor film, *Nothing Sacred,* also 1937, one of the funniest of the screwball comedies. He was extremely versatile and made some fine westerns, war movies, thrillers and romantic comedies. His last film, *Lafayette Escadrille* (1957), was a semi-autobiographical tribute to the American pilots who flew with the French during World War I.

4

The Last Command

Paramount. DIRECTOR: Josef von Sternberg. 88 MINS.

FIRST SEEN: *Union Theatre, University of Sydney, 26 August 1967.*

'Hollywood 1928! The Magic Empire of the Twentieth Century.' These opening titles—written by Herman J. Mankiewicz who, 13 years later, would be the co-author of *Citizen Kane*—introduce Leo Andreyev (WILLIAM POWELL), a Russian director preparing a film about the Russian Revolution. A photograph of an extra who is willing to accept payment of only $7.50 per day catches his eye; his assistant says the man claims to be the cousin of the late Czar. Former Grand Duke Sergius Alexander (EMIL JANNINGS) is living in a squalid boarding house and eagerly goes to the Eureka Studio the next day, joining a large crowd of potential extras ('The Bread Line of Hollywood'). As he dons costume and make-up, and pins on himself a medal the Czar himself had given him, Alexander remembers the year 1917 when he was Commanding General of the Russian Armies. He orders the arrest of two civilians: one is Andreyev, 'Director of the Kief [*sic*] Imperial Theatre', and the other Natacha Dabrova (EVELYN BRENT), an actor; both are supporters of the imminent revolution. Andreyev escapes from custody, but Natacha stays to (presumably) become Alexander's mistress. At the outset of the revolution she helps him escape and shortly afterwards dies when the train in which she's travelling crashes into an icy river. In the present, Andreyev prepares a scene in which Alexander hits a dissident soldier with a riding crop (just as Alexander had hit Andreyev 11 years earlier). While the Russian national anthem plays and the camera rolls, Alexander gives his last command: 'Forward to Victory. Long live Russia.'

The Last Command is a showcase for the great Swiss-born German actor Emil Jannings, who specialised in roles in which he was humiliated, usually by a younger woman. He had worked for the best German directors, Ernst Lubitsch and F.W. Murnau, and his role as a loyal hotel doorman demoted to the squalid role of washroom attendant in Murnau's *Der letzte Mann*—mis-translated in English as *The Last Laugh* (1923)—had made him world-famous. He arrived in Hollywood a star; *The Last Command* was the second film he made there and he would subsequently work again

with Josef von Sternberg on *Der blaue Engel/The Blue Angel* (1930), one of
the first talkies produced in Germany, in which Jannings' character suffers
humiliation from a dazzlingly youthful Marlene Dietrich. Jannings' role
as the Russian aristocrat reduced to working as a Hollywood extra is one
of his most powerful; he is a brutal but charismatic leader of men in the
Russian scenes, and a pathetic shadow of a man, given to uncontrollable
shaking, in the Hollywood scenes.

The screenplay expects the viewer to believe that Evelyn Brent's revo-
lutionary falls in love with this character, who represents the opposite of
everything she stands for, which is frankly a big ask; but Sternberg just
about gets away with the contrivance (such narrative improbabilities were
more acceptable in the cinema of the silent era). With its impressive sets,
and boasting Bert Glennon's fluid photography, *The Last Command* looks
wonderful, and it also offers intriguing insights into 'the Mecca of the
World' (as one title describes Hollywood) in the dying days of the silent era.

At this time the writing of inter-titles was a specialised task and was rarely
given to the official screenwriter, who in this case was John F. Goodrich
(working from a story by Lajos Biro). Mankiewicz's titles are suffused with
dark irony ('[Natacha] is pretty enough to merit my personal attention',
Alexander remarks when warned she is 'the most dangerous revolutionist
[*sic*] in Russia'). Later, when he presents her with a pearl necklace, one of
his men—eavesdropping—remarks, 'That sort of thing should always be
done after caviar.' These are the pearls Natacha returns to Alexander to
help finance his escape from Russia just before she is killed. Mankiewicz is
disdainful of the Bolsheviks: a scene of men and women engaged in plot-
ting is described as 'A group of obscure people meet[ing] to decide the fate
of Russia.' The film's ending foreshadows the resolution of Orson Welles'
Touch of Evil, made 30 years later. 'He was a great actor,' says the Assistant
Director (JACK RAMOND) as Alexander dies. 'He was a great *man*,' responds
Andreyev—an unlikely line, perhaps, but in the context a satisfying one.

Josef von Sternberg (real name, Jonas Sternberg) (1894–1969) was born
in Vienna and came to America with his family when he was seven years
old. His first film, *The Salvation Hunters* (1925), was a semi-experimental
feature made entirely outside the studio system. It was well liked by influ-
ential people but Sternberg, who had a reputation of being difficult to work
with, had major problems on his next two pictures, *The Exquisite Sinner*
(1925), which he made at MGM and which was taken away from him and
completely reshot, and *The Seagull*, aka *A Woman of the Sea* (1926), which

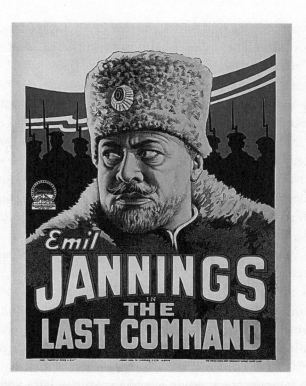

President Dugmore Merry (right) and myself (left), then Director of the Sydney Film Festival, greet Josef von Sternberg on his arrival at Sydney Airport in June 1967.

was a drama produced by Charles Chaplin as a vehicle for his long-time leading lady, Edna Purviance. Chaplin, it seems, disliked the film and shelved it; it has never been seen publicly. Despite these setbacks, Sternberg persevered and signed a contract with Paramount where, in 1927, he scored his first big success with *Underworld,* one of the earliest gangster pictures. This was followed by *The Last Command, The Drag Net* and another lost film, *The Docks of New York,* (all 1928) and *The Case of Lena Smith* (1929), of which only fragments survive. *The Blue Angel* was so successful that Sternberg was able to bring its star, Dietrich, back to Paramount where together they made a delirious series of stunningly photographed melo-dramas: *Morocco* (1930), *Dishonored* (1931), *Shanghai Express* and *Blonde Venus* (both 1932), *The Scarlet Empress* (1934) and *The Devil is a Woman* (1935). His post-Dietrich period had its ups and downs, especially when he was unable to complete a prestigious Alexander Korda production, *I, Claudius,* in England in 1936. The final film he completed was *The Saga of Anatahan* (1953), which he made on a sound stage in Tokyo (though *Jet Pilot,* which he started filming in 1949 for producer Howard Hughes, was finally released in 1957). Sternberg was an innovative director and an unparalleled visual artist whose films repay repeated viewing.

In 1967 I invited Sternberg to attend the Sydney Film Festival. When he first arrived he certainly lived up to his reputation and proved to be a demanding guest, but during his two-week stay we became friends and were on first-name terms by the time he left. We remained in touch and I visited his home in Los Angeles in December 1969. He delighted in showing me some of his memorabilia (a letter from director and film theorist Sergei Eisenstein, photographs taken on the set of *Duel in the Sun* [see #22]) and he took me to dinner at a Japanese restaurant before driving me back to my hotel in his ancient Jaguar. Eighteen days later he died of heart failure.

5

City Lights

USA, 1931

United Artists–Charles Chaplin Productions. DIRECTOR: Charles Chaplin. 85 MINS.
FIRST SEEN: *Piazza San Marco, Venice, Italy. 3 September 1972.*

When a monument to Peace and Prosperity is unveiled in the centre of an unnamed city, a tramp (CHARLIE CHAPLIN) is discovered sleeping on the statue. Later, the Tramp falls instantly in love with a blind flower seller (VIRGINIA CHERRILL), who assumes he's a wealthy man. That night, on the bank of the river that flows through the city, the Tramp encounters a drunken millionaire (HARRY MYERS) and saves him from drowning. For the next few nights, the Tramp and the Millionaire carouse together as best friends, but every morning the sober Millionaire fails to recognise the Tramp and has him thrown out of his house. The Millionaire gives the Tramp $1000, which enables him to pay for the Flower Seller's rent and for an operation to restore her eyesight; but the Tramp is arrested for stealing the money. By the time he is released from prison, looking shabbier than ever, the Flower Seller's sight has been restored and she is running her own flower shop.

The most sublime of the many great films made by Chaplin, *City Lights* is both hilarious and deeply moving, with one of the most touching conclusions ever recorded on film when the Flower Seller gradually realises that the shabby Tramp, who is gazing at her so soulfully, is her benefactor, the man who paid for the operation that restored her sight. The pathos conveyed in this scene stems from the fact that both the Tramp and the Flower Seller are overwhelmed, he because he realises that she can now see, and she because she realises the man she had fallen in love with when she was blind is not wealthy, as she had imagined, but homeless and impoverished.

Alongside this genuinely touching narrative strand, beautifully acted by Chaplin and Cherrill, is the slapstick for which Chaplin was so famous and so adored, and the comedy in *City Lights* represents some of his finest work. Since the release of the part-talkie *The Jazz Singer* in 1927, the unique art form that was silent cinema had disappeared almost overnight, ruining the careers of many actors who possessed 'unsuitable' voices and bringing an end to the employment of countless musicians all over the world. By 1929, virtually every film released was a talkie, so when Chaplin made

City Lights in 1931 he was bucking the trend. Convinced that the public would not accept the Tramp if he talked, Chaplin made what was essentially a silent film, for which he himself composed the lilting music score. There are some sound effects—such as the gobbledygook that spews from the mouths of the pompous officials at the unveiling of the statue, or the unwitting noises the Tramp makes after he's swallowed a whistle (and which disrupt the performance of a self-important singer)—but the comedy is purely visual, and the inter-titles are kept to a minimum.

The plot gives Chaplin plenty of opportunities to have fun with inebriated characters, comic business based on celebrated routines he'd developed in the English music halls. One of the highlights is a boxing contest in which the Tramp has nervously agreed to participate in the hope of earning money to pay the Flower Seller's rent. During the hilarious contest, the Tramp, his tough opponent and the referee move about the ring as though they are dancing.

The Tramp also attempts to earn some money from cleaning up horse manure on the city streets, and Chaplin does a lovely double take when he spots an elephant being led down the road. One comedy routine follows another in quick succession until the sentiment of the final reel takes over: the Tramp and the Millionaire constantly falling into the river; the large lady in evening dress sitting on a lighted cigar; chairs being repeatedly removed just as people are about to sit on them; the Tramp eating spaghetti that becomes entwined with paper streamers; the hapless sanitary worker—played by a long-time member of the Chaplin stock company, Albert Austin—confusing soap with cheese while eating a sandwich; the Flower Seller rolling a ball of wool, unaware that the material she is winding constitutes the Tramp's singlet.

Chaplin was a slow worker and a perfectionist. *City Lights* was three years in production and as *The Unknown Chaplin* (1983), a revealing documentary made by Kevin Brownlow and David Gill, clearly demonstrates, he shot some scenes over and over again until he was satisfied.

Charles Chaplin (1889–1977) was born into extreme poverty in London. His mother, a none-too-successful actor, was often unemployed and frequently committed to asylums, and he never knew his father. He found work as a child actor in the theatre at the age of five, and became a star of the music halls, working for the Fred Karno troupe (the same company that employed Stan Laurel). The troupe came to America for a tour in 1913, and Chaplin was headhunted by the Mack Sennett Company who starred him in

their popular two-reel silent comedies. He started directing his own material the following year, and quickly became a superstar, one of the most loved and recognised men in the world. In 1919 he became one of the founders of United Artists, together with pioneer director D.W. Griffith and the hugely popular actors Mary Pickford and Douglas Fairbanks. Chaplin's comedies became gradually more sophisticated and elaborate until, in 1923, he directed his first full feature—unexpectedly, *A Woman of Paris* was a melodrama in which he did not appear. However, the features that followed—*The Gold Rush* (1925), *The Circus* (1928) and, in the sound era, *Modern Times* (1936) and *The Great Dictator* (1940)—were all enormously popular. The latter film, in which Chaplin mocked the Führer who had the temerity to sport a moustache similar to that of the Tramp, outraged American isolationists, including FBI head J. Edgar Hoover, who had been suspicious of Chaplin's alleged socialist politics for years. Chaplin was also criticised for *Monsieur Verdoux* (1947), in which he played a completely different character from the Tramp—that of a serial killer of women—and transformed this grim theme into a black comedy that was ahead of its time.

My first viewing of *City Lights* was indeed a memorable one. The film had been unavailable for years when the Venice Film Festival arranged a gala outdoor screening in the Piazza San Marco on a huge screen. When the film ended, sobbing could be heard from the thousands of people seated or standing in the magnificent square. And then a spotlight focused on one of the balconies to the right of the piazza and there was Charlie himself, white-haired, rosy-cheeked, smiling, waving and acknowledging the thunderous applause of the crowd. You don't get many experiences like that!

6

Love Me Tonight

USA, 1932

Paramount. DIRECTOR: **Rouben Mamoulian.** 89 MINS.
FIRST SEEN: *San Francisco Film Festival. USA. 8 October 1971.*

Paris. Maurice (MAURICE CHEVALIER), a tailor, has not been paid for the suits he has made for the Viscount Gilbert de Varèze (CHARLIE RUGGLES). Egged on by other retailers the Count has also failed to recompense, Maurice arrives at the isolated castle where de Varèze lives with his father (C. AUBREY SMITH), sister, Princess Jeanette (JEANETTE MACDONALD) and cousin, Countess Valentine (MYRNA LOY). Maurice is mistaken for a member of the nobility, a misunderstanding that de Varèze, fearing his father's wrath, encourages. After surviving a traditional hunt, during which he rescues the frightened deer from the hunters, Maurice and the Princess fall in love with one another. But when Maurice offers to redesign her unattractive riding habit the word gets out that 'the son of a gun is nothing but a tailor!' He leaves the château, but the Princess pursues him on horseback and succeeds in stopping his train.

The screenplay for this deliciously funny musical comedy, concocted by Samuel Hoffenstein, Waldemar Young and George Marion Jr, was based on a play by Leopold Marchand and Paul Armont, and the songs were composed by Richard Rodgers and Lorenz Hart. The score includes such all-time favourites as 'Isn't it Romantic?' but the film's chief delights lie in the saucy dialogue and Mamoulian's remarkably fluid and inventive direction. Made in the legendary period before the introduction in 1934 of a strict Production Code, an official censorship regime that would restrict the depiction of crime, sex, narcotics and radical politics until 1967, the film is packed with the sort of material that would not have been possible two years later. Charlie Butterworth, who is superb as a self-styled 'ardent' suitor of the Princess, topples from a ladder—after 'wooing' her at her bedroom window—and moans that 'I fell flat on my flute! I'll never be able to use it again.' Myrna Loy's Countess is constantly on the lookout for a new man (asked if she could go for a doctor she replies, 'Certainly! Bring him right in!' and later when Jeanette demands of her 'Do you ever think of anything but men?' she responds, without a pause, 'Oh yes. Schoolboys'). Such dialogue

was cheeky then, and would still confront some people today, although Loy handles it with such sophisticated style that few could really take offence.

The film's opening sequence is a stylised, rhythmic depiction of the sounds of Paris and its citizens early in the morning. Before he began his cinematic career, Mamoulian's 1927 stage production of *Porgy* had opened with a similar scene, in that instance a depiction of the early morning activity on Catfish Row—Mamoulian also directed the 1935 musical version of the play, *Porgy and Bess*, on Broadway. At the conclusion of this wonderfully conceived curtain-raiser, the camera moves into an attic apartment where we see Chevalier's celebrated straw hat before we meet the man himself, and he sings 'The Song of Paris' before setting off along the streets—flirting with women along the way—to his shop. His first customer's visit is interrupted by the arrival of the Viscount de Varèze in his underwear ('BVDs' as they were called); he explains he was in bed with a married woman when the husband turned up and he had to leave his clothes behind. He tells Maurice to deliver all the suits he's ordered to the castle, where he, and other local retailers, will be paid in full.

Mamoulian is at his most creative in the following sequence. Maurice begins the famous song, 'Isn't it Romantic?', addressing it to his customer, who leaves humming the tune, which is taken up by a passing artist and then by the driver of a taxi the artist hails to drive him to the railway station. On the train the song is picked up by a parade of soldiers marching beside the railway track and, later, on a route march in the countryside, they in turn pass it on to a gypsy, who plays it on the violin by his campfire, which is close to the château where Princess Jeanette, standing on her balcony, hears the melody and completes the song. Thus the song is used, quite brilliantly, to link the two main characters, Maurice and Jeanette, who have not yet met.

The next day they *do* meet, when the car in which Maurice is being driven to the château breaks down and Jeanette rides by singing 'Lover'. He's instantly smitten and responds with the love song 'Mimi', even though that isn't her name (the song was one of Chevalier's greatest hits). At the château, seeking the 63,000 francs de Varèze owes him, Maurice is mistaken for a nobleman, Baron Courtelain. He reluctantly takes part in the hunt, astride a very feisty steed, and attends a fancy-dress ball as an 'Apache', the name given to the low-life gangsters of Paris at the time. In the garden that evening, he and Jeanette declare their love ('Love Me Tonight') but the next day he admits that he's a tailor and is driven from the château in

disgrace—even the pompous castle chef, singing a verse of the song 'The Son of a Gun is Nothing but a Tailor', admits that 'I've given indigestion to a President, ptomaine to a Duke' and then goes on to declare that he's ashamed to have fed a low-life like Maurice. One of the maids sings that she's ashamed to have washed the BVDs of a man who was not a nobleman. There is, of course, a happy, fairytale ending.

Rouben Mamoulian (1897–1987) was born in what is now Tbilisi, Georgia. He studied theatre in Paris and Moscow and arrived in the USA in 1923 with a reputation as an innovative theatre director. With the coming of sound, he was headhunted by Paramount and scored a success with the backstage story *Applause* (1929), which was banned by the Australian censors, apparently because of the presence of a great many scantily clad chorus girls. He became one of the most important innovators of early talkies, a creator whose inventive use of the new medium, with films like *Dr. Jekyll and Mr. Hyde* (1931), impressed critics around the world. He made the first feature produced in full Technicolor (*Becky Sharp*, an adaptation of Thackeray's *Vanity Fair*) in 1935. He subsequently remade two celebrated silent films, *The Mark of Zorro* (1940) and *Blood and Sand* (1941)—the latter notable for its outstanding use of colour—but later his career faltered. He was removed from the direction of both *Laura* and *Porgy and Bess* (Otto Preminger took over both films) and was fired from the expensive epic *Cleopatra* when its star, Elizabeth Taylor, fell ill.

I first met Mamoulian in San Francisco in 1971 at a film festival screening of *Love Me Tonight*. We met again in Spain two years later when he was President of the Jury at the San Sebastián International Film Festival. I invited him to Australia, and he attended both the Sydney and Melbourne film festivals in 1974. The Sydney Film Festival, which was taking place in the magnificent State Theatre for the first time, opened with a special 35mm screening of *Love Me Tonight* in the presence of the director. The event was attended by then prime minister Gough Whitlam.

7

Trouble in Paradise

USA, 1932

Paramount. DIRECTOR: Ernst Lubitsch. 82 MINS.
FIRST SEEN: *ATN Channel 7, Sydney, 30 March 1966.*

Venice. Gaston Monescu (HERBERT MARSHALL), a professional thief posing as a baron, robs M. Francois Filibert (EDWARD EVERETT HORTON) of 20,000 lire by pretending to be a doctor and gaining access to the Royal Suite at a hotel located on the Grand Canal where the hapless victim is staying. That same evening, Gaston has a liaison with a 'Countess' (MIRIAM HOPKINS), who is actually a crook named Lily. Several months later, now living together and working as a team, Gaston and Lily rob wealthy Mariette Colet (KAY FRANCIS) of a valuable diamond-studded handbag during a night at the opera. Mariette posts a large reward for the bag's return, so Gaston obligingly returns it. Gaston charms the widow, who owns a profitable perfume company, Colet et Cie, and obtains a position as her secretary. He then hires Lily as his assistant. Mariette has two rather dull suitors, the Major (CHARLIE RUGGLES) and none other than Filibert. M. Giron (C. AUBREY SMITH), who manages Colet et Cie, resents Gaston's interference in his affairs, and when Filibert finally recognises Gaston as the man who robbed him, the game is up. But will Gaston stay with Mariette or flee with Lily?

The opening sequence of *Trouble in Paradise* is justly famous. After the brief credits—which are accompanied on the soundtrack by an anonymous tenor singing the title song ('Most any place/Can seem to be a paradise/ While you embrace/The one that you adore')—Lubitsch opens his brilliant romantic comedy with a deliberately unromantic scene in which Venetian garbage collectors heap rubbish into gondolas and sail down the Grand Canal singing 'O sole mio'. Inside the Royal Suite of the hotel above them— Room 2535-7-9—Filibert lies on the floor; a few rooms away, an elegantly dressed Gaston awaits the 'Countess', who arrives by gondola. They will have dinner in his room. He tells the waiter: 'If Casanova suddenly turned out to be Romeo having supper with Juliet, who might become Cleopatra, how would you start [the meal]?' 'Cocktails,' says the waiter firmly. During the course of their intimate soiree Gaston and Lily discover more about each other ('When I first saw you I thought you were an American,' she

says. 'Thank you,' he replies), and they quickly establish the fact that they're both skilled pickpockets and thieves. Meanwhile M. Filibert is explaining to the police and journalists that a man posing as a doctor arrived and asked to look at his tonsils—before Filibert passed out and awoke to find he'd been robbed.

The film continues with the same level of sophistication and elegance. Lubitsch was famous for his 'touch', which basically referred to his ultra-sophisticated use of the innuendo, and his amused suggestion of naughty sexual activity. He never showed sex, of course, but he hinted at what was going on behind closed doors with devices such as a series of shots of clocks as time passes, or a chaise longue where the lovers once reclined and that is suddenly no longer occupied.

Cast and technical credits were often sketchy for films made in 1932, but the production design and sets of the uncredited Hans Dreier are remarkable, especially in the wonderfully art deco interiors of Mme. Colet's Paris home. Lubitsch loved staircases, and Dreier supplies a beauty. There are some similarities to *Love Me Tonight*: the two films have three actors in common—Charlie Ruggles, C. Aubrey Smith and Robert Grieg, who plays the portly butler in both. But the key link is that of screenwriter Samson Raphaelson, whose sensibilities and love of language perfectly matched the proclivities of both Mamoulian and Lubitsch. Raphaelson (1896–1983) was a New York playwright whose works included *The Jazz Singer*, which was adapted into the famous Al Jolson part-talkie in 1927. He wrote several films for Lubitsch, including the sublime film *The Shop Around the Corner* (1940), and he taught screenwriting after his retirement from the movie business.

Lubitsch extracts wonderful performances from every member of his cast. Herbert Marshall, a British actor who lost a leg in World War II and thereafter walked with a slight limp, was never better; his world-weary Gaston positively reeks of charm. Miriam Hopkins, too, is at her peak here, as is Kay Francis whose delivery of lines like 'When a lady takes off her jewels in a gentleman's room where does she put them?' are handled with barely suppressed lust. Charlie Ruggles was one of the most skilled comedians of the era; his pompous Major is perfectly matched by Edward Everett Horton's dithering Filibert.

Ernst Lubitsch (1892–1947) was born in Berlin to a Jewish family and his early films, made between 1915 and 1918, in which he also acted, are broad ethnic comedies in which his Jewishness is strongly emphasised.

He graduated to spectacle films, like *Madame Du Barry* (1919), *Sumurun* and *Anna Boleyn* (both 1920), obtaining the nickname of Germany's D.W. Griffith. These films brought him to the attention of Hollywood, and Mary Pickford—then one of the most important actors and producers—invited him to America to direct her in *Rosita* (1923). He never returned to Germany, but the same year commenced, with *The Marriage Circle*, the series of unforgettable comedies about 'modern' relationships that made him famous. During the silent era he made several films, including a version of Oscar Wilde's *Lady*

Thieves and lovers: Gaston Monescu (HERBERT MARSHALL) and the 'Countess' (MIRIAM HOPKINS) in *Trouble in Paradise*. (ALAMY)

Windemere's Fan (1925). Unfortunately, *The Patriot* (1928), an epic that was chosen to open Sydney's celebrated State Theatre in June 1929, is lost today.

His first talkie, *The Love Parade* (1929), teamed Maurice Chevalier and Jeanette MacDonald and proved that Lubitsch, like Mamoulian, was a creative innovator when it came to the use of sound in the early period of the sound revolution. Subsequent hits included *The Smiling Lieutenant* (1931) and *One Hour with You* (1932).

With the imposition of much stricter censorship (the Production Code) early in 1934, Lubitsch found himself unable to direct the kind of film that made him famous (*Trouble in Paradise* was withdrawn and wasn't seen again for about 35 years). He was made production manager at Paramount in 1935, but freelanced later in the 1930s and made one of his greatest comedies, *Ninotchka* (1939), at MGM; one of the writers of that film was Billy Wilder, a refugee from Nazi Germany, who was immensely influenced by Lubitsch. The following year, *The Shop Around the Corner*, set in Budapest, proved to be one of the greatest romantic films ever made, with unforgettable performances from James Stewart and Margaret Sullavan. The independently made *To Be or Not to Be* (1942), with Jack Benny and

Carole Lombard, found Lubitsch mocking Hitler and the Nazis in a brutally funny comedy about Poland under the Occupation. (In *Trouble in Paradise*, Gaston insults the insufferable M. Giron by calling him 'Adolf', and he strongly resents it!) Lubitsch's first colour film was the super-elegant *Heaven Can Wait* (1943). He died of a heart attack in 1947 while filming *That Lady in Ermine*, which was completed by Otto Preminger.

For years afterwards, Billy Wilder's office featured a poster with the words: 'How Would Lubitsch Do It?

8

It's a Gift

USA, 1934

Paramount. DIRECTOR: Norman [Z.] McLeod. 69 MINS.
FIRST SEEN: *ATN Channel 7, Sydney, 29 December 1963.*

Small-town America. Harold Bissonette (pronounced 'Bis-on-ay' as he keeps insisting) (W.C. FIELDS), owner of a grocery and general store, longs to acquire an orange ranch in California. Despite the objections of Amelia (KATHLEEN HOWARD), his overbearing wife, and Mildred (JEAN ROUVEROL), his lovesick daughter, he heads west with his family only to discover that the property he's been sold by Mildred's boyfriend, John (JULIAN MADISON), is worthless—or is it?

The credits for *It's a Gift* appear over a scene that actually occurs later in the film as Bissonette and his family are driving to California ('California, Here I Come' is heard on the soundtrack) in their ramshackle, overloaded jalopy. The film proper begins in uneasy domesticity. Fields is first seen in the bathroom attempting to shave with a cutthroat razor while the selfish Mildred hogs the mirror in order to apply her make-up. The ways in which Bissonette deals with this problem provide the first of a series of frequently hilarious comedy routines. The hapless Bissonette subsequently falls down the stairs after treading on his small son's rollerskates (Fields is said to have loathed children, and when they appear in his films they're usually monsters).

After ten minutes of preliminaries in the Bissonette household, in which it's established that both Amelia and Mildred are ferociously opposed to Harold's scheme to start a new life on a California orange farm, there comes one of the classic sequences of 30s comedy when Harold arrives at his shop. His gormless assistant (TAMMANY YOUNG) is ignoring an impatient customer (MORGAN WALLACE) who is demanding ten pounds of cumquats—in a hurry. (Fields is said to have found the word 'cumquat' comically suggestive). The customer never gets his cumquats, because the store is disrupted by the arrival of Mr Muckle (CHARLES SELLON), a blind and deaf man who accidentally smashes the windows and much of the glassware while demanding that his modest purchase of a packet of chewing gum be wrapped and delivered to his home. Fields' treatment of this disruptive

customer, who keeps waving his walking stick in the direction of breaka-
bles, is both funny and touching. He showers the cantankerous old man
with affection, calling him 'dear' and even 'darling', and is horrified when
Muckle leaves the store and crosses the road; the usually quiet thoroughfare
on this occasion becomes a perilous journey because Mr Muckle's crossing
coincides with a high-speed police chase. The sequence ends when Fields'
regular nemesis, child star Baby LeRoy, whose mother fails to control him,
floods the store with molasses ('Closed on account of molasses' reads the
sign on the shop door afterwards).

The next sequence is a re-creation of one of Fields' successful stage
routines. Sick of Amelia's nagging, Harold attempts to get some sleep on
his verandah, only to be pestered by a series of unwelcome interpolations:
an insurance salesman, a milkman and the neighbours, as well as inani-
mate but still disruptive items like a squeaky washing line and a coconut.

The family eventually sets off for California in their jalopy, stopping
along the way to trash the gardens of a stately home—which they've mistaken
for a public park—and for Fields to have such difficulty working out how
to open a deckchair that he gives up and throws it on a bonfire. When
they arrive they find the farm that Harold has acquired is in a hopelessly
dilapidated state, but fortunately it's located on top of oil deposits, so all
ends well.

I first discovered W.C. Fields when I saw what was effectively his last
film, *Never Give a Sucker an Even Break* (1941), at a London repertory
cinema in 1957. My father, not a film-goer, was a major fan of Fields and
kept a poster-sized photograph of the comedian on the wall of his study;
after seeing Fields on screen for the first time I understood why.

W.C. Fields (1880–1946), christened William Claude Dunkinfield, was
the son of a cobbler who migrated to Philadelphia in the 1880s. As a boy
he ran away from home and became a thief and a juggler, attributes he
transformed into a career as a comedian-juggler in vaudeville, touring not
just America but also much of the world, including Australia. He entered
films in the silent era, but his most representative screen work consists of
the 13 films he made at Paramount (1932–1937). Often writing the stories
and scripts for his films under unlikely pseudonyms (the story of *It's a Gift*
is credited to Charles Bogle, a Fields alias), Fields incorporated many of his
old vaudeville routines into plots that invariably cast him as a henpecked
husband, alcoholic and hater of small children.

The Fields character, that of a testy middle-aged man who is bullied by his wife and tormented by children, is far from being politically correct by today's standards. But the comic's mastery of slapstick and his perfect timing still astonish today. During the Depression, audiences flocked to see comedy films, and the studios supplied plenty of them. At Paramount alone during this period comedies were being made starring Mae West, the Marx Brothers, and the husband and wife team of George Burns and Gracie Allen, among others.

The director of *It's a Gift*, Norman Z. McLeod (1898–1964), worked with many of the above-mentioned comedians and also made an eccentric version of *Alice in Wonderland* (1933) in which Fields appeared as Humpty Dumpty. In later years McLeod worked with a subsequent generation of screen comics, including Bob Hope and Danny Kaye. His films included *Monkey Business* (1931), *Horse Feathers* (1932), *Topper* (1937), *Merrily We Live* (1938), *Road to Rio* and *The Secret Life of Walter Mitty* (both 1947), *The Paleface* (1948) and *My Favorite Spy* (1951).

A year after *It's a Gift*, Fields was cast in George Cukor's magnificent adaptation of Charles Dickens' *David Copperfield*, which was given the full MGM treatment; Fields was just about perfect as Mr Micawber, and clearly embraced the opportunity to play a 'straight role'. He continued to write (under a variety of aliases) and star in films until his death. He co-starred with Bing Crosby in *Mississippi* (1935), re-created his celebrated stage character of Professor Eustace P. McGonigle in *Poppy* (1936), played Larson E. Whipsnade in *You Can't Cheat an Honest Man* (1939), co-starred with Mae West in *My Little Chickadee* (1940)—though neither was seen at their best in that one—and played a small-town character involved with a film company in *The Bank Dick* (also 1940). After *Never Give a Sucker an Even Break*, alcoholism seriously affected his performances. His episode in the multi-part *Tales of Manhattan* was removed (though it can be seen in some recent video releases). He appeared as himself in three forgettable variety films, and died on Christmas Day, 1946.

9

A Night at the Opera

USA, 1935

MGM. DIRECTOR: Sam Wood. 91 MINS.

FIRST SEEN: *Classic Cinema, Baker Street, London, UK 13 January 1958.*

Milan. In a smart restaurant, Mrs Claypool (MARGARET DUMONT) has, she angrily tells the waiter, been waiting an hour for her date, Otis B. Driftwood (GROUCHO MARX), who, as it happens, is sitting directly behind her sharing a table with an attractive blonde. On receiving his bill, Driftwood declares that the amount—$9.40—is an outrage, hands it to the blonde and advises her not to pay it. The rendezvous is supposed to have been arranged so that Driftwood, a conniving wheeler-dealer, can introduce the wealthy Mrs Claypool to Hermann Gottlieb (SIGFRIED RUMANN), the pompous director of the New York Opera. In order to become a member of the New York social set, Mrs C. has agreed to become a generous donor to the opera.

Meanwhile a performance of *Pagliacci* is in progress (presumably at La Scala) starring the obnoxious tenor Rodolfo Lassparri (WALTER KING). Driftwood professes amazement when he learns that Lassparri earns $1000 per night. ('For 75c you can get a record of Minnie the Moocher. For a buck and a quarter you can get Minnie!') Enter Fiorello (CHICO MARX) and Tomasso (HARPO MARX), who are friendly with Rosa (KITTY CARLISLE) who is in love with Ricardo (ALLAN JONES), also a tenor. All concerned set sail for New York where Fiorello, Tomasso and Ricardo, who stowed away on the ship, are sought by police officer Henderson (ROBERT EMMETT O'CONNOR). Driftwood helps his three friends sabotage the New York debut of Lassparri in *Il Trovatore*, forcing Gottlieb to hire Ricardo and Rosa as his singing stars.

A Night at the Opera was the first film the Marx Brothers made at MGM, after being based at Paramount for their first five features. The Paramount films, which also starred Zeppo, the fourth brother, who played the straight man, were made on the cheap but they were 'purer' than the later films in that for the most part the Brothers' routines were undiluted with anything resembling a serious plot or production values. Many regard their last Paramount film, *Duck Soup* (1933), as their finest, and I would tend to agree—but this book is about favourite films and *A Night at the*

Opera was the first Marx Brothers film I saw, so it holds a very special place in my film-going experience.

This movie contains some of their funniest material. The opening sequence in the restaurant is hilarious, with Groucho at his wisecracking best and the wonderful Margaret Dumont the perfect, long-suffering foil for his assaults on snobs and socialites. 'Three months ago you promised to put me into society,' Mrs Claypool complains, 'and in all that time you've done nothing but draw a very handsome salary.' 'You think that's nothing?' retorts Driftwood. After Gottlieb kisses Mrs C.'s hand, Driftwood ostentatiously examines it 'to make sure your rings are still there'. Congratulating Mrs C. on her anticipated contributions to the arts, Gottlieb tells her, 'All New York will be at your feet' while Driftwood, looking under the tablecloth, remarks, 'Well, there's plenty of room.' This was the sort of savagely funny repartee for which Groucho, with his painted-on moustache, rolling eyes and inevitable cigar, was famous.

The film's other great scene takes place on the ship as Driftwood is escorted to the tiny cabin Gottlieb has assigned to him; there's hardly space enough to fit his trunk, in which Fiorello, Tomasso and Ricardo have stowed away. Driftwood has arranged an assignation with Mrs Claypool, but his unwanted guests insist on ordering a complicated amount of food and there are visits from the maids who come to make up the bed, the engineer and the engineer's assistant, a woman who gives Driftwood a manicure, and a young woman searching for her Aunt Milly. ('Well if she isn't here you can probably find somebody just as good,' Driftwood tells her.) When Mrs C. opens the cabin door everyone who has been packed inside tumbles out. It's a marvellous, ten-minute sequence, perfectly timed and executed.

Later in the voyage Chico and Harpo are given the opportunity to play the instruments for which they were renowned when they entertain steering-class children. Chico plays 'All I Do is Dream of You' on the piano, while Harpo, who visibly relaxes as he approaches an incongruously positioned harp, performs 'Alone' (a song composed by future MGM musical producer Arthur Freed and Nacio Herb Brown, which had been performed earlier—in one of the film's extraneous musical sequences—by Allan Jones and Kitty Carlisle).

Apart from the mercifully brief romantic episodes and the musical numbers involving Jones and Carlisle, *A Night at the Opera* is pure Marx,

leading up to the climactic scene in which the opera is transformed into hilarious mayhem by the brothers (a sequence more or less copied by Danny Kaye in his 1954 comedy, *Knock on Wood*).

One of my favourite moments in the film comes when the irascible Detective Henderson comes to search the hotel room in which Driftwood has been enjoying a chaotic breakfast with the other three, who, to avoid the policeman, have quickly decamped to the balcony. When Driftwood denies that he's been with Fiorello, Tomasso and Ricardo, Henderson remarks: 'Your table's set for four,' to which, quick as a flash, Driftwood responds, 'That's nothing. My alarm clock's set for eight!'

The Marx Brothers—Groucho (1890–1977), born Julius Henry; Chico (1887–1961), born Leonard; and Harpo (1888–1964), born Adolph, whose 'gimmick' was that he never spoke—perfected their characters and comedy routines in vaudeville before making their first film, *The Cocoanuts* (1929), at the beginning of the sound era. The last film in which the three of them appeared was *Love Happy* (1950) after which Groucho continued to make solo appearances and starred in a long-running TV game show, *You Bet Your Life* (1950–1960).

Sometime in the mid-1950s my parents took me to see Chico Marx performing on stage at the Bristol Hippodrome. I'd never seen a Marx Brothers film at this stage, so I wasn't as impressed as I might have been. Most of his act consisted of playing the piano, and he was a tiny figure in what seemed to me to be a vast auditorium (we were in the cheap seats).

On 15 November 1972, Robert Altman invited me to the Goldwyn Studios in Hollywood to see a rough cut of his new film, *The Long Goodbye*. One of the other guests was Groucho Marx. We shook hands and I was, frankly, at a loss for words in the presence of one of my all-time heroes.

The director of *A Night at the Opera*, Sam Wood (1883–1949), started his career in the silent era, making his first film, *Double Speed*, in 1920. He also directed the subsequent Marx Brothers film, *A Day at the Races* (1936) and the very popular *Goodbye Mr. Chips* (1939) as well as several impressive melodramas, including *Kitty Foyle* (1940), *King's Row* (1942) and *Command Decision* (1948), plus an underwhelming version of Ernest Hemingway's *For Whom the Bell Tolls* (1943). His last film, *Ambush*, was made in 1949.

10

The Awful Truth

USA, 1937

Columbia. DIRECTOR: Leo McCarey. 91 MINS.
FIRST SEEN: *ATN Channel 7. Sydney. 19 February 1971.*

New York. Philandering husband Jerry Warriner (CARY GRANT) is mortified when his wife, Lucy (IRENE DUNNE), comes home one morning in evening dress accompanied by her dapper music teacher, Armand Duvalle (ALEXANDER D'ARCY). She tells a preposterous story about a car breakdown and an innocent night in a hotel. Jerry and Lucy argue and decide to divorce. Lucy meets Oklahoma oil millionaire Daniel Leeson (RALPH BELLAMY) and starts dating him. Jerry becomes engaged to socialite Barbara Vance (MOLLY LAMONT). But on the day before their divorce becomes final, Lucy and Jerry spend a night in a log cabin and succumb to 'that old feeling'.

The Awful Truth, scripted by Vina Delmar and based on a play by Arthur Richman, is generally considered to be the film that once and for all established Cary Grant as a debonair, charming, ultra-sophisticated leading man. After the opening credits, which are placed over a series of formal dinner settings, the film begins at 4 pm at the Gotham Athletic Club where the cheerful Jerry is having a quick artificial suntan. He tells a friend that he was supposed to have been in Florida for the past two weeks attending a convention, but it's broadly hinted that he's been with another woman. 'What wives don't know won't hurt them' is his mantra.

Jerry arrives back at his New York apartment with four friends in tow, but, to his surprise, his wife isn't there. He assumes she's with her Aunt Patsy (CECILY CUNNINGHAM), but Patsy soon shows up also wondering where her niece might be. Lucy eventually arrives, elegantly attired, accompanied by the dapper and very continental Armand, who is dressed in white tie and tails. The friends leave and an awkward conversation ensues ('I am a great teacher, not a great lover,' Armand protests in a lame attempt at defending himself, while Lucy responds with: 'No one could accuse you of being a great lover!'). This sort of dialogue somehow managed to slip past the watchful Production Code.

While the Warriners' intelligent fox terrier, Mr Smith, looks on concernedly, Lucy calls her lawyer about a divorce. In one of the film's most trenchant

scenes, the lawyer (EDMUND MORTIMER), who is dining at home with his wife, leaves the dinner table to answer Lucy's phone call. He tries to talk her out of a divorce, telling her that 'Marriage is a beautiful thing'—while breaking off the conversation to yell at his wife (SARAH EDWARDS) to 'Please shut your mouth!' when she insists that he stop talking on the phone and return to the dinner table. In the divorce court the judge (PAUL STANTON) gives custody of Mr Smith to Lucy, with visiting rights to Jerry.

Ralph Bellamy was frequently saddled with the role of the 'other man' and he's perfect in the role of the rival, Dan. (Cary Grant would be his rival again in *His Girl Friday* two years later.) He's visiting Lucy when Jerry turns up—it's his day to visit Mr Smith—and apologises for the intrusion. ('I know how I'd feel if I was sitting with a girl and her husband walked in,' he tells Dan. 'I bet you do!' returns Lucy.)

As the film proceeds, with Irene Dunne wonderfully costumed and wearing a series of spectacular hats, there is scene after scene of hilarity. A chance encounter at a nightclub introduces Dixie Bell (JOYCE COMPTON), Jerry's partner for the evening, who works at the club and performs a racy number in which her skirt blows up (similar to the way in which Marilyn Monroe's skirt famously behaves in *The Seven Year Itch* almost 20 years later). There's a scene of pure French farce when Armand visits Lucy's apartment and hides when Jerry shows up. Thanks to Mr Smith's game of hide and seek, Jerry finds himself wearing Armand's hat—Grant is sublime in this scene—and then both men hide in the bedroom when Dan arrives.

A montage sequence showing Jerry out on the town with Barbara concludes with another hilarious set piece in which Jerry is attending a formal dinner at the home of Barbara's snooty parents (ROBERT WARWICK, MARY FORBES) when Lucy turns up uninvited, posing as Jerry's sister, and acts outrageously for the benefit of the horrified Vances.

Born in Bristol, England, Cary Grant (1904–1986) had made almost 30 films prior to *The Awful Truth* and though some of them were pretty good, he hadn't hit the really big time until the release of this film, which was followed soon afterwards by *Bringing Up Baby*; in these two films he was able to demonstrate his perfect comedic timing, the expressive gestures and looks, and throwaway lines. As one of Hollywood's superstars, Grant was adept at drama as well as comedy—he is chillingly good in Hitchcock's *Suspicion* and *Notorious*—and he remained a popular leading man until he retired in 1966 after making *Walk Don't Run*. As a child discovering movies and growing up not far from Bristol, I was impressed by the fact

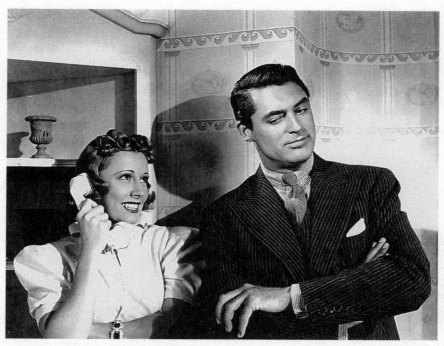

Lucy (IRENE DUNNE) and her errant husband, Jerry (CARY GRANT) in Leo McCarey's *The Awful Truth*.

that Grant, whose real name was Archie Leach, would 'come home' every Christmas to visit his elderly mother who, apparently, never wanted to move to America.

The versatile Irene Dunne (1898–1990), who had scored in both dramas (*Cimarron*, *Back Street*) and musicals (*Roberta*, *Show Boat*, *High Wide and Handsome*) prior to *The Awful Truth*, was an accomplished comedian, and was also given an opportunity to demonstrate her singing voice. Incidentally, two years later she worked with director McCarey again in the weepie *Love Affair* opposite Charles Boyer; McCarey himself directed the remake, *An Affair to Remember*, with Cary Grant and Deborah Kerr.

The entire delicious concoction is the work of Leo McCarey (1898–1969), who started his career making two-reel comedies for Hal Roach and Laurel and Hardy, including the classic *From Soup to Nuts* (1928). In 1933 he made *Duck Soup*, which, for many, is the best of the Marx Brothers comedies, and he also worked with Mae West and W.C. Fields. *Ruggles of Red Gap* (1935), with Charles Laughton, is another comic masterpiece. Later in his career McCarey abandoned comedy to make sentimental dramas. Though

many of these films were very good indeed (*Make Way for Tomorrow,* made immediately after *The Awful Truth,* is outstanding) others tended to be mawkish, though *Going My Way* (1944)—in which Bing Crosby stars as a singing priest—won seven Oscars including Best Film and Best Director. McCarey's career hit its nadir with *My Son John* (1952), a pro-McCarthy drama about parents who discover their son is a Communist sympathiser and denounce him. His last film was the dreary *Satan Never Sleeps* (1962).

11

Snow White and the Seven Dwarfs

USA, 1937

Walt Disney Features (originally distributed by R.K.O. Radio). SUPERVISING DIRECTOR: David Hand. 83 MINS.
FIRST SEEN: *Odeon, Andover, UK early 1940s.*

Once Upon a Time there lived a beautiful Princess, Snow White, whose wicked stepmother, the Queen, was evil and vain, and forced Snow White to wear rags and to perform menial chores. Every day the Queen consulted her Magic Mirror to demand who was the fairest in all the land—and when one day the Mirror told her that Snow White was now the fairest, instead of herself, she plotted with her Huntsman to have the girl killed and her heart provided as proof of the killing. Snow White, who has meanwhile met Prince Charming, escapes when the Huntsman hesitates, and she dashes into the forest accompanied by an assortment of fauna. She arrives at the isolated home of the Seven Dwarfs, who are away working in their diamond mine. Assisted by the birds and animals, she cleans up the filthy place and when they return from their diamond mine the Dwarfs—Doc, Happy, Sneezy, Dopey, Grumpy, Bashful and Sleepy—find her asleep in the bedroom. Meanwhile the Queen, told by the Mirror that Snow White still lives, and where she's to be found, takes a magic potion and transforms herself into a crone. She arrives at the cottage with a poisoned apple that brings about 'sleeping death', cured only by 'Love's First Kiss'. Snow White bites into the apple and falls into a deep sleep; the dwarfs pursue the Queen to her death. The Prince arrives, kisses Snow White, and they live Happily Ever After.

Snow White and the Seven Dwarfs was not the first feature-length animated film—that honour goes to Germany's Lotte Reiniger for her 62-minute movie *The Adventures of Prince Achmed* (1926)—but it was the first of the sound era and the first American animated feature. Made at what was then an enormous cost (a reported US$1,500,000), the film represented a huge risk for Walt Disney, who had previously been known for his *Silly Symphonies* shorts and his films with Mickey Mouse, Donald Duck and Goofy. It was labelled 'a folly' during the extended production period, but when it was finally released, in time for Christmas in 1937, it was hailed an instant masterpiece—and no wonder. With its delicately shaded

Technicolor, its memorable songs ('I'm Wishing', 'One Song', 'Some Day My Prince Will Come', 'Hi-Ho, Hi-Ho', 'With a Smile and a Song') and its skilful combination of romance, comedy, suspense—with even a touch of horror—the film was an instant triumph and for many years, until it was released on DVD in the 1990s, was reissued regularly so that every new generation of children had the opportunity to see it. (I first saw it during one of those revival seasons.)

The film opens with a statement from Disney: 'My sincere appreciation to the members of my staff whose loyalty and creative endeavor made possible this production.' The credits that follow are rather sketchy. Disney himself is clearly in overall control, but David Hand is credited as Supervising Director. Five 'Sequence Directors' are named, plus four 'Supervising Animators', eight 'Story Adaptors', two 'Character Designers', three Music Composers, ten 'Animation Directors', seven 'Background Designers' and twenty-four Animators—among the latter are James Algar, Ward Kimball and Wolfgang [Woolie] Reitherman, all of whom worked for Disney for years and directed some of his later productions. There are no credits for the voice cast. These days much is made of the famous names that provide the voices for the cartoon characters, but in 1937 they were anonymous. However, we know that Snow White was voiced by Adriana Caselotti, Prince Charming by Harry Stockwell, the Queen by Lucille La Verne and that the dwarfs were voiced by Roy Atwell (Doc), Pinto Colvig (Sleepy and Grumpy), Scotty Mattraw (Bashful), Billy Gilbert (Sneezy) and Otis Harlan (Happy). Dopey doesn't speak ('He never tried').

The magic begins with the opening of an ornate book and the basic plot is provided by three pages of written text. The film proper begins with the Queen consulting her Mirror (voiced by Moroni Olsen). Accompanied by 'I'm Wishing (For the One I Love)', Snow White is seen at a wishing well where she's spotted by Prince Charming, who happens to be riding by ('One Song'). The Queen gives the Huntsman his orders, but Snow White flees from him into a forest filled with rabbits, squirrels, deer and birds, cute creatures that seem to be rehearsing for *Bambi,* which arrived five years later. The clean-up of the dusty, dirty home of the dwarfs ('Whistle While You Work') is played for slapstick—and the sequence contains some exceptional animation. The dwarfs themselves are introduced 21 minutes into the film and there is then nearly 15 minutes of their antics before they finally meet Snow White. These scenes compare interestingly with those in Stanley Donen's delightful musical *Seven Brides for Seven Brothers* (1954) in which

a lone woman is also—very willing—to cook and clean and generally serve seven unkempt and rowdy males. A celebratory get-together ('The Dwarfs' Yodel Song') is another fun sequence. Then comes the scene in which the Queen evokes Dr Jekyll and Mr Hyde and transforms herself, by means of an elaborately produced green potion, into the horrid witch—a sequence that has given children nightmares over the decades. Nightmarish, too, is the pursuit of the witch during a thunderstorm to the top of a mountain from which she falls to her death.

Walter Disney (1901–1966), together with his brother, Roy, established an animation studio in Hollywood in the early 1920s and, in collaboration with Ub Iwerks, created the cartoon character Mickey Mouse. Walt himself provided the voice of the beloved rodent. He pioneered the use of both colour and sound and, over an illustrious career, was the recipient of many awards, including 22 Oscars (the most awarded to any individual). After the success of *Snow White* he produced other trail-blazing and hugely popular animated features: *Pinocchio* and *Fantasia* (both 1940), *Dumbo* (1941), *Bambi* (1942), *The Three Caballeros* (1945), *Make Mine Music* and *Song of the South* (both 1946), *Fun and Fancy Free* (1947), *Melody Time* and *So Dear to My Heart* (both 1948), *Ichabod and Mr. Toad* (1949), *Cinderella* (1950), *Alice in Wonderland* (1951), *Peter Pan* (1952), *Lady and the Tramp* (1955) and *Sleeping Beauty* (1958). The last animated film he personally produced was *101 Dalmations* (1960). Meanwhile the Disney studio branched out into live-action family films, amusement parks and merchandising of all kinds. In 2019, the Disney Company acquired 20th Century Fox Film Corporation, now 20th Century Studios, and has become one of the world's most powerful entertainment organisations.

12

The Rules of the Game
(*La règle du jeu*)

FRANCE, 1939

La Nouvelle Edition Française. DIRECTOR: **Jean Renoir**. 102 MINS.
FIRST SEEN: *Melksham & District Film Society, Wiltshire, UK 22 September 1962.*

Paris. An excited crowd at the airport greets aviator André Jurieux (ROLAND TOUTAIN) who has just flown the Atlantic in 23 hours. He's disappointed that Christine de la Chesnaye (NORA GREGOR), with whom he is in love, isn't there to meet him. His friend, Octave (JEAN RENOIR), has arranged for André to be invited to a weekend house party at La Colinière, the château belonging to Christine's husband, Robert, the Marquis ([MARCEL] DALIO). Other guests include Geneviève (MILA PARÉLY), mistress of the Marquis; Christine's flirtatious maid, Lisette (PAULETTE DUBOST), married to the intensely jealous Schumacher (GASTON MODOT), the estate gamekeeper; and Marceau ([JULIEN] CARETTE), a cheeky poacher newly employed by Robert, who proceeds to flirt with Lisette. During the weekend relationships evolve and become more complex until the gathering ends in a tragedy that is quickly covered up.

Jean Renoir's 'dramatic fantasy' has been described by French critic Claude Beylie as 'a perfectly constructed film which (with Orson Welles' *Citizen Kane*) is the source of everything of importance in modern cinema'. The film begins with a quote from *The Marriage of Figaro*: 'For if love has wings it is to soar to liberty.'

The chaotic scene of the airport arrival is marred by the fact that André, the 'national hero', behaves, as his friend Octave admonishes him, 'like a kid' because Christine, the woman with whom he's in love, hasn't turned up. Christine, who was born in Austria, has been listening to the radio broadcast of his flight and safe arrival with mixed feelings. She talks to her maid, Lisette, about the latter's apparently numerous lovers. 'What about friendship?' asks Christine, and Lisette replies, 'Friendship with a man? That's asking for moonlight at noon.'

Meanwhile, as he is driving to Paris from the airport with Octave, André deliberately crashes his car. As they walk away from the wreck, André expresses his belief that Octave also loves Christine. He admits it ('In my

fashion') and explains how he first met her when he studied music in Salzburg, and was taught by her father who 'treated me like a son'. Octave promises to arrange for André to be invited to the weekend at the de la Chesnaye château. Robert confides to Geneviève that 'I've a feeling the fun is over.'

Octave meets with Robert to ask him to extend the invitation to André and he agrees, noting that 'I'm against barriers.' It's at this point that Octave makes the significant observation that 'the terrible thing is that everyone has his reasons', a sentiment often quoted in relation to Renoir's films in general.

Twenty minutes into the film, Robert and Christine arrive at the château, followed shortly afterwards by the other guests. While on a tour of his property with his surly gamekeeper, Schumacher, Robert encounters Marceau the poacher and, to Schumacher's evident annoyance, makes a spontaneous decision to hire the man to work in the château.

The superbly choreographed comings and goings of the guests and the staff upstairs and downstairs in the following sequences are beautifully handled. Both of the classes, upper and lower, delight in gossip and innuendo. The justly famous sequence of the hunt, in which scores of rabbits and game birds are shot, ends when Christine sees at a distance her husband embracing Geneviève, not knowing that he has just told her he is ending their affair.

The evening entertainment consists of a stage act in which some of the participants don Tyrolean costumes; Octave appears in a bearskin from which he later can't extract himself. During the evening, Robert and Marceau discover that they have a strange rapport ('Women can be a nuisance,' the servant avers as he ties his master's tie. 'I always try to make them laugh.') And, indeed, what follows very often veers into silent-style slapstick as the jealous Schumacher chases Marceau through the rooms of the château, startling the guests as he fires a pistol at his rival. Meanwhile another pair of rivals, in this case for the affections of Christine—her husband, André and Octave—flit like bees near a honeycomb around her, and one of them will become a victim before the night is over.

Renoir said of the film: 'I was torn between my desire to make a comedy of it and the wish to tell a tragic story. The result of this ambivalence was the film as it is.' It seems to have been partly this ambivalence—the sudden shifts between farcical comedy and sombre drama—that alienated French audiences in July 1939, but there was another reason: billed only as Dalio, the fine actor who plays Robert, the Marquis, was Jewish, and it appears

that casting a Jewish actor as a member of the French nobility was too much for many people at that moment in time. Whatever the reason, there was reportedly a riot at the film's premiere and an attempt to burn down the cinema. Cuts were made to remove some of the scenes that seemed to be giving offence, but in October, a few weeks after World War II broke out, the French government banned the film, a ban that continued during the German Occupation. After the war it was feared for a long time that the cut scenes were forever lost, but in the early 1960s, under Renoir's supervision, the film was restored and re-released, this time to considerable acclaim.

I first saw it when I screened it at the film society I had started in my home town (Melksham, Wiltshire, UK) soon after its re-release.

Jean Renoir (1894–1979) was the son of the famous painter Auguste Renoir. He began to make films in 1924 and his breakthrough came in 1931 with *La chienne*, a powerful melodrama starring Michel Simon as a humble man who becomes involved with a prostitute (Fritz Lang directed the Hollywood remake, *Scarlet Street*, in 1945). During the 1930s, Renoir made a series of impressive films including *Boudu sauvé des eaux/Boudu Saved from Drowning* (1932), *Chotard et cie* (1933), *Toni* and *Madame Bovary* (both 1934), *Le crime de M. Lange* (1935), *Les bas fonds* (1936, based on Maxim Gorky's *The Lower Depths*), *La grande illusion*, which is considered to be one of the great anti-war films, and *La Marseillaise* (both 1937) and *La bête humaine* (1938, based on the Emile Zola novel). During the Occupation he successfully made his way to Hollywood where he made *Swamp Water* (1941), *This Land is Mine* (1943, about the German occupation of a small French town), *The Southerner* (1945) and *Diary of a Chambermaid* (1946). He travelled to India to make an adaptation of Rumer Godden's *The River* (1951) and made *Le carrosse d'or/The Golden Coach* (1952) in Italy before his triumphant return to France with *French Can-Can* (1955), *Elena et les hommes* (1957), *Le déjeuner sur l'herbe/Lunch on the Grass* (1959) and *Le caporal épinglé/The Vanishing Corporal* (1961). Towards the end of his career he started working in television, one of the few 'big name' directors to do so at the time: *Le testament du Dr. Cordelier* (1959, a version of *Dr. Jekyll and Mr. Hyde*) and *Le petit théâtre de Jean Renoir* (1969) were both made for the small screen.

13

The Grapes of Wrath

USA, 1940

20th Century-Fox. DIRECTOR: John Ford. 129 MINS.
FIRST SEEN: *Bath Film Society, UK 27 February 1963.*

Rural Oklahoma, the 1930s. When Tom Joad (HENRY FONDA), after serving four years in prison for manslaughter, returns to the tenant farm where his family has lived and worked for decades, he discovers that they have been forced off the property because the banks have foreclosed in the wake of the 'dustbowl' caused by prolonged drought. Packed into a rickety old car with all their possessions, the Joads—including Ma (JANE DARWELL) and Pa (RUSSELL SIMPSON), and accompanied by Casey (JOHN CARRADINE), a disgraced preacher—head west. After a difficult journey in which both of Pa's parents die, the Joads arrive in California to find exploitation and violence on the picket lines at the farms where fruit-picking jobs are supposedly on offer. Casey is murdered by strike breakers and Tom is injured trying to defend him. After a spell in a well-managed Department of Agriculture camp, Tom leaves his family to face an uncertain future as a fugitive.

'Considering the rumpus caused by John Steinbeck's book ... it took courage' to make a film of *The Grapes of Wrath,* the trade paper *Variety* noted in its glowing review of the film (31 January 1940). The movie is assuredly not typical of the sort of entertainment churned out by one of Hollywood's major studios at the time, and it says much for the determination of producer Darryl F. Zanuck, associate producer/screenwriter Nunnally Johnson and director John Ford that they brought the challenging material to the screen with only minor modifications.

After the simple credits, which are backed on the soundtrack by variations on the 'Red River Valley' theme used throughout the movie, the film opens at a crossroads where the solitary figure of Tom Joad is seen on foot heading for home. It's the first of many breathtaking location scenes photographed by Gregg Toland, one of the finest cinematographers of the period. The following sequence, set in the cabin of a truck giving Tom a lift, quickly establishes the parolee's recent history and his quick temper. He meets with Casey, who tells him he is 'no longer so sure' about preaching,

and who accompanies him to the deserted farm of Muley (JOHN QUALEN), who explains that all the local tenant farmers are being forced to leave.

Twenty-three minutes into the film we meet the rest of the Joads, who are optimistically preparing to leave for California. There's a beautiful scene in which Ma, lit only by firelight, sorts out her treasured belongings, including a small china dog acquired at the 1904 Louisiana Purchase Exposition. But along the way, travelling down Route 66, the grim reality slowly sinks in; thousands of other 'Okies' are in the same position, jobs aren't as plentiful as promised and exploitation is rampant.

Typical of Ford's humanist approach is a scene in a New Mexico diner. Pa enters the establishment, accompanied by the two younger children, seeking to buy bread. The waitress is dismissive (they only sell sandwiches, she explains, curtly, not bread), until the owner tells her to let them have the bread. ('It's yesterday's, anyway.') The children spot some sticks of candy, which the chastened waitress sells to them at less than the retail price. Pa and the children leave. Two truck drivers, who have witnessed all of this, pay their bill—and leave a larger than usual tip. The waitress gratefully mutters 'Truck drivers!' as they walk out the door. It's a simple but emotionally wrenching and completely unsentimental scene.

As the odyssey continues it becomes clear that, as far as the law is concerned, anyone who questions the authorities is an 'agitator' or a 'troublemaker' or even a 'Red'. ('Who are these "Reds" anyway?' demands Tom.) Ma bemoans the fact that 'they're working on our decency' as the orchard owners drive down the price paid for fruit picking, supported by police and armed thugs.

Ford loved sequences involving dancing and there's a beauty here when Tom partners with his mother at a dance held at the Department of Agriculture camp, and her face lights up with the pleasure of it. The scene in which Tom says goodbye to Ma is distinguished by Fonda's reading of a speech taken from the book: 'Wherever there's a fight so hungry people can eat I'll be there; wherever there's a cop beating up a guy, I'll be there . . .'

Jane Darwell, with her unkempt hair topped by an aged straw hat, creates one of the greatest female characters from this period in cinema. The men in the film are mostly weak, but Ma is the strongest of the strong and Darwell is astonishing in the role.

The novel ends with a painfully poignant scene in a barn in which Rose of Sharon (DORRIS BOWDON), who has just lost her baby, gives her breast to a starving man. Clearly that would not have been possible in a film made

in 1940, so Johnson and Ford end the film with a speech from Ma, which occurs earlier in the novel, as she and Pa drive down the highway: 'Rich fellas come up an' they die and their kids ain't no good and they die out, but we keep a-comin' . . . We'll go on forever, 'cos we're the people.'

I first discovered John Steinbeck when I saw Elia Kazan's fine screen adaptation of the last third of *East of Eden* in 1954. I read the novel soon afterwards, and my mother lent me her copy of *The Grapes of Wrath,* which I still have. The book moved me beyond words, and angered me, too, sentiments reinforced when I saw the film at a local film society some time later.

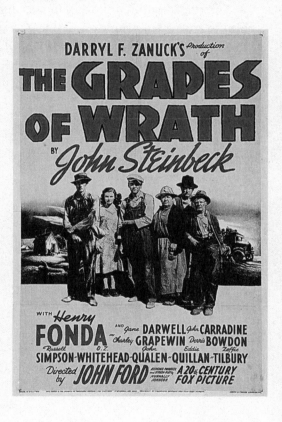

John Ford (1894–1973) entered the industry in the silent era and made his first western, *The Tornado*, in 1917—one of sixteen films he made that year. 'I make westerns,' he said proudly when establishing his credentials, and he was responsible for some of the best: *The Iron Horse* (1924) and *3 Bad Men* (1926) were two fine silent westerns. Oddly enough, he did not make another western until *Stagecoach* (1939), which made a star of John Wayne, but after that there were many: *Drums Along the Mohawk* (1939), *My Darling Clementine* (1946, with Henry Fonda as Wyatt Earp), *Fort Apache* and *Three Godfathers* (both 1948), *She Wore a Yellow Ribbon* (1949), *Wagonmaster* and *Rio Grande* (both 1950), *The Searchers* (1956), *The Horse Soldiers* (1959), *Sergeant Rutledge* (1960), *Two Rode Together* (1961), *The Man who Shot Liberty Valance* and the Civil War sequence of *How the West was Won* (both 1962) and *Cheyenne Autumn* (1964). He also earned acclaim with adaptations of famous novels, including *The Informer* (1935, for which he won his first Oscar), *How Green*

was My Valley (1941, his third Oscar) and *The Quiet Man* (1952, his fourth). He won Best Director for *The Grapes of Wrath,* and the exceptional Jane Darwell was the well-deserved winner of the Best Supporting Actress Oscar.

It must be said that Ford also made some very bad films, but even at his most slapdash and uninvolved he was entertaining. It was difficult indeed to choose just one of his films as a 'favourite' here, but *The Grapes of Wrath,* book and film, changed my life and so it has to take pride of place.

Interviews with Ford, who, in later life, wore a black eye patch, show him to have been grumpy and uncommunicative. My late friend, Pierre Rissient, who looked after him when he visited Paris in the 60s, confirmed that he was extremely difficult to deal with. No matter, he was indisputably one of the great American directors.

14

Citizen Kane

USA, 1941

R.K.O. Radio–Mercury. DIRECTOR: **Orson Welles.** 119 MINS.

FIRST SEEN: *BBC Television, UK 19 March 1960.*

Xanadu. Following the death of media magnate Charles Foster Kane (ORSON WELLES), a newsreel depicting the major events of his life is being prepared for *News on the March.* Thompson (WILLIAM ALLAND) is sent by his editor to interview those who knew Kane best and to attempt to discover the meaning of his last word, 'Rosebud'. From Walter Thatcher (GEORGE COULOURIS), Kane's lawyer, Thompson learns that, at the age of five, Kane inherited a vast fortune and was removed by Thatcher from the modest home of his parents (AGNES MOOREHEAD, HARRY SHANNON) to be educated. Kane's business associate, Bernstein (EVERETT SLOANE), talks about the day he, Jedediah Leland (JOSEPH COTTEN) and Kane took over the *Inquirer* newspaper in New York and made a success of it. Leland discusses Kane's marriage to Emily Norton (RUTH WARRICK), niece of the President of the USA, and how Kane had refused to submit to the blackmail of shady operator Jim W. Gettys (RAY COLLINS), who exposed his secret affair with Susan Alexander (DOROTHY COMINGORE). Leland also reveals that his friendship with Kane ended when, as dramatic critic of the *Inquirer,* he began writing a very negative review of Alexander's performance at the opening of the opera house Kane had built for her. Alexander herself talks about Kane's decline and fall, and finally his butler, Raymond (PAUL STEWART), sheds some light on his final days. The mystery of 'Rosebud' remains unsolved, but a sledge with that name painted on it is thrown into a furnace along with other pieces of Kane memorabilia.

More has probably been written about *Citizen Kane* than any other film in history. Seeing it for the first time is an unforgettable experience, but repeated viewings confirm its brilliance, starting with the clever mock-newsreel—which includes a shot of Kane with Hitler! Given carte blanche by R.K.O. to make a film of his choice, Orson Welles, then aged 26 and already celebrated for his progressive stage and radio productions—including his notorious, panic-inducing 1938 *War of the Worlds* radio adaptation of H.G. Wells—learnt how to make films by watching them; he later recalled that he ran John Ford's *Stagecoach* over and over again as a lesson in editing.

He assembled the best people in the business as his collaborators. Writer Herman J. Mankiewicz (the subject of David Fincher's excellent film *Mank*, 2020) co-authored the screenplay with Welles while Gregg Toland, the master cinematographer who had just photographed *The Grapes of Wrath* (1940), shares the director's title card with Welles in the end credits. Robert Wise, a future director of stature, was editor. The sets, complex make-up—which convincingly shows many of the characters ageing over the years—and the visual effects were all state of the art. Most members of the cast—certainly all of the key roles—had never acted in a professionally made film before but all of them had worked with Welles in his Mercury Theatre.

At the time the film impressed on a number of levels, and was seen as boldly original. The use of sets that clearly had ceilings; the overlapping dialogue; the deep-focus photography (used in, for example, the scene in which Kane's mother signs the paper that will change the boy's life: the mother is in the extreme foreground; the lawyer and the father in middle-range; and the boy himself, still in sharp focus, is outside, seen through the window playing with his sledge in the snow). In fact, most of these innovations had been used in earlier films, though not as well and not as brilliantly. Welles and Toland were not afraid to hide the identities of some of the minor characters in shadows (in the final scene one of the reporters is a barely visible Alan Ladd), and the face of William Alland, the investigator and audience surrogate, is never seen.

Just as crucial to the *look* of the film was the theme. Welles was clearly targeting the Rupert Murdoch of his day, William Randolph Hearst, the powerful newspaper and magazine owner whose life in many respects paralleled that of the fictitious Kane—though Welles himself admitted years later that he did an injustice to Marion Davies, Hearst's very talented mistress of many years, in his depiction of the character of the untalented and disagreeable Susan Alexander.

Whether written by Welles or Mankiewicz (there has been some dispute over authorship), the dialogue boasts a level of maturity rare in American cinema then or now. My favourite scene is the one in which Bernstein suggests that 'Rosebud' might have been a girl Kane once knew, and when Thompson finds that suggestion improbable, the old man reveals that 'One day back in 1896 I was crossing over to Jersey on the ferry . . . on another ferry was a girl in a white dress carrying a white parasol. I only saw her for one second and she didn't see me at all—but I'll bet a month hasn't

gone by since that I haven't thought of that girl.' This moving speech gets my vote for one of the key moments in all cinema.

Famous, too, is the montage of breakfast scenes that depict the deteriorating marriage of the workaholic Kane and his first wife, concluding with a shot of Emily Kane reading a rival newspaper. Kane's 'invention' of a war in Cuba—a ploy to increase circulation and something of which Hearst was also accused—confirms that 'fake news' is nothing new and that despots who claim to own the trust and love of their 'base' have been with us for many years.

Orson Welles (1915–1985), a child prodigy, was never able to match the critical success of *Citizen Kane*, which—partly because of a boycott by Hearst newspapers—failed at the box office. Two of his brilliant films— *The Magnificent Ambersons* (1942) and *Touch of Evil* (1958)—were both taken from his hands and partly reshot and re-edited; others, like *The Stranger* (1946) and *The Lady from Shanghai* (1947) were compromised in other ways; his Shakespeare films—*Macbeth* (1948), *Othello* (1951) and the masterly *Chimes at Midnight* (1966)—were made on tiny budgets and with great difficulty. *Confidential Report*, aka *Mr. Arkadin* (1955) and *The Trial* (1962) were filmed in Europe, and several of his films were never completed, among them versions of *Don Quixote*, *The Deep* (later filmed by Philip Noyce as *Dead Calm*) and *The Merchant of Venice*. *The Other Side of the Wind*, in which John Huston played a Welles-like film director, commenced filming in 1970 and wasn't completed until 33 years after the director's death. On the other hand, Welles achieved great success as an actor in films like Carol Reed's *The Third Man* (1949).

I had a brief encounter with Welles in San Sebastián, Spain, in September 1973. He had come there for the premiere of what proved to be the last film he personally completed, *F for Fake*, at the local film festival and we were staying at the same hotel. The elevator was one of those tiny, cage-like affairs, and Welles was accompanied by a very large dog of the mastiff variety; once Orson and the hound were in the lift everyone else had to wait. But who minded waiting for the director of *Citizen Kane*?

The Lady Eve

USA, 1941

Paramount. DIRECTOR: Preston Sturges. 94 MINS.
FIRST SEEN: *ATN Channel 7. Sydney. 5 May 1964.*

Somewhere in South America. After spending a year with an anthropological expedition on the Amazon, Charles Pike (HENRY FONDA), heir to the Pike Ales fortune, boards the SS *Southern Queen* to sail to New York. On his first night on board he meets Jean Harrington (BARBARA STANWYCK), whose father, 'Handsome Harry' (CHARLES COBURN), is a card sharp. Harry plans to fleece the gullible Charles, but Jean falls in love with him and he with her. When Mr Murgatroyd, aka Muggsy (WILLIAM DEMAREST), Charles' bodyguard, obtains proof that the Harringtons are professional crooks, the disillusioned Charles confronts Jean with the evidence, and the affair comes to a bitter end. After arriving in New York, Jean—seeking revenge—has the idea of posing as Lady Eve Sidwich and, accompanied by her 'uncle', Pinky, aka Sir Alfred McGlennan Keith (ERIC BLORE), attends a formal dinner at the Pike home where she gets along famously with Charles' no-nonsense father, Horace (EUGENE PALLETTE). Despite Muggsy's warnings that she is 'the same dame', Charles falls in love with Eve and they marry. But on their honeymoon in a sleeping car on a speeding train, Eve reveals to her husband her past affairs with at least seven other men, and he leaves her. She refuses to accept any compensatory money from the Pike family. On a liner taking Charles back to the Amazon he is happily reunited with Jean but he warns her that he's a married man.

The beautifully crafted screenplay for *The Lady Eve* ensures that it's one of the funniest of the screwball comedies of Hollywood's golden age. A year after playing the noble working man, Tom Joad, in *The Grapes of Wrath*, Henry Fonda gives another great performance as the self-absorbed and rather simple Charles Pike who announces from the start that 'I'd like to spend all of my time in the pursuit of knowledge.' When Jean deliberately trips him up in the dining room of the liner, he immediately succumbs to her charms. First seen eating an apple, Jean is an Eve who knows what she wants and sets about getting it. Her seduction of the hapless Charles, while the tune 'Isn't it Romantic?' plays on the soundtrack,

is hilarious—and pushes the censorship barriers of the time about as far as they could be pushed.

After playing cards with Jean and her father—they let him win the first time—Charles assures her that 'with a little coaching' she'll be a great player, and he insists on showing the swindlers card tricks. 'Don't you think we ought to go to bed?' asks Jean later, to which Charles responds: 'You're certainly a funny girl to meet for someone who's been up the Amazon for a year.' He takes her to his cabin to meet Emma—his pet snake—and they wind up together on the floor. So when her father decides it's time to make some money out of the sap, Jean decides to ensure 'Hopsy', as she calls him, isn't swindled. When Charles shows her the proof that she and her father are crooks, her happiness is instantly shattered; this scene takes place at a shipboard bar, and Jean assures him, 'I was going to tell you. You don't think I'd marry you without telling you?' Stanwyck's mood changes are superbly handled; this was, next to her very different role in Billy Wilder's *Double Indemnity* three years later, her greatest screen part.

Fifty minutes into the film the second half of the story commences with Jean posing as the Lady Eve at the Pikes' soiree. In this extended sequence Sturges proves he's not only a master of dialogue but also of slapstick as the hapless Fonda is subjected to one pratfall after another. Despite the fact that Eve looks exactly like Jean, she convinces Charles that she really has just arrived from England. ('I didn't know the boats were running,' Mrs Pike—Janet Beecher—remarks, to be assured by 'Sir Alfred' that she came on a cruiser.) Muggsy is suspicious ('It's the same dame') but Charles is convinced ('They look too much alike to be the same,' he rationalises). And when 'Sir Alfred' tells him about the Sidwich family secret ('The Sorrow of Sidwich') he's completely convinced. He proposes, and in a very amusing—silent except for music—sequence the Pike household prepares for the wedding. Eugene Pallette, as the ale millionaire from a humble background, is hilarious, a down-to-earth character who delights in befriending the woman he believes to be an English aristocrat; Pallette, with his gravelly bass voice, had been a fine character actor since he appeared in the very first all-talking picture, *Lights of New York* (1928).

Eve's wedding night revelations about her unsavoury past with Angus, a stable boy, and several others brings a speedy end to the marriage, paving the way for the deliriously happy conclusion back on board the ship and William Demarest's immortal final line: '*Positively* the same dame.'

The Lady Eve is not only extremely funny, but it is also quite moving. The hapless Charles is so naïve and the self-confident Jean is so skilled at playing him for a sucker—and so determined to keep him once she falls in love with him—that the film is, at its core, a compelling love story.

Preston Sturges (1898–1959) was a renaissance man who wrote plays, composed songs and invented things. Raised by his mother, a friend of Isadora Duncan's, Sturges spent many of his formative years in Paris. He established himself in Hollywood as a screenwriter and then, at the start of the 1940s, seized the opportunity—as did John Huston and Billy Wilder at about the same time—to become a writer-director. Between 1940 and 1944 he made a series of hit comedies: *The Great McGinty* and *Christmas in July* (both 1940), *The Lady Eve* and *Sullivan's Travels* (both 1941), *The Palm Beach Story* (1942), *Miracle of Morgan's Creek* (1943) and *Hail the Conquering Hero* (1944). These films are notable not only for the skill of the scripts but also for the appearances of a host of character actors who were part of the director's stock company, many of them in *The Lady Eve*, including William Demarest (Muggsy), Torben Meyer (the Purser), Robert Greig (in yet another butler role), Luis Alberni (Pike's chef), Jimmy Conlin (ship's waiter) and others. The director fell out with Paramount over a non-comedy film, *The Great Moment* (1944), about a pioneering dentist. He worked for a while with Howard Hughes, and then made two films for 20th Century-Fox, *Unfaithfully Yours* (1948) and *The Beautiful Blonde from Bashful Bend* (1949). The commercial failure of the latter, and also of his Hollywood restaurant, The Players, led to his decision to relocate to Paris, where he made his final film, *The Diary of Major Thompson* (1955).

An American friend of mine who lived in Paris in the 50s met Sturges on a number of occasions and recalled that he seemed to have become a bitter man who still could not accept that his spell as an A-list Hollywood director had been so brief.

16

Casablanca

USA, 1942

Warner Bros. DIRECTOR: Michael Curtiz. 103 MINS.
FIRST SEEN: *TCN Channel 9. Sydney. 3 April 1965.*

Casablanca, French Morocco, December 1941. Desperate refugees from Nazi-occupied Europe flood this outpost of Unoccupied (i.e. Vichy) France hoping to obtain visas for flights to Lisbon and thence on to the USA. Two German couriers carrying letters of transit are murdered aboard the train from Oran. The killer, Ugarte (PETER LORRE), asks Rick (HUMPHREY BOGART), whose café/bar is the most popular nightspot in the city, to hide the letters of transit for him; soon afterwards Ugarte is killed on the orders of corrupt Capt. Louis Renaud (CLAUDE RAINS), Prefect of Police, who is trying to impress visiting German officer Major Heinrich Strasser (CONRAD VEIDT). The prominent Czech anti-Nazi and concentration camp escapee Victor Laszlo (PAUL HENREID) arrives in Casablanca with his wife, Ilsa (INGRID BERGMAN). Ilsa and Rick had been lovers in Paris prior to the German Occupation. Rick, unaware that Ilsa is now married, is hurt and angry and refuses to sell or give the letters of transit to Laszlo, but he has a change of heart and, after killing Strasser and seeing Victor and Ilsa safely on the Lisbon plane, decides to join the Free French.

The enduring popularity of *Casablanca*, which won three Oscars in 1943 (Best Film, Best Director and Best Screenplay, the latter for Julius J. and Philip G. Epstein and Howard W. Koch) surely rests on a series of fortunate accidents. The play on which the screenplay is based, *Everybody Goes to Rick's*, by Murray Burnett and Joan Alison, seems to have been nothing out of the ordinary and the fact that the entire movie was shot in the studio, much of it on the Rick's Café set, might, with the wrong cast and a different ending, have been pretty ordinary. Ronald Reagan, Ann Sheridan and Dennis Morgan—the original choices for the three leads—seem unlikely to have been the stars of a project that would attract long-lasting affection, and the film was almost completed before the now celebrated ending was devised, apparently by director Michael Curtiz himself.

After the opening credits, printed over a map of Africa, the film begins with a shot of the globe and an anonymous announcer explaining the

significance of Casablanca. The camera cranes down from a minaret into a crowded street, but the confines of the Warner Bros. sound stage prevent the setting from being entirely convincing. A fleeing man is shot dead under a huge wall painting of the Vichy leader, Marshal Petain. Various brief vignettes illustrate a cross-section of the types of people to be found in this outpost prior to the arrival by plane of Strasser. 'Unoccupied France welcomes you' is the obsequious Renaud's greeting, and he assures the German that, to find the killer of the couriers, he has 'rounded up twice the usual number of suspects'.

That night at Rick's, Sam (DOOLEY WILSON) is playing 'It Had to Be You' and other familiar tunes on the piano. We first meet Rick as he is playing chess with himself and, soon afterwards, showing off his world-weary cynicism in an exchange with the slippery Ugarte ('You despise me,' says the thief. 'If I gave you any thought I probably would,' Rick replies). In a famous exchange Renaud asks Rick why he came to Casablanca. 'For my health. For the waters,' he replies and then notes that he was 'misinformed' because there are no waters in Casablanca. In this exchange, Rick also confirms that 'I stick my neck out for nobody', though Renaud—correctly—suspects that underneath 'you're still a sentimentalist'. Twenty-five minutes into the film we get our first sight of the radiant Bergman—stylishly dressed in a way that would have been the envy of any genuine refugee in 1941!—as Ilsa arrives with Laszlo, recognises Sam, and asks him to play and sing the immortal 'As Time Goes By'. Later that evening a bitter and drunken Rick insists that Sam play the song for him. 'I bet they're sleeping in New York,' he muses. 'I bet they're sleeping all over America.' And then, another immortal line: 'Of all the gin joints in all the towns in all the world, she walks into mine.'

And walk back in she does, just after a 12-minute flashback to pre-war Paris when Rick and Ilsa were lovers (Bogart plays these scenes beautifully, looking relaxed and cheerful in contrast to the bitter character we've seen hitherto). The intrigues that follow are photographed by Arthur Edeson in the shadowy style popular during this period. 'Here's looking at you, kid' is Rick's affectionate toast to his love in Paris, and he repeats it when she comes to beg for his help and agrees to stay with him if he'll help Laszlo escape.

The romance of the mist-shrouded airport finale (affectionately parodied by Woody Allen in *Play it Again, Sam* 30 years later) and the huge close-ups of Bogart and Bergman—plus Max Steiner's music score—combine to create an emotional punch, leavened by Claude Rains' cheerfully corrupt

Renaud, who throws a bottle of Vichy water into the garbage, signalling his decision to change sides and join the Free French. Rick makes his great sacrifice, insisting Ilsa leave with her husband ('I'm no good at being noble but it doesn't take much to see that the problems of three people don't amount to a hill of beans in this crazy world'). So the film fulfils one of its objectives: to show the great American cinema audience that a cynic who refuses to accept that the war had anything to do with him, can, in the right circumstances, be converted into a patriot.

Casablanca was an instant hit, and, thanks to repeated TV screenings, remained popular for decades afterwards. This is due not only to the elements mentioned above, but also to the flawless performances of a great supporting cast including director Curtiz's Hungarian compatriots Peter Lorre and S.Z. Sakall (who plays Rick's head waiter), and also to John Qualen (as a Norwegian resistance leader), Sydney Greenstreet (the devious owner of the rival Blue Parrot bar) and Marcel Dalio as the croupier.

Michael Curtiz (1886–1962) was born in Budapest and found work as a stage actor before appearing in films from 1912. He started directing in about 1914, and his early film, *Jon az ocsem (My Brother is Coming)*, deals with the aftermath of the failed Communist revolution of 1919. He worked in several European film industries before he arrived in Hollywood in 1926. He was a talented storyteller, and was extremely prolific, equally at home when making musicals, westerns, thrillers, romantic comedies, war films and social dramas, but under contract to Warner Bros. he was frequently called upon to direct inferior scripts. As a result his output is exceptionally uneven, though when he was fully committed, he proved to be a master director. His talent is on display in films such as *Noah's Ark* (1928), *Mystery of the Wax Museum* (1933), *Captain Blood* (1935, and other early Errol Flynn showcases), *Angels with Dirty Faces* (1938), *Yankee Doodle Dandy* (1942), *Mildred Pierce* (1945) and *The Breaking Point* (1950).

The Hungarian film *Curtiz,* made by Tamas Yvan Topolanszky in 2018, offers a fictionalised version of the filming of *Casablanca* and features a convincing performance from Ferenc Lengyel as the director. The film asserts that a representative of the Office of War Information (a US Federal agency) was constantly on the *Casablanca* set to ensure that the film's message would make a positive contribution to the war effort.

17

"Went the Day Well?"

UK, 1942

Ealing Studios. DIRECTOR: Cavalcanti. 94 MINS.
FIRST SEEN: *TTV. UK 2 June 1963.*

England, Saturday, 23 May 1942. A platoon of Royal Engineers (Sappers) led by Major Hammond (BASIL SYDNEY) arrives in the tiny Gloucestershire village of Bramley End. Declaring that they are taking part in an exercise, the Major and his second-in-command, Lieutenant Maxwell (DAVID FARRAR), seek the help of the villagers to find accommodation for their men; the Major is billeted at the vicarage and the Lieutenant at the Manor House. However, it soon becomes clear that these are not English soldiers but Germans, and that their local liaison is Oliver Wilsford (LESLIE BANKS), the village's leading citizen and head of the local Home Guard. The German mission is to take over communications for a 300-mile radius in preparation for an imminent German invasion. The vicar (C.V. FRANCE) is the first to be killed when he defies 'Hammond', and the death toll mounts before the villagers rise up against the enemy and hold siege to the manor until help—summoned by George (HARRY FOWLER), a small boy who had succeeded in escaping from the village—arrives.

It still seems astonishing that in 1942, with the outcome of the war still very much in the balance, a film like *"Went the Day Well?"* could be made in Britain. Of course, it's a clever piece of propaganda, a dire warning that there may be quislings and fifth columnists—traitors—hiding in plain sight even in the least likely community in England and that vigilance is essential. But it's also a call to arms in which, in the climactic battle, women and children take part in the fight against the Nazi enemy.

Based on a story by Graham Greene, and scripted by John Dighton, Angus MacPhail and Diana Morgan, the film's opening image is of a signpost pointing to Bramley End. As the camera glides into the village, the words of a poem—the authorship uncredited, but, in fact, an epitaph written by John Maxwell Edmonds in 1918—appear on screen: 'Went the day well?/We died and never knew./But, well or ill,/Freedom, we died for you.' The tracking camera stops by the church to be greeted by Charlie Sims (MERVYN JOHNS), the rector, who points out the grave where German

The vicar's daughter (VALERIE TAYLOR) confronts the traitor (LESLIE BANKS) in Cavalcanti's *"Went the Day Well?"* (ALAMY)

invaders were buried. 'Nothing was said about it till after the war and old Hitler got what was coming to him,' says Sims—a pretty bold prediction to have been filmed in 1942!

The fake Germans arrive and we are introduced to some of the locals: Mrs Collins (MURIEL GEORGE), the plump, forgetful woman who runs the post office, telephone switchboard and general store; Peggy (ELIZABETH ALLAN) who, later that day, is to marry Jim (NORMAN PIERCE), the publican's son; Ivy (THORA HIRD), Peggy's friend; Nora (VALERIE TAYLOR), the vicar's daughter, who is secretly in love with Oliver Wilsford; Mrs Frazer (MARIE LOHR), the owner of the manor.

Eleven minutes into the film the viewer is given information not available to the villagers: that 'Major Hammond' is actually Major Ortler and that Wilsford is a traitor in league with the Nazis. This would have come as a considerable shock to British cinema-goers in 1942, not only because of Wilsford's prominent position as the leading (male) citizen of Bramley End—it was a fact that some members of the British 'upper class' were Nazi

sympathisers—but also because Leslie Banks, who plays him, had been a popular leading man in countless films, among them Alfred Hitchcock's 1934 version of *The Man Who Knew Too Much*.

On the Saturday evening, Mrs Frazer entertains the officers, Wilsford, the vicar and Nora at the manor. The talk embraces the fact that the French 'let us down' and speculates on 'this famous invasion the papers are trying to scare us about'. 'I can't understand what a Fifth Columnist has to gain in the long run,' puzzles Nora, and Wilsford responds instantly and tellingly with one word: 'Power.'

Gradually, though, some of the villagers, especially Nora, become suspicious of the new arrivals. A bar of chocolate found in the bedroom used by 'Major Hammond' is labelled 'chokolade—Wien'. A piece of paper used by the soldiers for scoring at a card game has German-style numbering. Nora goes to Wilsford with her suspicions, and he alerts Ortler; the Germans immediately drop their masquerade and herd the villagers into the church. When the vicar protests and attempts to sound the church bells—something that, during the war, was the signal of an invasion—Ortler shoots the old man. The one fake note in an otherwise masterly film comes when Basil Sydney overplays his reaction in this scene: his 'Quiet, you fools!' is too much, bordering on the comic.

Cavalcanti demonstrates that he has learnt a great deal from Hitchcock not only because he reveals the identity of the quisling early on, thus maximising the suspense, but also in nerve-racking scenes in which the villagers attempt to reach the outside world: a message written on an egg, which is promptly crushed under the wheel of a car; another written on a piece of paper, which is consumed by a dog. When the villagers *do* rise up, it's with unexpected violence. Jolly Mrs Collins throws pepper in the face of her German guard and then hits him with an axe; it does her no good, sadly, as she's bayoneted almost immediately afterwards. They play it rough in this film.

There are plenty of heroes and heroines. Peggy and Ivy, given weapons, become crack shots, though Ivy admits that her only prior experience with a gun was when she won a prize at Blackpool. Young George courageously slips out of the village to seek help and, though shot in the leg, is able to alert the authorities in the nearby community of Upton. Snobbish Mrs Frazer sacrifices her life to save the refugee children in her care when the Germans start lobbing grenades into the manor.

Perhaps the reason I embraced this film so warmly is that I grew up in a part of England not unlike Bramley End. I knew villages like this one, I was familiar with women like Mrs Collins and Mrs Frazer and men like Charlie Sims. *"Went the Day Well?"* might have told a fantastical story, but the details seemed all too believable.

Cavalcanti (1897–1982) was born Alberto de Almeida Cavalcanti in Rio de Janeiro. After studying law and architecture he lived for a while in Paris and became a member of the avant-garde. He made several short films and French features between 1925 and 1933, and then he left France for England. He became part of the well-regarded British documentary movement (*Coalface*, *Men of the Alps*, *Java Head*) before co-directing— with Charles Frend—his first British feature, *The Big Blockade* (1942). This was immediately followed by *"Went the Day Well?"* and, soon after, the comedy *Champagne Charlie* (1944). He was one of four Ealing Studios directors who worked on the classic exercise in the supernatural, *Dead of Night* (1945), and later he made a screen adaptation of Dickens' *Nicholas Nickleby* (1946) and the superb post-war crime thriller *They Made Me a Fugitive* (1947). Subsequently he divided his time between Brazil, Europe and America; he worked as a teacher of film at UCLA, wrote a seminal book *Film and Reality* and returned to England to direct his last film, *The Monster of Highgate Ponds* (1961), for the Children's Film Foundation.

18

Meet Me in St. Louis

USA, 1944

MGM. DIRECTOR: **Vincente Minnelli.** 113 MINS.

FIRST SEEN: *Royal Cinema, Marble Arch, London, UK 10 April 1958.*

St Louis, 1903, Summer. Lawyer Alphonse Smith (LEON AMES) lives with his wife, Ann (MARY ASTOR), his father (HARRY DAVENPORT) and his five children, Rose (LUCILLE BREMER), Al Jr (HENRY H. DANIELS JR), Esther (JUDY GARLAND), Agnes (JOAN CARROLL) and Tootie (MARGARET O'BRIEN) in a house on a suburban street. The family is excited because the following year a World Fair—the Louisiana Purchase Exposition—is to be held in their city. Rose is hoping Warren Sheffield (ROBERT SULLY), who is currently visiting New York, will propose to her by long-distance telephone. Esther is attracted to John Truett (TOM DRAKE), who has recently moved in next door. The family is shattered when Mr Smith announces that he's been promoted to his firm's New York office and that they will be leaving St Louis after Christmas. Fortunately, he has a change of heart.

I once asked Gene Kelly to name his favourite musical and, to my surprise, he named *Meet Me in St. Louis,* a film that has none of the elaborate song and dance routines that are such an important ingredient in Kelly's own musicals (or, indeed, those of his friend Fred Astaire). Kelly explained that he admired the film because of the natural way the musical numbers were integrated into the narrative.

As a child of World War II, I have vivid memories of hearing the songs from the film—composed by Hugh Martin and Ralph Blane—which were played constantly on the radio, 'The Trolley Song' being one of the big hits of 1944.

In addition to being a wonderful example of the golden age of musicals—and of the work of the MGM producer Arthur Freed, who was responsible for the best of them—*Meet Me in St. Louis* is one of the most delightful films ever made about an 'ordinary' family. The well-observed characters, who first appeared in short stories written by Sally Benson that were originally published in *The New Yorker* between 1941 and 1942, are very much of their time—the beginning of the 20th century—yet the feelings and interrelationships they depict are timeless.

The film is divided into four parts, each part introduced by an illustration of the Smith house designed like a greeting card, an illustration that dissolves into a moving image. The first section, titled Summer 1903, which, at about 47 minutes, is the longest, is mainly set on a hot summer night when Rose expects her New York call and Mr Smith, after a hard day at the office, has no patience with his family's plotting to finish dinner early so that she won't be disturbed—the phone, a recent addition to the house, is inconveniently placed in the dining room. Katie (MARJORIE MAIN), the live-in maid and in almost every sense a member of the family, is in on the plot to have dinner early, the excuse being that she has to comfort her sister who 'is having trouble with her husband, him being a man!' When Warren's phone call eventually arrives it proves maddeningly inconclusive ('I wouldn't marry a man who proposed over an invention,' mutters Katie).

Esther, portrayed by Garland at her most radiant, is smitten with The Boy Next Door—cue for a plaintive ballad of that title. The excuse to meet him is a party at the Smith house. The song 'Skip to My Lou' has everyone dancing and the superb, seemingly unrehearsed choreography is by Charles Walters, who later became a talented director. Five-year-old Tootie, sent to bed along with Agnes, crashes the party and wants to sing, too; in one of the film's most charming sequences, the little girl and Esther sing and dance to 'The Cake Walk'. This sequence contains a most curious case of bad continuity—observed, I must confess, by my wife, not by me. Margaret O'Brien starts the number wearing pink slippers, but after the sisters add straw hats and canes to their routine O'Brien's slippers mysteriously change colour from pink to blue.

After the guests have gone, Esther has a chance to be alone with John when he helps her extinguish the gas lights, though he's not very romantic, telling her that the perfume she's wearing is 'exactly the kind my grandmother uses'. And when he leaves he shakes her hand!

This sequence is followed by the film's show stopper, 'The Trolley Song', performed by Garland and the ensemble aboard the streetcar as it rattles along towards the fairgrounds. That exhilarating scene ends Part One.

Part Two, Autumn 1903, runs about 21 minutes and the highlight is Halloween night, when Tootie—a little girl with a macabre streak—accepts a challenge to confront the feared Mr Brauckoff (MAYO NEWELL) and later shows up with a cut lip and a missing tooth, damage she—wrongly—blames on John Truett. Esther's spirited defence of her sister eventually results, to her surprise, in her first kiss. The Halloween sequence is surprisingly

dark for a film that otherwise promotes feel-good family life. Part Two ends with Mr Smith's announcement that the family is moving to New York, news greeted with disbelief and hostility, though the sequence ends with a lovely scene in which husband and wife sing and play 'You and I' at the piano—Mary Astor is so good as the 'perfect' mother that it's hard to realise that only three years earlier she had played the duplicitous femme fatale in John Huston's *The Maltese Falcon*.

Part Three, Winter 1903 (about 29 mins), involves the annual ball and Esther's initial disappointment when her date, John, finds himself without a tuxedo—her grandfather steps in to escort her. At the end of this section, Garland sings the timeless 'Have Yourself a Merry Little Christmas' to a weepy O'Brien. The fourth section, Spring 1904, is very brief, consisting of a trip to the fairground by the entire family, with all the females dressed in white.

With its magnificent costumes, designed by Irene Sharaff, and the production design of Cedric Gibbons, Lemuel Ayres and Jack Martin Smith, plus the rich Technicolor photography by George Folsey, *Meet Me in St. Louis* looks absolutely stunning. Its evocation of a more innocent era is lovingly handled by Vincente Minnelli, a director with an artist's sense of colour and style.

Minnelli (1903–1986) began his career as a costume and scenery designer in the theatre and was art director at Radio City Music Hall before he directed his first film, the all-black musical *Cabin in the Sky* (1943). In the following years he alternated between musicals (*Yolanda and the Thief*, 1945; *The Pirate*, 1948; the Oscar-winning *An American in Paris*, 1951; *The Band Wagon*, 1953; *Brigadoon*, 1954; *Gigi*, another Oscar winner, 1959); melodramas (*The Bad and the Beautiful*, 1952—a contender for one of my favourite films!; *Some Came Running*, 1959); and comedies (*Father of the Bride*, 1950; *Designing Woman*, 1957). He married Judy Garland, who was 22 when she made *Meet Me in St. Louis*, in 1945; they divorced in 1951 when their daughter, Liza, was five years old.

In 1971, when the San Francisco Film Festival organised a tribute to Minnelli, I met with him and sat next to him during a screening of his beautiful film about Vincent van Gogh, *Lust for Life* (1957). Sadly, the vibrant colour of the original film had faded almost completely in the copy supplied by MGM, and the great filmmaker was—understandably—far from happy.

Les enfants du paradis

FRANCE, 1945

Pathé Consortium Cinéma. DIRECTOR: Marcel Carné. 185 MINS.
FIRST SEEN: *Scala, Oxford, UK 16 June 1960.*

Paris, the 1830s. Part One: The Boulevard of Crime. Garance (ARLETTY) poses semi-naked in a carnival sideshow on the crowded street. She later visits Lacenaire (MARCEL HERRAND), a self-professed criminal who 'declared war on society long ago'. Meanwhile Frédérick Lemaître (PIERRE BRASSEUR), who is confident he'll one day become a famous actor, talks his way into the backstage area of the Funambules, the famous mime theatre. Garance is accused of stealing a gold watch from a man outside the Funambules (Lacenaire is, in fact, the thief) but Baptiste Deburau (JEAN-LOUIS BARRAULT), a mime artist, proves her innocence. Baptiste and Garance soon find work at the Funambules, but, though Baptiste helps Garance get a room in his hotel, he's too shy to express his feelings for her and instead she sleeps with Lemaître. Nathalie (MARÍA CASARES), daughter of the theatre manager, who loves Baptiste unrequitedly, is sad to see him pining for Garance. Count Édouard de Montray (LOUIS SALOU), a rich dandy, visits the Funambules and is overwhelmed by Garance's beauty; he visits her dressing room and gives her his card. When Garance is subsequently suspected of being an accomplice in an armed robbery carried out by Lacenaire and his friend, Avril (FABIEN LORIS), she shows the investigating policeman the Count's card.

Part Two: The Man in White. Several years have passed. Baptiste is now a major star of the Funambules, hugely popular with the 'children of the gods' in the cheap seats upstairs; Lemaître has also found success as a 'legitimate' actor—he is described as the greatest actor in Europe by Baptiste—but his vanity and reckless behaviour have alienated him from his co-workers. Garance has been away, mostly in England, but has returned and sits, veiled, every night in a box at the Funambules to watch Baptiste, now married to Nathalie and the father of a small boy. One night Lemaître joins Garance in her box; he later tells Baptiste she has returned, and Baptiste walks off the stage in mid-performance. At a reception following the first night of *Othello*, starring Lemaître, the Count sees Garance together with Baptiste. Lacenaire kills the Count in a Turkish bath. Baptiste and Garance

spend the night together in a hotel, but next morning Nathalie arrives and Garance flees into the crowded street where the carnival is being celebrated. Baptiste vainly searches for her.

With its magnificent sets by Alexandre Trauner (who was later to work in Hollywood) and soaring music by Joseph Kosma, *Les enfants du paradis* looks and sounds wonderful. It was the most expensive French film made at the time, and production—partly in film studios in Nice—continued over three years during the war until the film's release in March 1945, a couple of months after Paris was liberated. Marcel Carné and screen-writer Jacques Prevert—who had collaborated on some significant pre-war films—based the screenplay on reality: Baptiste, Lemaître and Lacenaire were all based on real 19th-century characters (the latter wound up on the guillotine). The film originally screened in two parts, running about 100 minutes and 90 minutes respectively, but was later edited into a version of 162 minutes—that was the version I first saw in 1960—and later still it was restored to its present length.

Literate and beautifully scripted, *Les enfants du paradis* is a tribute to French theatre of the past, both the 'legitimate' theatre where Lemaître becomes a success and the less 'respectable'—but often more popular—mime theatre of which the Funambules was the best known example. The film contains lengthy sequences of performances in both styles, but the scenes of mime—in which Barrault is magnificent—are the more exciting because they're more 'foreign' (though the original mime artists influenced the cinema of the silent era). There are plenty of insights into life back-stage as well—the jealousies, tantrums, intrigues and conflicts as well as the camaraderie.

In spite of wartime restrictions and shortages, the film looks magnifi-cent. Hundreds of extras crowd the studio-built streets as Roger Hubert's camera weaves its way past entertainers of all kinds—jugglers, tightrope walkers, clowns—and glides past an apparently naked Garance posing as 'Truth' in a tank of water up to her neck. The opening and closing scenes of the streets filled with noise and humanity make perfect bookends to a film that otherwise revels in its theatricality (the credits are printed over a curtain that rises to start the story and falls to end it).

The film is packed with wonderful characters from the rich and famous, like the effete Count, to the poor and miserable—like the ragged informer, Jéricho (PIERRE RENOIR)—and they all have their places in the drama that unfolds. The ambitious Lemaître claims, at the beginning, that he wants

to amuse and to move the audience up in the gods; but after he becomes a success, his boorish behaviour—he refuses to stick to his lines, infuriating the authors of the play in which he's performing, and even leaves the stage during a scene to sit in a box—reveals a man who has squandered his talent. The evil Lacenaire, with his strange, kiss-curl fringe, is 'destined to be loved by no one', and he takes it out on society, robbing and killing apparently because he enjoys his crimes. The Count believes that money will buy the love of Garance, who moves with hardly a thought between one lover and another until she realises—too late—that it's Baptiste she really loves.

As for Baptiste, he is unable to appreciate the love of the loyal Nathalie and betrays her, and their son, to spend one night with Garance. 'Were you always thinking of her when living with me?' Nathalie asks him, and he has no reply. Nathalie is the film's most sympathetic character, the only one who is selfless and loyal—but her future is uncertain as the film ends with her husband's fruitless attempt to stop the woman he loves from leaving.

Marcel Carné (1906–1996) was considered to be, along with Renoir and Julien Duvivier, among the greatest French directors of the 30s. After working as an office clerk he entered the film industry as assistant to directors René Clair and Jacques Feyder and made his first film, *Nogent, Eldorado du dimanche,* in 1929. This was followed by a string of successes: *Jenny* (1936), *Drole de drame* (1937), *Hôtel du Nord* (1938) and two starring Jean Gabin as a doomed working-class hero, *Le quai des brumes* (1938) and *Le jour se lève* (1939). His first wartime film, *Les visiteurs du soir* (1942), was a fantasy. *Les enfants du paradis,* undoubtedly his masterpiece, is considered by many to be the best French film ever made. After the war, however, he went into a major decline and films in which he attempted to interest the youth market (*Les tricheurs,* 1957; *Terrain vague,* 1960) were despised by the young newcomers of the French *Nouvelle Vague* (New Wave). He continued to direct until 1974, when he made his last film, *La merveilleuse visite,* but his later films were seen by few people in France and fewer still abroad.

The Best Years of Our Lives

USA, 1946

Samuel Goldwyn Productions. DIRECTOR: William Wyler. 170 MINS.
FIRST SEEN: *Sydney University Film Group, 7 September 1964.*

1945. Three veterans of World War II return to their homes in (fictitious) Boone City after spending three years abroad. Al Stephenson (FREDRIC MARCH), who worked in banking before the war, attained only the rank of Sergeant; married to Millie (MYRNA LOY) and father of a grown daughter, Peggy (TERESA WRIGHT), and a teenage son, Woody (VICTOR CUTLER), who is still at high school, Al is given a new position at his bank in charge of loans to veterans. Fred Derry (DANA ANDREWS), who came from a humble background and was a soda jerk before the war, rose to the rank of Captain and flew bombers; he returns to find that Marie (VIRGINIA MAYO), the glamorous showgirl he'd married on his last leave, has been unfaithful. Homer Parrish (HAROLD RUSSELL) lost both his hands in the war and is afraid that his childhood sweetheart, Wilma (CATHY O'DONNELL), will pity him.

When *The Best Years of Our Lives* was released in December 1946 (it opened in 1947 in the UK and not until 1948 in Australia) the war was still fresh in the memories of audiences that flocked to see William Wyler's masterpiece. The wonderfully intuitive screenplay by Robert E. Sherwood (based on a novel by Mackinlay Kantor) incisively and without compromise attempts to illustrate many of the problems facing returning veterans. The very first scene, which is set in a regional airport, makes no bones about some of these difficulties. Fred Derry has just returned from overseas and is trying to get a flight home to Boone City (Cincinnati, Ohio, doubles for Boone in the location footage); he's told that all the commercial flights are full, but a portly businessman whose black chauffeur carries his golf clubs has no trouble obtaining a seat. After many frustrating delays, Fred finds himself on an Air Transport Command flight together with Al and Homer, who are also heading home.

The men share a cab from the airport and after the long flight they've already become friends. Al and Fred look on anxiously as Homer is dropped off at his suburban house and is greeted by his parents and by Wilma, who lives next door. They do their best not to look at his ugly—though very

practical—artificial hands, and it's clear that Homer is embarrassed and ashamed. The scene is all the more poignant because Harold Russell, who had never acted before, really did lose his hands in the way he describes in the film.

Al lives in a grand apartment and is warmly greeted by his wife and children—though Millie makes a point of postponing a dinner engagement she was going to that evening. His children have grown up ('I don't recognise you,' he tells them); Woody—who has learnt about the atomic bomb at school—is clearly unimpressed with his father's gifts of a samurai sword and a tattered Japanese flag. 'You were at Hiroshima. Did you see the effects of radiation?' he asks his father, who is nonplussed, clearly never having considered any such thing.

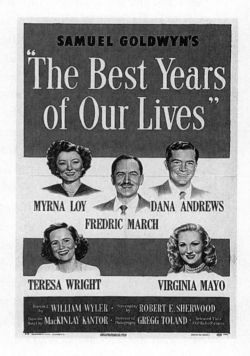

Fred, whose father (ROMAN BOHEN) and kindly stepmother (GLADYS GEORGE) live on what Americans call 'the wrong side of the tracks', discovers that the wife he hardly knew has moved into her own apartment and is working in a nightclub. Unable to find her, Fred heads for the bar owned by Homer's Uncle Butch (HOAGY CARMICHAEL). There he finds Homer, who has fled from his family, and Al who arrives merrily drunk, with Millie and Peggy after doing a round of the city's nightspots. None of the three is able to adjust back to an 'ordinary' life, at least not immediately.

In the weeks to come Al settles into his new job at the Cornbelt Trust Company Bank, assured by his boss, Mr Milton (RAY COLLINS) that he has a free hand with loans to veterans—as long as they have collateral. 'Conditions are not too good,' Milton complains. 'Taxes are still ruinous.' Fred discovers that the little drugstore where he'd worked before the war has been sold to a larger company. The new boss, a sour character named Thorpe (HOWLAND CHAMBERLIN), warns him that 'we're under no legal obligation to give you

your old job back' and is unimpressed to be told by Fred that 'I didn't command anyone. I just dropped bombs.'

Another key scene in the film occurs in the drugstore after Fred has been forced to take a low-paid position. Homer is sitting at the bar having a milkshake when he gets into conversation with a stranger wearing an American flag pin and reading a newspaper with the headline: 'Senator Warns of New War'. The opinionated stranger complains that 'we were sold down the river. The Germans and the Japs just wanted to fight the Limeys and the Reds; we fought the wrong people. We got deceived by a bunch of radicals in Washington.' Challenged, he protests that 'I'm not selling anything but plain old-fashioned Americanism.' Homer rips the pin from the man's lapel and Fred knocks the stranger down, and is fired as a result. The stranger is played by Ray Teal, a fine character actor who frequently played villains in westerns and thrillers.

As the lengthy film proceeds the complex relationships are explored in depth. Fred and Peggy find themselves falling in love, to Al's concern. Fred returns to his apartment to find Marie with Cliff (STEVE COCHRAN) 'an old friend'. It's Marie who enunciates the film's title, complaining that she gave Fred 'the best years of my life'. Homer asks Wilma to come to his bedroom to see how he removes his artificial limbs to prepare for bed, and her reaction convinces him that she really cares for him. The film ends with the wedding of Homer and Wilma at Wilma's house, and Fred—who has left Marie and who, by chance, has obtained a job working for a company that turns obsolete aircraft into prefabricated housing—proposes to Peggy.

Striking throughout is the photography by Gregg Toland who, in the wake of *The Grapes of Wrath* (1940) and *Citizen Kane* (1941), again experiments with deep focus photography, notably in a scene in Buck's where Homer and Buck play a tune on the piano for Al while, in the far background, but in sharp focus, Fred reluctantly telephones Peggy to break off their relationship—only temporarily, as it transpires.

The film won seven Oscars, but Toland was not a recipient. Awards were given for Best Film, Director, Actor (March), Supporting Actor (Russell), screenplay, editing (Daniel Mandell) and to Hugo Friedhofer for his magnificent, full-blooded score.

William Wyler (1902–1981) was born in Alsace and came to America in 1922. He served his apprenticeship as a film editor and assistant director before directing his first film, *Crook Buster*, in 1925. He gained a reputation for the meticulousness and intelligence of his work, and by 1938,

when he made *Jezebel* with Bette Davis, he was at the top of his profession. Among his subsequent outstanding films are *Wuthering Heights* (1939), *The Westerner* and *The Letter* (both 1940), *The Little Foxes* (1941) and *Mrs. Miniver* (1942). During the war he was one of the Hollywood professionals who made documentary war films (*The Fighting Lady*, 1943; *Memphis Belle*, 1944). His successes continued after the war: *The Heiress* (1949), *Detective Story* (1951), *Carrie* (1952), *Roman Holiday* (1953) and *The Desperate Hours* (1955). *Ben-Hur* (1959), though it won Oscars galore, was a bloated big-screen epic, and Wyler's last big success was the musical *Funny Girl* (1968), with Barbra Streisand. His final film, *The Liberation of L.B. Jones* (1970) was a failure critically and commercially.

The Big Sleep

USA, 1946

--

Warner Bros. DIRECTOR: Howard Hawks. 116 MINS (1945), 114 MINS (1946)
1946 VERSION FIRST SEEN: *ActV TV (UK). 2 May 1959.*
1945 VERSION FIRST SEEN: *DVD. 12 June 1997.*

--

Los Angeles. Private detective Philip Marlowe (HUMPHREY BOGART) is commissioned by the ailing General Sternwood (CHARLES WALDRON) to pay bookshop owner Arthur Geiger (THEODORE VAN ELTZ) the gambling IOUs of his younger daughter, Carmen (MARTHA VICKERS). The old man remarks that when he had previously been blackmailed, by a man named Joe Brody (JEAN LEWIS HEYDT), over Brody's relationship with Carmen, the matter had been handled by Sean Regan—but that Regan had left recently without saying goodbye. At the Sternwood house, Marlowe encounters the flirtatious Carmen ('You oughta wean her. She's old enough,' he tells the Sternwood butler) and her older sister, Mrs Vivian Rutledge (LAUREN BACALL). He gets no help from Agnes (SONIA DARRIN), who manages Geiger's bookshop, and follows the bookseller to his home where he finds Geiger shot dead and Carmen in a stoned state. That night Bernie Ohls (REGIS TOOMEY), Marlowe's policeman friend, calls him at 2 am to tell him that a car belonging to the Sternwoods had been found in the bay. In the car is the dead body of Owen Taylor, the family chauffeur. Vivian tells Marlowe that she obtained the money to pay the blackmailer from Eddie Mars (JOHN RIDGELY), a gambler whose wife disappeared at the same time as Regan. Brody is shot by an unseen gunman when he opens his apartment door; the killer is Carol (TOM RAFFERTY), Geiger's gay lover, who mistakenly thought Brody had killed his friend. (In a scene deleted from the 1946 version of the film, Marlowe tells the district attorney that he believes Taylor had killed Geiger.) The case seems to be over and Sternwood pays Marlowe a generous fee, but Marlowe has become obsessed with locating Regan and continues the investigation, while falling in love with Vivian.

Raymond Chandler's novel, published in 1939, had, even by the standards of private-eye fiction, a pretty complicated plot. No less a writer than William Faulkner tackled the screenplay, as did, at different times, Leigh Brackett and Jules Furthman, both of whom regularly worked with director

Howard Hawks. Hawks was eager to re-team Humphrey Bogart with Lauren Bacall. Bacall had made her screen debut at the age of 19 in Hawks' *To Have and Have Not* (1944), a loose adaptation of a book by Ernest Hemingway, and had become Bogart's lover, though he was still married at the time. That film had been a major success, and *The Big Sleep* seemed the ideal follow-up. Bogart had played another famous private eye, Sam Spade, in John Huston's superb adaptation of Dashiell Hammett's *The Maltese Falcon* (1941), and he was perfect for the role of the hard-bitten investigator with a smart line in small talk (when told by Vivian that she doesn't like his manners, he agrees: 'I grieve over them on long winter evenings').

Bacall isn't the only woman with eyes for Bogart in *The Big Sleep*; practically every female he comes across in the course of the movie is (a) beautiful and (b) flirtatious. These include a taxi driver, who gives him her card ('Call me at night—I work days'), various waitresses and the girl with glasses (DOROTHY MALONE) who manages the bookshop across the way from Geiger's establishment and with whom Marlowe appears to spend some quality time (a fade to black usually suggests intimacies in this context).

Filmed entirely on the sound stages of Warner Bros., *The Big Sleep*, with its shadowy interiors and misty exteriors, is the quintessential film noir, made when the genre was at its most popular and influential. There was clearly a struggle to placate the censors—several different endings were proposed, some of which were vetoed by the Production Code—and despite the verbal banter the film is pretty grim, with a considerable number of shootings and, most memorably, the poisoning death of the hapless Harry Jones (ELISHA COOK JR) who dies rather than betray the woman he loves.

Some of the confusion surrounding the film lies in the fact that two different versions were produced. The first, released in 1945, running 116 minutes, premiered in the Philippines for American troops stationed there. In effect, this version became a sort of rough cut, and before the film opened in the States and elsewhere the following year some scenes had been deleted and others added, the latter to make the repartee between Bogart and Bacall more extensive and, within the bounds of censorship, more risqué. Also changed was a scene midway through the picture in which Vivian shows up outside Marlowe's office wearing a net veil; this was considered, on reflection, to be unbecoming and she was unencumbered by a veil when the same scene crops up in the post-war version. At least one key scene was deleted, too; this was one in which Marlowe sums up the case thus far to the district attorney and his friend Bernie, a scene which could have been

helpful in shedding light on the murky plotting. Even more extraordinary, the actor who played the absconding Mrs Mars in the 1945 version, Pat Clark, was replaced by Peggy Knudsen for the 1946 version. For many years the second version was the only one available; the first version only became widely seen when it appeared as a DVD extra in the 90s.

In the 1940s, cigarette smoking denoted glamour and romance. Behind the film's opening credits Bogart, seen in silhouette, lights Bacall's cigarette before lighting his own; the remainder of the credits play out against two smouldering fags in an ashtray.

Howard Hawks (1896–1977) drove racing cars before entering the film industry in the prop department at Paramount. He started directing in 1926 with *The Road to Glory* and by the coming of sound he had perfected his art. He was exceptionally versatile and made arguably the best gangster movie (*Scarface*, 1932), some of the best screwball comedies (*Twentieth Century*, 1934; *Bringing Up Baby*, 1938; *His Girl Friday*, 1940) and some of the best westerns (*Red River*, 1948; *Rio Bravo*, 1959). He made the uneven but mostly delightful Marilyn Monroe–Jane Russell musical *Gentlemen Prefer Blondes* in 1953 and produced—some say partly directed—the seminal horror film, *The Thing*, in 1951. A Hawks film is instantly recognisable for the way his female characters behave: women like Jean Arthur in *Only Angels Have Wings* (1939), Lauren Bacall (*To Have and Have Not*, 1944; *The Big Sleep*) and Angie Dickinson (*Rio Bravo*, 1959), among others, are feisty, proud and proactive in their relationships with men. His films also regularly focus on men who are involved in dangerous occupations (*The Dawn Patrol*, 1930; *The Crowd Roars*, 1932; *Ceiling Zero*, 1935, and several more); these are guys who simply get on with it because it's their job. They don't complain, and they tend to despise people who do.

In October 1972, the San Francisco Film Festival held a mini-Hawks retrospective and I was able to meet with this great filmmaker and to chat with him about some of his unforgettable films.

22

Duel in the Sun

USA, 1946

The Selznick Studio. DIRECTOR: King Vidor. 129 MINS.
FIRST SEEN: *Odeon, Andover, UK 1946 (exact date unknown).*

Texas. After Scott Chavez (HERBERT MARSHALL) is executed for the murder of his Native American wife (TILLY LOSCH) and her lover (SIDNEY BLACKMER), his daughter, Pearl (JENNIFER JONES), is sent to Spanish Bit, the ranch owned by Senator Jackson McCanles (LIONEL BARRYMORE); the Senator's wife, Laura Belle (LILLIAN GISH), is a distant cousin of Chavez. Though Laura Belle is kind to Pearl, the Senator is openly hostile and racist because of her Native American blood; their two sons, Jesse (JOSEPH COTTEN) and Lewton (GREGORY PECK) also have opposing attitudes—Jesse is kind and thoughtful, Lewt is superior and predatory. Lewt seduces Pearl. Jesse and his father quarrel over the railway that is being built on Spanish Bit land and Jesse moves to Austin. Sam Pierce (CHARLES BICKFORD), owner of a small nearby ranch, proposes to Pearl; though Pierce is unarmed, Lewt guns him down in a bar and then goes into hiding. When Jesse, now married to Helen Langford (JOAN TETZEL), daughter of the railway boss (OTTO KRUGER), 'rescues' Pearl from Lewt's influence, Lewt shoots his unarmed brother. Pearl receives a message from Lewt and meets him in the desert; they kill one another.

Producer David O. Selznick's wonderfully lurid folly, which aimed to rival his production of *Gone with the Wind,* made seven years earlier, begins with an obviously phony studio set of a rocky landscape and a cliff into which a face has been carved, all of it bathed in red light, and an uncredited voice—actually that of Orson Welles—describing how 'Deep among the lonely sun-baked hills of Texas the great weather-beaten stone still stands.' The voice continues on to recount the 'legend of the wild young lovers who found heaven and hell in the shadows of the rock'.

We now know that, although the sole director credit on the film goes to King Vidor, Selznick himself—who wrote the screenplay based on a novel by Niven Busch—oversaw the production in minute detail and that several other directors worked, uncredited, on the film, including William Dieterle. Josef von Sternberg told me in 1969 that he directed the first scene in which Walter Huston appears as Jubal Crabby, the 'Sin Killer', who, summoned

to Laura Belle's boudoir to counsel Pearl, describes the girl—dressed only in a blanket—as 'a full-blossomed woman fit for the devil to drive men crazy'. Sternberg showed me photographs taken on the set to prove that he was behind the camera on the day that scene was shot.

The lack of a single director no doubt accounts for the film's uneven quality. Many of the 'outdoor' scenes, such as the one where Jesse travels across country to bring Pearl to Spanish Bit for the first time, are clearly shot in the studio and employ the use of unconvincing back projection. On the other hand, the film's 'big' scene, in which the crippled McCanles leads his cowboys—hundreds of them—to the railhead in an attempt to stop the progress of the railway line, is given full cinematic treatment.

Performances are uneven, too. Jennifer Jones, who was married to actor Robert Walker during filming but who was widely known to be Selznick's mistress (they married in 1949), has some strong scenes as the conflicted mixed-race girl—who is referred to throughout as 'half-caste'—trying in vain to avoid being used by the unscrupulous Lewt; but in other scenes, like the ridiculous finale in which she and Lewt pump bullets into one another while professing their love, she is unable to make her character remotely believable. Similarly Gregory Peck, who gets third billing after Jones and Joseph Cotten, is miscast as the evil Lewt, a shameless extrovert and womaniser who takes after his disreputable father: he confesses to the Senator that he spent time at 'The Last Chance'—presumably a brothel—during the recent cattle drive, and the Senator cheerfully assures him that *he* picked up the bill. Peck was just too *nice* to give Lewt the undertones of evil that the character requires. The casting would have worked better if his role and that of Cotten's, as the thoroughly decent Jesse, had been reversed.

As the loathsome McCanles, Lionel Barrymore rants and raves to his heart's content. Confined to a wheelchair since 1938, due to crippling arthritis and a broken hip, Barrymore was a well-loved character actor who needed firm direction to control his excesses. It's interesting to see him in scenes with Lillian Gish, who gives a glowing performance as the unhappy Laura Belle; both actors, early in their careers, had starred in the pioneering silent films made by D.W. Griffith. Walter Huston, father of John, was also a former leading man and much-loved character actor, as was Charles Bickford, who brings dignity to his brief role as the doomed Sam Pierce.

Thanks to the film's fairly explicit sex scenes, which were bold by the standards of the day, the film gained a notorious reputation and was dubbed *Lust in the Dust* by the tabloids. It was a major box-office success, but to

Selznick's disappointment it came nowhere near *Gone with the Wind* in terms of either critical acclaim or box-office performance.

It is, however, a film close to my heart. My grandmother took me to see it—against my mother's wishes as I soon discovered—and, at the age of seven, I was enthralled, shocked, moved, scared and generally enraptured by it. I never forgot it, and I often think it's the movie that got me hooked on movies in the first place.

In addition to Sternberg, I had the good fortune to meet other key talent involved with *Duel in the Sun* over the years. Gregory Peck remembered the filming as difficult and exhausting. Lillian Gish loved working with Barrymore and Vidor, who had been friends since the silent days. Vidor himself, with whom I spent some time at film festivals in Venice and Moscow during the late 1960s and early 1970s, was willing to talk about any of his films except *Duel in the Sun*. Obviously the experience was a bitter one.

King Vidor (1894–1982) was a Texan who acted in silent films and began his long career as director with *The Turn in the Road* (1918). He was prolific during the silent era and cemented his reputation as a skilled and inventive craftsman with his World War I epic, *The Big Parade* (1925). Subsequently he made an impressive version of *La Bohème* (1926) with Lillian Gish and John Gilbert; *The Crowd* (1928), a gritty realist film that was cast with unknown actors; and a Hollywood comedy, *Show People* (also 1928). In 1929 he made the revolutionary *Hallelujah*, an early talkie with an entirely black cast. He was at home with westerns (*Billy the Kid*, 1930; *The Texas Rangers*, 1936; *Northwest Passage*, 1939; *Man Without a Star*, 1955), melodramas (*The Champ*, 1931; *Stella Dallas*, 1937; *Beyond the Forest* and *Lightning Strikes Twice*, both 1949, and *Ruby Gentry*, 1952, with Jennifer Jones), literary adaptations (*The Citadel*, 1938; *H.M. Pulham Esq*, 1941; *The Fountainhead*, 1949), epics (*War and Peace*, 1956; *Solomon and Sheba*, 1959) and the occasional hard-hitting social-realist drama (*Our Daily Bread*, 1934; *An American Romance*, 1944; *Japanese War Bride*, 1952).

As for David O. Selznick (1902–1965), there were only three more Selznick productions after *Duel in the Sun*: one of Alfred Hitchcock's lesser films, *The Paradine Case* (1947), William Dieterle's *Portrait of Jennie* (1948) and Charles Vidor's adaptation of Ernest Hemingway's *A Farewell to Arms* (1957).

23

Great Expectations

UK, 1946

Cineguild. DIRECTOR: David Lean. 113 MINS.

FIRST SEEN: *Classic Cinema, Baker Street, London, UK 2 January 1958.*

The coast of Kent in the 1850s. Young Pip (ANTHONY WAGER), an orphan who lives with his bad-tempered sister (FREDA JACKSON) and her uneducated but good-natured blacksmith husband, Joe Gargery (BERNARD MILES), on the marshes east of London, is visiting the grave of his parents when he's startled by the appearance of an escaped convict, Magwitch (FINLAY CURRIE). The terrified boy agrees to bring 'vittels' and a file to Magwitch the next morning. The convict is soon arrested, but Pip keeps silent about having seen him. A year later Pip is summoned to Satis House, the forbidding home of Miss Havisham (MARTITA HUNT), an eccentric spinster who lives with her young ward, Estella (JEAN SIMMONS). 'You can break his heart,' Miss Havisham tells Estella. The years pass and the grown Pip (JOHN MILLS) is visited by a lawyer, Jaggers (FRANCIS L. SULLIVAN), whom he had already encountered at the Havisham house. Jaggers informs him that he has 'great expectations' thanks to the instructions of a 'liberal benefactor' whose identity must remain unknown. Pip, dressed as a gentleman, travels to London where he shares lodgings with Herbert Pocket (ALEC GUINNESS), a distant relative of Miss Havisham. He meets Estella (VALERIE HOBSON) again and falls in love with her, though she seems to prefer the caddish Bentley Drummell (TORIN THATCHER). One night Magwitch arrives unannounced at Pip's lodging and reveals that *he* was the benefactor: that he had escaped and made a fortune sheep farming in NSW. Jaggers warns Pip that Magwitch will be arrested if he's found in England. Pip and Herbert attempt to help Magwitch escape but the convict is betrayed and captured. Miss Havisham dies in a fire. It is revealed that Estella is the daughter of Magwitch and that her mother is a murderess who is employed as Jaggers' servant. Pip and Estella are reconciled.

The novels of Charles Dickens pose a challenge for screen adaptation both on account of their length and because of the myriad interesting characters they contain. David Lean, directing his fifth feature, wrote the screenplay of Dickens' novel in collaboration with producer Ronald Neame

(who later also became an important director), Anthony Havelock-Allan, actor Kay Walsh and Cecil McGivern. The film is an object lesson in how to transfer a hefty book to the screen; the basic plot is retained, as are the intentions and mood of the book, but on screen the epic narrative runs for under two hours. A narration (spoken by John Mills) is used to bridge a few gaps.

The opening sequence is a classic of its type. In silhouette, Pip is seen running along the edge of the marshes, past two forbidding-looking gibbets. It's dark and windy, and as he climbs a low wall and enters the churchyard, trees groan and sway and assume an almost threatening aspect. As the boy leaves his parents' graves the camera tracks left with him as he runs towards the wall straight into the arms of the very sinister Magwitch. It's a brilliantly timed shock moment and a stunning start to the film. The camerawork by Guy Green, who later also became a director, is impressive here and throughout.

On the whole *Great Expectations* is beautifully cast. John Mills and Jean Simmons are perhaps a bit too old for their roles, but Martita Hunt's spiteful Miss Havisham, living alone in a room filled with cobwebs and mice, bitterly brooding over the man who betrayed her 25 years earlier, is a wonderful creation. Francis L. Sullivan was born to play Jaggers, the portly lawyer with some very strange clients—in fact, he played the character twice, having taken the same role 12 years earlier in Stuart Walker's insipid, Hollywood-made version of the novel. Bernard Miles gives a most touching performance as kindly, decent Joe Gargery; the scene in which he comes to London to see Pip, who has, in the meantime, adopted all the snobbish attributes of a 'gentleman' and as a consequence humiliates one of his most loyal supporters, is heartbreaking. Alec Guinness, in his first on-screen appearance, commences a long-lasting collaboration with Lean as the pleasant, friendly Herbert Pocket.

There are marvellous contributions in smaller roles: Ivor Barnard as Wemmick, Jaggers' clerk; Freda Jackson as the shrewish Mrs Joe; Hay Petrie as Uncle Pumblechook; and O.B. Clarence as Wemmick's Aged Parent. Finlay Currie succeeds in being both sinister and touchingly vulnerable as Magwitch, the true source of Pip's 'great expectations'. Valerie Hobson is a wonderfully superior and arrogant Estella.

There have been numerous screen and TV versions of this book, but Lean's is by far the best. The film is directed with intelligence, taste and great affection for the source material. I would agree that Lean, and George

Cukor—with his superb 1935 version of *David Copperfield*—have been the most successful directors at capturing the essence of the author.

David Lean (1908–1991) entered the film industry as a clapper boy and graduated to editing newsreels and some significant feature films. In 1942 he was chosen by Noel Coward to co-direct Coward's flag-waving World War II naval drama, *In Which We Serve*; Coward also played the leading role. Lean stayed with Coward to direct three more of the actor-writer's screenplays: *This Happy Breed* (1943) and *Blithe Spirit* and *Brief Encounter* (both 1945). The enormous critical and commercial success of the last film led Lean to make *Great Expectations* in collaboration with Ronald Neame, and he followed its success with an almost equally fine adaptation of Dickens' *Oliver Twist* (1948), in which Alec Guinness gave a startling performance as Fagin. After this came *The Passionate Friends* (1949), *Madeleine* (1950) and *The Sound Barrier* (1952), all of which starred Lean's then wife, Ann Todd. He made the comedy *Hobson's Choice* (1953) with Charles Laughton and John Mills; *Summer Madness*, aka *Summertime* (1955), with Katharine Hepburn, on location in Venice; and then the first of his major epic films, *The Bridge on the River Kwai* (1957), for which he won a Best Director Oscar. *Lawrence of Arabia* (1962) won him his second Oscar, and was followed by *Doctor Zhivago* (1965). There was a five-year delay before Lean's next film, *Ryan's Daughter* (1970), an intimate story set in Ireland about adulterous lovers, which was given epic treatment—70mm camerawork and extended running time. The relatively disappointing reaction from critics led to a 14-year gap before Lean made his last feature film, *A Passage to India* (1984).

I met Lean on two occasions. The first was in 1984 when I conducted a career-spanning audio interview with him in London to be used in an ABC radio program. A year later I was invited to a lunch in Cannes to celebrate the British film industry and the relaunching of *Lawrence of Arabia* in a newly restored director's cut. I was seated opposite Lean and diagonally across from the guests of honour, the Prince and Princess of Wales.

It's a Wonderful Life

USA, 1946

Liberty Films. DIRECTOR: Frank Capra. 130 MINS.
FIRST SEEN: *BBC Television, UK 24 December 1957.*

Bedford Falls, USA, Christmas Eve. Prayers reach Heaven on behalf of George Bailey (JAMES STEWART). Clarence Oddbody (HENRY TRAVERS), Angel 2nd Class, who has yet to win his wings, is assigned to the case and given a quick tutorial on George from the age of 12 in 1919 when he rescued his younger brother, Harry, from drowning in a frozen lake. George's father, Peter (SAMUEL S. HINDS), runs a small building society together with his eccentric brother, Billy (THOMAS MITCHELL). Henry Potter (LIONEL BARRYMORE), Bedford Falls' richest and most powerful citizen, is constantly at odds with the Baileys. At Harry's graduation in 1928, George discovers that Mary (DONNA REED), whom he knew as a little girl, has grown into a beautiful teenager, and proposes to her; but that night Peter Bailey dies of a stroke and instead of travelling to Europe as he'd planned, George stays to run the Building and Loan until Harry is ready to take over. Four years later Harry returns from college with a wife and a new job, so George is obliged to stay where he is. On the day of George's marriage to Mary, a run on the bank causes a cancellation of their honeymoon. The couple raise four children and renovate their dream house until the fateful Christmas Eve that Uncle Billy mislays $8000 of the company's money just as a bank examiner arrives to go over the books. Distraught, George contemplates suicide but is stopped by Clarence, who arranges for him to experience what the world would have been like if he'd never been born. George recovers his spirits, his friends rally round with the cash and there's a happy ending—with the news that Clarence has won his wings.

'No man is a failure who has friends' is one of the messages of Frank Capra's gloriously sentimental post-war comedy-drama, a film that bears a number of resemblances to the Michael Powell/Emeric Pressburger *A Matter of Life and Death* (see #25). In his first post-war film, and his first screen appearance in five years, James Stewart gives one of his finest performances, going through a series of emotional highs and lows and revealing a level of acting not seen in his pre-war screen appearances. Capra, who co-scripted

the film with Frances Goodrich and Albert Hackett, from a story by Philip Van Doren Stern, takes his time to tell the story of George's 'wonderful' life, and packs the film with colourful characters: H.B. Warner's Mr Gower, the druggist saved by the young George from accidentally poisoning a patient; Gloria Grahame's sultry Violet, a 'bad' girl treated with kindness by George; Frank Faylen and Ward Bond as respectively the town's taxi driver and cop; Beulah Bondi as Mrs Bailey. The same year that he played the powerful rancher in *Duel in the Sun,* Lionel Barrymore gives another larger-than-life performance as the odious capitalist, Potter, who despises the Baileys because they try to help their impoverished clients, many of them migrants—or 'garlic eaters' as Potter calls them—leave the squalor of the slums and make a new start in decent housing. 'Are you running a business or a charity ward?' Potter demands of Peter Bailey, and refers to the working class as 'rabble'. 'People were human beings to my father,' George tells the 'warped, frustrated old man'. 'But to you, they're cattle.'

During the 16-minute sequence in which George finds himself in a town called Pottersville where no one knows him because he's never been born, the film enters a nightmarish world—though, truth to tell, the transformation of Bedford Falls doesn't seem that much different from the way many small towns have changed since the 1940s. One of Capra's most telling comments is that the cinema showing *The Bells of St. Mary's*—a mawkish Bing Crosby vehicle directed by Leo McCarey—has been replaced by a strip club. George's kindly mother (BEULAH BONDI) has been transformed into a bitter old widow and, in the film's most unlikely proposition, the lovely, vibrant Mary has become a bespectacled old maid and is employed as the town's librarian.

Frank Capra (1897–1991) was born near Palermo, Sicily, and came to America in 1903 with his parents. He worked as a gag-man for slap-stick comedy producer Hal Roach, and found success as a screenwriter before directing his first film, *The Strong Man*, with silent comedian Harry Langdon, in 1926. He made several interesting early talkies including *The Miracle Woman* and *Platinum Blonde* (both 1931); *American Madness* (1932), which, like *It's a Wonderful Life*, includes a sequence depicting a run on a bank; *The Bitter Tea of General Yen* (1932); and *Broadway Bill* (1934). *It Happened One Night* (1934) won five Oscars including Best Film and Best Director, and its success ensured that Capra's name was placed 'above the title'—in other words was recognised by the public and was seen to be as much of a draw as the film's actors. The films that followed, including

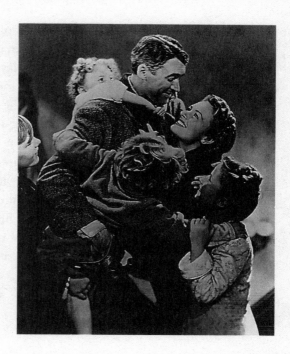

George Bailey (JAMES STEWART), his wife Mary (DONNA REED) and their children celebrate George's decision to live at the end of *It's a Wonderful Life*.

Mr. Deeds Goes to Town (1936) and *You Can't Take it with You* (1938), both of which won Best Director Oscars, *Mr. Smith Goes to Washington* (1939) and *Meet John Doe* (1940), all celebrated the 'ordinary' man and his struggle against the rich and powerful.

During the war Capra worked for the government and was responsible for the educational *Why We Fight* series, six extended propaganda documentaries with titles like *The Nazis Strike* (1943) and *The Battle for Russia* (1943). Returning exhausted from his wartime work, Capra decided that he was tired of working for the demanding Harry Cohn, his pre-war boss at Columbia Pictures. He formed his own company, Liberty Films, to produce his first post-war feature, *It's a Wonderful Life*, but, to the surprise of many, the film flopped at the box office. Capra was disillusioned and struggled to regain his previous form in the five features that followed, though the political comedy *State of the Union* (1948) with Spencer Tracy and Katharine Hepburn is engaging. He had some success with *A Hole in the Head* (1959), a Frank Sinatra vehicle that he made after an eight-year absence from the screen. Capra's final film, *Pocketful of Miracles* (1961), was a rather bland remake of his own, far more successful 1933 comedy-drama, *Lady for a Day*, based on a story by Damon Runyon.

Copyright on *It's a Wonderful Life* was not renewed and the film fell into the public domain for a long period. The rights were acquired cheaply by TV stations the world over and the film played, often in poor copies, as a Christmas attraction. In this way the film found a whole new audience, and a highly appreciative one, so that by the time Capra published his autobiography, *The Name Above the Title*, in 1971 he had become a hero to a young generation of film buffs, though it must be said that his book has been severely criticised for its inaccuracies.

I met Capra in San Francisco in 1971 when he was promoting the book and interviewed him. He was excellent company, full of delightful stories and eager to talk about himself and his work. Though his career rather fizzled out in the later stages, for most of the 30s he was known as one of Hollywood's most talented and influential filmmakers.

25

A Matter of Life and Death

UK, 1946

The Archers. DIRECTORS: Michael Powell, Emeric Pressburger. 104 MINS.
FIRST SEEN: *ABN Channel 7, Sydney, 20 November 1965.*

The English Channel, 2 May 1945. Squadron Leader Peter Carter (DAVID NIVEN) is flying a crippled aircraft home after a bombing raid over Germany. The plane is on fire, his gunner, Flying Officer Trubshawe (ROBERT COOTE) is dead and the rest of the crew have parachuted to safety but there are no more chutes left. Peter communicates with June (KIM HUNTER), an American girl working for the RAF. He quotes poetry to her and they exchange names before he jumps to a certain death. Miraculously he survives and quite by chance encounters June on the beach as she walks home. They fall instantly in love. But Peter is troubled with headaches and hallucinations: he has visions of an 18th-century fop, Conductor 71 (MARIUS GORING), who has been sent to bring him to heaven. The fact that he survived was, this stranger informs him, a mistake caused by the fog. June seeks help from her friend, Dr Frank Reeves (ROGER LIVESEY), who diagnoses 'adhesive arachnoiditis' that requires urgent brain surgery. But Peter is convinced that he has to stand trial in a heavenly court whose verdict will determine whether he will live or die. His prosecutor is Abraham Farlan (RAYMOND MASSEY), who was killed by the British during the American Revolutionary War. When Frank is killed in a motorcycle accident, Peter appoints him as his defence counsel, and Frank successfully proves to the court that Peter and June really do love one another.

It's a fascinating footnote to movie history that two of the key films of 1946, *It's a Wonderful Life* and *A Matter of Life and Death*, are fantasies that begin in a celestial heaven and involve heavenly messengers who come down to Earth. It was, of course, a coincidence that each of these two otherwise very different films had such a similar basic premise. Co-directed and scripted by Michael Powell and Emeric Pressburger—though it's generally accepted that the direction and visual invention were that of Powell while Pressburger's area of expertise was the screenplay—the film begins with a written statement: 'Any resemblance to any other world known or unknown is purely coincidental.' As the camera pans across a blue sky filled with stars,

planets and a black hole, a narrator enthuses over 'the Earth, *our* Earth' and expresses the wish that 'all our aircraft got home safely'.

Peter Carter's plane has not got home safely, and the emotional conversation he has with radio operator June, 'the American girl I shall never see who will hear my last words', is movingly filmed in tight close-ups. One could argue that Niven, who is excellent, was too old for the part; his character emphatically states that he is 27, but Niven was 35 when filming took place.

One of the amusing elements of this quite humorous fantasy is that Earth is photographed in colour and Heaven in black and white, as we discover when we are transported to a *Metropolis*-like Heaven (courtesy of art director Alfred Junge) where the dead wait to be processed. Among them we glimpse a young RAF pilot (Richard Attenborough in an early role) and a brash American (BONAR COLLEANO). Trubshawe—the moniker itself is a joke; David Niven liked to have a character with that name appear somewhere in his films—is waiting in vain for Peter and his complaint triggers an investigation that sends Conductor 71 down to a vividly coloured Earth ('One is starved of Technicolor up there!' he quips). He insists that Peter's time was up and that only the fog ('the ridiculous English climate') saved him. Peter protests that, in the hours he has continued to live since his non-death, he has fallen in love with June; the Conductor assures him he will see her again ('She will live to be 97').

Gravel-voiced Roger Livesey is lively company as Frank, the village doctor who is able to diagnose Peter's problem. During this part of the film there are frequent visits from the Conductor (who brings with him a smell of fried onions); when these happen the other characters 'freeze' and when they awake know nothing about what has occurred.

The trial sequence is justly famous and deliberately spoke to American audiences in 1946. The kindly judge (Abraham Sofaer, who also plays the surgeon operating on Peter in the real world) is strenuously non-partisan, but the prosecutor, Farlan, is formidable. He especially objects to the fact that June was born in Boston, which was also his birthplace, yet has fallen in love with an Englishman, since he despises the English. He is fanatically pro-American ('An American baby sucks in freedom at his mother's breast') and believes that 'America is the only place where Man is full grown.' However, Frank proves to be an effective and wily defence council, persuading June—magically brought to the court to give witness—that she should agree to sacrifice herself in Peter's place to prove her love for him. In

the end Prosecution and Defence agree that 'the rights of the *uncommon* man must always be respected'.

Filled with technical wizardry that was state of the art for the time, *A Matter of Life and Death* is dazzlingly photographed by Jack Cardiff. It was a major box-office success on both sides of the Atlantic, no doubt in part because Niven had been appearing in Hollywood productions since the mid-1930s.

Michael Powell (1905–1990) worked as a cameraman, editor and screen-writer before directing his first film, *Two Crowded Hours*, in 1931. For most of the 30s he churned out low-budget 'quota quickies' of limited interest, but he made an impact with *The Spy in Black* (1939) and *Contraband* (1940), thrillers steeped in up-to-the-minute intrigue. He began to co-direct with Hungarian-born Emeric Pressburger (1902–1988) with *49th Parallel* (1941), and the films that followed—*One of Our Aircraft is Missing* (1942), *The Life and Death of Colonel Blimp* (1943), *A Canterbury Tale* (1944) and *I Know Where I'm Going* (1945)—are among the best British films of the war years. The pair followed *A Matter of Life and Death* with *Black Narcissus* (1947), a Technicolor melodrama set in India but filmed entirely in a London film studio; *The Red Shoes* (1948) and *The Small Back Room* (1949) followed. This run of highly regarded successes ended with the disappointments of *The Elusive Pimpernel* and *Gone to Earth* (both 1950, the latter re-edited and partly reshot by David O. Selznick). After a couple of average war films in the 1950s, Powell alone made the controversial horror film, *Peeping Tom* (1959). At the end of his career he directed two films in Australia, *They're a Weird Mob* (1966) and *Age of Consent* (1969, which was Helen Mirren's film debut). Powell's last film, *The Boy who Turned Yellow* (1972), was made for the Children's Film Foundation.

I got to know Powell quite well while he was working in Australia. I visited the sets of both his Australian-made films, and he was a welcome guest at the Sydney Film Festival. Later, in America, he became a mentor to both Francis Ford Coppola and Martin Scorsese.

26

The Big Clock

USA, 1948

Paramount. DIRECTOR: John Farrow. 95 MINS.
FIRST SEEN: *ATN Channel 7, Sydney, 13 August 1963.*

New York, Friday, 25 April, 11.23 pm. George Stroud (RAY MILLAND), a married man with a wife, Georgette (MAUREEN O'SULLIVAN), a young son (B.G. NORMAN) and a responsible job, takes refuge inside the big clock that dominates the lobby of Janoth Publications, the company for which he works as editor of *Crimeways Magazine*. Thirty-six hours earlier he had entered that lobby intending to hand over to his deputy (DAN TOBIN) while he took a long overdue vacation in West Virginia. But his boss, Earl Janoth (CHARLES LAUGHTON), who is concerned with the falling circulation of the magazines in his empire and sees George as his most efficient editor, keeps him so occupied that he misses the train, and his wife and son leave without him. George drowns his sorrows in a bar where he encounters Pauline York (RITA JOHNSON), a former model for *Styleways Magazine*, and Janoth's secret mistress. Pauline has come from meeting with Janoth in his top-floor office ('The Berchtesgaden of the publishing world,' as she calls it), in which she demanded more money for her services. Pauline and George go on a drunken spree together searching for a green clock (Janoth has a clock obsession) and in an antique shop George buys a hideous modern painting, the work of eccentric artist Louise Patterson (ELSA LANCHESTER), who witnesses the sale. At Burt's Bar they acquire a heavy brass sundial shaped like an arrow and encounter a radio actor, McKinley (LLOYD CORRIGAN). Pauline awakens George in her apartment just as Janoth himself arrives. Pauline and Janoth have a violent argument (he accuses her of having affairs with a cab driver among others, while she calls him 'flabby and disgusting') and he kills her with the sundial. Determined to pin the blame on the mystery man who had been seen with Pauline at various locations about the city that night, and who is known only as 'Jefferson Randolph', Janoth and his editor-in-chief, Steve Hagen (GEORGE MACREADY), employ all the facilities of *Crimeways* to identify 'Randolph'. George finds himself in charge of an investigation in which all the clues and the witnesses point to himself.

This ingeniously plotted and fast-paced film noir is suffused with a deliciously eccentric sense of humour, thanks in no small measure to the performances of husband-and-wife team Charles Laughton and Elsa Lanchester. As the megalomaniacal Janoth—an autocratic publisher to rival Charles Foster Kane—Laughton, his face twitching as he orchestrates the hunt for a fall guy who will take the blame for the murder he's committed, gives a wonderfully sly portrayal incorporating occasional flashes of insane fury—the killing of Pauline is a particularly brutal act. He is tough on his staff (to an unfortunate secretary he barks: '*Miss* Abbott—how is that baby of yours?') and he fires staff members for the smallest infractions. He also keeps close to him a sinister, silent bodyguard/masseur named Bill (HENRY MORGAN), who is clearly willing to kill for his boss. Lanchester has a great deal of fun with her character, a much-married bohemian who lives with her unruly children and who is so delighted to discover that George admires her work that she agrees not to betray him ('We're trying to find a collector of your pictures,' says Janoth's arts editor, played by Harold Vermilyea. 'So have I—for fifteen years,' Miss Patterson responds). When, as one of the witnesses who has actually seen Pauline's companion of the night before, she is asked to draw his portrait, she comes up with a wonderfully bizarre piece of abstract art ('I think I've captured his mood rather successfully!') that is so weird it temporarily silences the loquacious Janoth.

The film's opening credits unfold on copies of the various magazines published by Janoth's company—including *Sportways*, *Airways*, *Futureways*, *Newsways* and *Artways*—before moving in on the murder weapon itself. After a pan across a cityscape at night, John F. Seitz's camera moves down the Janoth skyscraper and enters the building where it homes in on George, trying to avoid the security guards who have been told to shoot on sight if they spot the man everyone is hunting for. That man is George himself, and, in voice-over, he bemoans the fact that 'Thirty-six hours ago I was a decent, respectable citizen' before the film moves into a flashback lasting 83 minutes.

Jonathan Latimer's screenplay, based on a novel by Kenneth Fearing, barrels through the set-up leading to the murder—and from then on the suspense rarely falters as the investigation into the identity and whereabouts of the hapless Pauline's mysterious companion on the night she died goes into high gear and every clue points back to George. The irony, of course, is that George knows the identity of the killer because he saw Janoth enter the dead woman's apartment just as George was leaving. The

other key character here is Hagen, who is so fanatically loyal to Janoth that he goes to Pauline's apartment to tamper with the evidence and remove incriminating clues.

Matters move towards an exciting climax when the owner of the antique shop (HENRI LETONDAL) recognises 'Jefferson Randolph'—actually George—walking through the lobby of the Janoth building. The exits are immediately closed and everyone leaving the building has to pass by this witness; when that doesn't work, a floor by floor search is instigated (this is where the flashback began) until only the executive floor remains to be investigated.

The Big Clock is the best film made by Australian-born director John Farrow whose wife, Maureen O'Sullivan (mother of Mia Farrow), plays Georgette Stroud. Farrow keeps the tension bubbling along, helped by the excellent screenplay and well-chosen cast.

In 1987 the book was refilmed as *No Way Out,* with a number of variations, notably that the action was relocated to the Pentagon and a foreign agent was involved. Coincidentally, the remake was the work of Australian-born Roger Donaldson, who hailed from Ballarat, but who had made his reputation in New Zealand.

John Farrow (1904–1963) was born in Sydney, claimed to be educated at Newington College (this proved to be false), and served for four years in the Royal Australian Navy before he arrived in Hollywood in 1928. He contributed stories, and then screenplays, to several films before he was given a chance to direct *Men in Exile* (1937). Until the outbreak of war his films were efficient rather than remarkable, but *Wake Island* (1942), which was rushed into production, completed and released very soon after the momentous events it depicted, made his reputation. Other war subjects followed: *The Commandos Strike at Dawn* (1942), *The Hitler Gang* and *China* (both 1943). Contracted to Paramount, he demonstrated his versatility with thrillers (*You Came Along,* 1945; *Night Has a Thousand Eyes,* 1947; *Where Danger Lives,* 1950) and westerns (*California,* 1946; *Copper Canyon,* 1949; *Ride Vaquero!* and *Hondo,* both 1953, the latter filmed in 3D; *A Bullet is Waiting,* 1954). A couple of his films had Australian connections: *Botany Bay* (1952) and *The Sea Chase* (1955, which opens with scenes set in Sydney Harbour). A documentary about Farrow, made by Claude Gonzalez and Frans Vandenburg, was completed in 2020.

Letter from an Unknown Woman

USA, 1948

Universal International–Rampart. DIRECTOR: Max Ophüls. 87 MINS.
FIRST SEEN: *TCN Channel 9, Sydney, 2 September 1967.*

Vienna, about 1900. When composer Stefan Brand (LOUIS JOURDAN) returns to his apartment late one night his manservant, John (ART SMITH), hands him a letter delivered earlier in the evening. The letter, sent from a Catholic hospital, begins: 'By the time you read this I may be dead.' The letter is from Lisa Berndal (JOAN FONTAINE) who, while still a schoolgirl, became obsessed with Stefan when he first moved into the apartment building where she lived with her mother (MADY CHRISTIANS). When Frau Berndal marries Herr Kastner (HOWARD FREEMAN) and the family moves to the provincial town of Linz, Lisa, now grown, rejects the suitor (JOHN GOOD) selected by her parents and returns to Vienna where she finds work as a model. One night Stefan sees her in the street near his apartment. They spend an evening together, and she sleeps with him. Next day he leaves on a concert tour, vowing to return to her in two weeks. He never does. She gives birth to a son she calls Stefan. Nine years later she is married to Johann Stauffer (MAURICE JOURNET), a military officer who knows about her past. One night at the theatre she sees Stefan and is overcome with emotion. She leaves the theatre, and Stauffer sees her talking to Stefan. Lisa decides to place Stefan Jr in a boarding school and takes him to the station, but she is unaware that the carriage in which she says goodbye to the boy has been closed because of a case of typhus. Lisa returns to Stefan, who has been challenged to a duel by Stauffer but has no intention of keeping the appointment. But Stefan doesn't recognise her, and she leaves his apartment to join her son, only to discover that he has died of typhus. She is admitted to hospital, dying, and writes the letter.

This adaptation of a story by Stefan Zwieg, written for the screen by Howard Koch and exquisitely directed by Max Ophüls, credited as 'Opuls' on the film, is one of the screen's finest evocations of turn-of-the-century Vienna. Art director Alexander Golitzen's work, and the photography of Frank (Franz) Planer, combine to evoke a long-gone world, filmed entirely on the sound stages at Universal, that seems perfect in every detail. The

cobbled streets, the apartment buildings with their winding staircases and large courtyards, the cafés, the theatre, the horse-drawn carriages, the street flower sellers—everything seems absolutely perfect. If you've ever been lucky enough to visit an old-fashioned café in Vienna or Budapest, you'll instantly recognise the authenticity of the settings.

The story involves an obsessed young woman who—literally—throws her life away on a worthless man. But Joan Fontaine is so extraordinary as Lisa, ageing convincingly from 13-year-old schoolgirl to mature woman, and Louis Jourdan so charming as the amoral Stefan that the ugly side of the relationship is less unpleasant than it might have been in the hands of other actors or a less sensitive director. Fontaine gives her best screen performance here. She is completely convincing as a callow schoolgirl at the start. When she secretly explores Stefan's apartment for the first time her face lights up with wonder and excitement; she is radiant when she finally connects with her lover during that long, memorable night; and she is a tragic figure at the conclusion of the drama.

A film about a composer requires a great music score, and in this regard Daniele Amfitheatrof contributes one of the very best. The main theme is repeated with variations at intervals and lends this great movie a very special distinction.

'Though you didn't know it you were giving me some of the happiest hours of my life,' writes Lisa in her letter, referring to the hours she spent as a young teenager listening to Stefan play the piano in his apartment on the floor below. The tragedy is that, to him, she is just another transitory conquest. John, his servant, beautifully played by Art Smith, cannot speak but is clearly never in any doubt as to Lisa's identity.

'The course of our lives can be changed by such little things—nothing happens by chance,' writes Lisa in the letter, and indeed the randomness of the events that lead to tragedy—the coincidence that Lisa and Stauffer are attending the same theatre performance as Stefan, the existence of typhus on the train—are key elements of the drama. Twice there is a railway station farewell, both times involving a separation of what is supposed to be two weeks but which turns into a far longer parting.

Joan Fontaine was married to William Dozier whose company, Rampart, produced the film (the credited producer is John Houseman, who had worked with Orson Welles and who later became a distinguished character actor). Ophüls was a visual artist of the highest order, but he worked slowly and the film went over budget. This seems to have been the chief

reason that Fontaine herself held it in such low regard. In February 1982 she was President of the International Jury of the Berlin Film Festival, and I was a jury member. We spent two weeks in one another's company, but I was unable to persuade her how great she was in *Unknown Woman*; she remembered only the many takes, the frustrations and the financial problems.

Max Ophüls (1902–1957) was born in Saarbrücken, Germany, and worked as a stage actor before directing his first film, *Dann schon lieber Lebertran* (1930). During the 1930s his amazingly itinerant career had him making films in five different countries: Austria (*Liebelei*, 1932); Germany (*Lachende Erben*, 1933); Italy (*La Signora di Tutti*, 1934); Holland (*Komedie om Geld*, 1936) and France (*La tendre ennemie*, 1936; *Sans lendemain*, 1939). He was admired for his fluid visual style and for his exhilarating employment of lateral tracking and crane shots. With the outbreak of war he fled Europe for America, but unlike other directors who followed the same path—René Clair, Julien Duvivier, Jean Renoir, Billy Wilder, Robert Siodmak—he initially found it impossible to get work in Hollywood and did not direct his first American film (the significantly titled *The Exile*) until 1947. He followed *Letter from an Unknown Woman* with two James Mason vehicles, *Caught* (1948) and *The Reckless Moment* (1949), but returned to Europe in 1950 and made his last four features, all of them sublime, in France: *La Ronde* (1950), *Le Plaisir* (1951), *Madame De . . .* (1953) and *Lola Montès* (1955), the latter his only film in colour.

He constantly fought with producers because he took his time to achieve the rich visual look and the insightful performances that characterise his films. James Mason wrote this delightful verse tribute to him, which explains quite a lot:

'I think I know the reason why/Producers tend to make him cry./ Inevitably they demand/Some stationary set-ups, and/A shot that does not call for tracks/Is agony for poor dear Max,/Who, separated from his dolly,/Is wrapped in deepest melancholy./Once, when they took away his crane,/I thought he'd never smile again . . .'

Kind Hearts and Coronets

UK, 1949

Ealing Studios. DIRECTOR: Robert Hamer. 106 MINS.
FIRST SEEN: *Melksham & District Film Society, Wiltshire, UK 18 April 1959.*

London, about 1900. Louis d'Ascoyne Mazzini, Duke of Chalfont (DENNIS PRICE), is in the death cell awaiting execution by hanging—with a silken rope as befits his rank. He passes the time by writing his memoirs. His mother (AUDREY FILDES), a member of the d'Ascoyne family, had eloped with Mazzini, an Italian singer (also played by Dennis Price), and was therefore ostracised by her family. Mazzini died the day Louis was born and subsequently his widow lived in near poverty until her early death. When he grew up, Louis became obsessed with exacting revenge against the d'Ascoyne family for the way they treated his mother and, because the Dukedom of Chalfont—established by Charles II for services rendered—is unique in that it is passed on via *both* the male and female lines, decides to eliminate everyone between him and the title (eight family members, all played by Alec Guinness). He causes a river accident that drowns Ascoyne d'Ascoyne and an explosion that kills Henry d'Ascoyne. He poisons the Rev. d'Ascoyne and shoots down the hot air balloon from which Lady Agatha is disseminating suffragette propaganda. Finally he shoots dead the Duke and inherits the title, along with Edith (VALERIE HOBSON), the widow of Henry. But his jealous mistress, Sibella (JOAN GREENWOOD), makes it appear that he murdered her husband, Lionel (JOHN PENROSE). Louis is tried by his peers in the House of Lords and found guilty after Sibella lies under oath. But that's not the end of the story . . .

In Roy Horniman's novel *Israel Rank*, on which the screenplay for this supremely elegant black comedy is based, the central character is ostracised because he is Jewish. The change made by screenwriters Robert Hamer and John Dighton is interesting but, in the end, not really important. As an indictment of England's in-bred, born-to-rule nobility, the film is trenchant and uncompromising. The first of the handful of black comedies that gave Ealing Studios its formidable reputation, the film wastes no opportunity for mordant humour. The hangman, Mr Elliott, played with relish by Miles Malleson, arrives at the prison clearly excited about the prospect of

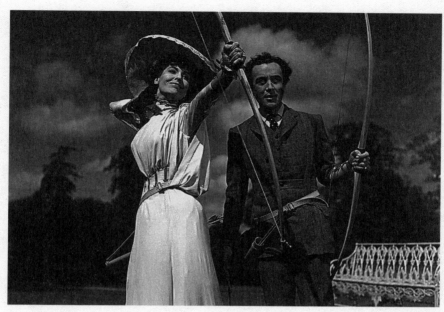

Multiple murderer Louis Massini (DENNIS PRICE) courts Edith, Duchess of Chalfont (VALERIE HOBSON) in *Kind Hearts and Coronets*.

executing a member of the nobility, something denied to his predecessor. 'What a finale to a lifetime in the public service,' he tells the prison governor (CLIVE MORTON). Assured that the condemned man is expected to be calm he complains that 'some tend to be very hysterical. So inconsiderate!' and reminisces that 'the last execution of a Duke in this country was very badly bungled—that was in the old days of the axe, of course'.

Louis' story is filled with telling details that touch on the snobbishness of England's class system. Reduced to working in a drapery store as a 'general assistant', a role he describes as being akin to 'an inferior race', Louis, though he professes to hate blood sports, is perfectly happy to murder his relatives. His first killing, of Ascoyne d'Ascoyne, who is spending a clandestine weekend on the river at Maidenhead with a young lady (ANNE VALERY), is—as Louis' regular narration reveals—tempered by the fact that the innocent young woman was also a victim—'but [I] found some relief in the reflection that she had presumably, during the weekend, already undergone a fate worse than death'.

The two women who become involved with Louis are beautifully contrasted. Sibella, his childhood sweetheart, grows up to be calculating,

immoral and wicked. She marries the boorish Lionel but remains Louis' mistress until he decides to marry the widowed Edith. Then she turns on him with a vengeance. Edith, something of a prude and an ardent teetotaller, is very proper indeed, yet overcomes her pride to testify at Louis' trial for murder. Antony Mendelson's costume design is ravishing—to say that the hats worn by these women are extravagant is putting it very mildly.

The murders are, for the most part, handled with grim humour. The blowing up of Henry—with petrol replacing paraffin in the dark room where he keeps his secret stash of alcohol—takes place as Louis shares tea outdoors with Edith—and smoke billows up on the other side of the garden wall. The addled old vicar ('The d'Ascoynes have sent the fool of the family into the Church') is poisoned by Louis who is visiting his church posing as the Bishop of Matabeleland. Lady Agatha's hot air balloon is punctured by an arrow fired by Louis ('I shot an arrow in the air/She fell to earth in Berkeley Square'), while the General, a pompous old bore forever telling the same tall story of his achievements in Africa, is killed by a bomb secreted in a jar of caviar. Louis doesn't have to kill the Admiral, a befuddled character who, mistaking port for starboard, causes a nautical accident and goes down, saluting, with his ship. Lord Ascoyne d'Ascoyne, a banker and the only member of the family to show any kindness to Louis, dies of natural causes. It's the murder of the Duke, Ethelred, that is the most shocking; while out shooting game on the estate, Louis contrives to have the Duke caught in one of his gamekeeper's illegal mantraps, and then shoots him at point-blank range.

The irony, of course, is that when Scotland Yard catches up with Louis it's not for any of these killings but on an entirely trumped-up charge—the alleged murder of Sibella's husband, Lionel, who had, in fact, committed suicide. This accusation turns out to have been an act of revenge by the jealous Sibella and leads to the trial, conviction and the film's brilliant conclusion.

Dennis Price is effortlessly suave as Louis, while Hobson and Greenwood portray the two women with elegance and humour. Not surprisingly it was the eight roles played by Alec Guinness that captured the attention of the public and went a long way to making the film a box-office success. Each character is distinctly different and Guinness was able to elaborate on his roles in the two Dickens films that preceded this and to become, for a while, one of Britain's most popular actors.

Robert Hamer (1911–1963) worked his way up through the film industry from the role of a humble clapper boy to the editor of several important films, including Alfred Hitchcock's *Jamaica Inn* (1939). He directed the haunted mirror sequence in the portmanteau ghost movie *Dead of Night* (1945) and the same year made the Victorian-era murder mystery *Pink String and Sealing Wax*. *It Always Rains on Sundays* (1947) is one of the finest examples of British post-war realism, and *The Long Memory* (1952) is a fine revenge thriller. In his later years Hamer's career was affected by his alcoholism and the stresses of being a closet homosexual; as a result his ambitions—on films like *Father Brown* (1954, with Guinness as the famous detective), *The Scapegoat* (1958), with Guinness in two roles, and *School for Scoundrels* (1960)—were not entirely realised. He died at the age of only 52 while preparing a comedy titled *They All Died Laughing*; the film was completed by Don Chaffey and released in 1964 as *A Jolly Bad Fellow*.

All About Eve

USA, 1950

20th Century-Fox. DIRECTOR: Joseph L. Mankiewicz. 138 MINS.
FIRST SEEN: *TCN Channel 9. Sydney. 14 August 1964.*

New York. At a ceremony where Eve Harrington (ANNE BAXTER) is presented with the highest award the American theatre can offer, some of those present who know her recall her rise to fame. She remembers waiting outside the stage door of the theatre where Margo Channing (BETTE DAVIS), a very famous and talented actor, was starring in the long-running play *Aged in Wood* when she encountered the kindly Karen Richards (CELESTE HOLM). Karen took the stagestruck youngster backstage and introduced her to Margo, Karen's husband, Lloyd (HUGH MARLOWE), author of the play, and the director, Bill Sampson (GARY MERRILL), who was leaving that night for Hollywood. Despite the reservations of Margo's longstanding dresser, Birdie (THELMA RITTER), Eve moved in with Margot as her secretary and companion during Bill's absence. She made herself indispensable and became Margo's understudy. Margo became increasingly resentful of Eve, especially when one night—because of a 'joke' played on her by Karen—Margo missed the play and Eve gave a performance that received raves from the critics who were specially invited, among them the caustic columnist Addison DeWitt (GEORGE SANDERS). Determined to star in Lloyd's next play, *Footsteps on the Ceiling*, Eve seduced him; she also became the mistress of DeWitt, who knew that she had consistently lied about herself. After the awards ceremony Eve returns home to find Phoebe (BARBARA BATES), a young fan, awaiting her.

This consummately well-written film, in common with many other cinema classics, unfolds in flashback. The framing story involves the awards night of the fictional Sarah Siddons Society, an event the world-weary DeWitt compares favourably with the awards given by 'that film society', the first of several barbs about Hollywood contained in the screenplay. Interestingly, though some Hollywood veterans objected to the way the movie capital was portrayed in Billy Wilder's *Sunset Blvd.*, made the same year, no such objections were heard about Mankiewicz's film. DeWitt, a wonderful role for Sanders, who won one of the film's six Oscars, describes himself as a member of the profession but 'I toil not, neither do I reap. I am a critic.

I am essential.' Later he suggests that 'we theatre folk are a breed apart from the rest of humanity'. And the world of the theatre, as depicted from Mankiewicz's acidic viewpoint, is, beneath the glamour and artistry, a place of vaunting egos, backstabbing, ruthlessness, ambition—and a rather pitiful level of insecurity.

The film flashes back from June to the previous October when Karen finds the apparently starstruck Eve, who claims to have seen every performance of the current play, and introduces her backstage to Margo, her idol. Margo removes her stage make-up (Bette Davis bravely showing her age), and, together with the others, listens to Eve's sob story (a childhood of poverty, a young husband killed in the war), which later proves to be a pack of lies. Only the cynical Birdie is unimpressed at the time ('It had everything but the bloodhounds snapping at her rear end!') but the others are convinced.

Eve queries why Bill is going to Hollywood (to make a film for Zanuck, producer of *All About Eve*, he explains), suggesting the theatre is somehow more pure than the cinema; Bill responds with a witty speech reminding her that 'theatre' means different things to different people: 'Theatre is a flea circus, opera, carnivals, Punch and Judy, a one-man band, Donald Duck, Ibsen, The Lone Ranger, Sarah Bernhardt, Betty Grable—wherever there's magic and make believe and an audience there's theatre.'

The film's most famous sequence is the party Margo hosts in her apartment to celebrate Bill's return from the coast. Jealous of Bill's interest in Eve, she drinks too much ('Fasten your seat belts. It's going to be a bumpy night,' she warns), prompting Lloyd to remark, 'The atmosphere is very Macbeth-ish.' DeWitt crashes the party with his latest 'protégé', Miss Caswell (an early role for Marilyn Monroe), who, he quips, is a graduate of the Copacabana School of Dramatic Art.

Gradually Eve manipulates both the men and women in Margo's circle, almost breaking up the marriage of Lloyd and Karen and the relationship between Bill and Margo, and succeeding in taking away the leading role of Lloyd's new play from her older rival.

The screenplay by Mankiewicz is rich and witty: 'Do they have auditions for television?' asks Miss Caswell, and DeWitt replies, 'That's all television is, my dear—auditions.' 'Why not read my column?' DeWitt says to Karen. 'The minutes will pass like hours.' But the film is more than just a brilliantly written and constructed screenplay, more than a comedy-drama about art, friendship, ambition, jealousy and growing old. The direction

matches the level of the text—few films that rely so heavily on words are also so visually inventive.

The film revived Bette Davis' flagging career and made her a major star—and a gay icon. It was an enormous success at the box office and won Oscars for Best Picture; Director and Screenplay (Mankiewicz had received these same two awards a year earlier for *A Letter for Three Wives,* back-to-back Oscars that have never since been matched); Supporting Actor (George Sanders); Costume Design (Edith Head and Charles LeMaire); and Sound. Davis also won Best Actress at the Cannes Film Festival.

The success of *All About Eve* inevitably produced imitators in its wake. For example, in 1952, Vincente Minnelli's *The Bad and the Beautiful,* a film about a notorious Hollywood producer, was similarly structured. And though *All About Eve* was an original screenplay there was, eventually, a stage production and, inevitably, a Broadway musical, *Applause* (1970); Lauren Bacall starred in the original Broadway production and the show boasted songs by Betty Comden and Adolph Green. In his Oscar-winning *All About My Mother* (1999), Spanish director Pedro Almodóvar specifically pays tribute to *All About Eve* (see #102).

Joseph L. Mankiewicz (1909–1993) worked as a journalist in Berlin before joining his older brother, Herman (co-author of *Citizen Kane* among other achievements), in Hollywood. He scripted and produced a number of films before his directorial debut on the gothic period drama *Dragonwyck* (1946). He really hit his stride in 1949 with both *House of Strangers*, a thriller about a divided family, and the witty *A Letter to Three Wives*. Prior to *All About Eve* he made another fine film in 1950—*No Way Out*, in which Sidney Poitier made his screen debut as a doctor who treats the brother of a vicious, racist criminal (RICHARD WIDMARK). *Five Fingers* (1951), with James Mason as a spy operating at the British Embassy in Ankara during World War II, was followed by an adaptation of Shakespeare's *Julius Caesar*, with Marlon Brando as Mark Antony, James Mason as Brutus and John Gielgud as Cassius. *The Barefoot Contessa* (1954) attempted to do for international cinema what *All About Eve* did for the theatre. *Guys and Dolls* (1955) was a robust screen version of the hit Broadway musical; *The Quiet American* (1957) a flawed adaptation of the Graham Greene novel and *Suddenly Last Summer* (1959) an intense version of the Tennessee Williams play. The epic *Cleopatra* (1963) was a costly flop that damaged Mankiewicz's career; his final film, *Sleuth* (1972), was a screen adaptation of the popular play and starred Laurence Olivier and Michael Caine.

In a Lonely Place

USA, 1950

Columbia Pictures–Santana Pictures. DIRECTOR: Nicholas Ray. 94 MINS.
FIRST SEEN: *Imperial Cinema, Moseley, Birmingham, UK 7 February 1957.*

Hollywood. Cynical, quick-tempered screenwriter Dixon Steele (HUMPHREY BOGART), who hasn't written a hit movie since before the war, accedes to the wishes of his agent, Mel Lippman (ART SMITH), and agrees to adapt a best-selling novel, *Alicia Bruce*, for the screen. At Paul's bar and restaurant, Dix meets Mildred Atkinson (MARTHA STEWART), a naïve young woman who has read the book; he invites her back to his apartment to tell him the story—and thus save him the trouble of reading it—and later in the evening points her in the right direction to find a taxi. At five o'clock the next morning, Detective Brub Nicolai (FRANK LOVEJOY), who had served under Dix in the war, arrives to bring him to police HQ where he is questioned by Captain Lochner (CARL BENTON REID) over the murder of Mildred, whose strangled body was thrown from a moving car the night before. Dix's neighbour, Laurel Gray (GLORIA GRAHAME), a small-time movie actor who had recently ended a relationship with a rich real estate agent, tells the police that she saw Mildred leave Dix's apartment alone. Dix and Laurel begin a relationship that quickly becomes intense; he pulls himself together and works long hours on the screenplay. But Laurel becomes troubled by his temper tantrums and his outbursts of violence and confesses to Sylvia (JEFF DONNELL), Nicolai's wife, that though she loves him she's afraid of him. She tells Mel that 'I'm not even sure he didn't kill Mildred.' After one particularly violent outburst, Laurel makes plans to leave for New York even though Dix is arranging a wedding for them in Las Vegas. The news that Mildred's real killer has confessed comes too late to save the relationship.

I first saw *In a Lonely Place* when it was playing in a double bill at a re-run suburban cinema; the accompanying feature, *The Lemon Drop Kid* (1951), was a Bob Hope comedy—a strange pairing indeed. I had expected the film to be a conventional thriller, and was initially disappointed that it was not; but this is one of those movies that grows and grows on you.

It was produced by Humphrey Bogart's own company, Santana (named after his beloved yacht), and was the second film director Nicholas Ray had

made for the company (the first, *Knock on Any Door*, 1949, also with Bogart, was a drama about juvenile delinquency). From the very first image—Bogart's name superimposed over an unusual shot taken from a moving car with the actor's troubled face seen in the prominently placed rear-vision mirror—the film grabs you and holds on to you. Dixon is quickly established as a weary cynic, dismissing a hack director by calling him a 'popcorn salesman' and telling an overly eager ex-lover, who asks if he ever answers his phone, 'Not to people who have my number.' When the self-obsessed son-in-law of a movie mogul treats his friend, alcoholic has-been actor Charlie Waterman (ROBERT WARWICK), badly, Dix punches him.

When Lochner quizzes Dix over the brutal death of the young woman he had invited to his house the night before, his reaction to the killing is petulance (at being dragged out of bed so early in the morning) and some lame jokes. More than one person with whom he comes into contact feels there's something 'strange' about him, yet Laurel is, at first, confident of his innocence. Bogart gives one of his finest performances as this troubled soul, who is quite possibly suffering from the effects of his recent wartime service, but Dix, despite flashes of charm, is not the most likeable protagonist, necessarily so. Gloria Grahame, who was married to director Ray when the film was made, never looked more beautiful than she does here and she evocatively displays the conflicts of a woman who both loves and fears the man in her life. It has been said that it was during the filming of *In a Lonely Place* that Ray discovered that Grahame was involved with his 13-year-old son, Tony; Grahame married Tony Ray in 1960.

Apart from the two leads there are some interesting actors in minor roles, notably Art Smith (Louis Jourdan's butler in *Letter from an Unknown Woman*) who had been a member of the left-wing Group Theatre and who, not long after appearing in the film *In a Lonely Place*, was blacklisted. (The blacklist was a grim aspect of the sometimes hysterical anti-Communist attitudes of the time as represented by the House Un-American Activities Committee (HUAC) congressional hearings in which alleged Communists, socialists, left-wingers or 'fellow travellers' were questioned under oath and invariably forced to name other like-minded people in the film industry. Hundreds of film people were blacklisted and unable to work, Art Smith among them.) Ruth Gillette is impressive in her small role as Martha, Laurel's masseuse and friend, albeit a rather sinister friend whose barbed comments ('You can't be a nursemaid, sweetheart, cook *and* secretary,

Angel') are uttered with menace rather than affection. Even more fleet-ingly seen is Hungarian-born character actor Steven Geray who plays Paul, owner of the restaurant/bar Dix frequents; coincidentally, Geray had played a head waiter in *All About Eve*. On the technical side, Burnett Guffey's noir-like photography is consistently impressive, as is George Antheil's score.

Andrew Solt's witty screenplay, adapted from a book by Dorothy B. Hughes, contains some gems: 'You make me homesick for some of the worst years of our lives,' remarks Detective Brub Nicolai, while Charlie tells the ill-mannered relative of a movie mogul, 'You've set the son-in-law business back fifty years.' Captain Lochner remarks of Dix: 'He's hiding something, and I doubt it's a heart of gold.' One of the key scenes occurs after the increasingly irrational Dix has beaten up a young foot-ball player with whose car he collided (the fault being Dix's); Dix asks Laurel to continue the drive and, out of the blue, asks her opinion of some dialogue he's been trying to fit into the screenplay: 'I was born when she kissed me. I died when she left me. I lived a few weeks while she loved me.' He gets her to repeat the lines 'to see how they sound', and at the end of the film, after he has almost killed her, she remembers them with a mixture of pity and regret.

Nicholas Ray (1911–1979) worked as an assistant to Elia Kazan before directing his first film, *They Live by Night* (1948). He soon gained a repu-tation as a director of unusually intelligent dramas and thrillers that were rather more than thrillers. His rodeo drama, *The Lusty Men* (1952), is especially fine, and he followed it in 1954 with one of the most unusual westerns of the period, *Johnny Guitar*, which, like *High Noon* (1952), was an allegory of the blacklist but which also turned many of the conven-tions of the genre on their head, with the final gun duel fought between two powerful women (Joan Crawford and Mercedes McCambridge). *Rebel Without a Cause* (1955) confirmed the talents of James Dean, and *Bigger than Life* (1956) is a cautionary tale against the overuse of prescription drugs. Ray went on to make more conventional, but still superior, west-erns (*Run for Cover*, 1954; *The True Story of Jesse James*, 1956), a gangster movie (*Party Girl*, 1958) and a biblical epic (*King of Kings*, 1961). Ray's last Hollywood film was a 70mm epic about the Boxer Rebellion in China, *55 Days at Peking* (1963), after which he virtually retired. He taught film at colleges and made a couple of counter-culture independent films hardly

anyone saw. He played roles in films by two European directors, in Miloš Forman's adaptation of the musical *Hair* (1979) and in Wim Wenders' *The American Friend* (1977). As Ray was dying of cancer, Wenders made an affectionate tribute to him, *Lightning Over Water* (1980), which was released posthumously and for which Ray shared the director credit.

The African Queen

UK, 1951

Horizon Pictures–Romulus. DIRECTOR: John Huston. 105 MINS.
FIRST SEEN: *Gaumont, Chippenham, UK 21 December 1955.*

German East Africa, September 1914. Charlie Allnut (HUMPHREY BOGART), captain of *African Queen*, arrives at the 1st Methodist Church of Kundu to deliver the mail. He is welcomed by Rev. Samuel Sayer (ROBERT MORLEY) and his sister, Rose (KATHARINE HEPBURN). Allnut brings news of the war that has broken out in Europe; soon after he leaves, a German patrol enters the village, rounds up all the local men and burns the houses, including the church. Sayer loses his mind as a result of this brutal invasion and dies shortly afterwards. On his return, Allnut helps Rose bury her brother and agrees to take her with him on the *African Queen*. Rose is determined to avenge her brother's death and, on learning that some distance downstream there is a large lake patrolled by a German gunboat, *Queen Louise*, which is armed with a six-pounder—'the biggest gun in Central Africa'—she persuades a very reluctant Charlie to sail down the river to destroy the enemy ship with home-made torpedos of dynamite and oxygen cylinders. At first the pair quarrel; Charlie gets drunk and Rose throws away his stash of gin. Despite this they succeed in passing a German fort and fording the rapids. The danger brings them closer together. At the lake they head towards the enemy ship when a storm blows up and *African Queen* sinks. Charlie and Rose are captured and brought on board the *Queen Louise*, where they are interrogated and sentenced to hang. Charlie asks the Captain (PETER BULL) to marry them, which he does. The *Queen Louise* collides with the wreck of *African Queen*, which explodes. Charlie and Rose escape.

A British production with two famous American stars and a highly regarded American director, *The African Queen* was filmed, at considerable risk, on location in the Congo. Director John Huston and former critic James Agee adapted C.S. Forester's book for the screen, and the magnificent location Technicolor photography was the work of Jack Cardiff. The river used for the film was the Ruiki, home not only to the crocodiles seen in the film but also to snakes and parasitic worms known as bilharzia. The decision to film on a real and hazardous location means that *The African*

Queen is a far cry from the studio-set jungle pictures of the past. The scene in which Charlie finds himself covered in leeches looks all too real.

The credits unfold as the camera tracks forwards through the jungle to arrive at the village where a church full of locals is (supposedly) singing 'Rock of Ages', led by Rev. Sayer while Rose plays the organ. The cacophony ends with the arrival of *African Queen*, cheerfully blowing its whistle, and a general exodus as the congregation flocks to see what goods and trinkets Charlie has brought with him. The hospitable Sayers invite Charlie, who is unshaven and rather grubby, to afternoon tea, and serve him bread and butter, but they are all embarrassed by the noisy rumbling sounds that emanate from his empty stomach. After he leaves, Sayer refers to him as 'a wretched little man'. In his delirium after the village has been destroyed, the Methodist minister reveals his true misgivings about his sister—'Even for such as she, God has a purpose,' he mutters.

When the journey down the river commences, Rose badgers Charlie with questions, always calling him 'Mr Allnut', while he calls her 'Miss'. Accustomed to being his own boss, Charlie becomes increasingly exasperated with Rose's seemingly unrealistic demands and, when he gets drunk, calls her, to her face, a 'crazy, psalm-singing, skinny old maid'. But as their hazardous journey—with its very well-staged dangers—proceeds, this unlikely odd couple find themselves drawn to one another. 'I don't think another man could have done it!' she tells him, and he calls her 'the living picture of a heroine'. Hepburn, who modelled her character on Eleanor Roosevelt, gives one of her finest performances but it was Bogart, as the irascible, rough-hewn ex-pat who visibly softens when he unexpectedly falls in love, who won the Best Actor Oscar.

The lake that represents the end of the journey is presumably Lake Victoria. In fact, rivers do not run *into* the lake, but out of it towards the sea. The film, like the novel on which it was based, plays around with geographical facts. In 1987, Hepburn wrote an informative and enjoyable book—*The Making of The African Queen or How I Went to Africa with Bogart, Bacall and Huston and Almost Lost my Mind*.

The African Queen was an enormous box-office success worldwide. The combination of the spectacular African locations, the suspenseful journey and the unconventional romance charmed audiences everywhere.

John Huston (1906–1987) was the son of celebrated movie actor Walter Huston. He had an adventurous youth during which he tried many different jobs; he was a professional boxer, a small-time actor and even served with

the Mexican cavalry before he found his niche in Hollywood, first as a screenwriter (*Jezebel*, 1938; *Juarez*, 1939; *High Sierra*, 1941) and then as a director, starting in 1941 with *The Maltese Falcon*, the third screen version of Dashiell Hammett's private-eye novel, which starred Humphrey Bogart as Sam Spade. During the war Huston made military documentaries (*Report from the Aleutians*, 1943; *The Battle of San Pietro*, 1944). The first film he made on his return to Hollywood was *The Treasure of the Sierra Madre* (1947), a superb drama filmed in Mexico starring Bogart and Huston Sr. as gold prospectors. Three excellent thrillers (*Key Largo*, 1948; *We Were Strangers*, 1949; *The Asphalt Jungle*, 1950) were followed in 1951 by an adaptation of Stephen Crane's Civil War novel, *The Red Badge of Courage*. Journalist Lillian Ross wrote an exceptional book, *Picture* (1952), about the making and unmaking of that film. The frustrations Huston experienced over *Red Badge* led him to relocate, first to Britain for *The African Queen* and *Moulin Rouge* (1952, a biopic of French artist Henri de Toulouse-Lautrec) and then to Ireland,

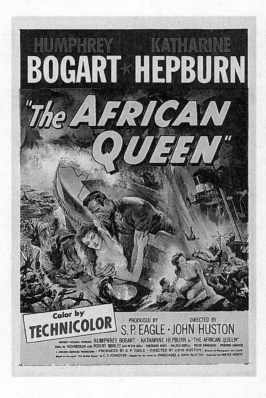

though he frequently returned to America to work. Thereafter his career was spotty, with the occasional highs (*The Unforgiven*, 1960; *The Misfits*, 1961; *Fat City*, 1972; *The Man who Would Be King*, 1975; *Wise Blood*, 1979; *Prizzi's Honor*, 1985; *The Dead*, 1987), but also a great many lows.

Peter Viertel, a novelist based in Europe, was approached by Huston to collaborate—without credit—on the screenplay of *The African Queen*. Viertel accepted and wrote a book in 1953, *White Hunter, Black Heart*, inspired by working with Huston—who notoriously used some of the time he spent in Africa to go on safari and 'bag' an elephant. The book was made into a 1990 film directed by and starring Clint Eastwood.

I met Huston only once. In 1984, at the Cannes Film Festival, I was assigned by *Variety* to review the veteran director's *Under the Volcano*, a very respectable adaptation of Malcolm Lowry's novel, with Albert Finney as an alcoholic diplomat based in Mexico. I was invited to meet Huston in his hotel room to discuss some aspects of the film. He was hooked up to a respirator and looked extremely unwell, so I was unable to stay for very long; but ill as he was, he radiated the strength and humour that suffused all of his best work.

32

Bend of the River

USA, 1951

Universal-International. DIRECTOR: Anthony Mann. 91 MINS.

FIRST SEEN: *Gaiety Cinema, Coleshill, Birmingham, UK 3 March 1957.*

Oregon, 1850. Glyn McLyntock (JAMES STEWART) is guiding a wagon train north to Oregon Territory; the settlers for whom he is working include Jeremy Baile (JAY C. FLIPPEN) and his daughters, Laura (JULIA ADAMS) and Marjie (LORI NELSON). Glyn saves Emerson Cole (ARTHUR KENNEDY) from a lynch mob and the two become friends. Both have dark secrets they are determined to conceal from the settlers. Laura is badly injured by an arrow shot by a Shoshone warrior. The wagon train reaches Portland where the settlers order, and pay for, supplies for the coming winter. In Portland they encounter Trey Wilson (ROCK HUDSON), a gambler who is quick on the draw. Glyn and the settlers sail north on the *River Queen*, a Mississippi River paddleboat, leaving Laura behind to recover from her injuries. Emerson also elects to stay in Portland. With winter approaching, the supplies the settlers ordered fail to arrive, so Glyn and Jeremy return to Portland where they find a gold rush has transformed the previously quiet town. Their supplies are now worth far more than they paid for them. Accompanied by Emerson and Laura, who have become romantically involved, as well as by Trey, they succeed in loading the *River Queen* and set sail, pursued by townspeople who want the supplies for the cash-rich miners. Glyn offers a bunch of goldminers payment if they help escort the wagons and cattle to the settlement, but Emerson betrays him, joins the miners and takes off with the priceless supplies. Glyn follows, seeking revenge.

The 1950s was a particularly rich decade for the Hollywood western. Hundreds were produced, some—like the impressive cycle of films starring Randolph Scott and directed by Budd Boetticher—were made on a modest scale and often shown in double bills in cinemas at the time. But there were also the 'A'-grade westerns made by John Ford, Howard Hawks, Delmer Daves, Anthony Mann and others. Growing up and discovering cinema at a time when westerns were so popular and numerous, it's no wonder that I retain a considerable fondness for the genre.

Many westerns are about pioneers, heading west in their wagon trains, sometimes threatened by hostile Native Americans, sometimes by greedy landowners and ranchers or outlaws. In *Bend of the River* the settlers are heading not just west but north-west, into the beautiful mountainous country of Oregon.

Like all of Mann's westerns, *Bend of the River* is distinguished by its location photography (Irving Glassberg was the cinematographer), although the location work—most of it in sight of the same snow-capped mountain—is somewhat marred by the obvious use of studio sets for campfire scenes, a flaw shared by many films of this period. On the subject of flaws, Rock Hudson's nattily dressed gambler is a puzzling character whose loyalties shift in a nanosecond. But there are compensations in the darkly amusing dialogue and the tense relationship between the two so-called friends, Glyn and Emerson. Arthur Kennedy gives a magnificent performance as the ultra-charming but totally amoral Emerson Cole; time and again the viewer is led to believe that the moment has arrived when Cole will betray Glyn, but when he finally does turn on his friend it still comes as a shock. It's a *Mutiny on the Bounty* moment as a bloodied Glyn, about to be robbed and abandoned on an isolated mountain, quietly threatens revenge on his erstwhile friend. To Cole's parting 'I'll be seein' you,' Glyn growls: 'You'll be seein' me. Every time you bed down for the night you'll look back into the darkness and wonder if I'm there. And some night I will be. You'll be seein' me!' Stewart handles this exchange with an intensity far removed from the mainly comedic roles he'd played before the war (during the war he enlisted in the United States Air Force and took part in the bombing raid on Dresden, Germany).

Also of more than usual interest is the friendship between Mello (CHUBBY JOHNSON), the riverboat captain whose constant regret for leaving the Mississippi becomes an amusing refrain, and his mate Adam, played by Stepin Fetchit, an African-American actor often called upon to play caricatures of subservient black men. In this film the two men are not only colleagues but also clearly very good friends—in their final scene together they walk off with Mello's arm around Adam's shoulder, an unusually intimate depiction of an interracial friendship for the time.

The action scenes are well staged (when Laura is struck by an arrow it's a genuinely shocking moment) and there's an enjoyable gallery of character actors, among them Jack Lambert, Royal Dano, Henry Morgan and Howard Petrie, who portray assorted villains.

Bend of the River was the second of five great westerns directed by Anthony Mann and starring James Stewart. Each one explored, in a variety of ways, the notion of vengeance, and they became darker with the passing years, ending with the very bitter film *The Man from Laramie* (1955). *Bend of the River* might not be the best western made by Mann, or the best starring Stewart, but it was one of the first that I saw and so it retains an important place in my movie-going memory. In England the film was mysteriously retitled *Where the River Bends*—surely a pretty pointless decision.

Mann (1906–1967), an actor and writer, directed his first film—*Dr. Broadway*—in 1942, and he made his first western, *Border Incident*, in 1949. Prior to that he had made several high-class films noir, among them *Railroaded!*, *Desperate* and *T-Men* (all 1947). His western noir, *The Furies* (1950), is most impressive and the same year he made the first of the Stewart films, *Winchester '73*. This was followed by *The Tall Target* (1951), a remarkable period thriller set almost entirely on a train, with Dick Powell as a detective named Kennedy who is trying to prevent the assassination of President Abraham Lincoln. *The Naked Spur* (1952), *The Far Country* (1954) and *The Man from Laramie* rounded out Mann's Stewart series and in between them he directed Stewart in the musical biography *The Glenn Miller Story* (1953). After one last great western, *Man of the West* (1958), starring an ageing Gary Cooper, Mann turned to the then-fashionable epic cinema, working with producer Samuel Bronston on *El Cid* (1961) and *The Fall of the Roman Empire* (1964).

I never met Mann, but I had the pleasure of sharing a dinner table with Stewart in Berlin in February 1982. He was, unsurprisingly, a charming man whose stories of Hollywood's golden days were related with generosity, warmth and humour.

The Man in the White Suit

UK, 1951

Ealing Studios. DIRECTOR: Alexander Mackendrick. 85 MINS.

FIRST SEEN: *Assembly Hall, Bradfield College, Berkshire, UK. 2 February 1954.*

The North of England. 'Now that calm and sanity have returned to the textile industry I feel it my duty to reveal something of the true story behind the recent crisis.' Spoken by Alan Birnley (CECIL PARKER), the pompous owner of a mill where artificial fibres are being manufactured, the narration ushers in a familiar flashback structure. Birnley is visiting a smaller mill owned by Michael Corland (MICHAEL GOUGH), who is seeking financial investment— as well as the hand of Birnley's daughter, Daphne (JOAN GREENWOOD). It is Birnley who spots some weird apparatus, which is making curious rhythmic noises, in a corner of Corland's laboratory. After some investigation, it is discovered that the 'thing', which is costing the company several thousand pounds in parts, is the brainchild of a humble cleaner, Sidney Stratton (ALEC GUINNESS), a Cambridge graduate and passionate scientist who is working on the invention of an artificial fibre that will never wear out and never get dirty. After being fired by Corland, Sidney obtains a job as a labourer at Birnley's mill and is befriended by Bertha (VIDA HOPE), a dedicated union member. Eventually Sid manages to persuade Birnley to allow him to carry on his experiments, despite the mounting costs and structural damage— the result of a series of explosions that rock the building. But no sooner does he achieve success with his formula, and a white suit, luminous in the dark, is made from the cloth he has invented, than opposition emerges on two fronts. Corland summons Sir John Kierlaw (ERNEST THESIGER), the aged doyen of the textile industry, and other mill owners and urges them to suppress the invention ('It'll knock the bottom out of everything, right down to primary producers'). Meanwhile the union leaders, horrified at the thought of 'six months' work and that'll be the lot!', find themselves in willing agreement with the mill owners. Capital and Labour join forces to prevent Sidney from telling the outside world about his invention.

A comedy with something interesting to say about the state of the world is rare enough, making *The Man in the White Suit* a very special film. It was based on an unproduced play, 'The Flower Within the Bud', by Roger

MacDougall, who collaborated on the screenplay with director Alexander ('Sandy') Mackendrick and John Dighton; the play, drastically altered for the film, was performed just once, in 1954, three years after the film's release. Though in the end the film takes a conservative line in which Capital and Labour unite to frustrate Science, the very fact that the screenplay raises such issues makes the film unusually intriguing. As the Shop Steward, Frank (PATRIC DOONAN) points out, other 'radical' inventions—like a car that can run on water—have been suppressed in the past. The 'delicate balance of the market' can never be disrupted.

Despite these weighty themes, the film is first and foremost a comedy and a very funny one. Alec Guinness, by 1951 one of Britain's most popular actors, gives a delicious performance as the obsessed scientist with a completely fixated and blinkered outlook on the world. His explosive experiments are treated with broad humour, yet ultimately he's rather a tragic figure. Towards the end of the film he's confronted by his diminutive landlady (EDIE MARTIN), who has been kind to him. 'Why can't you scientists leave things alone?' she asks him. 'What about my bit of washing when there's no washing to do?' Sidney looks at her and for a second there's a 'What have I done?' moment, akin to the one at the conclusion of another Guinness film, *The Bridge on the River Kwai*, made six years later.

Mackendrick's direction is intelligent and subtle, and his comedic timing is second to none. This was only his second feature (after *Whisky Galore*, 1948) and he doesn't put a foot wrong. There are some very dark moments: unable to convince Sidney to sell his invention for a quarter of a million pounds, one of the mill owners (HOWARD MARION CRAWFORD) suggests that Daphne might seduce him into agreement—this isn't spelt out in so many words, but the implication is clear. Daphne, who is engaged to marry Corland, seeks the opinion of her fiancé, and he goes along with the idea: the virtue of his wife-to-be is, it seems, less important than the future of the textile industry.

Michael Gough is suitably seedy in this pivotal role, while Cecil Parker, a great character actor with a wonderfully distinctive voice, has one of his best parts as the pompous Birnley. But the cast is brimming with consummate character actors. The two women, the elegant Joan Greenwood and the down-to-earth Vida Hope, are beautifully contrasted. There's also a lovely performance from a child, Mandy Miller, who helps Sidney escape from his pursuers. In Mackendrick's next film, titled simply *Mandy* (1952), this talented youngster would play a deaf and mute child. There's also a

brief but memorable cameo from Miles Malleson (the hangman in *Kind Hearts and Coronets*, 1949) who plays the tailor given the task of making the first suit from this most unusual material.

Alexander Mackendrick (1912–1993) was born in Boston to Scottish parents who were living temporarily in the USA. He was educated in Glasgow and made short films and documentaries before graduating to features. He had instant success with his early, very British, films, which have been mentioned above. He subsequently made *The Maggie* (1953), which is set—like *Whisky Galore*—in Scotland, and *The Ladykillers* (1955), a brilliant black comedy in which Guinness plays the leader of a ruthless gang of robbers (Cecil Parker is one of the gang members, as is Peter Sellers).

After these popular and well-reviewed successes, Mackendrick was head-hunted by Burt Lancaster, who hired him to direct a totally different kind of film: the abrasive, chilling, New York set drama *Sweet Smell of Success* (1957), in which Lancaster plays a right-wing columnist and Tony Curtis an amoral press agent. The film was critically praised, and Lancaster hired Mackendrick again to direct an adaptation of George Bernard Shaw's *The Devil's Disciple*. Mackendrick fell out with Lancaster during production and was replaced by Guy Hamilton.

The experience seemed to shake him. It was four years before he made another film, an African adventure titled *Sammy Going South* (1963), which was followed by a pirate drama, *A High Wind in Jamaica* (1965). Mackendrick's final film, *Don't Make Waves* (1967), was a feeble comedy with few redeeming features. After this there were several projects that never came to anything; they were either abandoned or assigned to other directors. Mackendrick ended his film career as a teacher: he was appointed the first Dean of the film school at the California Institute of the Arts in Los Angeles.

34

High Noon

USA, 1952

United Artists–Stanley Kramer Productions. DIRECTOR: Fred Zinnemann. 84 MINS.

FIRST SEEN: *Carlton Cinema, Sparkbrook, Birmingham, UK. 30 November 1956.*

The small western town of Hadleyville, 1865. Marshal Will Kane (GARY COOPER) marries Amy Fowler (GRACE KELLY), a Quaker, in a civil service at 10.35 one Sunday morning. As the ceremony is completed, word arrives from the depot that Frank Miller (IAN MACDONALD), a killer Kane had arrested five years earlier, has been released from a northern prison after his death sentence was commuted. His brother, Ben (SHEB WOOLLEY), and two members of his gang, Jim Pierce (BOB WILKE) and Jack Colby (LEE VAN CLEEF), are at the depot awaiting Miller's arrival on the noon train. Kane, though his term as marshal has officially ended, decides to stay in town because the new marshal is not due for another day. He expects the townspeople, who have always supported his law-and-order policy, will form a posse to help him, but as the minutes tick by towards noon it becomes clear that, for a variety of reasons, no one is going to come to his aid: he's alone. Amy, whose religion opposes violence, leaves him; Harvey (LLOYD BRIDGES), his feckless deputy, is resentful that he hasn't been given the job of marshal and is uncomfortable in his relationship with Helen Ramirez (KATY JURADO)—who owns much of the town including the saloon—because she was previously the mistress of both Kane and Frank Miller; Judge Mettrick (OTTO KRUGER), who passed sentence on Miller, packs up his law office and leaves while the going's good; habitués of the saloon miss the good old days when the Millers ran the place; the 'good' townspeople, who are attending church, take part in a heated debate and come to the conclusion that Will should have left town. He is left to face the four gunmen alone.

At the beginning of the 1950s, a handful of westerns—including Henry King's *The Gunfighter* (1950), George Stevens' *Shane* (see #35), the films of Anthony Mann, and *High Noon*—ushered in the 'adult western', westerns that were more nuanced than the usual simplistic good guy vs bad guy (or 'Cowboy vs Indian') fare. The plot of *High Noon*, which was based on a short story, 'The Tin Star', by John M. Cunningham, is pretty basic, but the treatment was original. Much was made of the time factor: again and

again, director Fred Zinnemann draws our attention to the ticking clocks that are prominent all over Hadleyville. The suggestion is that the action of the film, which would have lasted about 105 minutes, takes place in real time—clearly not possible in a film running 84 minutes; the time compressions are there if you care to search for them.

The film was produced by Stanley Kramer, an independent with a social conscience (he would later direct the screen version of Nevil Shute's post-World War II classic *On the Beach* [1959] in Australia), and it was the last of several films Kramer made with the writer Carl Foreman. An alleged member of the Communist Party, Foreman was called before the House Un-American Activities Committee during the filming of *High Noon* but he refused to testify or to give to HUAC members the names of other party members he knew. He was immediately blacklisted and left for the UK where he worked for many years, writing or co-writing films—including *The Bridge on the River Kwai* (1957)—under aliases. *High Noon*, like the subsequent *Johnny Guitar* (1954), can be seen as a blacklist allegory. Will Kane is an honest man who holds to his convictions and his conscience while the citizens of Hadleyville behave like the average American who failed to stand up to reject the injustices of McCarthyism. The point is most powerfully made in the scene where the judge packs up the symbols of justice—the American flag, his law books, scales of justice—and rides off ('I've no time for a lesson in civics'). Gary Cooper, whose long career was on the wane in 1952, was a dedicated anti-Communist, and had been a 'friendly witness' before HUAC; Lloyd Bridges had agreed to 'name names' before HUAC and so had saved his career—something Foreman and many others refused to do. There must have been quite a few tensions on the set of the movie.

Visually, *High Noon*—photographed by Floyd Crosby—is very impressive, commencing with the opening shot (a man, a horse, two trees silhouetted in the middle distance) and continuing to the last (the camera crane rises as Will and Amy ride out of Hadleyville in their sulky). A crane shot is used again, very impressively, to emphasise the isolation of Kane as he walks down the empty main street of the town to meet the killers.

The film's editing—by Elmo Williams—is also notable, especially in the sequence building up to the train's arrival in which the film cuts back and forth between the various characters and the time of the ticking clock.

The famous ballad that accompanies the film was added after test screenings. Tex Ritter sings the Dmitri Tiomkin–Ned Washington lament

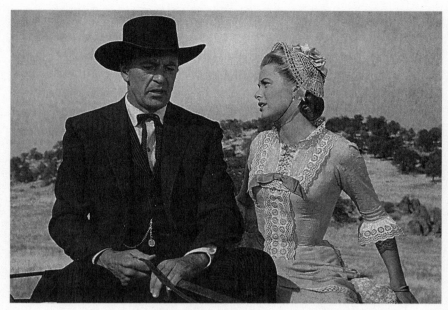

A moment of decision: ex-marshal Will Kane (GARY COOPER) and his bride, Amy (GRACE KELLY).

that, right from the first minute of the film, foreshadows the plot ('The noonday train will bring Frank Miller'; 'Do not forsake me, oh my darlin', you made that promise when we wed'; 'I can't be leavin' until I shoot Frank Miller dead!'). The song became a hit recording and helped make the film a major success.

Cooper, who was aged 51 when the film was made and who was suffering from a painful ulcer, is clearly too old to be marrying Grace Kelly, who was just beginning her short but illustrious career—many films of the 1950s cast ageing stars, who first came to fame in the 30s or earlier, opposite young leading ladies—but Cooper undoubtedly deserved the Best Actor Oscar he won for the film (Oscars were also awarded for Best Editing, Best Song and Best Music Score). The film was very influential and in later years aspects of it were borrowed by other filmmakers. Even Akira Kurosawa makes a direct reference to it in his film *Yojimbo* (1961) in a discussion about the number of coffins that should be prepared before a coming showdown—and Sergio Leone, in his unofficial remake of *Yojimbo*, *Per un pugno di dollari*/*A Fistful of Dollars* (1964) continues the coffin reference.

Fred Zinnemann (1907–1997), who was born in Vienna and came to America in 1929, was never much admired by critics who espoused the

auteur theory because they saw no personal, directorial 'voice' in his varied output. But he was a consummate craftsman whose three films about the aftermath of World War II (*The Search*, 1948; *Act of Violence*, 1949; *The Men*, 1950, Marlon Brando's screen debut) are extremely impressive. His literary adaptations (*From Here to Eternity*, 1953; *The Nun's Story*, 1958; *The Sundowners*, 1960, made in Australia; *The Day of the Jackal*, 1973) are meticulous transpositions from page to screen, while his film versions of celebrated stage productions (*The Member of the Wedding*, 1952; *Oklahoma!*, 1954; *A Hatful of Rain*, 1957; *A Man for All Seasons*, 1966) added to his reputation. His last film, *Five Days Last Summer*, was made in 1982.

35

Shane

USA, 1952

Paramount. DIRECTOR: George Stevens. 118 MINS.
FIRST SEEN: *Waldorf Cinema, Sparkbrook, Birmingham, UK 29 March 1957.*

Wyoming, around 1890. Shane (ALAN LADD), a professional gunman, rides into an isolated valley where homesteaders are in conflict with Rufus Ryker (EMILE MEYER), owner of a vast cattle ranch. Shane is given shelter by Joe Starrett (VAN HEFLIN) and his wife, Marion (JEAN ARTHUR), and from the start he is idolised by their young son, Joey (BRANDON DE WILDE). While visiting Grafton's, the mercantile and saloon in the nearby township, Shane gets into a fight with Chris Calloway (BEN JOHNSON), one of Ryker's men. Ryker offers Shane, and then Joe, employment, but they refuse; meanwhile his men continue to terrorise the other settlers in the valley. After a saloon fight in which Joe comes to Shane's aid as he takes on Ryker's men, Ryker sends for help in the form of notorious Cheyenne gunman Jack Wilson (JACK PALANCE), who, shortly after his arrival, kills 'Stonewall' Torrey (ELISHA COOK JR), one of the settlers. Given that the nearest marshal is 100 miles—or three days' ride—away, the other homesteaders prepare to move out of the valley, but Joe persuades them to stay while he promises 'to take this thing up with Ryker—even if I have to kill him'. But Shane takes Joe's place for the fatal confrontation with Ryker, Wilson and Ryker's treacherous brother, Morgan (JOHN DIERCKES). He is wounded in the ensuing gunfight and rides away from the valley while Joey, who has witnessed the shootings, calls after him.

Shane was completed in 1952 but its release was delayed for several months while the director, George Stevens, argued with the studio, Paramount, over how it should be presented. Eventually it opened at Radio City Music Hall in April 1953, but it took several more months before this great western opened in the UK, the problem, apparently, being censorship (two minutes of fisticuffs were removed before British audiences were allowed to see it, even with an 'A'—for adults—classification). The delay meant that by the time the film opened in British cinemas the old standard screens had been replaced by wide screens, so that serious cropping was inflicted on the film, mainly involving the cutting off of the tops of

heads; this was noted by future film director Karel Reisz when he reviewed the film for *Monthly Film Bulletin* in September 1953.

Neither *High Noon* nor *Shane* was made by a director known for the western genre. Unless you count *Annie Oakley* (1935), a biography of the sharpshooting woman who inspired the musical *Annie Get Your Gun*, *Shane* is the only western Stevens ever made, yet it clearly inspired Sam Peckinpah and even seems to have influenced John Ford's majestic *The Searchers* (1956).

The film opens and closes with the figure of Shane on horseback; he rides into the valley behind the opening credits and out of the valley as 'The End' is displayed. The valley itself, superbly photographed by Loyal Griggs who won the film's only Oscar, is surrounded by snow-capped mountains (Grand Tetons); in the middle is the tiny township dominated by the general store and saloon owned by Sam Grafton (PAUL MCVEY), who is a force for moderation in the community. Scattered around the area are the little farms operated by families like the Starretts, farms that outrage cattle baron Rufus Ryker, a wild-haired, bushy-bearded capitalist who looks more like an unkempt Moses than the urbane rancher usually depicted in westerns. In A.B. Guthrie Jr's screenplay, based on the book by Jack Schaefer, Ryker is given an opportunity to state his reasons: he tells Starrett—whose name Emile Meyer pronounces as if it were 'Start'—that he and other pioneers '*made* this country—we found it and we made . . . the range safe. Then people move in [and] take irrigation water so the creek sometimes runs dry.' He claims to still have a Cheyenne arrowhead in his shoulder. But Starrett responds with spirit: 'You think you've got the right to say no one else has got any right.' During this exchange, Shane is eyeing off Wilson, the black-clad gunfighter Ryker has imported into the valley; both men are soft-spoken, both are fast on the draw. It's a particularly compelling performance from Palance (billed as Walter Jack Palance), who had already made a big impression in Elia Kazan's thriller *Panic in the Streets* two years earlier. Alan Ladd also made his name playing a villain (as Raven in *This Gun for Hire*, 1942). Jean Arthur had been a big star in the 1930s, especially in Frank Capra films like *Mr. Deeds Goes to Town* (1936), *You Can't Take it with You* (1938) and *Mr. Smith Goes to Washington* (1939), but when she was cast as the conflicted Marion in *Shane* she hadn't acted in a film for four years and this proved to be her final screen appearance. Van Heflin was a fine stage actor and versatile screen actor whose persona was that of honourable rectitude.

Given that the plot of *Shane* is straightforward, even predictable, it's the details that make the film so memorable. The wistful way in which Shane,

arriving at the Starrett farm, comments, 'It's been a long time since I've seen a Jersey cow.' Marion laying the best crockery and cutlery when Shane has dinner the first night, something her husband finds 'kinda funny'. The brave, blustering Torrey, a Southerner who proposes a toast to 'the sovereign State of Alabama' and whose squalid death in the mud is so deeply distressing. The sounds of thunder in the distance as the homesteaders, with their wives and children, come into town to shop. Torrey's dog who, as his master's coffin is lowered into its grave, places a tentative paw on top of it. The beautiful, if incongruous, singing of 'Abide with Me' as Joe and Marion celebrate their tenth wedding anniversary on 4 July. Marion saying goodbye to Shane ('Please Shane,' she begins and then, unable to continue, shakes his hand).

I find Brandon De Wilde, with his constant stream of questions, slightly grating as Joey, but the idea of having the story basically seen through the eyes of an innocent child generally works well, and the final scene where Shane explains to him that he's moving on because 'a man has to be what he is. You can't break the mould', is beautifully handled by both actors. De Wilde made a few other films, including John Frankenheimer's *All Fall Down* (1962) and Martin Ritt's *Hud* (1963), but, tragically, he was killed in a car accident at the age of 30.

The other element that made *Shane* so popular—in box-office terms it was the most successful western of the 1950s—is Victor Young's beautiful music score, music that seems to emphasise the extraordinary beauty of the landscape in which these violent events unfold.

George Stevens (1904–1975) entered the film industry as a cameraman but also devised gags for silent movies. He directed for the first time in 1933, and followed an eclectic path: an Astaire–Rogers musical (*Swing Time*, 1936); a literary adaptation (*Quality Street*, 1937); a screwball comedy (*Vivacious Lady*, 1939); a colonial adventure (*Gunga Din*, 1939); and the first film to co-star Spencer Tracy and Katharine Hepburn (*Woman of the Year*, 1942). He served with the military during World War II and his camera team covered parts of the European campaign. His post-war comeback, *A Place in the Sun* (1951), was a fine adaptation of Theodore Dreiser's novel *An American Tragedy*. He followed *Shane* with *Giant* (1956), a sprawling adaptation of Edna Ferber's novel; *The Diary of Anne Frank* (1959); and the lengthy biblical epic *The Greatest Story Ever Told* (1965). His last film, *The Only Game in Town*, was made in 1969.

Singin' in the Rain

USA, 1952

MGM. DIRECTORS: Gene Kelly, Stanley Donen. 103 MINS.
FIRST SEEN: *Granby Cinema, Reading, UK 20 November 1961.*

Hollywood, 1927. A silent swashbuckler, *The Royal Rascal*, starring Don Lockwood (GENE KELLY) and Lina Lamont (JEAN HAGEN), a hugely popular on-screen couple, premieres at Grauman's Chinese Theatre to a rapturous reception. Don, who is invariably accompanied by his childhood friend, Cosmo (DONALD O'CONNOR), tells the fans a much-embroidered story of his rise to fame. Lina, who speaks with a broad Brooklyn accent, believes the fake studio publicity that she and Don are romantically involved. Fleeing from his fans, Don is given a lift by Kathy Selden (DEBBIE REYNOLDS), who has ambitions to become a stage actor and who is condescending about silent movies ('entertaining for the masses') and silent actors ('they don't talk, they don't act—just a lot of dumb show'). Don is amused when, at the party he's attending, Kathy pops out of a cake; she throws a cream cake at him but hits Lina, who has her fired. The release of *The Jazz Singer* spells the end for silent movies, and a sneak preview of the team's first talkie, *The Duelling Cavalier*, is laughed off the screen. Kathy and Don, by now in love, are egged on by Cosmo and decide to turn the disaster into a musical, *The Dancing Cavalier*. The problem is Lina, who can't sing and speaks with an ear-shattering accent. Cosmo has the idea of getting Kathy to dub over Lina's dialogue and musical numbers. The premiere is a smash hit, but Lina refuses to allow Kathy credit and demands that the dubbing arrangement is continued for future pictures. But Don, Cosmo and studio chief R.F. Simpson (MILLARD MITCHELL) turn the tables on her.

Singin' in the Rain is, as I've often said, my favourite movie. I have always had a soft spot for the musicals that were a regular feature of the cinema-going of my youth, and this is by far the best of them. The songs that are packed into the film every few minutes were not new in 1952; the lyrics (by MGM's top producer of musicals, Arthur Freed) and music (by Nacio Herb Brown) had been written in the 1920s, and the story of the film was inspired by the title song, which is elaborated into a witty screenplay by Adolph Green and Betty Comden. The period setting is exquisitely

realised and represents the studio's production values at their peak: the sets, by Cedric Gibbons and Randall Duell, and the costumes, by Walter Plunkett, are eye-popping.

The attention to detail is impressive, especially in the scenes in which the harassed film director, Roscoe Dexter (DOUGLAS FOWLEY), attempts to cope with the cumbersome new sound recording that involves having the camera shut in a soundproof box and microphones hidden in bushes or in the corsage of the leading ladies (anyone who has seen early talkies made in 1927–1928 will appreciate just how accurate all this is). The notion that a glamorous star of silent romantic dramas possessed a voice that was at odds with his or her screen image is drawn from fact: John Gilbert, co-star with Greta Garbo in several hugely successful screen love stories in the silent era, was mocked for his wooden performance in *His Glorious Night* (1929), in part perhaps because he was badly recorded, and his career never recovered.

There are also razor-sharp cameos of Hollywood types of the period: one female star is dating an elderly—but clearly wealthy—gentleman, while another is married to a minor European royal. All this and more is gushingly described by the Louella Parsons-like Dora Bailey (MADGE BLAKE) who hosts the first premiere. And then there are the voice coaches: the wonderfully named Phoebe Dinsmore (KATHLEEN FREEMAN), who tries in vain to get Lina to speak in 'round tones', and the pompous type (BOBBY WILSON) whose tongue-twisters lead to the energetic Kelly–O'Connor tap routine, 'Moses'.

The film is certainly funny, but it's the musical numbers that soar. They begin with 'Fit as a Fiddle', performed by Kelly and O'Connor in a flashback to their vaudeville days. Reynolds and a female chorus sing 'All I Do is Dream of You' at the post-premiere party. O'Connor's very physical 'Make 'em Laugh' routine is a show stopper—though the song is curiously similar to the Cole Porter number 'Be a Clown' performed by Kelly in Vincente Minnelli's *The Pirate* four years earlier. There's a splendid montage that pays tribute to films and songs of the period, which includes songs like 'I've Got a Feelin' You're Foolin', 'Wedding of the Painted Doll' and 'Beautiful Girl' (the latter performed anonymously by Jimmy Thompson), complete with Busby Berkeley-inspired staging. Kelly romances Reynolds in an empty studio to 'You Were Meant for Me'. The utterly charming 'Good Morning' takes place all over Don's house—from kitchen to dining room to staircase to lounge room—as the trio celebrates their plan to musicalise the disastrous *Duelling Cavalier*. This exuberant sequence is followed immediately by the exhilarating title number, Kelly's solo, which contains the most seductive

combination of music, dance and—crucially—gliding camera movements in any musical. At the finale, Kelly and Reynolds sing 'You are My Lucky Star', a song that originally also featured earlier in the film but which was cut in the post-production stage.

Many musicals of this period featured an elaborate production number including a ballet performance. In *Singin' in the Rain* this sequence lasts a full 13 minutes, and comes as Don describes to R.F. the 'modern' number he envisages for the film. It involves an eager young dancer who arrives in the city, falls for a vamp (CYD CHARISSE), is rejected in favour of a gangster, but finds success. The dance sequence in which Charisse wears an exceedingly long white veil is enchanting.

There's an intriguing footnote to a film about a performer with an 'unsuitable' voice who is dubbed by someone more acceptable. This was common practice with Hollywood musicals of the time; the songs 'sung' by Cyd Charisse in her films were always dubbed by an anonymous artist. That was not Deborah Kerr's singing voice in *The King and I* (1956) nor Audrey Hepburn's in *My Fair Lady* (1964). And, allegedly, it's not Debbie Reynolds' singing voice in *Singin' in the Rain*.

This was the second film of three co-directed by Gene Kelly (1912–1996) and Stanley Donen (1924–2019); it followed the pioneering *On the Town* (1949) and was followed by *It's Always Fair Weather* (1955). Donen was a dancer, and a member of the chorus in the Broadway production of *Pal Joey* (1940), where he met Kelly, who was playing the lead. He collaborated with Kelly on dance routines for several musicals. After their work together ended, Donen directed such popular musicals as *Seven Brides for Seven Brothers* (1954), *Funny Face* (1956) and *The Pajama Game* (1957) as well as several non-musicals, including *Indiscreet* (1958), *Charade* (1963), *Two for the Road* (1966) and *Movie Movie* (1978).

Kelly came to fame in the stage production of *Pal Joey*, and subsequently starred in many screen musicals, beginning with *For Me and My Gal* (1942), directed by Busby Berkeley. The last musical Kelly directed was the lavish *Hello Dolly!* (1969). In the autumn of 1970 he invited me to his home in Beverly Hills and we spent the best part of a day talking about his work. He was a kind and generous host and a great raconteur.

37

M. Hulot's Holiday
(*Les vacances de M. Hulot*)

FRANCE, 1953

Cady Films–Discina. DIRECTOR: Jacques Tati. 99 MINS.
FIRST SEEN: *Cinedrome, Padstow. UK, 18 August 1954.*

France. Holiday-makers descend on the Hotel de la Plage in the seaside town of St. Marc-sur-Mer, among them the accident-prone M. Hulot (JACQUES TATI) who drives a dilapidated car and seems ignorant of the chaos that follows in his wake. He is unfailingly polite and kind to the other hotel guests, but succeeds in alienating most of them, except Martine (NATHALIE PASCAUD), who is holidaying with her aunt (MICHELE ROLLA).

Les vacances de M. Hulot was the second feature directed by former music-hall star Jacques Tati, after *Jour de fête* in 1949, in which he played a village postman, not the character of the shambling, pipe-smoking Hulot he made famous in *Vacances* and who featured in all three films he made subsequently. Inspired by silent slapstick, Tati's handling of visual comedy puts him on par with masters like Chaplin, Keaton, Lloyd, and Laurel and Hardy, and he owes a debt to all of them. Hardly a moment goes by in the film when something funny isn't happening, sometimes in the background, making this a film best seen on a large screen for maximum effect.

The very first scene—after an odd little shot of an empty rowboat on a beach—takes place in a railway station where the inaudible announcements made over the PA compel the prospective passengers, loaded with luggage, to dash from one platform to another via an underground walkway. Hulot himself travels to the seaside by car, though there are plenty of obstacles en route, including a sleeping dog who blocks a narrow village street. Hulot's decency is emphasised when he leans down to stroke the head of the somnolent hound before driving on.

His arrival at the hotel is chaotic because he leaves open the front door, causing a mighty wind to blow through the lobby. The hotel owner (LUCIEN FRÉGIS) and the waiter (RAYMOND CARL) are less than impressed with this disruptive force. The squeaky restaurant door becomes an aural motif,

as does the sound of the constant programs heard over the radio, mostly consisting of dire news reports about the economy.

The other hotel guests are amusingly depicted, among them the couple who constantly go for walks and are always first in the dining room for meals; the pompous ex-army officer, who never stops pontificating about something or other; the nerdy student who latches on to Martine and bores her to tears; the businessman who is constantly called away to the telephone to take an important call; the South American with his wayward moustache; the Englishwoman who takes a liking to M. Hulot; the little boy who is an observer of most of the mayhem (and who is a naughty kid, in one scene using a magnifying glass to burn the exposed flesh of a sunbather).

Comedy highlights include the scene in which a man is painting a small boat when the winch, helpfully handled by Hulot, slips, allowing the boat and the painter to slide into the water. In another highlight, Hulot kicks the rear of the fat businessman who he wrongly suspects is spying on Martine as she changes into her bathing costume (the innocent man was actually setting up yet another group photo shot). Hilarious, too, is the incident at the funeral where an inner tube from one of Hulot's car tyres, sticky and covered with leaves, is mistaken for a wreath. The celebrated tennis scene is a highlight: Hulot's unorthodox serve—first demonstrated to him by the local shopkeeper—allows him to defeat all comers and becomes a talking point for everyone. In another wonderful scene Hulot is sailing in a small canoe that suddenly folds up on him; it looks like a shark is eating him. The moment where Hulot steps on a towrope just as the towing car moves forwards and he is propelled into the harbour is a masterpiece of comic timing, and there's an explosive climax in which the hapless holiday-maker accidentally sets fire to a shed full of fireworks.

The first time I saw this wonderful comedy I was on holiday myself. My family was enjoying their annual two weeks in Cornwall and, of course, it was raining most of the time. I was deeply unhappy because the local cinema back home had chosen exactly those two weeks to show *The Robe* (1953), the first film made in the wide-screen system, CinemaScope, and I was dying to see it. *Vacances* was something of a compensation. I laughed until it hurt, and every time I see the film I laugh all over again.

I met Jacques Tati in America in 1972 when he was promoting his film *Trafic*. We hit it off and spent quite a bit of time together. I had the

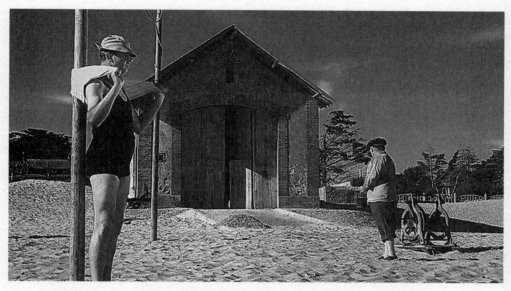

M. Hulot (JACQUES TATI) (left) dries off after a swim at the French seaside in *Vacances*.

impression that he was quite a melancholy man, despite the laughter he brought to the world. He carried with him a small notebook and made a habit of writing down any funny business he observed, sight gags that might be useful in a future film. The following year he came to Sydney and I helped him find a lawyer to retrieve the distribution rights to his films in Australia; the rights had expired many years earlier, but the films were still being exhibited without payment to Tati. One morning I had a breakfast meeting with him at the hotel where he was staying in Sydney's Macleay Street. We were looking out of the top-floor window across the street when a man in a singlet and slacks, wearing suspenders, emerged onto the opposite roof; he was accompanied by a large dog. The man stretched and yawned; so did the dog, in perfect mimicry. It was a great Jacques Tati moment, and it was duly noted down in his pocketbook.

Jacques Tati (1908–1982) was the son of Russian immigrants (his real name was Tatischeff). He rose to fame as an acrobat in the Paris music halls and made his first short film (*Oscar, champion de tennis*) in 1932. During the German Occupation he played a ghost in Claude Autant-Lara's *Sylvie et le fantôme* (1944). After directing and starring in *Jour de fête* and *Les vacances de M. Hulot*, he filmed the further adventures of Hulot in *Mon*

oncle—winner of the Oscar for Best Foreign Film of 1958—*Playtime* (1967) and *Trafic* (1971). His last film, *Parade* (1974), was a plotless series of gags made for Swedish television.

He was a perfectionist who regularly re-edited and otherwise 'improved' his films. In 1978 he re-edited *Les vacances de M. Hulot* and removed some ten minutes from the running time. Some DVDs offer both versions of this hilarious masterpiece.

38

I vitelloni

ITALY/FRANCE, 1953

Peg Films–Cite Films. DIRECTOR: Federico Fellini. 107 MINS.
FIRST SEEN: *Royal Cinema, Marble Arch, London, UK 27 January 1958.*

Italy. In a small coastal town, five men aged about 30 hang out together. They are jobless and mostly live with family members. Fausto (FRANCO FABRIZI), an amoral womaniser, is their leader; Alberto (ALBERTO SORDI) is always hungry; Leopoldo (LEOPOLDO TRIESTE) is the intellectual, a poet and would-be playwright; Riccardo (RICCARDO FELLINI, the director's brother) has a beautiful tenor singing voice; Moraldo (FRANCO INTERLENGHI) is the youngest and, as his name suggests, the most moral—he lives with his parents and sister, Sandra (ELEONORA RUFFO). On the last night of summer, Sandra is crowned Miss Mermaid of 1953, but afterwards collapses. It is revealed that she is pregnant by Fausto, whose inclination is to leave town immediately until his father (JEAN BROCHARD) forces him to stay and marry her. Marriage doesn't really change Fausto, who continues to flirt with other women, including Giulia (LIDA BAAROWA), the wife of Michele Curti (CARLO ROMANO), a kindly businessman who gives Fausto a job in his shop, where religious artefacts are sold. Leopoldo becomes excited when Sergio Natali (ACHILLE MAJERONI, in a role originally conceived for Vittorio De Sica), a famous actor, visits town and he attempts to read a play he has written to the celebrity, but the actor wants him for another, more carnal purpose. Humiliated by her husband's affairs, Sandra leaves home with their baby and the friends search all night for her. She is found at the home of her father-in-law, who beats Fausto with his belt. While his four friends are asleep, Moraldo leaves town by train, without telling anybody that he is departing for good.

The credits of *I vitelloni* are placed over a scene of the five friends singing a drunken song as they stagger through the empty streets of the unnamed town at dawn. The unseen narrator then introduces the five *vitelloni*, close friends who are bored with life ('This town's dead in the water'). They talk aimlessly about visiting Africa or India, they wish they could have dates with Esther Williams or Ginger Rogers—anything to escape the boring reality they actually inhabit. Although he has impregnated Sandra, Fausto is first seen aggressively flirting with a contestant at the Miss Mermaid

contest, but she brushes him off. A thunderstorm drenches everyone as they celebrate the event ('It's like the end of the world!') and the confusion and chaos that follow are superbly handled by the director.

The wedding of Fausto and Sandra is a simple, rather sad affair—no bridal gown is worn—and the 'happy' couple head off by train to honeymoon in Rome. The railway station is a symbol of escape—the final scene of the film takes place on the platform. The return of the bride and groom a couple of weeks later is staged on the main street; Fausto demonstrates to his friends a gramophone he's acquired, and he and Alberto dance to a mambo. Fausto becomes a very reluctant employee at the shop owned by Michele Curti, a friend of his father-in-law. He is a seriously faithless husband; while taking Sandra to the cinema he plays footsie with the woman sitting next to him (ARLETTE SAUVAGE) and follows her into the street when she leaves. At the annual fancy-dress ball, he even flirts with Signora Curti, which causes him to be fired ('I pity you,' Curti tells him. 'I pity your poor wife even more'). While the hapless Leopoldo is anxiously reading his play to the clearly disinterested Natali in a trattoria, Fausto is coming on to one of the actors from the old man's company and, indeed, spends the night with her, an act of infidelity that leads to Sandra's departure. Alberto, meanwhile, is troubled because his sister, Olga (CLAUDE FARELL), is having an affair with a married man.

The film's last scene foreshadows the conclusion of *La dolce vita* made six years later. Moraldo, who is generally considered to be the Fellini surrogate, is leaving town; at the station he is farewelled by a young boy, Guido (GUIDO MARTUFI), who works there. Guido represents innocence and possibility, just like the young woman who unsuccessfully invites Marcello (MARCELLO MASTROIANNI) to join her at the end of *La dolce vita*. The Fellini-like character Mastroianni plays in *Otto e mezzo/8½* (1963) is also called Guido.

Although it is usually assumed to be set in Rimini, Fellini's home town, *I vitelloni* was not filmed there; shooting took place in the winter of 1952–1953 in Florence, Viterbo and Rome. It was the first Fellini film to receive international distribution, but translating the title proved a challenge. In the USA it was named *The Young and the Passionate*; in the UK, *Spivs* (or *Drones*). Current versions of the film on DVD translate the word simply as 'guys'. It has been said that the title refers to calves (veal), but it is, in fact, derived from *vidlon*, a word used in the Rimini dialect to refer to out-of-work students or youths. The film was well received everywhere: *Newsweek* magazine compared it favourably to the Oscar-winning *Marty* (1955).

I vitelloni is also often described as autobiographical, but Fellini always denied this—he was never a *vitelloni*, he claimed, and *Amarcord* (1973), also set in Rimini, was far more personal. At the 1953 Venice Film Festival no first prize (Golden Lion) was awarded; two films shared the Silver Lion—Kenji Mizoguchi's *Tales of Ugetsu* from Japan and *I vitelloni*.

Federico Fellini (1920–1993) was one of the most celebrated European directors of his era. A journalist, newspaper cartoonist and screenwriter before he co-directed (with Alberto Lattuada) his first feature, *Luci del varieta/Variety Lights* (1950), he won Oscars for *La strada* (1954) and *Notti di Cabiria/Nights of Cabiria* (1957), both starring his wife, Giulietta Masina, and again for *8½*. Personally I prefer his early films to his later, more grandiose, spectacles, the wonderful *Amarcord* (1974) and *Ginger e Fred* (1985) excepted. His fascination for the tawdrier aspects of show business, amply demonstrated in *I vitelloni,* became more and more dominant in his later films as did his obsession with studio-bound artificiality, which, while sometimes impressive, eventually became tiresome in such extravaganzas as *Giulietta degli spiriti/ Juliet of the Spirits* (1965), *Satyricon* (1969), *Casanova* (1976), *Citta delle donne/City of Women* (1980) and *E la*

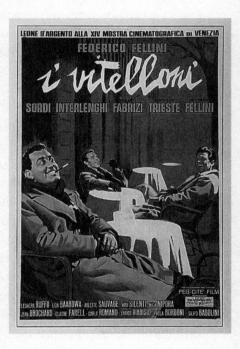

nave va/*And the Ship Sails On* (1983). *Ginger e Fred*, with Mastroianni and Masina as an Astaire and Rogers–like dance team who reunite after many years, was a robust return to form, and *Intervista* (1987) is also of great interest. His final film, *La voce della luna/The Voice of the Moon* (1989) proved disappointing.

My only personal contact with Fellini, which occurred in a toilet in the Palazzo Ducale, or Doge's Palace, in Venice in 1966 at a party following the opening of the Venice Film Festival, has been amply recorded in my 2007 memoir, *I Peed on Fellini*. The title of the book says all you really need to know about this most regrettable incident.

Bad Day at Black Rock

USA, 1954

MGM. DIRECTOR: John Sturges. 81 MINS.
FIRST SEEN: *Royal, Marble Arch, London, UK, 31 March 1958.*

October 1945. The express Streamliner train, crossing the Arizona desert, stops for the first time in four years at the tiny town of Black Rock. John Macready (SPENCER TRACY), a one-armed, smartly dressed ex-soldier, alights and quickly discovers that almost everyone he comes across is hostile towards him. These include Reno Smith (ROBERT RYAN), a local rancher; Pete (JOHN ERICSON), the hotel manager; cowboys Coley Trimble (ERNEST BORGNINE) and Hector David (LEE MARVIN); and Hastings (RUSSELL COLLINS), the station master and telegraphist. Doc Velie (WALTER BRENNAN) and Pete's sister, Liz (ANNE FRANCIS), who runs the local garage, are marginally more sympathetic; the town sheriff, Tim Horn (DEAN JAGGER) is a drunk. Constantly needled by Smith, Trimble and David, Macready succeeds in hiring a jeep from Liz and drives to Adobe Flat, where he finds a burnt-out house and an unmarked grave. Unable to leave town, and now openly threatened by Smith, Macready is provoked into a fight with Trimble and, despite his disability, easily defeats him. Pete reveals that Komoko, the Japanese-American farmer who had lived at Adobe Flat, had been murdered by Smith on the day after Pearl Harbor, and Macready explains that Komoko's son had won a posthumous medal saving Macready's life in Italy and that he had wanted to give the medal to the soldier's father. Liz offers to drive Macready out of town, but takes him into a trap set by Smith.

When it opened in cinemas in 1954, *Bad Day at Black Rock* was immediately compared to both *High Noon* and *Shane* (both 1952); the former because of the train element and the latter because Macready, like Shane, refuses for a long time to be provoked by the men who want to kill him in a fight. In fact, John Sturges' film, scripted by Millard Kaufman from a story by Howard Breslin, is quite original. From the dazzling opening shots of the very modern train speeding across the desert, and stopping at a township that appears to have no more than a dozen buildings—including the hotel, bar and grill, law office and jail, doctor's office and garage—the viewer is transported into a very different kind of western. As Reno Smith

explains: 'Historians call this the Old West; book writers, the Wild West; businessmen, the Undeveloped West. To us this is Our West. I wish they'd leave us alone.' 'Leave you alone to do what?' is Macready's response.

Smith and most of the other inhabitants of Black Rock distrust and fear strangers, and no wonder given the crime they have conspired to cover up. We know now that a significant number of Japanese-Americans had a tough time after the attack on Pearl Harbor in 1941. Smith, first seen wearing a Trump-like red baseball cap, the body of a deer roped to the bonnet of his jeep, is a quintessential American reactionary; for him, all Japanese people were 'mad dogs' and he admits that 'we're suspicious of strangers', though Macready points out that the tradition of the Old West was supposedly its hospitality.

Like *High Noon*, *Bad Day at Black Rock* can be seen as an allegory of the blacklist, a Cold War movie in which ordinary people buckle under pressure and fail to do the right thing. Made only nine years after the events it depicts, the film touched a nerve.

Spencer Tracy is a powerful presence in the leading role, and convincingly plays the one-armed protagonist. In his smart dark suit and tie and trilby hat, he stands out among the casually dressed citizens of Black Rock. He's soft-spoken and polite (offering to help Liz carry a heavy can of gas while her supposed boyfriend, Smith, stands by watching) and refuses to be riled despite the insults hurled at him (the Lee Marvin character sneeringly calls him 'Boy', a derogatory term used at the time by white people when addressing African-Americans). Ryan and his friends despise him for what they see as weakness ('He pushes too easy') so when, about 50 minutes into the film, he has finally had enough of the taunts and flattens the burly Coley, audiences around the world cheered. Robert Ryan is perfectly cast as the xenophobic Smith, bringing quiet menace to every word he says. And Walter Brennan's doctor has a lovely line in grim humour: 'The whole town fell into a sort of settled melancholy,' he explains, discussing the events of four years earlier. Describing himself as having 'the innocence of a fresh laid egg', he alone among the townsfolk sees the opportunity of a new start.

This was a relatively early CinemaScope production. CinemaScope was the anamorphic wide-screen (2:55:1) system introduced by 20th Century-Fox in 1953 and licensed to other studios including MGM. Director Sturges and cinematographer William C. Mellor use the width of the screen with particular skill; in scene after scene the film's characters are placed right across the width of the screen. One key scene, in which Smith straddles

the railway line and the other principal characters are spread out on either side of him, represents an exemplary use of a screen format that, at the time, still seemed to pose challenges for some directors. Incidentally, at the very end when the entire population of Black Rock emerges to see the Streamliner stop for the second time, we suddenly realise that the small handful of characters involved in the drama so far do not represent the town's entire population.

My first reaction to the film, when I saw it in 1958, was bafflement. This was not the fault of Sturges and his team but because of censorship. The film ends with Macready, trapped by the rifle-wielding Smith in a canyon, making a Molotov cocktail out of an empty bottle and petrol from the jeep, and hurling it—very accurately—at his enemy. The British Board of Film Censors decided that it was unwise to show cinema audiences how to make such a weapon and eliminated the entire scene. Thus, in the version of the film released in the UK in 1954, we see Smith threatening Macready with a gun and the next moment lying burnt and smouldering on the ground. No such excision seems to have been made in Australia.

John Sturges (1910–1992) was an uneven director who worked as an editor at R.K.O. and as an assistant to David O. Selznick before directing his first film, *The Man who Dared* (1946). Eight films later he scored a success with *The Capture* (1949). For the next few years he made thrillers and melo-dramas, but he was at his best with westerns, many of them memorable. They include *Escape from Fort Bravo* (1954), *Backlash* (1956), *Gunfight at the O.K. Corral* (1957), *The Law and Jake Wade* (1958), *Last Train from Gun Hill* (1959), *The Magnificent Seven* (1960) and *Hour of the Gun* (1967). He also made some very indifferent melodramas and comedies, which is why many critics at the time had reservations about him. At his best, however, he could be very impressive. His last film, *The Eagle Has Landed* (1976), proved to be, in commercial terms, one of his most successful.

40

Les diaboliques

FRANCE, 1954

Filmsonor–Vera Films. DIRECTOR: H.G. Clouzot. 116 MINS.
FIRST SEEN: *The Bristol, Birmingham, UK, 22 October 1956.*

Michel Delassalle (PAUL MEURISSE), headmaster of the rundown boys' boarding school Institute Delassalle, is an unpleasant bully who regularly humiliates both his sickly, Spanish-born wife, Christina (VÈRA CLOUZOT), and his mistress, Nicole (SIMONE SIGNORET), one of the teachers. The women plot to kill the man they've both come to hate, and devise an elaborate plan that unfolds over a long weekend. Michel is lured to the village of Niort, Nicole's home, where he is drugged and then drowned in a bathtub. The body is transported back to the school at night and dumped in the swimming pool. But the next day there is no sign of it, and a number of incidents point to the fact that Michel might not, after all, be dead.

Les diaboliques was adapted by the director, Clouzot, and three other writers from *Celle qui n'était plus (He who is No More)* by Pierre Boileau and Thomas Narcejac, who also wrote the book, *D'entre les morts* (1954), on which Alfred Hitchcock's *Vertigo* (1958) was based. Both books employ a 'twist' ending that is faithfully followed by Clouzot but subverted by Hitchcock, who disliked the whodunit format.

With the help of his brilliant cinematographer, Armand Thirard, Clouzot creates an extraordinarily unpleasant atmosphere. After an opening quote from 19th-century mystery writer Jules Barbey d'Aurevilly ('A painting is always quite moral when it is tragic and it evokes the horror of the things it depicts'), the opening credits unfold over the stagnant waters of what is soon to be revealed as the school's swimming pool.

In the early scenes, Clouzot quickly sketches in the drab setting, the uninviting classrooms, the bored boys and the gossipy, unmotivated staff. Paul Meurisse's Michel occasionally displays flashes of the charm that presumably endeared him to these two women in the first place, but his sadistic tendencies are barely suppressed. In her dark glasses and with a cigarette usually dangling from her mouth, Nicole seems like a woman attempting one last chance to improve her life. Christina, or Cricri as her husband calls her, is, on the other hand, defeated; she suffers from low

self-esteem, is clearly unwell and accepts Michel's demeaning description of her as 'a cute little ruin'.

'How have you stood [the marriage] that long?' wonders Nicole, but Christina is clearly too fragile to stand up for herself. Nicole is the strong one in this relationship; it's she who devises the diabolical plan to drown Michel in her own home—interestingly the village in which she lives, Niort, is where Clouzot was born—and to dump the corpse in the school swimming pool.

When it comes to the crunch Christina hesitates to offer Michel the drugged whisky the women have prepared for him; but the murder goes ahead without a hitch and a nosy neighbour (NOËL ROQUEVERT) even helps the women carry the laundry basket containing the corpse to their car.

But then the mystery begins. There's no sign of the corpse next day, and when the pool is eventually drained there's still no body. The suit Michel had worn on that fateful day is returned from the dry cleaners and Moinet (YVES-MARIE MAURIN), a boy given to telling tall stories, insists that the headmaster personally punished him, and confiscated his catapult, for smashing a window.

When Christina nervously goes to the local morgue to see if a corpse found in the nearby river could be Michel—it isn't—she encounters Alfred Fichet (CHARLES VANEL), a retired police officer with time on his hands. He's only too eager to start sniffing around for the supposedly missing Michel.

Famously, *Les diaboliques* has a 'surprise' ending (and the film's final title urges audiences not to be 'diabolical' and reveal it to their friends). The last half hour of the film is almost unbearably suspenseful, and even after you've seen the movie several times the skill of the direction and the excellent performances prove seductive.

On my first viewing of the film it was screened as part of a double bill together with a British film titled *X the Unknown* (1956), directed by Leslie Norman. At the time, the 'X' classification imposed by the British Board of Film Censors forbad entry of children under 16 to films so rated. All X double bills like this, in which a European film with some sensational content (usually sex) was paired with a low-budget British horror film, became quite common and were invariably huge successes at the box office.

Henri-Georges Clouzot (1907–1977) trained as a journalist and entered the industry as an assistant director and screenwriter. He directed his first feature, *L'assassin habite au 21/The Murderer Lives at Number 21*, in 1943 during the German Occupation, and followed it that same year with

Le corbeau/The Raven, a grim story of a poison-pen letter writer active in a small 'typical' French town. Like many other French films of this period, *Le corbeau* was produced by Continental, a wholly owned German company, and many French directors who made films for Continental were later accused of collaboration, Clouzot among them. As a result, his career stalled in the immediate post-war period but he recovered with another thriller, *Quai des Orfèvres* (1947), which was followed by the charming *Miquitte et sa mère* and the hard-hitting *Manon* (both 1950). In 1954 Clouzot enjoyed an international success with *Le salaire de la peur/The Wages of Fear*, a classic suspense film about desperate men driving trucks loaded with high explosives across bumpy roads in South America, although the version that originally screened in many English-speaking countries was significantly shortened from the original two-and-a-half-hour running time. After *Les diaboliques* there came a change of pace with the documentary *Le mystere Picasso/The Picasso Mystery* (1956), made with the full cooperation of the artist. *Les espions/The Spies* (1957) was a rather strange comedy-thriller and was followed by *La vérité/The Truth* (1960) in which Brigitte Bardot gave a strong performance as a woman accused of murder. In 1964, Clouzot began work on *L'enfer/Hell*, but filming had to be abandoned when the director fell ill with heart problems. It was never completed. Clouzot's final film, *La prisonnière* (1968), delved into some then-fashionable sexual fantasies and was a lesser achievement. However, on the strength of *The Wages of Fear* and *Les diaboliques* alone Clouzot must be counted as one of the great directors of suspense thrillers.

41

On the Waterfront

USA, 1954

Columbia–Horizon. DIRECTOR: **Elia Kazan**. 108 MINS.
FIRST SEEN: *Maxime Cinema, Melksham, UK 25 March 1955.*

New York. A criminal gang, led by Johnny Friendly (LEE J. COBB), runs Longshoremen's Union Local 374 on the waterfront. Friendly's thugs ensure that only men who pay kickbacks are allowed to work. Joey Doyle (BEN WAGNER), who had been talking to Crime Commission investigators, is thrown off a rooftop to his death. Ex-boxer Terry Malloy (MARLON BRANDO) meets Joey's sister, Edie (EVA MARIE SAINT), who has returned from convent school. He falls in love with her and, with the support of Father Barry (KARL MALDEN), she attempts to persuade him that the Friendly gang, which includes Terry's older brother, Charlie the Gent (ROD STEIGER), was directly responsible for Joey's death and for that of Kayo Dugan (PAT HENNING), another longshoreman. Afraid that Terry is about to 'sing', Friendly sends Charlie to get him to change his mind or kill him, and when he fails in this mission Charlie is murdered. Terry decides to testify in front of the Crime Commission. Some of his friends abandon him in the wake of his testimony, but he faces up to Friendly and, despite being badly beaten, becomes the leader of the dockworkers.

Any understanding of Elia Kazan's greatest film requires a knowledge of its background. Kazan, who had been a member of the influential Group Theatre in the 1930s and who had, for a short time, been a member of the Communist Party, had, in 1952, become the most prominent member of the entertainment industry to testify before the House Un-American Activities Committee where he agreed to name other party members he had known. Many of his former friends never forgave him for this apparent betrayal. *On the Waterfront* was scripted by Budd Schulberg, also a so-called 'friendly' witness before HUAC, and was inspired by newspaper articles by Malcolm Johnson about unrest on the waterfront. But it's pretty safe to say that crime on the docks was never as all-pervasive as it's shown to be in the film. The corrupt union is depicted like an underworld gang in a film of the early 30s (and wonderfully cast with some very tough-looking characters). Johnny Friendly is a sort of Scarface—violent, unpredictable,

powerful. And it's quite clear that Kazan and Schulberg set out to make a movie that would justify 'snitching' on former colleagues. Terry can be seen as a substitute for Kazan himself, who eventually sees the light of day and testifies before the Crime Commission, and, as a result, is boycotted by some of his closest friends, who consider him to be a stool pigeon— hence the scenes with the pigeons that Terry breeds—though he is seen as a hero by the majority. Lee J. Cobb, incidentally, was another 'friendly' witness during the McCarthy period.

Marlon Brando had been Kazan's discovery. They had worked together in the theatre and Brando came to fame, under Kazan's direction, in Tennessee Williams' play *A Streetcar Named Desire*, which opened on Broadway in 1947; subsequently Brando repeated his stage role in the 1951 film version, which Kazan also directed. Brando heard about his mentor's appearance before HUAC while on the set of Joseph L. Mankiewicz's *Julius Caesar* (1953), and when he was approached to play the ex-boxer in *On the Waterfront* he initially declined—Frank Sinatra was seriously considered as his replacement before Brando relented. Brando won one of the film's eight Oscars for the role, the others being Best Film, Director, Supporting Actress (Eva Marie Saint), Screenplay, Cinematography (Boris Kaufman), Art Direction and Editing.

Brando's performance is legendary and some of it was improvised, including the famous sequence in which he is walking across a city square with Eva Marie Saint when she drops one of her gloves; he picks it up, sits on a swing, fiddles with it, and then puts it on. None of this was in the original screenplay, but it's an exceptionally touching and revealing gesture. Terry first appears to be rather simple-minded, a 'rubber-lipped ex-tanker' and punch-drunk idler who hangs around the gang and accepts the cushy jobs they offer. But as the pressure mounts for him to make a stand ('It's like I'm carrying a monkey on my back') he gradually changes and with the change comes the realisation that his beloved brother has betrayed him; in the famous scene where the brothers sit in the back seat of a car and Charlie—a superb Rod Steiger—attempts to find out where Terry stands, Brando makes the celebrated speech: 'Remember that night at the Garden? You said, "Kid, this ain't your night. We're going for Wilson." . . . You was my brother, you shoulda looked out for me. I coulda had class. I coulda been a *contender*. I coulda been a SOMEBODY, instead of a bum, which is what I am.'

Saint, 'introduced' in the credits, is also impressive, evolving from a shy, convent-bred girl into a rebellious fighter for justice even as she finds

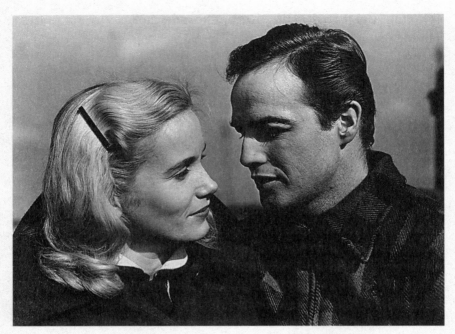

A convent girl (EVA MARIE SAINT) and a former boxer (MARLON BRANDO) find common ground in *On the Waterfront*.

herself falling in love with a man who may have lured her brother to his death. Malden's pugnacious priest brings with him the film's flashes of Christian symbolism (rising from the bowels of the ship after the death of Kayo), while Cobb's fearsome Friendly, whose real name turns out to be Michael J. Scully, is in the great tradition of movie gangsters.

Apart from the acting and the gutsy screenplay, what sets *On the Waterfront* apart is the location photography; Kaufman's work is brilliant—it's intriguing to note that he was born in Russia and that his brother, Dziga-Vertov, was one of the pioneers of Soviet cinema. Also intriguing is a very brief scene during the television hearings of the committee: a businessman, sitting with his back to camera, is watching the proceedings and smoking a cigar. When a manservant approaches him, his employer instructs him, 'If Mr Friendly calls, I'm out.' This is, presumably, Mr Big—but Kazan and Schulberg, tantalisingly, provide no more details.

Elia Kazan (1909–2003) was born in Constantinople (now Istanbul) of Greek parents. He came to the USA as a child with his family and became an actor and, as noted, a very important stage director. His first film, *A Tree*

Grows in Brooklyn (1945), was followed by the enthralling docu-drama *Boomerang!* and the worthy but stodgy *Gentleman's Agreement* (both 1947). *Panic in the Streets* (1950), a fine, location-shot thriller, was followed by *Viva Zapata!* (1952), about the Mexican revolutionary Emiliano Zapata, played by Brando with a screenplay by John Steinbeck. Kazan was responsible for encouraging and promoting many talented actors, including James Dean, whose first starring role was in Kazan's *East of Eden* (1954), and Warren Beatty, who came to prominence in *Splendor in the Grass* (1961). *America, America* (1963) was an autobiography and *The Arrangement* (1969) was adapted from the director's own novel. His final film, *The Last Tycoon* (1976), was based on F. Scott Fitzgerald's unfinished novel and starred Robert De Niro. His 1988 autobiography, *A Life*, is extremely candid and exceptionally informative.

I met Kazan only once and under less than optimal circumstances. His then wife, Barbara Loden, had directed her one and only feature film, *Wanda* (1970), which screened in competition at Venice that year. I admired the film and sought to invite it to the Sydney Film Festival. When I went to meet with Loden at her hotel, Kazan opened the door to me. He seemed uncomfortable with the fact that he was not the centre of attention. I would, of course, have loved to talk to him about his illustrious career, but it was just not the right moment, something I've always regretted.

42

Seven Samurai
(*Shichinin no Samurai*)

JAPAN, 1954

Toho. DIRECTOR: **Akira Kurosawa**. 206 MINS (INCLUDING 5 MIN INTERMISSION).
FIRST SEEN (IN 155 MIN VERSION): *Bournville Film Society, Birmingham, UK 16 April 1957.*

Japan, the early 16th century—a chaotic period in which civil war has led to poverty and violence. A gang of marauding bandits regularly attacks villages to steal crops and rape women. A group of impoverished farmers seeks advice from the village elder and decides to try to recruit samurai (warriors) to protect them, but because they are so poor, they can only hire samurai who are desperate. A delegation is sent to a nearby town where they witness Kambei (TAKASHI SHIMURA), posing as a priest, rescue a kidnapped child. He agrees to help them and assists in the recruitment of five others: Katsushiro (KO KIMURA), a young man and eager disciple; Shichirōji (DAISUKE KATŌ); Gorobei (YOSHIO INABA); Heihachi (MINORU CHIAKI); and Kyūzō (SEIJI MIYAGUCHI). A seventh man, Kikuchiyo (TOSHIRO MIFUNE), a half-crazed braggart with aspirations to become a samurai, tags along uninvited. After overcoming the concerns of the villagers (who fear for their wives and daughters), the seven prepare for the bandit raids. After the final battle the bandits have been vanquished, but only three of the samurai survive.

This monumental epic was the first Japanese film I ever saw. It is unquestionably extremely accessible because of its obvious affinities with the American western, and it was duly remade by John Sturges in 1960 as *The Magnificent Seven*. What is instantly impressive is the reality and ferocity of the battle sequences that occupy the final hour or so of the film, with the decisive battle taking place in driving rain and on ground that has turned into slippery mud. The bandits, some with primitive but very effective rifles, gallop furiously into one ambush after another, and when one falls from his horse he is hacked to pieces by the villagers. No Hollywood film of the period would have depicted such savagery. Full credit goes to the astonishingly immediate cinematography by Asaichi Nakai and the editing by Kurosawa himself. Multiple cameras were used

to shoot scenes from a number of angles, and long-distance lenses were also employed, bringing the action very close to the camera. It is, however, a shame that the film was made just before wide-screen cinematography arrived in Japan; Kurosawa's subsequent films in the Scope ratio reveal he was a master of the new screen format. The brisk editing and jump cuts also foreshadow the films of early Jean-Luc Godard.

But the film is far more than a series of brilliantly staged battles. Kurosawa and his fellow screenwriters, Shinobu Hashimoto and Hideo Oguni, examine in some detail the gulf between the impoverished farmers, who desperately need help, and the 'noble' samurai, even though the six featured in the film (the seventh, played with tremendous gusto and athleticism by Toshiro Mifune, is only pretending to be a samurai) are so reduced in circumstances that they are willing to accept the modest offer of the villagers. The first 65 minutes or so of the film are taken up with establishing the basic plot and introducing the seven, especially their leader, played with Zen-like serenity and a soft smile by Takashi Shimura, one of Kurosawa's favourite actors. Forever stroking the top of his head (which he had shaved so that he could pose as a priest to overcome the kidnapper), Kambei is a formidable figure. Mifune's rambunctious Kikuchiyo is his polar opposite, but ultimately the men come to respect one another. It is Kikuchiyo who points out that if the villagers are basically untrusting of the saviours they've hired, it's because they've had bad past experiences with other itinerant warriors.

When the seven first arrive in the windswept, dusty village there's no one around; the villagers wanted their help but are afraid of them. Kikuchiyo uncovers a stash of armour, presumably taken from samurai the villagers have, in the past, succeeded in killing. Manzo (KAMATARI FUJIWARA) tells his beautiful daughter, Shino (KEIKO TSUSHIMA), to cut her hair and dress like a boy; when he discovers that she's slept with Katsushiro his first reaction is to beat her for the disgrace she's brought on him.

And in the famous ending, with only three samurai left alive, Kambei, standing before the graves of the four who have died, accepts that 'Again we're defeated. The winners are the farmers—not us.' The suggestion is that Katsushiro will stay on in the village with Shino, but for the other two the future remains uncertain.

In the West, *Seven Samurai* premiered in a shortened version at Venice in 1954, where it won the Silver Lion. The two-and-a-half-hour version shown outside Japan attempted to tighten the film's leisurely pace and cut

to the chase; despite or because of that, it was widely admired and became an art-house favourite. The integral version finally became available with the arrival of a restored DVD.

Kurosawa was, in the West, the most prominent of the great Japanese directors of the country's golden age of cinema, a richly talented movement that more or less ran parallel with Hollywood's golden age. Admirers of Japanese cinema also relish the family dramas of Yasujiro Ozu, the elegant period dramas of Kenji Mizoguchi and the portraits of women brought to the screen by Mikio Naruse, among many others.

Akira Kurosawa (1910–1998) was an artist and writer before directing his first film, *Sugata Sanshirō/Judo Saga* (1943). He made several interesting films before his international breakthrough, *Rashōmon*, won the Golden Lion in Venice in 1950. Thereafter he alternated films set in modern times (like the great *Ikiru/Living*, 1952, in which Takashi Shimura plays a dying public servant) with period films, the latter including loose Shakespeare adaptations (*Throne of Blood*, 1957, from *Macbeth*; *Ran*, 1985, from *King Lear*) as well as *The Hidden Fortress* (1958), which George Lucas has said was an inspiration for *Star Wars* (1977). *Yojimbo* (1961), with Mifune as a wandering samurai, was unofficially remade by Sergio Leone as *Per un pugno di dollari/A Fistful of Dollars* three years later. It was followed by an equally entertaining sequel, *Sanjuro* (1962), and by *High and Low* (1963), which was based on an American crime book by Ed McBain. Kurosawa's first film in colour, *Dodes'ka-den* (1970), which he personally produced, was a box-office failure after which he had difficulty financing his increasingly expensive productions. The Oscar-winning *Dersu Uzala* (1975) was made in the Soviet Union and the epic *Kagemusha* (1980) was produced with the help of Francis Ford Coppola. His final film, *Madadayo,* was released in 1993.

I met Kurosawa on several occasions, in Tokyo, Moscow and New Delhi. He was a tall man who spoke softly but with a quiet passion. In 1971 I negotiated with him to attend the Sydney Film Festival as a special guest but, unfortunately, illness led to the cancellation of his visit. In 1977 I joined him, Indian director Satyajit Ray and Italy's Michelangelo Antonioni on a tour of the Taj Mahal. In the summer of 1985 my wife and I attended the world premiere of *Ran* in Tokyo in the presence of the Crown Prince and an audience of film notables from around the world. Kurosawa himself was not in attendance (he was reportedly unwell) but the following day he played host to friends and media, clearly exhausted by the preparations entailed in bringing one of his finest films to the screen.

43

A Star is Born

USA, 1954

Warner Bros–Transcona Enterprises. DIRECTOR: George Cukor. General release running time: 154 MINS. Reconstructed version (1983) running time: 176 MINS.
FIRST SEEN: *Regal Cinema, Trowbridge, UK 28 June 1955.*
FIRST SEEN RECONSTRUCTED VERSION: *Odeon, Leicester Square, London, UK 27 November 1983.*

Hollywood. Alcoholic movie star Norman Maine (JAMES MASON) interrupts a Motion Picture Relief Benefit concert at the Shrine Auditorium but singer Esther Blodgett (JUDY GARLAND) stops him making a fool of himself. Later that night he hears her sing at a small supper club and tells her she could be a star. He advises her on her appearance and make-up, and intercedes on her behalf with studio head Oliver Niles (CHARLES BICKFORD). She is cast in a musical, *A World for Two*, which, when sneak-previewed together with a Norman Maine film, *Another Dawn*, is hugely successful with the audience. The studio renames her Vicki Lester. Esther and Norman marry and move to a beachside house in Malibu, but Niles is forced to cancel Norman's contract with the studio. Norman goes on drunken binges and, on the night Esther wins a Best Actress Oscar, makes an impromptu speech asking for work, during which he accidentally slaps her. Later, after he is arrested for being drunk and disorderly and resisting arrest, a judge places Norman in Esther's care. She decides to retire to look after him, but Norman, overhearing this commitment, drowns himself. A year after they first met, Esther attends the benefit and introduces herself as Mrs Norman Maine.

The genesis for *A Star is Born* was really a 1932 film, directed by George Cukor, titled *What Price Hollywood?* Five years later, a very similar story, titled *A Star is Born*, was directed by William A. Wellman, with Janet Gaynor and Fredric March in the leading roles. The 1954 version, by far the best of the four 'official' films based on this story, marked a triumphant comeback for Judy Garland four years after she had been dropped by MGM, the studio that had made her a child star back in the 1930s; her then-husband, Sidney Luft, produced the picture. Garland is quite magnificent, not only in her performance of a number of Howard Arlen–Ira Gershwin songs, most notably 'The Man That Got Away' and 'A New World', but also in the dramatic scenes in which her depiction of a woman torn apart with

misery because the husband she loves is an alcoholic is achingly effective. She deserved to win the Oscar for this performance, and it's one of Hollywood's great shames that she didn't (it went that year to Grace Kelly playing against type in *The Country Girl*; *A Star is Born* wasn't even nominated for Best Picture).

The other great performance is that of James Mason. No other actor at the time could have given that performance—Laurence Olivier might have come close. Mason allows us to experience the charm of Norman and what made him a superstar, but also the flashes of temper, the vanity and, in the end, the heartbreak. It is his finest screen performance (he lost to Marlon Brando for *On the Waterfront* in the Oscar race).

Cukor's direction is masterly. He was the first director to use the relatively new CinemaScope format well in his dynamic staging of both the musical numbers and the dramatic scenes—such as the Oscar banquet in which a black and white TV on the far right of the screen mirrors the events on stage. Like *Singin' in the Rain* (1952), *A Star is Born* opens spectacularly with a big Hollywood event; it closes with the same event a year later, a year in which Esther, a singer with one of the bands performing on stage at the beginning, has been transformed into Vicki, a movie star, and Norman, a famous movie star, has become a drunk and a has-been. Many such stories actually happened in the movie capital, of course, which makes this story all the more poignant.

The musical numbers vary from the intimate (Esther performing her studio routine at home for Norman when he's unemployed) to the elaborate (the 15-minute 'Born in a Trunk' show stopper, designed by Irene Sharaff).

As a portrait of Hollywood in 1954 the film has many insights. There are scenes in the publicity department, overseen by Jack Carson's vengeful Libby—a truly despicable character who harbours a growing resentment against Norman for all the humiliations he has received at his hands over the years—as well as on the sound stages (Esther's first 'acting' job is waving through a train window in a snowstorm as the director warns her that her face must not be seen), the make-up department, the back lot peopled by dozens of extras in costume and the projection rooms. Esther first learns her name has been changed to Vicki Lester when she goes to receive her pay cheque and is ordered to report to window L.

The original running time didn't survive much longer than the film's initial runs in New York and Los Angeles, after which about half an hour was removed. In 1983, thanks to the work of Ron Haver, a film authority,

a reconstructed version was premiered that included a previously deleted musical number ('Lose That Long Face') in which Garland looks very much like her daughter, Liza, in later years; a scene in which a boom mike records Norman's proposal of marriage to Esther; a ten-minute sequence that takes place the morning after Norman's promise to find Esther work at the film studio—he is drunk and is packed off to a movie location at sea; and a short scene in which Esther is taken ill while Norman is driving her to the preview of her film. For the latter two sequences Haver was able to locate the soundtrack but not all of the footage—the images we see in the restored version consist of black and white production stills from Cukor's own collection.

Following the London premiere of the reconstructed version, I attended a reception where I talked to James Mason—whom I'd met previously in Australia while he was making *Age of Consent* in 1968. He was unwilling to rate his performance in the film highly, mainly, it seemed, because the experience of making it was far from happy—Garland's habitual lateness on the set being a major bone of contention.

George Cukor (1899–1983) directed plays on Broadway before turning to movies at the start of the sound era; he co-directed his first film, *Grumpy*, in 1930. He became known as a 'woman's' director because of the great work he did with Katharine Hepburn (*A Bill of Divorcement*, 1932; *Little Women*, 1933; *The Philadelphia Story*, 1940; *Adam's Rib*, 1949), Greta Garbo (*Camille*, 1936), Joan Crawford (*The Women*, 1939; *A Woman's Face*, 1941), Ingrid Bergman (*Gaslight*, 1944), Judy Holliday (*Born Yesterday*, 1950; *It Should Happen to You*, 1953) and Maggie Smith (*Travels with my Aunt*, 1972). It was because of this reputation as a woman's director that Clark Gable allegedly had him fired from *Gone with the Wind* (1939) after a few days' shooting. Yet the male actors in his films had nothing to complain about: Ronald Colman deservedly won an Oscar for playing an actor in the powerful backstage drama, *A Double Life* (1947). Cukor was also noted for his intelligent adaptations of novels, including *David Copperfield* (1935), one of the best Dickens adaptations to have emanated from Hollywood, and stage productions (*My Fair Lady*, 1964). He made his last film, *Rich and Famous*, in 1981.

44

The Night of the Hunter

USA, 1955

United Artists–Paul Gregory Productions. DIRECTOR: Charles Laughton. 92 MINS.
FIRST SEEN: *Birchfield Cinema, Perry Barr, Birmingham, UK 3 April 1957.*

Rural Ohio, the 1930s. Harry Powell (ROBERT MITCHUM), who poses as a preacher, is a serial killer whose 12 victims to date have all been rich widows. Arrested for stealing a car, he finds himself in the same prison cell as Ben Harper (PETER GRAVES), who has been convicted for murder after robbing a bank and killing two guards. Harper has hidden the $10,000 he stole in a doll belonging to his small daughter, Pearl (SALLY JANE BRUCE), and has sworn Pearl and her older brother, John (BILLY CHAPIN), to secrecy. After Harper's execution, Powell travels to Precept's Landing, the small town on the Ohio River where Harper lived, and ingratiates himself with the susceptible Willa Harper (SHELLEY WINTERS). Though John is hostile towards the preacher, Willa marries Powell. On their wedding night he rejects her ('That body was not made for the lust of men!') and when Willa discovers that Powell has been quizzing the children over the whereabouts of the hidden money, he stabs her to death and disposes of her body in the river. Next morning he claims that she has run away. That night the children escape in a skiff and row up the river, pursued by Powell on horseback. They're given shelter by Miss Cooper (LILLIAN GISH), a single woman who cares for orphaned children. Powell turns up at Miss Cooper's house, but she scares him away and the police arrest him.

Next to *Citizen Kane* (1941), *The Night of the Hunter* is the most exceptional and original directorial debut in the history of cinema. It is all the more regrettable that its commercial failure ensured that it was the only film Charles Laughton ever directed. Based on a novel by Davis Grubb, himself an Ohioan, and adapted for the screen by James Agee, the film is remarkable in many ways. The combination of gothic horror and spiritual grace is, to say the least, unusual, but most of all the film succeeds in seeing its characters from the distorted viewpoint of two frightened children.

The credits are printed against a starlit sky, and as they end the image of Miss Cooper appears in the foreground. Speaking directly to the audience as if they were small children, she talks about Jesus on the Mount

blessing the pure of heart—'And I know you won't forget Judge Not Lest Ye Be Judged.' The image changes to an overhead shot of the Ohio River and a small town where a group of boys discover a woman's body in a shed: the camera moves in towards the woman's legs and then retreats (as Miss Cooper continues her sermon—'A good tree cannot bring forth evil fruit, neither can a corrupt tree bring forth good fruit—wherefore by their fruits ye shall know them'). At this point Powell is seen driving his stolen car into town, talking to God ('I'm on my way to go forth and preach your word'). As he drives past a cemetery he continues: 'I wonder if you really understand. Not that you mind the killings. Your book is full of killings. But there are things you *do* hate: perfumed things, lacy things, things with curly hair,' and at this point the scene changes to a burlesque theatre where a grim-faced Powell is watching a scantily clad burlesque dancer—the image is framed like a keyhole—and he flicks open the switchblade knife he keeps in his pocket (a clear and disturbing metaphor for an erection).

The film continues in this way, wasting no time, with one brilliant sequence after another. Mitchum's Powell is a true monster, clearly insane, given to animalistic noises, yet posing as a Man of God, a member of a religion that, as he says, 'the Almighty and me worked out betwixt us'. It was this, no doubt, that got *The Night of the Hunter* banned in Australia for blasphemy, a ludicrous ban that lasted many years and denied cinemagoers one of the great films of the 1950s.

There are major contributions from master cinematographer Stanley Cortez, who had photographed Orson Welles' *The Magnificent Ambersons* (1942), and Hilyard Brown, whose production design is stylised and expressionistic. The film is filled with adventurous imagery, distorted perspectives, shadows and impossible angles as Laughton boldly mixes genres and moods.

Five years before audiences were shocked that a big-name star, Janet Leigh, was stabbed to death before the movie was halfway over in *Psycho*, Shelley Winters meets a similar fate just 40 minutes into this 92-minute film. And at the 57-minute mark the mood changes dramatically from suspense thriller—as the Hunter pursues the fleeing children—into a kind of nightmare fairytale as the boy and girl float down the moonlit river watched over by night creatures: a fox, an owl, a pair of rabbits, a frog, a spider in its web. Prior to this we have seen, through the eyes of John's unreliable friend, Uncle Birdie (JAMES GLEASON), the body of Willa, her throat cut, tied to the seat of the car in which she supposedly drove away, at the bottom of the river with river weeds floating past her—one of the most

haunting images in cinema. Incidentally, Gleason replaced the original actor cast as Birdie, Emmett Lynn, who, after a couple of days' shooting, was deemed unsuitable.

Innovative, too, is the unusual depiction of the hangman, Bart (PAUL BRYAR), who is first seen checking on his sleeping children when he returns home after he has executed Harper. Later in the film we see him happily announcing that 'this time it'll be a privilege' when he knows he is to hang Powell. Willa's friends, the eccentric Spoons (DON BEDDOE, EVELYN VARDEN), also undergo major changes; they are introduced as amiable but foolish small-town gossips but later we see them leading a lynching party.

The other key figure is that of Rachel Cooper, the Bible-quoting, kindly woman who cares for little children. 'My soul is humbled when I see the way little ones accept their lot,' she says to herself. 'The wind blows and the rain's cold yet they abide. They abide and they endure.' In 1969, Lillian Gish told me that in 1954 it was brought to her attention that Laughton was at the Museum of Modern Art watching the silent films she had made for D.W. Griffith. She went to meet him at MOMA and he told her that audiences used to 'sit up in their seats' to watch those pioneering films: his aim, he said, was to get people to sit up again. He cast Gish as Miss Cooper as a tribute to Griffith.

Sadly, *The Night of the Hunter* was misunderstood by most critics and generally dismissed in 1955. As a result, Laughton's plans to direct a screen version of Norman Mailer's novel *The Naked and the Dead* were permanently shelved.

Charles Laughton (1899–1962), who was born in Scarborough, Yorkshire, was an actor with a considerable reputation. During the 1930s, in a string of popular films including *The Sign of the Cross* (1932, in which he played Nero), *The Private Life of Henry VIII* (1933), *Ruggles of Red Gap* (1934), *Mutiny on the Bounty* (1935, as Captain Bligh), *Les Misérables* (also 1935, as Javert) and *Rembrandt* (1936), he had been highly regarded as a versatile character actor. But a string of lesser films, including the woeful *Abbott and Costello Meet Captain Kidd* (1952), had diminished his reputation, though his appearance in David Lean's fine comedy *Hobson's Choice* (1953) had somewhat restored it. It's sad that he was unable to direct another film after a masterpiece like *The Night of the Hunter*.

45

Attack

USA, 1956

United Artists–The Associates and Aldrich Co. DIRECTOR: Robert Aldrich. 108 MINS.
FIRST SEEN: *Odeon, Birmingham, UK 28 November 1956.*

Belgium, 1944. In a village recently occupied by the Germans, Fox Company is under the command of Captain Erskine Cooney (EDDIE ALBERT), a flaky, unreliable officer. A company platoon is slaughtered by German forces when it receives no support from base. Lieutenant Joe Costa (JACK PALANCE), who has a low opinion of Cooney, is sceptical when Lieutenant Harry Woodruff (WILLIAM SMITHERS), the company's second-in-command, promises to make a complaint about Cooney to Colonel Clyde Bartlett (LEE MARVIN). The scepticism proves justified, because Bartlett and Cooney are both from the same Southern town of Riverview, where Cooney's father is a judge; Bartlett, who has political ambitions, is not about to embarrass an important patron by demoting or disciplining his son. He assures Woodruff that he has it 'from the top' that it is '100 to 1 that we'll never see combat again', but no sooner has this assurance been made than Fox One is sent to occupy the village of La Nelle, without being told whether there are German forces there. Costa confronts Cooney, swearing that 'if I lose just one man on account of you you'll never see the States again'. Germans are, in fact, present in La Nelle in force and only five of the 40-strong patrol, led by Costa, make it to a farmhouse on the edge of the village. Despite repeated requests, no support is forthcoming. The men withdraw and all but one make it back to the village, which itself is now under attack from German tanks. Costa destroys one tank but is trapped in a doorway and partly crushed by another tank. He struggles back to the basement where the survivors, including Cooney, are hiding, but dies before he can avenge himself on Cooney. Woodruff kills Cooney as he prepares to surrender to the Germans.

Based on a play, *The Fragile Fox* by Norman Brooks, *Attack* is by any standard a powerful indictment of corruption in the officer class of the US military. Arguably Stanley Kubrick's *Paths of Glory*, made the following year, is even more scathing about the officer class—but that was set in World War I and featured officers in the French army (and, indeed, was

banned in France for several years); *Attack* is far more confrontational. Robert Aldrich, always a hard-hitting director, pulls few punches. The enlisted men that are portrayed in the film are heroic and resourceful, but the officers are morally bankrupt, self-serving, manipulative, loud-mouthed monsters. Cooney, in Eddie Albert's fine portrayal of cowardice and stupidity, is totally unfit to command Fox Company; he's there only because Colonel Bartlett is currying favour with his father (as Bartlett himself admits). 'He always wanted a son,' he says, disdainfully, 'and now I'm trying to give him one.' But Cooney, an alcoholic with a stash of fine bourbon and seemingly endless supplies of cigars, is incapable of leading his men; he knows it, Bartlett knows it and the men know it—when he attempts to press a drink on Sergeant Tolliver (BUDDY EBSEN), the sergeant rejects the offer with a withering putdown: 'Where I come from we don't drink with another man unless we respect him.' Cooney is truly pathetic: near the end he decides to surrender to the Germans despite the fact that one of the survivors of his Company, Bernstein (ROBERT STRAUSS), is Jewish. However, Bartlett is the film's real villain because he knows exactly what he's doing. As Woodruff tells him after he has shot Cooney, 'I may have pulled the trigger, but you aimed the gun.' In the end you feel some sympathy for the wretched captain; when Bartlett tells him 'If you foul up, I'll crucify you,' his pathetic response is 'I couldn't care less.'

The film's origins as a play, despite a generally fine adaptation by James Poe, are obvious at times. There's a good deal of forthright dialogue and a small handful of sets, principally the village town hall being used as the Fox Company HQ, the farmhouse where the survivors of the platoon wait in vain to be relieved and the cellar where the final drama unfolds. But the battle scenes are vigorously and convincingly handled, and the scene in which an unarmed Costa confronts a German tank is truly terrifying. Jack Palance, always an intense actor, gives one of his finest performances here. The closing scene in which Costa's body, his face rigid in death with his mouth agape, is chilling. Perhaps Woodruff's noble decision to report Bartlett to his superior officer is not, in the circumstances, entirely convincing—but presumably this was a price that had to be paid to ensure that the challenging film passed by the Production Code.

The film contains a notable amount of religious symbolism; Costa's apparent death and resurrection, only to die once again, is just one example of this. It also has some insights into American attitudes to the war: while trapped in the farmhouse, Private Ricks (JIMMY GOODWIN) asks of the Germans

besieging them, 'Why do they hate me? I'm an American—*they're* the enemy.' It's typical of a film of this period that, in the scene in which two Germans, an SS officer (PETER VAN EYCK) and an enlisted man (STEVEN GERAY), are found hiding in the cellar of the farmhouse there is no translation of the fair amount of German spoken. Subtitles just weren't used in this sort of scene in the 1950s, and anyway it's pretty easy to understand what's being said.

Incidentally, although the ads for the film and almost every review and article written about it follow the title with an exclamation mark (*Attack!*) no such punctuation appears when the title appears on the film itself.

Robert Aldrich (1918–1983) worked as an assistant to many important directors—among them Chaplin, Wellman, Renoir and Zinnemann—before making his first film, *The Big Leaguer*, in 1953. Like many other filmmakers of his generation he tackled a variety of genres with considerable skill, especially thrillers (*World for Ransom*, 1953; *Kiss Me Deadly*, 1955; *Whatever Happened to Baby Jane?*, 1962; *Hush Hush Sweet Charlotte*, 1964; *The Grissom Gang*, 1971; *Hustle*, 1975) and westerns (*Apache* and *Vera Cruz*, both 1954; *The Last Sunset*, 1961; *Ulzana's Raid*, 1972). His other war films included *The Dirty Dozen* (1967) and *Too Late the Hero* (1969). His political thriller, *Twilight's Last Gleaming* (1976), one of four films he made with Burt Lancaster, is one of the most interesting and downbeat Cold War movies ever to have been made in Hollywood—except that, unable to fund it in America, Aldrich made it in Germany. His last film, *All the Marbles*, was made in 1981.

Invasion of the Body Snatchers

USA, 1956

Allied Artists–Walter Wanger Productions. DIRECTOR: Don Siegel. 80 MINS.
FIRST SEEN: *The Bristol, Birmingham, UK 11 November 1956.*

Santa Mira, California. Recently divorced Dr Miles Bennell (KEVIN MCCARTHY) returns to his home town after attending a medical convention to find that some of his patients are behaving strangely. Jimmy Grimaldi (BOBBY CLARK) flees from his mother, crying out that 'she isn't my mother—don't let her get me!' Wilma Lentz (VIRGINIA CHRISTINE) claims that her Uncle Ira (TOM FADDEN), a 'typical' pipe-smoking, lawn-mowing small-town citizen, is not her uncle ('There's something missing. There's no emotion'). Wilma's friend, Becky Driscoll (DANA WYNTER), recently returned from London and newly divorced, was once Miles' sweetheart, and they commence a new relationship. Their friends, author Jack Belicec (KING DONOVAN) and his wife Teddy (CAROLYN JONES), seek Miles' help when a strange body, looking something like Jack, is found on their pool table. Gradually, Miles realises that 'something' is taking over the people of the town and robbing them of their emotions. Becky's father, Stanley (KENNETH PATTERSON), is also a victim, as is the town's psychiatrist, Dr Dan Kaufman (LARRY GATES). Jack and Teddy leave to get outside help; Miles and Becky hide out in Miles' office.

Next morning from the window they see the townspeople gather to receive the pods from which the duplicate creatures hatch. Jack turns up with Kaufman; he and Teddy have been 'replaced'. Miles and Becky overcome them and flee into the hills, but Becky falls asleep and her body is taken over. Miles tries to seek help and tells his story to two doctors, Hill (WHIT BISSELL) and Bassett (RICHARD DEACON).

In 1956, America was beginning to emerge from the damaging McCarthy era, but there was still plenty of paranoia around as is indicated by the considerable number of movies involving space invaders and creature mutations. *Invasion of the Body Snatchers*, one of the finest and most intelligent of this significant group of films that reflect a national fear of 'the other', is based on a short story by science fiction writer Jack Finney and is superbly adapted by Daniel Mainwaring—a writer who had narrowly avoided being blacklisted—into a troubling treatise on political conformity and hysteria.

Dr Miles Bennell (KEVIN MCCARTHY) confronts a pod from outer space in *Invasion of the Body Snatchers*.

At the time it was released, many saw *Invasion of the Body Snatchers* as a blacklist allegory, but today it could equally be seen as a story about a sinister virus that comes out of nowhere and decimates the population of a small community.

The story is told in flashback as a deeply agitated Miles Bennell, who has found his way to an emergency clinic somewhere in California, is telling his story to Dr Hill from the State Mental Hospital. Miles explains as the flashback begins that for him it started with the patients who mysteriously believed that family members were not genuine. The mystery deepens with the discovery of the 'body' that so closely resembles Jack, and the gradual realisation that something is terribly wrong and that more and more 'ordinary' citizens have been taken over by the horror. Indeed, the very fact that the evil stems not from a traditional movie monster but from the ordinary citizens—police officers, a doctor, a storekeeper, utility workers—of a 'typical' small town makes it even more chilling. Dr Kaufman describes what's happening as 'an epidemic of mass hysteria', but he's soon proved to have been one of the first to be taken over; actor Larry Gates is thoroughly convincing as this vaguely sinister pillar of the Establishment. Later on he explains to Miles and Becky what's happening: 'Less than a month ago people had nothing but problems. Then, out of the sky, came a solution— seeds drifting through space took root in a farmer's field.' Out of these seeds

came pods that duplicated human beings and took over their bodies and their memories but not their emotions: 'You'll be reborn into an untroubled world,' he enthuses. 'Where everyone's the same?' asks Miles. And in this new world there's no need for love. 'Love never lasts,' says Kaufman. 'Love, desire, ambition, faith—without them life is so simple.'

The film, then, has plenty to say, both about the human condition, and about America at the height of the Cold War. Producer Walter Wanger, one of the more ambitious independents—who had worked with John Ford, Alfred Hitchcock and Fritz Lang—cast little-known actors in the key roles. Kevin McCarthy had mostly played supporting parts; German-born Dana Wynter, who had grown up in England and had appeared in small roles in several British films, was featured in only her second American film. One of the bit players deserving of mention is future director Sam Peckinpah who appears in just one shot as Charlie, the gas man who plants a pod in Miles' cellar.

The film is so very effective that it's little wonder it became a cult success. In 1978, Philip Kaufman made a remake/sequel, set in San Francisco, that employed some creepy sequences of bodies popping out of the pods (an effect that wasn't quite so successful in Siegel's film). In Kaufman's film Siegel himself makes an appearance, as a treacherous taxi driver, and Kevin McCarthy, in a clever in-joke, seems to be playing the same character he did in the original film, still yelling dire warnings to an unheeding populace 22 years later. Abel Ferrara made a version (*Body Snatchers*, 1993) and there was an even stranger version, *The Invasion* (2007), made by Oliver Hirschbiegel, the German director who had come to the world's attention with the Hitler film *Downfall/Der Untergang* in 2004. In Hirschbiegel's version Dr Bennell is played by Nicole Kidman, Daniel Craig plays Ben (not Becky) Driscoll and there are car chases and shootings and a happy ending in which the virus is cured—all palpably ludicrous.

Donald (Don) Siegel (1912–1991) was born in Chicago but educated in Britain and studied acting at RADA (Royal Academy of Dramatic Art). In Hollywood he became a film editor and director of montage sequences for films including *A Tale of Two Cities* (1935), *Casablanca* and *Across the Pacific* (both 1942). After directing some short films he made his feature debut with *The Verdict* (1946) and then quickly established a reputation as a consummate practitioner of genre cinema, being equally at home with thrillers (*Count the Hours*, 1953; *Private Hell 36*, 1954; *Crime in the Streets* and *Baby-Face Nelson*, both 1957; *Edge of Eternity*, 1959; *The Killers*, 1964;

Madigan, 1967; *Charley Varrick*, 1973) and westerns (*The Duel at Silver Creek*, 1952; *Flaming Star*, 1960, with Elvis Presley; *The Shootist*, 1976, John Wayne's final film). He made several films with Clint Eastwood, beginning with *Coogan's Bluff* (1968), which was followed by *Two Mules for Sister Sara* (1969), *The Beguiled* (1970), *Dirty Harry* (1971) and *Escape from Alcatraz* (1979). When Eastwood directed his first film, *Play Misty For Me* (1971), he cast Siegel as a friendly bartender. Siegel's last film, *Jinxed!*, was made in 1982.

47

The Brothers Rico

USA, 1957

Columbia. DIRECTOR: Phil Karlson. 91 MINS.
FIRST SEEN: *Odeon, Birmingham, UK 2 November 1957.*

Bay Shore, Florida. Eddie Rico (RICHARD CONTE), former accountant for The Organisation, has turned away from a life of crime and lives an honest life, running a prosperous laundry business. On the day that he and his wife, Alice (DIANNE FOSTER), are supposed to sign the documents that will enable them to adopt an orphan, Eddie receives a summons from Sid Kubik (LARRY GATES), the head of The Organisation, and flies to Miami to meet him in a beachfront hotel. Kubik, an old friend who many years earlier was saved from a bullet by Eddie's mother (ARGENTINA BRUNETTI) in never-explained circumstances, is, he enthuses, like a member of the Rico family and he greets Eddie warmly. But he is concerned that Eddie's youngest brother, Johnny (JAMES DARREN), has disappeared without trace. Johnny had driven the car involved in the shooting by Gino Rico (PAUL PICERNI) of a mobster named Carmine. Johnny has married Norah (KATHRYN GRANT), whose brother, Peter Malaks (LAMONT JOHNSON), is suspected by Mob insiders to be planning to talk to the district attorney. Believing Kubik's assurances that he only wants to get Johnny and Norah safely out of the country, Eddie tracks his brother down on a farm near El Camino, California. But he has been followed, and Johnny is executed by local mobsters. Eddie learns that Gino has also been killed. Determined to expose Kubik, Eddie first makes sure Alice is safe and then goes to say goodbye to his mother—where Kubik is waiting. In the ensuing gunfight, Kubik is killed.

The most impressive aspect of this gripping adaptation of a Georges Simenon story is the sense that The Organisation is all-powerful, its tentacles stretching into every aspect of American life. Wherever Eddie goes—and he does a lot of travelling back and forth across America, mostly in planes at a time when arranging tickets and boarding flights were a lot less complicated—he's observed and followed by sinister strangers. They are waiting for him in airport terminals, railway stations and hotel lobbies; when Eddie leaves his mother's apartment there's a car hovering outside driven by a guy he vaguely knows accompanied by a pair of obviously available

blondes. He is offered a lift, but Eddie declines to take the bait. At the airport in Phoenix he encounters another suspiciously friendly fellow who watches his every move. When he goes to a branch of the Gotham Bank to withdraw cash from his strong box, one of the bank tellers immediately phones his superiors to alert them as to Eddie's whereabouts. Nowhere is safe. In El Camino, a small fictional town in the desert, we discover that even the sheriff has been appointed by Mike Lamotta (HARRY BELLAVER), The Organisation's local representative.

The opening credits, printed over an ominous-looking splash of blood, are followed by a couple of scenes of marital intimacy, scenes that are unusually candid for a film of this period. The domesticity is interrupted by a late-night phone call in which a representative of The Organisation demands that Eddie hide Joe Wesson (WILLIAM PHIPPS), a gunman who is arriving the next day from Kansas City, among the employees in his laundry. That call is the first Eddie has received in several years from the crime syndicate he thought he was over and done with, and with it comes the grim realisation that there's really no escape from the bad decisions he made when he was a young man.

For the rest of the film, director Phil Karlson ratchets up the suspense to almost unbearable levels. This was a B-picture for Columbia; it lacked major stars (steely-eyed Richard Conte was never a big name, but was proficient at playing both good guys and, especially, bad guys in films like *Cry of the City*, 1948, and *New York Confidential*, 1955). Yet the film is particularly well cast, with James Darren impressive as Johnny in the dreadful scene in which he realises he's about to be murdered, and Harry Bellaver equally good as the jaded small-town hoodlum assigned to watch over Eddie in a hotel room while, nearby, his brother is being killed. Also of note is Lamont Johnson, who plays the 'straight' guy, Malaks, whose dealings with the DA's office (which Kubik knows all about because he has a spy embedded there) bring about the downfall of the Rico brothers. Johnson moved away from acting to become a director in the 1960s, though without much distinction—he is best remembered for the notorious *Lipstick* (1976). Best of all is Larry Gates who, following his chilling role in *Invasion of the Body Snatchers* (1956), is equally ominous here as the conniving gang boss.

Filming mostly on location, cinematographer Burnett Guffey contributes an edgy noir look to the proceedings, a mood augmented by George Duning's rather mournful score. The fact that we never know exactly in what area of criminal activity The Organisation is involved makes its

omnipotence all the more chilling. The film's one false note is the tacked-on happy ending, which doesn't for a moment convince.

The first time I saw *The Brothers Rico* it was playing on the second half of a double bill together with *3:10 to Yuma* (1957), representing a combination of two excellent films offered to the public for the price of one.

Phil Karlson (1908–1985) was a prolific filmmaker who was rarely given the opportunity to make 'A'-grade films. He made his first film, *A Wave, A WAC and a Marine*, in 1944 and from then on tackled almost every genre of low-budget cinema, including westerns, musicals and lowbrow comedies. His first major entry into the world of film noir was *Scandal Sheet* (1952), an excellent thriller with Broderick Crawford as a newspaper editor involved in a murder. This was followed by other small-scale gems, including *Kansas City Confidential* (1952), *99 River Street* (1953), *Tight Spot*, *Five Against the House* and *The Phenix City Story* (all 1955) and *Key Witness* (1960). Later he became a prolific director of television series like *The Untouchables*. His career went into a serious decline in the mid-1960s, and his last film, *Framed* (1974), was negligible.

When I visited Hollywood for the first time in the summer of 1966 I was invited to Columbia Pictures Studios on Gower Street, where three films were in production. One of them, a western titled *The Long Ride Home*, starring Glenn Ford, was being directed by Karlson. I was able to watch him direct a scene in a bar-room and, during the break, was introduced to him. He seemed surprised and pleased that I knew his films, and that I was able to talk enthusiastically about his work and his achievements. *The Long Ride Home* didn't turn out very well, but meeting this erratically talented, prodigious director was one of the major delights of my first visit to the home of cinema.

48

The Incredible Shrinking Man

USA, 1957

Universal–International. DIRECTOR: Jack Arnold. 77 MINS.

FIRST SEEN: *Kingsway Cinema, King's Heath, Birmingham, UK 13 July 1957.*

The American West Coast. Scott Carey (GRANT WILLIAMS), an ex-navy man, and his wife of six years, Louise (RANDY STUART), are enjoying cruising on a borrowed boat when Scott is enveloped by a mysterious cloud that leaves his skin literally sparkling. Six months later he notices that his clothes no longer fit him. He consults a doctor who refers him to a specialist to whom he reveals that, sometime after his contact with the cloud—thought to be radiation—he was accidentally sprayed with insecticide. The combination has led to the shrinking process, which is uncontrollable. As he grows smaller, Scott becomes frightened and bitter. A chance meeting with Clarice (APRIL KENT), an attractive midget, gives him hope for a while, until he becomes even smaller than she is. In Louise's absence Scott is attacked by Butch, the family cat, and falls into the cellar where he is threatened by what is—to him—a giant spider. Assuming he has been killed by Butch, Louise sells the house and leaves. Scott shrinks until he becomes infinitesimal.

The 1950s was a great decade for screen science fiction. The combination of 'flying saucer' sightings led to a string of movies about visitors from outer space (*The Day the Earth Stood Still, When Worlds Collide* and *The Thing*, all 1951; *Red Planet Mars*, 1952; *War of the Worlds* and *It Came from Outer Space*, both 1953; *This Island Earth*, 1954; *Invasion of the Body Snatchers*, 1956—and countless lesser efforts). Meanwhile, the fears that nuclear testing might lead to mutations of animal life resulted in films about giant creatures that terrorise the populace: *The Beast from 20,000 Fathoms* (1953) was a giant octopus; giant ants on the march featured in *Them* (1954); the giant spider in *Tarantula* (1955) had to be nuked from a plane flown by an uncredited Clint Eastwood; and from Japan came *Gojira/ Godzilla* (1954), a true heir to King Kong.

The director of two of the best of these hugely entertaining films (*It Came from Outer Space* and *Tarantula*) was Jack Arnold who, with *The Incredible Shrinking Man*, made the most original entry into the field. The screenplay, no doubt influenced by *Gulliver's Travels* and *Alice in Wonderland*,

was written by one of the great sci-fi writers, Richard Matheson (whose influential and much-filmed book, *I am Legend*, was published in 1954). Matheson had contributed to the scripts of episodes of *The Twilight Zone* and would later adapt several Edgar Allan Poe stories for filmmaker Roger Corman, as well as providing the screenplay for Steven Spielberg's debut feature, *Duel* (1972). Together, Arnold and Matheson—with considerable assistance from talented technicians including special-effects cameraman Clifford Stine and optical-effects specialists Roswell A. Hoffman and Everett H. Broussard—created one of the most chilling sci-fi movies of the period.

It opens without preamble with the scene in which a strange mist envelops sunbathing Scott Carey while his wife, Louise, is below decks of the little boat they've borrowed from Scott's brother, Charlie (PAUL LANGTON). The experience leaves Scott literally glittering. Six months pass by, and now his clothes aren't fitting him ('You're probably just losing weight—it's very becoming,' Louise assures him). Dr Silver (RAYMOND BAILEY) advises him that 'people decrease in height during the day', but, after taking X-rays, he is forced to admit that Scott is getting smaller. Scott is referred to Dr Bramson (WILLIAM SCHALLERT) at the California Medical Research Institute who, after a series of intensive tests, tells him that his 'molecular structure' is being 'rearranged'. News of the double whammy of what was presumably a cloud of radiation (from nuclear testing?) and insecticide carelessly pumped from a passing truck leads Bramson to conclude that all Scott's organs are being reduced in size. As the unfortunate man leaves the institute, his wedding ring falls from his finger.

The next time we see him he's considerably smaller, has lost his job and is being hounded by the media. But his doctor has found a possible antidote that, he hopes, will check the degenerative process; for a time it does, but then the shrinking continues, though not until Scott has enjoyed a brief flirtation with the equally diminutive Clarice.

The horror really kicks in during the last part of the film. In Louise's absence, Scott is terrorised and mauled by what is—to him—a giant cat, the family pet. Louise assumes he is dead, but, in fact, he's trapped in the cellar, unable to climb back up the steps that look to him like 'cliffs rising upon cliffs'. He is able to quench his thirst from a dripping water heater and attempts to extract cheese from a mousetrap—a dangerous task that ends in failure when the cheese falls down the drain. The attack of the spider is very scary, even when seen today. Knocked down by the creature,

Scott is trapped underneath it while he rams a pin into the monster, whose blood pours down onto him.

The film's ending is unique for a movie of this period. Eventually Scott is so small that he can pass through the wire mesh that covers the cellar window. As he gazes up at the sky he asks, '[Am] I still a human being? Will other beings follow me into this vast new world? The infinitesimal and the infinite are so close—two ends of the same concept. The small and the vast eventually meet like the closing of a gigantic circle.' 'In that moment,' his narration explains, 'I knew the answer to the riddle of the infinite. That Existence begins and ends is Man's conception, not Nature's. And I felt my body melting, becoming nothing; my fears melted away and in their place came Acceptance. All the vast majesty of creation had to mean something. And then I, smaller than the smallest, meant something, too. *I still exist!*' The end title comes up over a star-filled sky. At the age of 16, when I first saw this remarkable film, I was very impressed by an ending that seemed logical rather than fanciful.

Despite a cast comprising virtually unknown actors, the film was an instant success and quickly assumed cult status. In a loose remake, *The Incredible Shrinking Woman* (1981), the sex of the protagonist was changed and Lily Tomlin played the role. There have been plenty of other films about people who have been shrunk, including *Honey, I Shrunk the Kids* (1989) and Alexander Payne's ambitious *Downsizing* (2017).

Jack Arnold (1916–1992) made documentaries before directing his first feature, *Girls of the Night* (1953). He became an expert at making films in 3D during the brief vogue for three dimensions in the early 1950s. His stereoscopic movies include *It Came from Outer Space* and *The Glass Web* (both 1953) and *Creature from the Black Lagoon* (1954). The same year that he made *The Incredible Shrinking Man* he also directed two taut thrillers—*The Tattered Dress* and *Man in the Shadow* (the latter boasting a compelling performance from Orson Welles). After *Shrinking Man* he seemed to lose his way, and the comedies he made—with the exception of *The Mouse that Roared* (1959)—are poor. A couple of exploitation films he made in 1974—*Boss Nigger* and *Sex Play*—did nothing to enhance his reputation. His decline is probably explained by the virtual extinction of the low-budget B-picture that came with the demise of the major film studios. But his sci-fi films still impress.

3:10 to Yuma

USA, 1957

Columbia. DIRECTOR: Delmer Daves. 92 MINS.
FIRST SEEN: *Odeon, Birmingham, UK 2 November 1957.*

Arizona. After three years of drought, farmer Dan Evans (VAN HEFLIN) is struggling to feed his wife, Alice (LEORA DANA), and two sons, Matthew (BARRY CURTIS) and Mark (JERRY HARTLEBEN). Dan and the boys witness the hold-up of the Butterfield stagecoach, which had been travelling between Contention City and Bisby, by a gang led by outlaw Ben Wade (GLENN FORD), and the fatal shooting of the coach driver. The gang stops for a drink at the saloon in Bisby and the local marshal (FORD RAINEY), who doesn't yet know about the hold-up, allows them to leave. Wade stays behind for a liaison with the barmaid, Emmy (FELICIA FARR), and Dan alerts the marshal and helps apprehend Wade. Butterfield (ROBERT EMHARDT) offers a $200 reward to two men who will help transport Wade to Contention and from there onto the 3.10 train for Yuma, where there is a federal prison. Dan volunteers along with Alex Potter (HENRY JONES), who is generally scorned as the town drunk. Dan keeps guard over Wade in the bridal suite of Hotel Contention while, in the absence of the marshal, Butterfield assembles a reluctant posse that quickly dissolves once Wade's gang, led by Charlie Prince (RICHARD JAECKEL), arrives in town. Wade tries unsuccessfully to bribe Dan, and, as 3 pm approaches, Alice and Butterfield both beg him to let Wade go; but Potter has been brutally killed and Dan is determined to get the outlaw to the train despite the odds stacked against him.

At the time of its release, Delmer Daves' fine film was criticised by some as being too derivative—*High Noon* meets *Shane* (both 1952) was typical of the commentary. It's true that there are elements of both classic westerns in Daves' film: the countdown to the arrival of a train and the difficulty of forming a posse to stand by the hero are themes from *High Noon*, and there's also a similarity in the depiction of the struggling farmer, emphasised by the fact that Van Heflin played a somewhat similar role in *Shane*. But overall *3:10 to Yuma* is distinguished by the superb filmcraft of its director, the mounting suspense and the pitch-perfect performances. Glenn Ford's soft-spoken gang leader is one of the least conventional bad

guys in cinema. On the one hand he unhesitatingly shoots one of his own men, who is being held at gunpoint by the unfortunate stagecoach driver, before shooting the driver as well. On the other, he's unfailingly polite and courteous, both to Alice, Dan's careworn wife, and to Emmy, the lonely barmaid so beautifully played by Felicia Farr—wife of Jack Lemmon—before he seduces her and leaves her with, as she says afterwards, 'something to remember'. 'A man you see once—he's with you the rest of your life,' is (in big close-up) Emmy's wistful conclusion to a memorable brief encounter. Alice allows Wade to join the family for dinner, but Dan insists that the outlaw remain handcuffed and cuts up his meat for him, removing the fat at the outlaw's request ('I don't like fat'). After dinner, while most members of his gang are off chasing the decoy stagecoach, Wade thanks Alice for her hospitality, adding, as he leaves with Dan: 'I hope I can send him back to you.' Dan is desperate for the $200 offered by Butterfield and, as his too-talkative younger son, Mark, avers, '$200 is a lot.' 'Not if he doesn't come back it isn't,' notes his wiser brother, Matthew.

At almost exactly the film's halfway point the action shifts to the hotel where Dan has to keep Wade a prisoner until it's time to leave for the station and catch the train. For the next 39 minutes much of the drama is confined to the hotel bridal suite where Wade alternately threatens and attempts to bribe his captor, offering up to $10,000 to Dan to let him escape and assuring him nobody will know. He also tells the increasingly agitated Dan that 'I'd treat [your wife] a whole lot better than you do. I bet she was a beautiful girl before she met you.' But he also demonstrates his dark side, referring to the stagecoach driver he killed as 'some fool who got what he deserved'. The cruel murder of the hapless Potter—a strong performance from Henry Jones—only strengthens Dan's resolve. As Wade predicts, Dan's few allies evaporate as the fateful moment of the train's arrival in Contention approaches and the gang congregates outside the hotel to prevent the two men making it to the nearby station. The posturing Butterfield, who said earlier in the day that 'I'll walk with you, every step of the way, to that station', capitulates in terror ('I'm not going through with it') but offers to pay Dan anyway. But Dan is not for turning. He tells Alice, who has arrived in a last-minute attempt to change his mind: 'Honest to God if I didn't have to do it I wouldn't. But I heard Alex scream. The town drunk gave his life—you think I can do less?'

The screenplay is by Halsted Welles, based on a short story by Elmore Leonard, which had been published in 1953. Arguably, the film's conclusion

is a problem. Facing impossible odds (five members of the gang facing him on the station platform as he pushes Wade at gunpoint towards the train), Dan is saved by Wade himself, who leaps into the baggage car with Dan behind him. Why? 'I don't like owing anybody any favours,' says Wade. 'And, besides, I've broke out of Yuma before.' And, as the train speeds away, thunder crashes and—out of a cloudless sky—it starts to rain.

If the ending is a bit weak, the film as a whole is immensely satisfying not least because it looks so magnificent. By 1957 most westerns were in colour; but the black and white photography by Charles Lawton Jr is one of the film's great assets. Daves was very fond of the crane shot, in which the camera, mounted on a boom, either rises or falls with hypnotic effect. The first time this occurs in the film is at the start as—while the credits roll and Frankie Laine sings the theme song—the camera rises up from the parched earth to reveal the Butterfield stagecoach travelling in a wide arc towards it. The much-repeated main theme, composed by George Duning, also adds greatly to the film—Glenn Ford even whistles it at one point.

Delmer Daves (1904–1977) was a screenwriter with some important script credits, including Leo McCarey's *Love Affair* (1939)—the original version of *An Affair to Remember* (1957)—and he was one of those writers given the chance to direct in the early 1940s. His first feature, *Destination Tokyo* (1944), was a submarine drama with Cary Grant, and thereafter he made a wide variety of films, including thrillers (*The Red House*, 1946; *Dark Passage*, 1947). However, he was mainly known for some excellent westerns: *Broken Arrow* (1950), *Drum Beat* (1954), *Jubal* and *The Last Wagon* (both 1956), *Cowboy* (1957), *The Badlanders* and *The Hanging Tree* (both 1958). His last films, from *A Summer Place* (1959) onwards, were mainly mawkish melodramas about teenage love—competently made but disappointing work from such a talented filmmaker. His career ended with *The Battle of the Villa Fiorita* (1964).

12 Angry Men

USA, 1957

United Artists–Orion-Nova. DIRECTOR: Sidney Lumet. 96 MINS.
FIRST SEEN: *Odeon, Birmingham, UK 20 June 1957.*

New York. A murder trial is coming to an end; an 18-year-old Latino youth is accused of stabbing his father to death. The jury adjourns and, when a vote is taken, they all vote guilty except Juror 8 (HENRY FONDA). Tempers run high among the all-male jurors—who are required to give a unanimous verdict in a case that carries a mandatory death sentence. Juror 8's reservations are ridiculed at first, but as the evidence is examined in more detail the other jurors change their minds one by one. The young man is eventually acquitted.

Reginald Rose's tense drama, which explores the very meaning of justice in America, started life as a television play, broadcast live on CBS on 20 September 1954. It was subsequently performed on stage before it became the first film to be directed by Sidney Lumet. That the film was made at all is a credit to Henry Fonda, who co-produced it with Rose, and who lent his famous name to a project that otherwise boasted a cast of character actors. Some of them—like Lee J. Cobb—were familiar to cinema audiences but most were total unknowns.

The film commences as Boris Kaufman's camera pans up the exterior of a courthouse and then pans down the interior of the lobby of the same building. People mill about, a family is celebrating a legal win, but in Court 228 a bored judge (RUDY BOND) sums up, telling the jury to 'separate fact from fantasy' and reminding them that the verdict must be unanimous. 'You are faced with the gravest responsibility,' he tells them, though he's clearly uninvolved with the case over which he's presiding. As the jury files out, the camera lingers on the face of the accused (JOHN SAVOCA), a painfully young kid with large, sad eyes.

For the majority of the jurors the case is a fait accompli. It's the hottest day of the year and the jury room is stifling; there is no air conditioning and a wall fan seems, at first, not to work. Juror 7 (JACK WARDEN) has tickets to a ball game that evening and is eager to come to a verdict as quickly as possible. Juror 10 (ED BEGLEY) constantly refers to the accused's ethnic background

('You know how those people lie,' he rants. 'They're all big drinkers—that's the way they are by nature. They have no feelings. There's not one of them who's any good'). Juror 3 (COBB), who runs a messenger service—'Beck and Call'—with 37 employees, is also bigoted, but his prejudices are directed against young people. 'What is this? Love Your Under-privileged Brother week?' he demands of Juror 8—an architect whose name, we discover at the end, is Davis. Juror 4 (E.G. MARSHALL), a stockbroker, is the only one who keeps his jacket on throughout ('Don't you ever sweat?' Juror 5, Jack Klugman, asks. He replies tersely: 'No, I don't'). Always calm and with an incisive mind, Juror 4 is one of the last hold-outs, becoming certain of the accused youth's innocence only when elderly Juror 9 (JOSEPH SWEENEY) convinces him that a woman who claimed to have witnessed the stabbing murder from across the street on the other side of an elevated railway track—while a train was passing—must have owned glasses because of the pinch marks on the sides of her nose but probably wasn't wearing them in bed when she says she saw the crime.

One by one other elements of the case are demolished. The weapon, a switchblade knife, had been described by the prosecution as being of a rare design. Juror 8 reveals that he easily bought an identical knife from a pawnshop near the apartment where the teenager supposedly killed his father. The 'killer' couldn't remember the names of the movies he was supposed to have seen that night. Juror 4, asked about movies he saw a few nights earlier, gets the details wrong. An old man with a limp who lived on the floor below claimed to have heard the murder occur, got out of bed and walked to the front door of his apartment in time to see the killer fleeing down the stairs—but by painstakingly timing an event of identical length Juror 8 proves it couldn't have happened as described. Though the father was taller than his son he was killed with an upward stabbing blow; Juror 5—who was raised in the ghetto—shows that this was a most unlikely wound given the use of a switchblade knife.

Though by its nature *12 Angry Men* is a film that relies heavily on its screenplay and its ensemble cast, Lumet's direction should by no means be discounted. Despite the claustrophobic atmosphere, he keeps the characters moving around the room and adroitly shifts from one to another. The 'calmer' members of the jury become increasingly aggravated by the bombastic posturings of the more aggressive members, and there's a wonderfully astringent moment when Juror 10, complaining that the accused is 'a common, ignorant slob. He don't even speak good English', has his grammar

quietly corrected by Juror 11 (GEORGE VOSKOVEC), a watchmaker who has immigrated from Eastern Europe. The 'foreigner' is promptly accused by Juror 7 of 'coming over here, running for your life, and [then] telling *us* what to do'.

There is, obviously, plenty of bigotry on display in this 'typical' jury room—and the point the film makes, very forcefully, is that under the American justice system, 'No jury can declare a man guilty unless it's *sure*.' This would have been wishful thinking in 1957 when, in America's South, all-white juries were still handing down racially influenced verdicts on African-Americans.

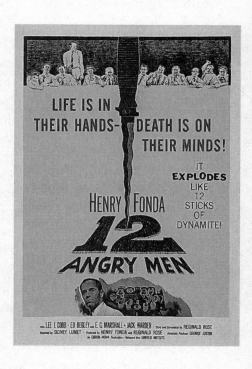

Made on a tiny budget, *12 Angry Men* was a prestige success and has become very influential. There have been numerous stage productions, including an all-female version; a TV version, made by William Friedkin in 1997 with Jack Lemmon and George C. Scott; a Russian version, *12* (2007), made by Nikita Mikhalkov; and other variations.

After this impressive debut, Sidney Lumet (1924–2011) enjoyed a prolific, though variable, career. Many of his films were set in New York, and many were thrillers, though he also tackled adaptations of plays (*The Fugitive Kind*, 1959; *A View from the Bridge*, 1961; *Long Day's Journey into Night*, 1962; *The Sea Gull*, 1968; *Equus*, 1977). Other highlights include *Fail-Safe* and *The Pawnbroker* (both 1964), *The Hill* (1965), *The Group* (1966), *Serpico* (1973), *Murder on the Orient Express* (1974), *Dog Day Afternoon* (1975), *Network* (1976), *Prince of the City* (1981), *The Verdict* (1982), *Daniel* (1983), *Running on Empty* (1988), *Night Falls on Manhattan* (1996) and *Before the Devil Knows You're Dead* (2007), his final film. I asked him once if he could name his own favourite among his films; he replied that he couldn't. He explained that it would be like naming his favourite child. In different ways, he said, he loved them all.

51

Wild Strawberries
(*Smultronstället*)

SWEDEN, 1957

Svensk Filmindustri. DIRECTOR: Ingmar Bergman. 91 MINS.
FIRST SEEN: *Melksham & District Film Society, Wiltshire, UK 23 April 1960.*

Stockholm. Seventy-eight-year-old Professor Isak Borg (VICTOR SJÖSTRÖM), a self-declared pedant, has withdrawn from nearly all relationships and lives a lonely life, cared for by Agda (JULLAN KINDAHL), who has been his loyal housekeeper for 40 years. After a bad dream, in which he sees himself as a corpse, he awakens on the morning he is to receive an honorary degree from the University of Lund. Instead of flying south, as he had originally planned, he decides to drive, accompanied by Marianne (INGRID THULIN), the estranged wife of his son, Evald (GUNNAR BJÖRNSTRAND). En route they stop to allow Isak to visit the lakeside house where he spent his summers as a child. The visit brings back memories, especially of his love for Sara (BIBI ANDERSSON), his cousin, to whom he was once engaged—but he imagines seeing her being kissed by Sigfrid (PER SJÖSTRAND), whom she will eventually marry. As the drive continues, Isak and Marianne give a lift to a modern-day Sara (also Bibi Andersson) and her two male companions, Victor (BJÖRN BJELVENSTAM) and Anders (FOLKE SUNDQUIST); and later to a quarrelling couple (GUNNEL BROSTRÖM, GUNNAR SJÖBERG) whose car has crashed. Isak pays a visit to his 96-year-old mother (NAIMA WIFSTRAND), who lives alone with her memories ('Nobody bothers to visit me unless they want to borrow money,' the elderly woman notes sadly). After the presentation, Isak dreams that Sara leads him to the place where he can see his parents: his father, who is fishing, appears not to see him, but his mother waves to him.

 In the second half of the 1950s, Ingmar Bergman became one of a handful of European directors who revitalised the world of cinema. In quick succession, a series of marvellous Bergman films—*Sommarnattens leende/Smiles of a Summer Night* (1955), *Det sjunde inseglet/The Seventh Seal* and *Wild Strawberries* (both 1957), *Ansiktet/The Face* (in the UK)/ *The Magician* (in the USA and Australia) (1958), *Jungfrukällan/The Virgin Spring* (1959)—screened in cinemas around the world and were eagerly

admired by a generation of film-goers. *Wild Strawberries* is, for me, his most beautiful and memorable film. A rather bitter, cold old man, estranged from his colleagues and from what remains of his family, experiences vivid nightmares and dreams of the distant past, of his youth and of his one true love and, in the end, of his beloved parents. It was a magical choice to cast veteran Victor Sjöström as Isak Borg (is it a coincidence that the character's initials are the same as those of the director?). Sjöström, together with Mauritz Stiller, had directed a series of achingly beautiful Swedish films in the silent era; Sjöström had also acted in such classics as *Berg-Ejvind och hans hustru/The Outlaw and His Wife* (1918) and *Korkarlen/The Phantom Carriage* (1921). Later he went to Hollywood where he directed the first film made by MGM (*He who Gets Slapped*, 1924). He was the same age as the character he plays in *Wild Strawberries*, 78, and long retired, but he gives an unforgettable performance as a man looking back with regret at a life of missed opportunities and mistakes. Sjöström died in 1960.

Heavy with symbolism (a clock without hands, a coffin that falls from a hearse—surely a reference to *The Phantom Carriage*), the film makes it clear that both Isak and his son, Evald, are cold, selfish and ruthless ('You know so much but you don't know anything,' Isak is told by his youthful love, Sara). Presumably because he lost the woman he really loved, he had treated his wife (GERTRUD FRIDH) with an icy disdain and had driven her reluctantly into the arms of a lover (ÅKE FRIDELL). Another nightmare, in which Isak is tested by a severe medical examiner (a second role for Gunnar Sjöberg), includes a moment of Christian symbolism as the old man's hand is pierced by a protruding nail.

Evald is behaving just like his father; when Marianne tells him she's pregnant, his response is that 'it's absurd to bring children into this world' and vetoes 'an unwanted child in a hellish marriage'. A similarly hostile relationship is depicted in the bitter quarrels of the couple whose car has crashed and who taunt one another mercilessly. On the other hand, the cheerful young Sara, who claims to be a virgin, succeeds in keeping her two boyfriends in suspense as they travel south. One of them, Anders, has plans to be a minister of religion, which elicits scorn from Victor, who is studying medicine and who doubts the existence of God. 'I always agree with the one who spoke last,' says Sara, rather infuriatingly.

Isak, it seems, has had a far more positive influence on those outside his inner circle. When he stops for petrol at a garage close to the town where he formerly worked as a district medical officer, the owner, Åkerman (MAX

VON SYDOW), calls him 'the world's best doctor' and refuses to accept payment for the fuel. 'Round here they remember your kindness,' the old man is assured, and, for a moment, he wonders if 'maybe I should have stayed here'.

Isak learns something from the events of the day, and after the ceremony suggests to Agda—who has flown from Stockholm to Malmö for the occasion—that they use first names, but she rejects any idea of intimacy. He also embraces Marianne, who appears to be reconciled with Evald. And the film concludes with a magical final sequence in which Sara (his youthful love) leads him by the hand across a field to a vantage point where he can see, below, a lake: his father, dressed in white, is fishing, his mother, also in white, sits behind him near a picnic basket. They look towards him; the mother waves—and Isak's face, beautifully lit, becomes a study in calm serenity. There is a dissolve and he is seen lying on his bed with the same look—as the film ends.

Incidentally, the film's Swedish title refers not to the wild strawberries themselves but to the place where they grow—'Wild Strawberry Patch' would be a more accurate translation.

Ingmar Bergman (1918–2007) was one of the most prolific artists of the 20th century, working not only in film but also in the theatre and television. His first feature, *Kris/Crisis*, was released in 1946, but it would be almost ten years, and 14 more films, before he achieved international recognition for *Smiles of a Summer Night* (1955). Rigorous and intellectual, though not without humour, his films often explore man's relationship to God, which is not surprising given that his father was a church minister. Among the highlights of an illustrious career are *Såsom I en spegel/Through a Glass Darkly* (1961), *Tystnaden/The Silence* (1963), *Persona* (1966), *Skammen/Shame* (1968), *Viskningar och rop/Cries and Whispers* (1972), *Scener ur ett äktenskap/Scenes from a Marriage* (1973), *Herbstonate/Autumn Sonata* (1978) and *Fanny och Alexander/Fanny and Alexander* (1982). His last feature, *Saraband* (2003), was made for television. His films are characterised by the extremely high quality of the acting involved, especially from a gallery of gifted women—Ingrid Thulin, Bibi Andersson, Harriet Andersson (no relation), Gunnel Lindblom and Norwegian actor Liv Ullmann. He also worked with two great cinematographers: Gunnar Fischer on the early films (including *Wild Strawberries*) and Sven Nykvist on the later ones.

52

Breathless
(À bout de souffle)

FRANCE, 1959

Les Films Georges de Beauregard. DIRECTOR: Jean-Luc Godard. 90 MINS.
FIRST SEEN: *Academy Cinema, Oxford Street, London, UK 15 September 1961.*

The Riviera. Former Air France steward turned thief, Michel Poiccard, aka Laszlo Kovacs (JEAN-PAUL BELMONDO), steals a car in a harbour town near Marseilles and heads for Paris. En route he is pursued by two motorcycle cops; he kills one of them with a gun he has found in the glove box of the car. In Paris he reconnects with Patricia Franchini (JEAN SEBERG), a 20-year-old American girl he'd met three weeks earlier in Nice; they'd slept together three or four times, and he has fallen in love with her. Patricia, who sells copies of the *New York Herald Tribune* on the Champs-Élysées, has ambitions to be a writer. She spends a night with an influential journalist (JEAN-LOUIS RICHARD) and returns to her tiny hotel room to find Michel waiting for her in her bed. He has been attempting to make contact with Antonio Berrutti (HENRI-JACQUES HUET), who owes him money, but he is being pursued by Inspector Vital (DANIEL BOULANGER). Patricia, who is pregnant but is not sure she loves Michel, betrays him to the police and he is shot dead on a Paris street.

The arrival of the French *Nouvelle Vague* (New Wave) at the end of the 1950s transformed my cinema experience. A group of talented young men—Claude Chabrol, François Truffaut, Jacques Demy, Philippe de Broca, Jacques Rivette—and one woman—Agnès Varda—plus the somewhat older Éric Rohmer suddenly emerged with new films that were fresh and original both visually and structurally. They were film lovers, and often included references to Hollywood movies that I also loved in their movies.

The most obvious such reference in Jean-Luc Godard's amazing feature debut, *À bout de souffle*, comes when Belmondo's Michel gazes admiringly at a photograph of Humphrey Bogart outside a cinema showing the actor's last film, *The Harder They Fall* (1956), muttering softly 'Bogey' while he strokes his lip just as the real Bogey did. It's not the only cinematic reference in the film: Robert Aldrich's *Ten Seconds to Hell* (1959) and Budd

Boetticher's *Westbound* (1958) also get a look-in, and Michel learns that his friend Bob Montagne—the name of the central character in Jean-Pierre Melville's *Bob le flambeur* (1955)—can't help him because he's in prison. Melville himself—a director admired by the New Wave—shows up in person later in the film, playing Parvulesco, an intellectual writer interviewed by Patricia at Orly Airport and whose 'modern' views on feminism and fate seem to accord with hers ('What's your greatest ambition,' she asks him, and when he replies 'To become immortal and then die', she looks directly into the camera lens as the scene fades). Patricia is a typical femme fatale of film noir, a beautiful seductress who betrays the hero at the end.

À bout de souffle is one of the most important feature film debuts since *Citizen Kane* (1941) and *The Night of the Hunter* (1955). Godard rewrote the grammar of cinema, using abrupt jump cuts mid-scene and employing the gliding hand-held camerawork of Raoul Coutard with extraordinary grace. Unusually, the film has no credit titles at all; apart from the title, and 'Fin' at the end, the only written text is a surely jokey dedication to Monogram Pictures, one of the cheapest and least interesting of American B-movie production houses. However, it is generally accepted that Godard wrote the screenplay (allegedly from a story by François Truffaut), that the superlative jazzy score is by Martial Solal, that Claude Chabrol was a 'consultant' and that the future 'man of cinema', Pierre Rissient, was assistant director.

As the film begins, Michel—hidden behind a newspaper—describes himself as a 'con' (translated usually as 'arsehole'). Dressed in a tweed jacket with tie, wearing a trilby hat pulled low over his eyes, chain-smoking foul-looking cigarettes, wearing dark glasses—this anti-hero is the epitome of 'cool'. He steals car after car, purloins money from Minouche (LILIANE ROBIN), an Italian girl who likes him, mugs a hapless guy in a toilet to steal his cash and, of course, kills a cop; he's beyond the pale yet, as played by Belmondo, he positively exudes a cynical charm ('Americans adore La Fayette and Maurice Chevalier,' he complains. 'They're the stupidest Frenchmen').

Seberg's Patricia is equally beguiling; with her boyish haircut, her ice-melting smile and her casual amorality, she represents the 'New Woman' who would enjoy the sort of freedom in the coming decade that her predecessors had barely known. 'I don't know if I'm unhappy because I'm not free or I'm not free because I'm unhappy,' she wonders. During the very long—23-minute—sequence that takes place in her tiny apartment as she and Michel get to know one another better—through music ('Aimez-vous Brahms?' she asks him, presumably a reference to the book of the same

name by Françoise Sagan, which had been published earlier in 1959), art, literature and, eventually, satisfactory (off-screen) sex—she is very much in charge, while he seems surprised to discover that he loves this American and desperately wants her to join him when he leaves for Italy. Godard, an admirer of Hollywood director Otto Preminger, cast Seberg after seeing her in the Preminger films *Saint Joan* and *Bonjour tristesse* (both 1957).

The word '*degueulasse*' is used several times in the film, and, in fact, is Michel's last word as he closes his own eyes with his hand, mocking Hollywood death scenes. The remark is addressed to Patricia, who asks Vital what it means. It's usually translated as 'disgusting' or, when a noun, as 'louse'.

Godard's revolutionary approach to this simple story seems as fresh today as it ever did. He and Coutard filmed scenes on the Champs-Élysées, unfazed when passers-by turn and stare at the camera. There are little in-jokes along the way: Godard himself plays the informer who recognises Michel and reports him to the police, while a young girl approaches Michel ('Have you anything against youth?' she inquires) selling copies of *Cahiers du cinéma*, the hugely influential film magazine to which most of the *Nouvelle Vague* directors had been contributors.

Allegedly because of its 'immorality', *À bout de souffle* was banned in Australia for several years, an act of cultural vandalism typical of the crudely anti-intellectual mood of the period. In 1983, Jim McBride, an American admirer of Godard, directed a remake starring Richard Gere and Valérie Kaprisky; though not a patch on the original, *Breathless* is still an interesting approach to the material.

Godard was not the easiest person to talk to. I met him a couple of times, once in Paris and once in Venice, but he proved a formidable and, it seemed, humourless character. Indeed, after his early films, his work became increasingly didactic, inbred and self-absorbed.

Jean-Luc Godard (b. 1930) was a film journalist and director of five short films before he made *À bout de souffle*. It was followed by *Le petit soldat* (1960), which was banned in France for a while because of its political content. A series of highly original and stimulating films followed: *Une femme est une femme* (also 1960), *Vivre sa vie* (1962), *Les carabiniers* and *Le mépris/Contempt* (both 1963), *Bande à part/Band of Outsiders* and *Une femme mariée* (both 1964, the latter also banned in Australia), *Alphaville* and *Pierrot le fou* (both 1965). Later films became increasingly preoccupied with radical politics, and though there were flashes of brilliance in *Weekend*

(1967), *Tout va bien* (1972), *Sauve qui peut (la vie)* (1980), *Prénom Carmen* (1983), the controversial *Je vous salue, Marie/Hail Mary* (1984), *Nouvelle Vague* (1990), *Éloge de l'amour* (2001), *Adieu au langage* (2014) and *Le livre d'image* (2018), these later films for the most part didn't connect with audiences in the ways in which the director's early work most certainly did.

53

The 400 Blows
(*Les quatre cents coups*)

FRANCE, 1959

S.E.D.I.F.–Les Films du Carrosse. DIRECTOR: François Truffaut. 95 MINS.
FIRST SEEN: *Curzon, Mayfair, London, UK 14 May 1960.*

Paris. Twelve-year-old Antoine Doinel (JEAN-PIERRE LÉAUD) lives with his parents (CLAIRE MAURIER, ALBERT RÉMY) in a small apartment. Antoine and his best friend, René (PATRICK AUFFAY), constantly get into scrapes, frequently play truant, and think nothing of stealing money from their parents to finance their escapades. The final straw comes when Antoine tells his teacher (GUY DECOMBLE), as an excuse to explain his absence from school, that his mother has died; when his parents arrive at the school, exposing his lie, he is suspended for a week. He steals a typewriter from his father's office, but his attempts to sell it fail and he's caught when he tries to return it. His father takes him to the police station and he's sent to a centre for juvenile delinquents. His mother visits to tell him his father no longer has any interest in him. He runs away.

François Truffaut's feature film debut, which to some extent draws from his own childhood experiences in a reformatory, is one of the finest movies ever made about childhood. At the time the film was released Truffaut remarked that adolescence is only seen as a pleasant period by adults with short memories. He wrote the screenplay, collaborating with Marcel Moussy on the dialogue. The film, which takes place in mid-winter, is not concerned so much with narrative as it is with the small details that define the character of its youthful protagonist. Truffaut's own childhood experiences had taken place during the German Occupation of Paris, but he was unable to finance a film that involved the re-creation of that period and so he set the movie in the present.

The credits are printed over images taken from a vehicle as it travels through the backstreets of Paris with the Eiffel Tower poking its head above rooftops and warehouse buildings. The film proper opens in a schoolroom— a bit rundown and inhabited only by boys—where it's quickly established that, although he is strict, the master who teaches French literature can't

control these kids. Antoine is regularly punished ('Here Antoine Doinel suffered unfairly,' he writes on the wall behind the blackboard). 'What'll France be like in ten years?' moans the teacher as the boys act up (one kid, writing with a leaky pen, rips every page out of his notebook in exasperation).

At home Antoine, who is expected to put out the garbage and who defiantly dries his dirty hands on the curtains, lives in a love-hate relationship with parents who both work. He has no interest in sports, expresses a wish to go to sea (he's never seen the sea) and he loves the movies. He steals a photograph of Harriet Andersson in a scene from Bergman's *Sommaren med Monika/Summer with Monika* (1952) from a cinema display cabinet. One day, playing truant with René, he sees his mother embracing a strange man. Her reaction is to try to win over his affections, telling him that when she was his age she ran off with a shepherd boy. She allows him to sleep in his parents' bed for a night and offers him a prize if he comes in the top five of his class for writing a French essay. When he accidentally starts a fire—after lighting a candle in honour of Balzac, his literary hero—she defuses the tension by suggesting they all take a trip to the cinema (to see Jacques Rivette's *Paris nous appartient*, a rather demanding night out one would have thought). It's the only really happy evening Antoine spends with both his parents, and he's always made aware of the fact that they married because his mother fell pregnant with him.

Accused of plagiarism by his teacher, Antoine is suspended and sleeps over at the home of René, who has equally dysfunctional parents. When, after the typewriter incident, his father turns him in to the police, his childhood effectively comes to an end. The film's celebrated conclusion has him running away from the juvenile centre, the camera tracking alongside him until he reaches a beach, steps into the small waves and then turns to look directly into the eye of the camera, whereupon the image freezes. It's a device that's been used countless times since, but seldom as effectively as in this troubling conclusion to a truly touching portrait of a kid who isn't really bad, just unloved and bored.

Léaud is heartbreakingly good in the film, and at times also very funny. The moment when he attempts to copy a letter written by René's mother to the school to explain the boy's absence—but gets the name wrong—is typical of the film's knowing humour. There's a lovely scene in which he experiences a Rotor (a sideshow ride involving centrifugal force).

The film, beautifully photographed by Henri Decaë, is filled with humour—for example, the overhead shot of the children, who are being

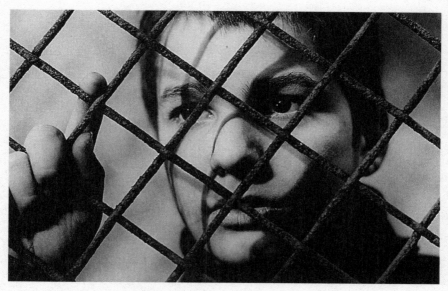

Jean-Pierre Léaud as Antoine Doinel in François Truffaut's *Les quatre cents coups*.

taken for a run through the streets by the sports master; they peel off in small group after small group until the oblivious man has only two kids following him. Such scenes are enlivened by Jean Constantin's catchy music score.

To cast the children in the film, Truffaut took ads in *France-Soir* in September and October 1958, and auditioned hundreds of youngsters. Léaud, who was 14 years old, was recommended by a friend—his mother was an actor and his father a screenwriter. After the success of *The 400 Blows*, Truffaut and Léaud continued to work together on films that charted Antoine's adult life, starting in 1962 with *Antoine and Colette*, an episode of the multi-part film *L'amour à vingt ans/Love at Twenty*, and continuing with *Baisers volés/Stolen Kisses* (1968); *Domicile conjugal/Bed and Board* (1970); and *L'amour en fuite/Love on the Run* (1979).

François Truffaut (1932–1984) became a film critic for the influential magazine *Cahiers du cinéma*, which, for a while, was edited by the much-respected film critic and theorist André Bazin, to whom *The 400 Blows* is dedicated. In 1954 he wrote a controversial polemic attacking traditional French films ('The Tradition of Quality') and directors. As a result he was refused accreditation to the Cannes Film Festival. Together with other writers for *Cahiers*, he turned to directing, first with the short film *Les Mistons* (1957) and then with *The 400 Blows*. Distinguished by their

cinematic skill, humour and emotion, his subsequent films included adaptations of American crime novels: *Tirez sur le pianiste/Shoot the Pianist* (1960); *La mariée était en noir/The Bride Wore Black* (1967); *La siréne du Mississippi/The Mississippi Mermaid* (1969); and his last film, *Vivement dimanche!/Finally Sunday!* (1983). He also filmed novels by French writers, including *Jules et Jim* (1962), *Les deux Anglaises et le continent* (1971) and *L'histoire d'Adèle H/The Story of Adele H* (1975); his only film made in English was an adaptation of Ray Bradbury's *Fahrenheit 451* (1966). Two of his most popular films were original screenplays: *La nuit américaine/Day for Night* (1975), in which Truffaut played a film director, and *Le dernier métro/The Last Metro* (1980), about the French Resistance.

His 1966 book, *Hitchcock/Truffaut*, consisted of lengthy interviews he conducted with his filmmaker idol: the book was turned into a film documentary in 2015. In 1977 he played a leading role, that of a French scientist, in Steven Spielberg's *Close Encounters of the Third Kind*.

His early death at the age of 52, soon after completing his last film, was caused by cancer of the brain.

North by Northwest

USA, 1959

MGM. DIRECTOR: **Alfred Hitchcock**. 136 MINS.

FIRST SEEN: *Odeon, Bath, UK 22 February 1960.*

New York. Twice-divorced Madison Avenue advertising man Roger O. Thornhill (CARY GRANT) is mistaken for George Kaplan, an American agent who has been on the trail of Communist spy Phillip Vandamm (JAMES MASON). Thornhill is kidnapped by a couple of Vandamm's goons and taken to the mountain-top home of Lester Townsend; when he refuses to cooperate—he, of course, has no idea who Kaplan is—he is almost killed, but manages to escape. Believing Townsend is the villain, he seeks him out at the United Nations building where he works as a diplomat, but Townsend (PHILIP OBER) is fatally stabbed before Thornhill can talk to him. On the run from the police who want him for the murder of Townsend, Thornhill takes the 20th Century Limited train for Chicago, which he knows to be the next destination of the mythical Kaplan. On the train he's seduced by Eve Kendall (EVA MARIE SAINT). Thornhill is unaware (a) that she's Vandamm's mistress and (b) that she's actually a US government undercover agent. Lured to a remote crossroads where he's supposed to meet Kaplan, Thornhill is attacked by a man piloting a crop duster but escapes. He is contacted by the Professor (LEO G. CARROLL), the head of the government spy agency, and agrees to help Eve complete her assignment.

North by Northwest was an affectionate throwback to the sort of films Hitchcock had made in Britain in the 1930s. Like the heroes of *The 39 Steps* (1935) and *Young and Innocent* (1937), Thornhill, played with debonair charm by Cary Grant, is hunted both by the villains and by the cops. And like them he has some outlandishly unlikely adventures, the most famous of which is his encounter with the crop duster, whose pilot is armed with a machine gun. This set piece, wonderfully staged as it is, makes no sense whatsoever in terms of the plot; Hitchcock, whose previous film, *Vertigo* (1958), was steeped in a doomed romanticism and whose next, *Psycho* (1960), would reinvent the horror film, was having fun with *North by Northwest*. The title is ostensibly a quote from *Hamlet* ('I am but mad north-north-west; when the wind is southerly I know a hawk from a handsaw') but it

also refers to Northwest Orient, the airline on which Thornhill and the Professor fly from Chicago to Grand Rapids, South Dakota.

Thornhill may be charming but, at the outset at least, he's pretty shallow. He has monogrammed handkerchiefs, and matchbooks with R.O.T. printed on them; when asked, he responds cheerfully that the 'O' stands for Nothing. 'I have a job, a secretary, a mother, two ex-wives and several bartenders dependent on me,' he proclaims. His mother, deliciously played by Jessie Royce Landis (who, in fact, was only eight years older than Grant) is equally sardonic ('You gentlemen aren't *really* trying to kill my son, are you?' she asks of the two goons Thornhill is attempting to escape as they, along with several other people, are packed into a hotel elevator). When she and Thornhill inspect Kaplan's hotel room her response to her son's revelation that the mystery man has dandruff is 'In that case, I think we should leave.'

Eva Marie Saint's femme fatale is the ultimate Hitchcock blonde. The scenes on the train are justly famous for the suggestive small talk provided by screenwriter Ernest Lehman. 'It's going to be a long night and I don't particularly like the book I've started,' she tells Thornhill soon after they first meet. As a come-on line it's hard to beat. Deep down, though, she's a sad character: she reveals she's suffered at the hands of men, like Thornhill, who don't believe in marriage. 'What do you mean?' he asks. 'I've been married twice.' 'See what I mean?' she replies.

James Mason's villain matches Grant's hero in British charm. Vandamm's motivations are not very clear—he seems to be planning to smuggle top-secret documents on microfilm into a Communist country—but he's so refined and urbane that it's a pity that his role is so small. Martin Landau, as his 'assistant', Leonard, is a marginally more interesting character: Hitchcock hints that he's gay (he talks about his 'women's intuition') and at one point Vandamm asks him if he's jealous of Eve. Leo G. Carroll's enigmatic Professor ('FBI, CIA, ONI—we're all in the same alphabet soup') is given the task of explaining the unlikely plot and asking Thornhill to cooperate. ('I'm an ad man, not a red herring!' says Thornhill) 'War is hell, even if it's a cold one,' the Professor reflects at one stage, and continues: 'I'm afraid we're losing it.'

Despite the film's length, Hitchcock keeps up the pace, dropping in revelations at regular intervals and inserting various 'big' moments: the knifing in the United Nations building (followed by an extraordinary overhead shot as Thornhill escapes onto the street); the aforementioned crop duster incident; the auction, where, finding himself trapped by Vandamm's men, Thornhill causes a disturbance with some crazy bidding that attracts

the police (a scene similar to one in *The 39 Steps*); the shooting in the café near the Mount Rushmore monument; and the cliff-hanging climax in which the main characters are dangling from the noses of former presidents (Hitchcock loved to stage scenes in famous locations). It's true that the ending is a bit perfunctory, and Vandamm's capture a bit of a letdown, but all is redeemed with the wonderfully cheeky conclusion back on the train: the lovers embrace and the express enters a tunnel!

Everything about *North by Northwest* is fun. The suspense is beautifully managed, and cinematographer Robert Burks (using the high-resolution, wide-screen vistaVision process pioneered by Paramount as a rival to CinemaScope) creates some wonderfully visual moments of frisson. The music by Bernard Herrmann is genuinely exciting, and Saul Bass' creative opening credit titles are a joy—the title 'Directed by Alfred Hitchcock' is immediately followed by the appearance of the filmmaker himself as he literally misses a bus.

Alfred Hitchcock (1899–1980) was one of the rare filmmakers who was known by name to the general public and was also revered by critics and other filmmakers. Extremely influential and constantly experimenting with the art form, Hitchcock began his career in London writing titles for silent films. He directed his first feature, *The Pleasure Garden*, in 1925. *The Lodger* (1926) was his first thriller and the most famous of his silent films. He made Britain's first talkie, *Blackmail* (1929), displaying rare invention in the use of the new medium. The thrillers that followed—*Murder!* (1930), *The Man Who Knew Too Much* (1934), *The 39 Steps* (1935), *Secret Agent* and *Sabotage* (both 1936) and *The Lady Vanishes* (1938)—made him internationally famous. His first Hollywood film was the Oscar-winning *Rebecca* (1940), which was followed by such classics as *Foreign Correspondent* (1940), *Suspicion* (1941), *Shadow of a Doubt* (1943), *Spellbound* (1945), *Notorious* (1946), *Rope* (1948, his first film in colour), *Stage Fright* (1950), *Strangers on a Train* (1951), *I Confess* (1953), *Dial M for Murder* (originally made in 3D) and *Rear Window* (both 1954), *To Catch a Thief* (1955), a remake of *The Man Who Knew Too Much* (1955), *The Wrong Man* (1956) and *Vertigo* (1958, which many think is the greatest American film ever made). *North by Northwest* was followed by *Psycho* (1960), *The Birds* (1963), *Marnie* (1964), *Torn Curtain* (1966), *Topaz* (1969), *Frenzy* (1972) and finally *Family Plot* (1976). Though some of his later films were disappointing, no Hitchcock film is without exceptional elements. He was undoubtedly one of the great filmmakers.

The Apartment

USA, 1960

United Artists–Mirisch Corporation. DIRECTOR: Billy Wilder. 125 MINS.
FIRST SEEN: *Regal. Newbury. UK 16 November 1960.*

New York. C.C. Baxter (JACK LEMMON), a junior employee at Consolidated Life, an insurance company, allows four company executives, all married men, to use his apartment at various times to 'entertain' their girlfriends because they have made vague promises of promotion. The arrangement comes to the attention of Jeff Sheldrake (FRED MACMURRAY), Director of Personnel, who orders Baxter to let him use the apartment. Baxter soon discovers that Sheldrake's girlfriend is elevator girl Fran Kubelik (SHIRLEY MACLAINE), to whom he is also attracted. On Christmas Eve Fran, given the brush-off by Sheldrake, who has gone home to his family, attempts suicide in the apartment; Baxter arrives home to find her unconscious. With the help of Dr Dreyfuss (JACK KRUSCHEN), Baxter's neighbour, Fran recovers. Sheldrake, whose wife has thrown him out, has plans to spend New Year's Eve with Fran but Baxter, who has been promoted to Assistant Director of Personnel, refuses to provide the key to his apartment and quits. On learning this from Sheldrake, Fran rushes to the apartment.

Very often the film that wins the Best Picture Oscar seems unworthy, but not in 1960 when Billy Wilder's masterpiece was the winner. With its basis in a very skilful original screenplay, written by the director and his frequent collaborator, I.A.L. Diamond, the film succeeds on any number of levels. Above all else it's a highly unconventional romance, played to perfection by Jack Lemmon and Shirley MacLaine, giving their finest screen performances. It's also a trenchant exposé of what would much later be called to attention through the Me Too movement: Consolidated Life, where the executives rarely seem to do any actual work, is peopled with middle-aged married men who have secret affairs with female staff members—secretaries, switchboard operators, elevator girls—over whom they have the power to hire and fire. The film brilliantly juggles scenes of high comedy with some of the most poignant and moving—yet unsentimental—scenes to be found in any Hollywood movie.

The sense of humour is established from the start in Baxter's voice-over as he sets the scene: 'On November 1, 1959, the population of New York City was 8,042,783. Consolidated Life employs 32,259. I work on the 19th floor in the Premium Accounting Division, desk 861. I've been with the company for three years and ten months. My pay is $94.70 per week. My hours are 8.50 to 5.20, but I often work late because, you see, I have this little problem with my apartment.'

It's Baxter's own fault, of course, and the way he closes his eyes to the predatory sexual behaviour of his superiors is despicable, but he's not a lost cause. When he falls in love with Fran Kubelik he becomes, in the words of wise Dr Dreyfuss, a *mensch*—a human being.

Early in the film Mr Kirkeby (DAVID LEWIS) is 'entertaining' Sylvia (JOAN SHAWLEE), who works on the switchboard. When they leave, Sylvia understandably objects to being dropped at a subway station and demands the taxi fare to her home in the Bronx. 'Why do all you dames have to live in the Bronx?' demands Kirkeby. 'You mean you bring other dames up here?' she asks. 'Certainly not,' he replies indignantly. 'I'm a happily married man.' Wilder and Diamond cut deep into the hypocrisy and mendacity of this sort of arrangement.

Once he gains access to his own apartment, Baxter tries to watch TV but there's nothing but westerns, or the almost 30-year-old *Grand Hotel*, which is constantly interrupted by advertisements for cigarettes or dentures. He's in bed, having taken a sleeping pill, when Mr Dobisch (RAY WALSTON) calls him to demand that he vacate the apartment: Dobisch has met a blonde (JOYCE JAMESON) who looks and talks like Marilyn Monroe (with whom Wilder had already made two very successful movies).

Notable among the supporting characters is Sheldrake's jealous and vengeful secretary, Miss Olsen (EDIE ADAMS), who is one of his former mistresses. ('He used to tell his wife I was the Branch Manager from Seattle!') Incisive, too, are the portrayals of the four womanising executives, especially Kirkeby who, denied access to the apartment, complains bitterly when he's forced to borrow his nephew's VW and take Sylvia to a drive-in in New Jersey ('Get yourself a bigger car or a smaller girl,' she tells him).

Dr Dreyfuss, his wife, Mildred (NAOMI STEVENS), and landlady, Mrs Lieberman (FRANCES WEINTRAUB), are testy but very good-hearted Jewish characters who might, in a lesser film, be caricatured. The same can be said for Mrs Margie MacDougal (HOPE HOLIDAY), a lonely wife Baxter meets in a

bar on Christmas Eve; her husband, she explains in a voice comparable to that of Jean Hagen's Lina Lamont in *Singin' in the Rain* (1952), is a jockey imprisoned in Cuba for doping a horse; she complains that she wrote to Castro—'that big shot'—but he never replied.

The film's conclusion is nothing short of sublime. Baxter, who has quit his job and is resigned to losing Fran, is packing his things to move. Fran discovers from Sheldrake that Baxter refused to let him use the apartment again, 'especially with Miss Kubelik'. A lovely smile appears on her face, and as 'Auld Lang Syne' plays in the Chinese bar where she always meets her lover, she dashes out into the night, arriving breathlessly at the apartment as she hears a loud bang: it turns out to have been the popping of a champagne cork. She sits next to Baxter on the sofa as he gets out the gin rummy playing cards. 'I absolutely adore you, Miss Kubelik,' he tells her. 'Shut up and deal,' she replies. The End. A year before, the last line of Wilder's *Some Like it Hot* ('Nobody's perfect') was an equal combination of the pithy, the funny and the touching.

The five Oscars the film won—for Best Film, Direction, Screenplay, Production Design (by veteran Alexander Trauner) and Editing (Daniel Mandell) were all very well deserved. It was a pity, though, that none of the wonderful actors was similarly recognised.

I was fortunate enough to meet Wilder a couple of times and appreciated his very dry, German-accented wit. On one occasion I was wearing a tie decorated with elephants. 'Don't tell me you vote Republican?' he demanded.

Billy Wilder (1906–2002) started his career as a sportswriter and crime reporter in Berlin before his involvement in the film industry. He fled Nazism and directed his first film, *Mauvaise graine/Bad Seed*, in France in 1933. In America he partnered with Charles Brackett on a number of clever screenplays before he was able to direct *The Major and the Minor* (1942), a cheeky comedy in which Ginger Rogers poses as a young girl—Wilder often pushed the boundaries of censorship in his films. *Double Indemnity* (1944), in which Fred MacMurray plays another memorable bad guy, is one of the greatest of all films noir. *The Lost Weekend* (1945) deals with alcoholism and *A Foreign Affair* (1948) is set in post-war Germany. *Sunset Blvd.* (1950) is a withering satire on and critique of Hollywood, while *Ace in the Hole* (1951) attacks gutter journalism. Some entertaining but more conventional films followed: *Stalag 17* (1953), *Sabrina* (1954), *The Seven Year Itch* (1955), *The Spirit of St. Louis*, *Love in the Afternoon* and *Witness for the Prosecution* (all 1957) and *Some Like it Hot* (1959, which is considered

by many to be the funniest ever comedy). After *The Apartment* there was more biting comedy—*One, Two, Three* (1961), *Irma la Douce* (1963, reuniting Lemmon and MacLaine), *Kiss Me Stupid* (1964, which fell foul of censors the world over), *The Fortune Cookie* (1966), *The Private Life of Sherlock Holmes* (1970), *Avanti!* (1972) and *The Front Page* (1974). His final films were *Fedora* (1978) and *Buddy Buddy* (1981).

Cleo from 5 to 7

(*Cléo de 5 à 7*)

FRANCE/ITALY, 1961

Rome-Paris Films. DIRECTOR: Agnès Varda. 89 MINS.
FIRST SEEN: *Australian Commonwealth Film Censorship Office, Sydney, 20 April 1966.*

Paris, Tuesday, 21 June. Florence, aka Cléo (CORINNE MARCHAND), a young singer with three hit-single recordings to her credit, has her fortune told. The fortune-teller (LOYE PAYEN) tells her she has a close woman friend who is a 'questionable influence'; that she is a musician; that she has little hope of marriage; that she's about to depart on a journey; and that she will experience change and suffering. After Cléo's departure, the fortune-teller says to a male colleague: 'I saw cancer. She is doomed.' In fact, Cléo is awaiting news of the results of some recent medical tests. Accompanied by her friend Angèle (DOMINIQUE DAVRAY), she goes shopping and buys a hat, returning home for a meeting with Bob (MICHEL LEGRAND), a songwriter. She is briefly visited by her workaholic lover, José (JOSÉ LUIS DE VILALLONGA), and then goes to a studio where her friend Dorothée (DOROTHÉE BLANCK) poses naked for sculpture students. She accompanies Dorothée to the cinema where Dorothée's boyfriend, Raoul (RAYMOND CAUCHETIER), works as a projectionist, and they watch a short silent comedy from the projection box. After breaking her mirror, Cléo goes for a walk in a park and encounters Antoine (ANTOINE BOURSEILLER), a talkative young soldier on leave from Algeria. He accompanies her to the hospital to receive her test results. Dr Valineau (ROBERT POSTEC) tells her that two months of chemotherapy will cure her.

Agnès Varda's second feature purports, somewhat misleadingly, to depict two hours in the life of a woman awaiting confirmation that she has cancer; in fact, the action unfolds in less than an hour and a half, and is divided into twelve chapters, each one dedicated to a character—most of them to Cléo, but also to Bob, Dorothée, Raoul, Antoine and, in one case, to 'Several Others'—with each chapter lasting a few minutes. As a portrait of a young woman under stress, the film is a remarkable achievement. Seldom off-camera, Corinne Marchand's Cléo is placed under a microscopic gaze so that we learn a great deal about her in a very short

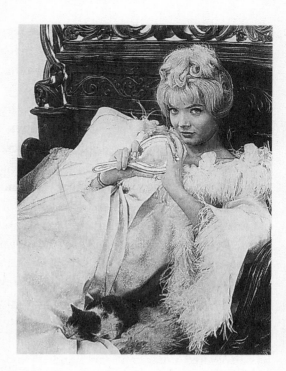

Two fateful hours in the life of a young woman: Cléo (CORINNE MARCHAND) in Agnès Varda's *Cléo de 5 à 7*.

time. She's superstitious, exhausted, mercurial, frightened, capricious and lonely—despite the support of her friends and colleagues. She lives in a light and airy apartment with a family of cats. She's clearly searching for something she can't find in her unreliable lover, José, who drops in for a quick, rather patronising, visit when he can spare a moment.

Cléo is self-conscious about her musical prowess. Riding in a taxi, she asks the driver to turn off the radio because it's playing one of her own songs and she can't bear to listen to it; later she goes into a café and plays another of her songs on the jukebox before leaving abruptly, perhaps because nobody seems to be listening. Bob, the songwriter—played, in a rare on-screen appearance, by one of the great composers of music for French cinema, Michel Legrand—sings a couple of songs for her before she gives an emotional rendition of the lovely 'Sans toi' ('Without You'), which becomes the film's theme. Yet later she erupts in anger, accusing Bob and his co-composer of trying to exploit her.

References to the Algerian War that was tearing France apart at the time abound: there are half-overheard conversations in the bars and cafés in which Algeria is the main topic, and the sympathetic Antoine is on

leave from the war. On the news there are reports of riots and demonstrations—and news of a summit meeting between Kennedy and Khrushchev. Beneath the surface of the City of Light on this lovely summer's day, something seems to be going wrong.

As Cléo wanders the streets of Paris on this, the first day of summer— and longest day of the year—she encounters 'ordinary' people with their private concerns (lovers arguing about where to meet, two women with small babies) and some 'eccentrics'—like one man who swallows live frogs and another who pierces his arm with a blade. A woman who works in the hat shop where Cléo, despite the advice of Angèle, purchases a winter hat (that she later gives to Dorothée) recognises her and requests her autograph. In the end she confesses that 'today everything amazes me'. In fact, this hour and a half proves to be a period during which she moves from being more afraid than ever before (as she reveals in the first café, where she bursts into tears) to becoming so relaxed in the company of Antoine, who calls her Florence, that she admits 'I think my fear is gone. I think I'm happy.' Maybe it's not exactly a case of love conquering all, but Cléo has discovered a new confidence and expanded her horizons.

There is an amusing interlude in the scene in the cinema where Raoul works (the feature screening is Richard Brooks' *Elmer Gantry*). A three-minute silent short film is part of the program, giving Varda a chance to indulge in a cheerful homage to vintage movie slapstick. The cast of this minor gem includes Jean-Luc Godard as the Hero, Anna Karina as the Heroine, and Eddie Constantine as a Man with a Hosepipe.

One of the film's chief pleasures is Jean Rabier's camerawork and its extensive coverage of Paris; the city itself becomes a protagonist in the story—its boulevards, shopping streets, backstreets, parks and, above all, its people, all photographed with loving affection. Many scenes are filmed from moving vehicles—taxis (one driven by a woman), a bus and the ancient car belonging to Raoul that Dorothée drives—rather nervously as she's only just passed her driving test.

I am fortunate to have met Agnès Varda several times over the years, first in the company of her husband, the equally talented Jacques Demy, and later, after Demy's early death, at various festivals and in Paris. She has visited my home in the NSW Blue Mountains (she preferred very weak tea to coffee and, not surprisingly, loved cats) and we enjoyed many enchanting conversations. As the only woman who came to the fore at the time of the

French *Nouvelle Vague*, she had a fund of stories to tell and knowledge to impart.

Agnès Varda (1928–2019) was born in Brussels and worked as a photographer before she made the pioneering feature film, *La Pointe Courte* (1954). After *Cléo* she made several impressive dramatic feature films—*Le bonheur/ Happiness* and *Les creatures* (both 1965); *L'une chante l'autre pas/One Sings, the Other Doesn't* (1977); *Sans toit ni loi/Vagabond* (1985); and *Jacquot de Nantes* (1991), a semi-fictionalised film about Demy. In America she made *Lions Love* (1969), a film about the counter-culture of the late 60s. But she effectively abandoned features in favour of documentaries, and made some very significant ones, including *Loin de Vietnam/Far from Vietnam* (1967); *Daguerreotypes* (1975), about the inhabitants of Rue Daguerre, the Paris street where she lived; *Jane B par Agnes V* (1987), a portrait of Jane Birkin; *Les glaneurs et la glaneuse/The Gleaners and I* (2000); *Les plages d'Agnes/The Beaches of Agnes* (2008); *Visages villages/Faces Places* (2017); and finally *Varda par Agnes* (2019).

The Day the Earth Caught Fire

UK, 1961

--

Pax–British Lion. DIRECTOR: Val Guest. 99 MINS.

FIRST SEEN: *Gaumont, Swindon, UK 19 February 1962.*

--

London. At the Fleet Street headquarters of the *Daily Express*, science editor Bill Maguire (LEO MCKERN) becomes concerned with stories about huge earthquakes in Indonesia, sunspots and an unusual amount of flooding in the wake of the latest American nuclear test in the Antarctic. When it is revealed that the Soviet Union also tested a larger than usual nuclear bomb in Siberia at almost exactly the same moment as the American explosion, alarm bells start ringing. Sent to investigate at the Met Office, alcoholic reporter Pete Stenning (EDWARD JUDD) is fobbed off with non-answers and succeeds in alienating Jeannie Craig (JANET MUNRO), one of the junior staff members. An unscheduled eclipse of the sun causes more concern; torrential rain floods the Libyan Desert and Western Australia is covered in water. A strange fog envelops England and some other countries, and it becomes considerably hotter. Water is rationed and fires break out in Covent Garden and in a number of state forests. Eventually the Prime Minister announces that the Earth has been jolted from its axis and is heading closer to the sun. The world powers agree to explode four nuclear bombs simultaneously in Siberia in an attempt to halt the passage of the Earth, but there is no guarantee this will succeed.

'In about four months there's going to be a delightful smell of charred mankind,' quips the cynical Maguire. *The Day the Earth Caught Fire* is perhaps the best sci-fi film ever to emerge from Britain and deals with climate change a long time before the concept was widely discussed. The reasons for global warning may be different—the unfortunate coincidental testing of US and Soviet nuclear devices simultaneously—but the result is the same: drought in some parts of the world and floods in others; the rationing of water; raging, uncontrolled fires; and a bleak future for humanity. This cautionary tale, with its unresolved conclusion, also happens to be one of the finest movies ever made about how a great newspaper works. Much of the film was shot at the offices and printing works of the *Daily Express* in Fleet Street; the former editor of the *Express*, Arthur

Christiansen, was Technical Adviser and also plays Jefferson, the editor. The depiction of the way in which the newsroom works, seemingly chaotic but actually very controlled, seems completely authentic, and the actors who appear as members of staff—Bernard Braden as the news editor, Michael Goodliffe as the night editor, Peter Butterworth as a copy writer and many more—also convince as being close to the real deal.

When Jefferson calls for conferences in his office, rapping out orders and getting VIPs on the phone to quiz them, there's a sense that his senior staff members always sat in the same places and reacted in similar ways to the crisis. There's a compelling moment when Jefferson phones the paper's owner, presumably Lord Beaverbrook, to bring him up to date, and then calls his own home to speak to his wife and update her on the latest situation.

Edward Judd's bitter Pete is also a richly drawn character. We discover that, some time before, he had returned home unexpectedly and found his wife, Angie (RENÉE ASCHERSON), with another man; they divorced and she won custody of his seven-year-old son, Michael (IAN ELLIS), who Pete is allowed to see only for short periods, usually at the Battersea funfair. Pete previously wrote a well-promoted column in the *Express*, but now he's kept on the paper as little more than a copy boy, though Bill—whose car he regularly borrows—covers for him.

On the opposite side of Fleet Street from the *Express* office is Harry's Bar, a home away from home for members of the press; Harry (REGINALD BECKWITH) and his loyal barmaid, May (GENE ANDERSON), are as much fixtures of this world of newspapers as the men who run the printing presses and who, resignedly, cop the imposition of a last-minute reworking of the front page when a new story breaks.

When the film was made, British movies were becoming franker about sex (*Saturday Night and Sunday Morning* had opened a few months earlier). The scenes with Janet Munro's Jeannie and jaded, in-for-the-main-chance Pete leave surprisingly little to the imagination. But, like the rest of the film, they are so well written—by director Val Guest and writer Wolf Mankowitz—that clichés are avoided. In fact, the dialogue is an almost nonstop series of cynical quips, humour that leavens the essentially grim and foreboding narrative.

The special effects are mostly very successful, especially considering when the film was made. Newsreel footage of floods, fires, heavy snow-storms, cyclones and droughts are skilfully intercut, and the film, superbly photographed by Harry Waxman, is bookended by sequences tinted in red

that really give a feeling of heat—that plus the profuse sweating by most members of the cast.

The film taps into the worldwide concern brought about by the Cold War (Stanley Kramer's post-apocalyptic *On the Beach* was made two years before, and the Cuban Missile Crisis was about to frighten the world). A real Campaign for Nuclear Disarmament (CND) demonstration is included and public feelings about atomic testing provide a powerful subtext. But a contemporary audience would also recognise the film's concerns. When the Prime Minister speaks glibly to the nation about the changing weather ('Some seasons may be disturbed or increase their intensity'), he goes on to say that 'The world's scientists can produce solutions for any of the problems we are likely to meet,' demonstrating a trust in science that some of today's leaders still fail to accept. 'People don't care about the news until it becomes personal,' sighs Jefferson, and that's another truism that makes this film resonate today as much as it ever did.

Apart from a misjudged scene of teenage rioting (accompanied by beat music), the film works beautifully on every level: as science fiction, as a newspaper story, as a story about a shattered man trying to get his life back together, as a story of friendship in a time of great crisis. The ending (two newspaper front pages, one reading 'World Saved', the other 'World Doomed') is a sobering conclusion to a very fine movie.

Val Guest (1911–2006) was a journalist who worked for a while in Los Angeles (on *The Hollywood Reporter*). His alarmingly uneven career commenced and concluded with embarrassingly poor comedies (his first: *Miss London Ltd*, 1943; one of his last: *Confessions of a Window Cleaner*, 1974). In between he made a couple of outstanding sci-fi movies, *The Quatermass Xperiment* (1955) and *Quatermass II* (1957), both based on successful BBC television series. He made some competent thrillers (*They Can't Hang Me*, 1955; *The Weapon*, 1956; *Hell is a City*, 1959; *Jigsaw*, 1962; *80,000 Suspects*, 1963) and unusually graphic war films (*The Camp on Blood Island*, 1957; *Yesterday's Enemy*, 1959) but also some feeble comedies (*Carry on Admiral*, 1957; *Up the Creek*, 1958; *Au Pair Girls*, 1972). He remains an enigma, but his best films are impressive on any number of levels and *The Day the Earth Caught Fire* is the best of them.

58

Viridiana

SPAIN/MEXICO, 1961

UNICI SA–Gustavo Alatriste PC–Films 59. DIRECTOR: Luis Buñuel. 91 MINS.
FIRST SEEN: *Tatler, Bristol, UK 31 May 1962.*

Spain. Viridiana (SILVIA PINAL), a young novice, is about to take her final vows. The Mother Superior (ROSITA YARZA) orders her to go to visit her sickly uncle at his country estate; although she has not seen him for a long time, he has supported her financially. Don Jaime (FERNANDO REY) lives with his housekeeper, Ramona (MARGARITA LOZANO), and still grieves over his wife who died in his arms on their wedding night. Viridiana reminds him so much of her that he pleads with her to stay with him, persuading Ramona to drug her after Viridiana has reluctantly agreed to dress in his wife's wedding gown. If he was planning to rape Viridiana, he is unable to go through with it but he lies to his niece, telling her he has seduced her, and then hangs himself. Feeling disgraced and unable to return to the convent, Viridiana inherits the estate, which she shares with Jorge (FRANCISCO RABAL), Don Jaime's son, who soon arrives with his girlfriend, Lucía (VICTORIA ZINNY). While Jorge plans to restore the neglected property, Viridiana invites a number of homeless beggars to shelter on part of the estate. Lucía soon leaves. While Viridiana and Jorge are in town the beggars enter the main house, cook a feast of lamb and wreck the place. The police eject them. Viridiana joins Jorge and Ramona, who has become Jorge's mistress, in his room, ostensibly to play cards.

Luis Buñuel's reputation was forged at the end of the silent era when he made the anarchic films *Un chien Andalou* (1929) and *L'age d'or/The Golden Age* (1930) in Paris in collaboration with Salvador Dalí. Forced into exile by the Spanish Civil War and the dictatorship of Franco, he settled in Mexico where he made a series of increasingly powerful films. In 1960 he was invited back to Spain where he made this extraordinary, deeply philosophical and fearlessly controversial work. The film was completed in time to premiere on the final day of the 1961 Cannes Film Festival as the official Spanish entry; it shared the festival's top Palme d'Or award, but reviews in the Catholic press were scathing and before it could be seen in Spain it was banned, and remained so for many years. To the eternal

shame of the authorities in Australia at the time, it was also banned in this country, on the grounds of blasphemy. Thus three of the most important and creative films made between 1955 and 1961—*The Night of the Hunter*, *À bout de souffle/Breathless* and *Viridiana*—were banned, a truly shameful state of affairs.

Buñuel's approach to the story seems straightforward enough. Viridiana (from the Latin *viridium*, meaning 'a green place', and there really was a Saint Viridiana) is not only innocent: she is kind and charitable and unworldly. She is too good to be true, in fact, and every good deed she attempts backfires. She agrees to wear the wedding dress in which her aunt died in order to please her lonely uncle, but she only succeeds in inflaming his passions so that he very nearly rapes her, although she can hardly be held responsible for sleepwalking in her nightdress, which also excites the old man. Don Jaime, who also seems inordinately interested in Rita (TERESA RABAL), Ramona's young daughter, hangs himself with the child's skipping rope when Viridiana insists on leaving—later that same skipping rope is used as a belt by the beggar who rapes Viridiana while she clutches its phallic-looking handle. Earlier, Viridiana had baulked at milking a cow whose udders looked remarkably phallic. Jorge, who is not overly concerned when Lucía decides to leave the estate, enjoys going through his father's belongings, especially when he discovers a crucifix that is combined with a penknife (Buñuel actually purchased this bizarre object in a local shop). Jorge is also given to acts of kindness. Seeing a dog tethered beneath a cart—because its owner doesn't believe it should ride with the passengers—he spontaneously purchases the animal; but the very next cart to drive by has another such dog tethered in exactly the same way.

The beggars are surprised and grateful to be invited to live in a part of the grand house, but they very quickly take advantage of the situation. Viridiana's charity doesn't prevent her violation at their hands. A scene in which she leads the beggars in prayer is intercut with Jorge's labourers working on the dilapidated buildings—the symbolism may be obvious but it's powerful. The bleak final scene was not in the original screenplay, which had Viridiana join Jorge in his room. That was thought to be too much for the censors but the scene that replaced it, suggesting a *ménage à trois*, is even more scandalous.

Throughout his career Buñuel returned to the same themes and symbols. There are obsessions with insects (a bee drowning in a water barrel), shoe

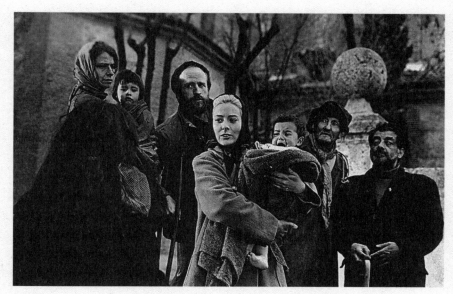

Viridiana (SILVIA PINAL) and the beggars she shelters in Luis Buñuel's *Viridiana*.

fetishism (Don Jaime putting on his dead wife's satin-covered high-heeled shoe), cross-dressing (he also wears her corset), religious artefacts (Viridiana travels with a crown of thorns in her suitcase—which is later burnt—and also carries nails and a hammer with her), ashes strewn over a bed cover and, most famously, the travesty of Da Vinci's *The Last Supper* at the beggars' banquet.

The message seems to be this: charity with strings attached will not only fail in the end but may well be counterproductive. As one beggar puts it before leaving: 'I can't stand this piety.' Human nature being what it is, purity is an endangered attribute. As Buñuel once said: 'Thank God I'm an atheist!' Yet his films show respect for the true believers; it was the hypocrites and bigots that he despised.

The only occasion on which I met Buñuel was in Los Angeles in November 1972, the night his film *Le charme discret de la bourgeoisie/ The Discreet Charm of the Bourgeoisie* was receiving its American premiere at the Chinese Theatre. The organisers of the event had mislaid a reel of the film, and the screening was delayed while they searched for it. He was happy to talk about his films while we waited and was kind enough to sign a book of his screenplays. The following day George Cukor hosted a lunch where Buñuel was the guest of honour and where the guest list also included another important Catholic director, Alfred Hitchcock.

Luis Buñuel (1900–1983) founded a film society in Madrid in 1920 and joined the avant-garde artists in Paris at the end of the decade. His first mainstream feature, *Gran Casino* (1947), was made in Mexico. He came to international attention in 1951 with *Los olvidados,* a devastating depiction of Mexico City slum children. *El* (1952) was a portrait of a sadist and *Abismos de pasión* (1954) was a transgressive version of *Wuthering Heights*. *Ensayo de un crimen/The Criminal Life of Archibaldo de la Cruz* (1955) and *Nazarin* (1958) confirmed his reputation. After *Viridiana* he made only one more feature film in Mexico—*El ángel exterminador/The Exterminating Angel* (1962). The rest of his career took place in Europe, mainly France, where he made *Le journal d'une femme de chambre/The Diary of a Chambermaid* (1964), *Belle de jour* (1967) and *La voie lactée/ The Milky Way* (1968). He returned to Spain for *Tristana* (1970), and then made *Le charme discret de la bourgeoisie* (1972), *Le fantôme de la liberté/ The Phantom of Liberty* (1974) and *Cet obscur objet du désir/That Obscure Object of Desire* (1977).

59

Advise & Consent

USA, 1962

Columbia. DIRECTOR: Otto Preminger. 138 MINS.
FIRST SEEN: *Odeon, Bath, UK 9 October 1962.*

Washington, DC. Knowing he hasn't long to live, the President of the USA (FRANCHOT TONE) nominates as Secretary of State Robert A. Leffingwell (HENRY FONDA), a controversial left-wing academic. Robert Munson (WALTER PIDGEON), the Senate Majority Leader, has the task of acquiring enough votes to get the nominee approved when the Senate members are asked to 'advise and consent' on the appointment. Brigham Anderson (DON MURRAY) is appointed chairman of the Foreign Relations Sub-Committee that will conduct a hearing into the nomination. Senator Seabright Cooley (CHARLES LAUGHTON), of South Carolina, though he belongs to the President's party, is strongly opposed to Leffingwell and, at the hearing, produces Bernard Gelman (BURGESS MEREDITH), who claims that Leffingwell taught him at the University of Chicago and that he was a Communist. Leffingwell easily destroys the hapless Gelman's evidence, but admits to Munson and the President that, in doing so, he lied under oath, and asks that his nomination be withdrawn. The President refuses. The happily married Anderson finds himself being threatened by a blackmailer who knows about a homosexual liaison he had during the war. Anderson commits suicide. When the nomination comes to a vote there is a tie; before the Vice-President (LEW AYRES) can give his casting vote, news of the President's death is announced.

Made during the year of the Cuban Missile Crisis and the period of the Kennedy presidency, *Advise & Consent*, which was adapted from a best-seller by Allen Drury and scripted by Wendell Mayes, is one of the finest of all political dramas. Centring around the upheavals created by an ailing President's controversial nomination for Secretary of State, the film, which was shot on the streets and in some of the public buildings in Washington, has a strong feeling of authenticity, even down to small details, such as the shuttle train that speeds the senators to the floor of the house when a quorum is called. The practically flawless cast has been unusually well chosen, with attention given to the smallest roles, including Will Geer as the minority leader, Edward Andrews as his deputy, Peter Lawford as a

womanising senator (a role for which he was apparently well qualified) and Gene Tierney as party-giver and socialite Dolly Harrison. In this company, a few names stand out: Henry Fonda, who was peerless when it came to portraying liberal thinkers; Walter Pidgeon as the politician who has seen it all; and, above all, Charles Laughton—who was sick with cancer during the filming of what proved to be the final performance of a most illustrious career—as the senator from South Carolina who 'abominates' the President's nominee because 'He will pursue a policy of appeasement.' Leffingwell counters, describing the 'old curmudgeon' as having 'a closed mind and an aged crust of prejudice'.

We see during the course of the drama that the Senate is evenly divided between left and right, and also that there is no such thing as 'the party line' as it is known in the Westminster system. Some senators are loyal to their party, but others, like Cooley, seem to relish making trouble for their own team. At the polar opposite to Cooley's right-wing convictions are the sinister tactics of Senator Fred Van Ackerman (GEORGE GRIZZARD), depicted as a fanatical man of the left who has formed his own Peace Party.

Leffingwell is far from an idealised figure. While his official platform is that 'We must not bind ourselves to the outworn principles of the past', he privately admits that he had once flirted with Communism (Will Geer had been blacklisted for once being a member of the party), but, apparently unable to explain the company he kept when he was at university in the heated atmosphere of the Senate hearings, resorts to destroying the evidence of the confused Gelman while lying himself about some of the details. Cooley is wise to him, and he is depicted as a nobler adversary than the fanatical Van Ackerman, who is clearly behind the blackmail that drives Anderson to cut his own throat. In this context it's worth noting that the scene in which Anderson makes a flying trip to New York to track down the blackmailer contains one of the first representations of the gay scene in a mainstream American film. At the address supplied by his wartime lover, Anderson finds the obese Manuel (LARRY TUCKER) in an over-decorated apartment filled with cats; Manuel sends him to Club 602, a gay bar where a Frank Sinatra torch song is heard and where Anderson recoils in horror at seeing his former buddy, surrounded by like-minded friends, in his natural environment.

The other fascinating character in the film is that of the Vice-President, Harley Hudson, beautifully portrayed by Lew Ayres (who was also blacklisted for a while, apparently because the star of *All Quiet on the Western Front* (1930) was a conscientious objector during World War II). Complaining that

he hasn't spoken to the President for weeks, that he's kept in the dark, that no one listens to what he's saying, Hudson confides to Munson that 'I'm not sure I've got the stuff to be president'. Yet he visibly assumes the dignity of the office when, at the end, he learns of the incumbent's death. It's clear throughout that Hudson disapproves of the President's obstinate refusal to back down on the Leffingwell nomination, a refusal that is creating a split in the party and boosting the ambitions of the devious Van Ackerman.

Filled with intrigue on any number of levels, *Advise & Consent* is *the* film for the political junkie. It's a film about powerful men who believe themselves to be principled but who, in most cases, come to question themselves as the drama unfolds.

Otto Preminger (1906–1986) was born in Vienna, started acting as a teenager, and became a film and theatre director in Germany before the Nazis rose to power. His first feature was *Die grosse Liebe* (1931), but it would be five years before he made a second, and *Under Your Spell* (1936) was produced in Hollywood. He became famous for thrillers, consummately produced films noir like *Margin for Error* (1943), *Laura* (1944, which was started by Rouben Mamoulian), *Fallen Angel* (1945), *Whirlpool* (1949), *Where the Sidewalk Ends* and *The Thirteenth Letter* (both 1950) and *Angel Face* (1952). He also made romantic comedies and musicals: *In the Meantime, Darling* and *Czarina* (both 1944), *Centennial Summer* (1946) and *The Fan* (1949). His adaptation of the novel *Forever Amber* and the romantic melodrama *Daisy Kenyon* were both made in 1947. Preminger became famous—or notorious—for challenging the censorship imposed by the US Production Code. Against the Code's advice he made a film version of a play, *The Moon is Blue* (1953), that contained the kind of dialogue the censors at the time wouldn't allow, words like 'virgin' and 'seduce'. He won that battle and later challenged the censors with *The Man with the Golden Arm* (1955) and its depiction of a heroin addict, played by Frank Sinatra. Meanwhile he continued to make a wide variety of films, including musicals (*Carmen Jones*, 1954; *Porgy and Bess*, 1959), a western (*River of No Return*, 1954), a classic filmed play (*Saint Joan*, 1957) and filmed novels: *Bonjour tristesse* (1957), *Anatomy of a Murder* (1959), *Exodus* (1960), *The Cardinal* (1963), *In Harm's Way* and *Bunny Lake is Missing* (both 1965) and *Hurry Sundown* (1966). His later films, which were inflated and stodgy, included *Skidoo* (1968), *Tell Me That You Love Me, Junie Moon* (1969), *Such Good Friends* (1971) and *Rosebud* (1975), but his final film—an adaptation of Graham Greene's *The Human Factor* (1979)—was a significant return to form.

A Kind of Loving

UK, 1962

Anglo Amalgamated–Vic Films. DIRECTOR: John Schlesinger. 107 MINS.
FIRST SEEN: *The Regal. Gloucester, UK 8 May 1962.*

An unnamed city in the North of England. Vic Brown (ALAN BATES) works as a draughtsman at Dawson & Whittakers. He is attracted to Ingrid Rothwell (JUNE RITCHIE), a 19-year-old who works in the factory's typing pool. They go out on a few dates and eventually, while her controlling mother (THORA HIRD) is away, she allows him to have sex with her in her living room. As a result she becomes pregnant and Vic, setting aside his dreams of travel and adventure, reluctantly agrees to marry her. They move into her mother's house, where Vic is treated as no more than a lodger. Ingrid suffers a miscarriage after a fall. Unable to cope anymore with the snobbish selfishness of Mrs Rothwell, Vic leaves, but gets no sympathy from his beloved older sister, Christine (PAT KEEN), or his working-class parents (BERT PALMER, GWEN NELSON). He meets Ingrid and they decide to rent a shabby apartment (with shared bathroom) as a way of escaping from Ingrid's mother.

A Kind of Loving marked the peak of the so-called British 'kitchen sink' movement that got underway in 1957 with J. Lee Thompson's *Woman in a Dressing Gown* and continued with Thompson's *No Trees in the Street* (1958), Jack Clayton's *Room at the Top* (1958), Tony Richardson's *Look Back in Anger* (1959), Karel Reisz's *Saturday Night and Sunday Morning* (1960) and Richardson's *A Taste of Honey* (1961). All these fine films, released at roughly the same time as a progressive period in English theatre and literature, represented a shift from stories set in London and the Home Counties to stories located in the Midlands and North—and the films introduced a new school of talented young actors—Albert Finney, Tom Courtenay, Rita Tushingham and Alan Bates among them—to bring to life people from backgrounds that had rarely been explored previously in British cinema.

The first feature directed by former actor and TV documentary director John Schlesinger, *A Kind of Loving* has a strong documentary feel—an attention to detail, a dedication to truth and realism—so that its small story about very 'average' people is transformed into a profound drama. At a time before the introduction of the birth-control pill, when 'dating'

was frustrating for young people of both sexes, the film captures with pinpoint accuracy the mixed feelings of both Vic and Ingrid as their love affair progresses. 'It's rotten being a girl sometimes,' complains Ingrid after Vic has temporarily dumped her because she won't 'do everything', and with nowhere to go to find privacy, except the cinema, or a draughty hut in the middle of a windswept park, it's no wonder they're unhappy. Even access to contraception is a challenge: anticipating 'success', Vic goes to a chemist's to buy condoms, but is discomfited when, because the male chemist is occupied with another customer, his female assistant offers to serve him—he's too embarrassed to tell her what he came for and leaves empty-handed (a scenario that would have been all-too-familiar to young men during the period when I was growing up).

The film was adapted, by Keith Waterhouse and Willis Hall, from a novel by Stan Barstow, and truth and realism are its hallmarks—the North Country expressions, minutely observed, include referring to family members as 'Our Dad', 'Our Vic', 'Our Christine'.

Vic, whose dad is an engine driver, is upwardly mobile and ambitious. He's proud of his parents, who've had it tough, and devoted to his older sister, whose church wedding to David (DAVID MARLOWE) opens the film. The couple now live in a small but comfortable flat, and Vic longs to meet a girl just like Christine. Ingrid is not that girl—how could she be, with a mother as ghastly as Mrs Rothwell, who is incarnated in a dazzling performance from Thora Hird.

Their first date, where they kiss in the cinema, is a promising start, but on their second evening together Ingrid brings along her friend, Dorothy (PATSY ROWLANDS), a dim-witted gossip, who seems to derive pleasure from undermining Vic. Later, in a café, as Ingrid talks about the latest TV show she's seen, Vic's eyes wander—to an apparently happy couple at another table, and to a group of blokes enjoying time together. Even before the sex, the relationship seems doomed.

Ingrid, like her mother, chatters nonstop, is addicted to TV game shows, gossips and generally adopts a middle-class Tory attitude to anyone she deems to be 'beneath' her. Mrs Rothwell behaves appallingly towards window cleaners, postmen and other 'lesser' beings she refers to as 'those people'. She complains about unions holding the country to ransom ('Look at the mines!') until an exasperated Vic explodes: 'Don't talk so wet, woman. You make me sick.' And, after a drunken night with a mate, he really *is* sick, all over Mrs Rothwell's new carpet. For Vic, living with his odious

mother-in-law—who won't even let him have a key to the house—becomes increasingly untenable until he snaps.

Denys Coop's superb black and white photography of this industrial landscape—filmed mainly in Preston and Bolton—emphasises the dismal weather, the dank, smoke-filled streets by the railway line, the rows of suburban houses on top of the hill above town where the Rothwells live, and the cobbled streets and rows of tiny houses like the one in which Vic grew up. Even the one park we see looks shabby and untended, and the out-of-season seaside resort where Vic and Ingrid 'enjoy' their honeymoon—after a particularly sad and tense wedding ceremony conducted in a matter-of-fact way in a registry office—is far from the sort of destination Vic once dreamed of exploring before 'settling down'.

There's a key scene near the end when Vic goes to see Christine, expecting sympathy and support over his decision to leave the Rothwell house. Instead, his sister scolds him: 'You've only yourself to blame,' she says. 'You made the decision when you did what you did.'

Credit should be given to June Ritchie who, in her first film, nails the character of Ingrid; sweet when she wants to be, selfish, needy, insensitive yet willing to offer herself sexually to keep the man she wants, only to have him visibly cool as soon as he's slept with her. Ritchie, who was born in Blackpool, only made a handful of films—but her debut is a remarkable performance.

John Schlesinger (1926–2003) was amiable, gentle, prematurely bald and very open to discussing his work on the couple of occasions that we met (he can be seen in one of his rare screen-acting roles playing the small-town solicitor in Roy Boulting's comedy *Brothers in Law*, 1956). He followed *A Kind of Loving* with *Billy Liar* (1963), an adaptation of a play by Keith Waterhouse and Willis Hall, starring Tom Courtenay and Julie Christie. In 1965 he directed Christie, Dirk Bogarde and Laurence Harvey in *Darling*, and then starred Christie in *Far from the Madding Crowd* (1967) opposite Alan Bates, Peter Finch and Terence Stamp. In America he directed the Oscar-winning *Midnight Cowboy* (1969) before returning to the UK to make *Sunday Bloody Sunday* (1971). Subsequent films included *The Day of the Locust* (1975), *Marathon Man* (1976), *Yanks* (1979) and *The Falcon and the Snowman* (1984). He also made TV films, including *An Englishman Abroad* (1983) and *Cold Comfort Farm* (1995). His last feature, *The Next Best Thing*, was made in 2000.

The Manchurian Candidate

USA, 1962

United Artists–M.C. Productions. DIRECTOR: John Frankenheimer. 126 MINS.
FIRST SEEN: *Gaumont, Swindon, UK 16 November 1962.*

Korea, 1952. An American army patrol, led by Captain Bennett Marco (FRANK SINATRA), is captured by Chinese forces, drugged and taken to Manchuria where the soldiers are brainwashed by a team of scientists led by Yen Lo (KHIGH DHIEGH). Staff Sergeant Raymond Shaw (LAURENCE HARVEY), whose stepfather is rabidly right-wing US Senator John Iselin (JAMES GREGORY), is transformed into a killer, who is activated when he is confronted with a Queen of Diamonds playing card. Back in America, Marco and his men have no memory of what actually happened. Shaw is awarded the Congressional Medal of Honour. He goes to work for left-wing columnist Holborn Gaines (LLOYD CORRIGAN). Meanwhile Marco, now a major working for army intelligence, is troubled with nightmares in which he sees Shaw killing two of his own men. After he is assigned to kill Gaines by the Russians, Shaw's American operator—who proves to be his fanatical mother (ANGELA LANSBURY)—orders him to kill left-wing Senator Thomas Jordan (JOHN MCGIVER), whose daughter, Josie (LESLIE PARRISH), he has just married; he shoots Jordan and Josie, but the next day remembers nothing. Now alert to the significance of the Queen of Diamonds, Marco deprograms Shaw, who is sent by his mother to assassinate the presidential candidate at the party's convention in New York's Madison Square Garden. Instead Shaw shoots Iselin (who has been nominated vice-president) and his mother before turning the gun on himself.

The Cold War conspiracy-theory thriller, *The Manchurian Candidate* was adapted from a novel by Robert Condon by the consistently witty screenwriter George Axelrod and was masterfully and imaginatively directed by John Frankenheimer. A plot that was, on first viewing, filled with surprises proved all too feasible, even prescient, a year after the film's release when President Kennedy was assassinated—after which the film was withdrawn from circulation for several years.

One of the cleverest scenes is the early sequence in which first Marco, and then Corporal Melvin (JAMES EDWARDS), the latter an African-American,

experience dreams in which they recall the briefing given by the avuncular Yen Lo to senior Communists from Russia, China and Vietnam. The Americans have been brainwashed into thinking they are in a hotel in Spring Lake, New Jersey, where a Mrs Henry Whittaker is giving a lecture titled 'Fun with Hydrangeas' (the men are 'not just [brain]washed—dry cleaned,' jokes Yen). As the camera pans around the room, 'Mrs Whittaker' and her audience of women, are replaced by the Communist officials observing the bored, hypnotised soldiers. Melvin sees the female audience as being composed of black women. As the camera continues to pan around the room, one woman is fondling a military-style knife. When Shaw strangles one of his own men and shoots another, the scene is all the more horrific because the other members of the patrol are oblivious to what's going on, even when a young soldier is shot in the head and his blood splatters over a huge portrait of Stalin.

Two years later, Marco, still brainwashed, thinks of Raymond as being 'the greatest, kindest, warmest, most wonderful human being I've ever known in my life' but, in his heart of hearts, he knows that 'Raymond's impossible to like. He's one of the most repulsive human beings I've met.'

On one level the film is a caustic satire of McCarthyism. Like Iselin, Joseph McCarthy was a US senator who spread unverified stories about the number of Communists in high places. Here Iselin, coached by his malignant wife—a superb Angela Lansbury—has an Abraham Lincoln fetish and is seen as an idiot who can't even remember the number of so-called Communists there are supposed to be in the State Department. While pouring tomato ketchup over his food, he asks his wife for a number he can easily remember and she comes up with 57 (the number of 'varieties' produced, and widely advertised, by the Heinz company, maker of the aforementioned sauce). This type of black humour is typical of Axelrod's screenplay. The strangely charming Yen Lo, visiting New York, is surprised to learn that the clinic where Shaw's condition is being tested by Soviet doctors is on the premises of a home for alcoholics that actually made a profit for the USSR in the previous fiscal year. He reveals that he intends to spend time in Macy's department store ('Mrs Yen has sent me with a long list') and even quotes an American TV commercial ('Tastes good, like a cigarette should').

The character of Thomas Jordan is also beautifully written, as well as acted. Jordan once sued Shaw's mother (who is never named) for calling him a Communist and then donated the damages he received to the Civil Liberties Union. He tells her, 'I despise Johnny and all that Iselinism has come to stand for. If John Iselin were a paid Soviet agent he could not do

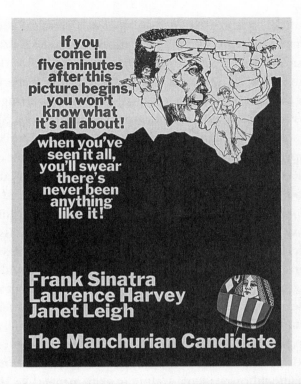

I first met John Frankenheimer on the set of *I Walk the Line* in 1969; he signed the photograph in Venice in 1999.

more to harm this country than he's doing now', a prescient comment and a chilling one to be expressed in a film made during the Cold War when McCarthyism was still a potent memory.

The killing of Jordan by Shaw is a particularly horrific scene: the Senator, wakened in the middle of the night by his visitor, is wearing a dressing gown and is taking a carton of milk from the fridge when Shaw fires a silenced gun at him; the bullet punctures the carton and milk flows out. Shaw then turns the gun on his new wife, Josie, who has come downstairs.

The climax, in which Shaw is disguised as a priest and is able to carry his rifle into the hall where the convention is taking place and to successfully locate a space designed for a spotlight in the roof of the building, now looks too easy; it was more plausible in 1962, before the JFK assassination.

Arguably, the film doesn't need the character of Rosie, played by Janet Leigh. Her role is so marginal, and her sudden romance with Marco so unexpected (they meet on a train travelling between Washington and New York and she comes to his aid when he has an attack of the jitters), that she tends to be annoying, which was certainly not the intention.

Jonathan Demme's 2004 remake of Frankenheimer's film is one of the best of its kind. 'Manchuria' is no longer a Communist country in Asia but a multinational corporation dealing in armaments (like Halliburton) and Demme's film explores the links between the political establishment and the military–industrial complex. The mother (MERYL STREEP) is almost as evil as Angela Lansbury's monster, and Rosie (KIMBERLY ELISE) is far more interesting—she's an FBI agent assigned to watch Denzel Washington's Marco.

John Frankenheimer (1930–2002) was one of a number of directors who moved from TV into cinema. His debut, *The Young Stranger* (1957), was a cinema remake of a TV drama. It was followed by *The Young Savages* (1961), and by an extraordinary three films made in 1962: *All Fall Down*, *Birdman of Alcatraz* and *The Manchurian Candidate*. *Seven Days in May* (1963) is another remarkable political drama, about a plot by senior military officers to overthrow the US government—Burt Lancaster, Kirk Douglas and Fredric March head a powerful cast. Frankenheimer replaced Arthur Penn as director of *The Train* (1964), and subsequently made *Seconds* and *Grand Prix* (both 1966), *The Fixer* (1968), *The Gypsy Moths* (1969) and *I Walk the Line* (1970). I first met him on the set of the latter film. He subsequently made a usually proficient series of thrillers of various sorts. His last films were *Ronin* (1998) and *Reindeer Games* (2000).

62

Dr. Strangelove, or How I Learned to Stop Worrying and Love the Bomb

UK, 1963

Columbia–Hawk Films. DIRECTOR: Stanley Kubrick. 95 MINS.
FIRST SEEN: *Sydney Film Festival, 12 June 1964.*

Burpelson US Air Force Base, somewhere in America. General Jack D. Ripper (STERLING HAYDEN), the base Commander, is convinced that the Communists are poisoning the 'vital fluids' of the free world with fluoride. He orders the B-52 bombers under his command to launch an attack on targets within the Soviet Union and seals his base off from the outside world, to the dismay of Group Captain Lionel Mandrake (PETER SELLERS), who is on assignment as part of a bilateral Officer Exchange Program.

On orders from President Merkin Muffley (also Sellers), US troops attack the base and, after a bitter battle, Ripper's men surrender. Ripper commits suicide without revealing the three-letter code necessary to halt the attacking aircraft. The President, unimpressed with the arguments of his hawkish Chief of Staff, General 'Buck' Turgidson (GEORGE C. SCOTT), contacts the Soviet Premier, Dimitri Kissoff, on the hotline and discovers that the Russians have a 'Doomsday' device designed to exterminate every living thing on the planet should they be attacked. Mandrake works out the code and the attack is halted—except for one plane, flown by Major King Kong (SLIM PICKENS), which has been damaged, has lost radio contact and is flying low to avoid Russian radar. Kong's plane drops one of its bombs and the Earth explodes, while Dr Strangelove (again Sellers), a former Nazi scientist, advises the President as to how a limited number of Americans would be able to survive underground.

The Peter George book *Red Alert* (formerly *Two Hours to Dawn*) was not comedic; both a dire warning and a plea for East–West cooperation, it was a deadly serious Cold War thriller. At some point Stanley Kubrick decided that the events that might lead to an accidental nuclear disaster bordered on farcical, hence the brilliantly funny screenplay he wrote in collaboration with George and satirist Terry Southern.

The potentially grim story unfolds over a few hours following a couple of 'statements' (one written, the other spoken), explaining the geopolitical background and offering the official assurances of the US Air Force that safeguards already in place would not permit a situation such as the one depicted in the film to occur. The literal trigger for the nuclear attack against Russia is General Ripper, a seriously deranged character, played straight by Sterling Hayden. Frequently filmed from below, with a huge cigar in his mouth, Ripper quotes French statesman Georges Clemenceau, recalling that he once wrote: 'war was too important to be left to the Generals. Fifty years ago he might have been right,' Ripper continues, 'but today war is too important to be left to politicians.' 'The Redcoats are coming!' he proclaims, excitedly, as he loads an automatic weapon and prepares to fire on his own troops.

Mandrake's 'silly ass' English accent and his mostly sensible concerns are a perfect counterpoint to Ripper's ravings about how he 'discovered' that the Communists were poisoning drinking water while he was engaged in the act of love—like a true conspiracy theorist, he reckons that fluoride is 'the most monstrously conceived Communist plot we have ever had to face'. Attempting to pacify this raving lunatic, Mandrake, in an almost touching revelation, talks about being tortured as a Japanese POW. ('It was their way of having fun, the swine. Strange thing is, they make such bloody good cameras!')

Ripper is not the only insane character in the film; there are plenty more to go around. There's Colonel 'Bat' Guano (KEENAN WYNN), who liberates Mandrake but suspects him of being a 'deviated prevert'. Turgidson, first seen in a Hawaiian shirt and shorts together with his mistress, Miss Scott (TRACY REED), is slow to respond to the order to report to the Pentagon ('You just start your countdown,' he tells bikinied Miss Scott, 'and Buckie will be back before you blast off.') Turgidson is a Cold War warrior who calls the Soviet Ambassador, DeSadesky (PETER BULL), 'a degenerate atheist commie' to his face, and, on hearing about the Doomsday machine that will destroy the world, expresses the wish that America had one, too. DeSadesky, who claims to know that the Americans were also working on a Doomsday machine ('Our source was *The New York Times*'), attempts to take photographs of the Pentagon's War Room with a camera hidden in a matchbox and gets into a fistfight with Turgidson; both men are reprimanded by the President. ('Gentlemen! You can't fight here—this is the War Room!')

Slim Pickens' King Kong (a role originally to have been yet another Sellers character), who swaps his pilot's helmet for a Stetson and literally rides the bomb as it descends on Russia, is another crazy character. We don't hear the voice of Premier Dimitri Kissoff, who, when called to the phone, is not only drunk but is also apparently in an intimate situation with a woman, but he's clearly ill-equipped to handle a crisis: 'Dimitri, can you turn the music down?' pleads Muffley and later, when told to contact the People's Central Air Defence HQ in Omsk to alert them to the coming B-52s, asks, 'You don't happen to have the number do you? Oh, just ask for Omsk Information?'

And then there's Strangelove, the German-accented, wheelchair-bound scientist whose mechanical arm frequently springs into a Nazi salute and who can hardly contain his excitement when he luridly describes the 'stimulating nature' of the 'sexual characteristics' of the women—ratio ten to each male—who might populate the post-nuclear war bunker where life will have to be lived for the next 20 years.

The three main strands of the narrative, which are intercut at regular intervals, unfold within the space of a couple of hours and it's greatly to Kubrick's credit that the film is as visually witty as it is aurally. It opens with Air Force footage of one aircraft refuelling another in flight; the use of the romantic song 'Try a Little Tenderness' on the soundtrack during this scene underlines the fact that the 'intercourse' looks incredibly suggestive. Throughout, Ken Adam's production design and Gilbert Taylor's photography (designed to look like a newsreel during the battle sequence) are exemplary. And the conclusion is masterly: as the world ends in a series of nuclear explosions, the soundtrack carries the Vera Lynn World War II ballad, 'We'll Meet Again/Don't Know Where Don't Know When'.

The film is both hilarious and deadly serious, and in 1963, with the Cold War at its height, it both chilled the marrow and provided genuine, if slightly nervous, laughter at the idiocies of the squabbling militarists and politicians up there on the screen.

Stanley Kubrick (1928–1999), a journalist and photographer before turning to cinema, made his independent feature debut, *Fear and Desire*, in 1952. A pair of superior B-grade thrillers, *Killers' Kiss* (1955) and *The Killing* (1956), impressed critics the world over, and he really made an impact with the World War I drama *Paths of Glory* (1957), which so offended the French that they banned it for several years. Kubrick replaced Anthony Mann on the big-budget spectacle *Spartacus* (1960) and tackled an adaptation of the

controversial novel *Lolita* (1961) before he made *Strangelove*. The remainder of his films were made in the UK, and were a varied and impressive bunch: the pioneering *2001: A Space Odyssey* (1968), *A Clockwork Orange* (1971), *Barry Lyndon* (1974), *The Shining* (1980), *Full Metal Jacket* (1987) and *Eyes Wide Shut* (1997). Many of his films were greeted with caution by critics on their first appearance but deservedly became acclaimed as time went by. He was reclusive and gave few interviews, confining his contact with the press to a small handful of trusted film writers.

63

The Leopard
(*Il gattopardo*)

ITALY/FRANCE, 1963

20th Century-Fox–Titanus–Pathé Cinema. DIRECTOR: Luchino Visconti. 186 MINS.
FIRST SEEN: *Palace, Sydney, 15 February 1964 (161 mins, English version).*

Sicily, 1860. Don Fabrizio, Prince of Salina (BURT LANCASTER), lives with his large family in a palace near Palermo. When Garibaldi's rebels enter the city, the Prince's favourite nephew, Tancredi (ALAIN DELON), joins them in a confrontation with soldiers. Sometime later Tancredi, now an officer in the army of King Victor Emmanuel, joins the Prince and his family at their summerhouse at Donnafugata in the mountains. The local mayor, Don Calogero Sedara (PAOLO STOPPA), a rich merchant, is invited to dinner and brings with him his beautiful daughter, Angelica (CLAUDIA CARDINALE). Although Tancredi is expected to marry Concetta (LUCILLA MORLACCHI), the Prince's eldest daughter, he falls in love with Angelica and she with him. The Prince is visited by Chevalley di Monterzuolo (LESLIE FRENCH), an emissary from the government, who invites him to represent Sicily as a senator; he refuses. At a grand ball he dances with Angelica, and then decides to walk home alone.

A costly international co-production, financed by Hollywood, *The Leopard* was originally screened outside Italy in a highly compromised version: it was poorly dubbed, poorly processed (using DeLuxe colour rather than the original, superior Technicolor) and heavily cut (161 as opposed to 186 minutes). Despite that, it was clear this was a very fine film. When the restored, Italian-language version became available internationally in 1984, it was revealed that this was a *great* film.

The novel by Giuseppe Tomasi di Lampedusa had been published in 1958. Working with four other writers, Luchino Visconti—who was himself from an aristocratic family, though an avowed Marxist—fashioned a literate screenplay filled with allusions to Italian politics in the mid-19th century, when the country was being united in what was called Risorgimento. The central character of the 45-year-old Prince of Salina is a representative of the aristocracy that is inexorably giving way to the new realities. When

first seen the Prince—majestically played by Burt Lancaster—is attending prayers with his wife, Maria Stella (RINA MORELLI), and seven children. The family priest, Father Pirrone (ROMOLO VALLI), who is officiating, later chides the Prince—a scientist and astronomer—for frequenting a brothel in Palermo; the Prince replies that his wife has never even permitted him to see her naked, so that she should be blamed, not him, for seeking sex outside the marriage. Love, he believes, consists of 'flames for a year followed by ashes for thirty years'.

Despite his position at the peak of Sicilian society, the Prince is tolerant towards Tancredi's decision to join Garibaldi's rebels; it is Tancredi who warns the older man that 'to remain the same, everything must change'. 'The middle class doesn't want to destroy us,' the Prince believes. 'It wants to take our place.' In the aftermath of the (vividly staged) battle for Palermo, the Prince and his family relocate to their country house, where the Prince enjoys hunting excursions with his friend, Don Ciccio (SERGE REGGIANI), who is bitter about the rigged vote in a referendum to approve of the new national government. Ciccio blames Don Calogero, describing him as a 'scourge from God' and a rich miserly opportunist who keeps his wife (also played by Claudia Cardinale) hidden from view. In these circumstances, the Prince's genuine support for Tancredi's marriage to Calogero's daughter, Angelica—especially since Tancredi was expected to marry his own daughter—is interesting. The pragmatic Prince realises that the *nouveau riche* merchant is a better bet as a future father-in-law than the impoverished nobility.

The Prince also, seemingly reluctantly, refuses the invitation to become a member of the new national government. In a telling scene with Chevalley, the King's emissary, he explains that 'I am a member of the old ruling class, hopelessly linked to the last regime. I belong to an unfortunate generation straddling two worlds and ill at ease in both.' Later he goes further: 'We were the leopards, the lions. Those who will take our place will be jackals and hyenas.'

The last 37 minutes of the film consist of the magnificently staged ballroom sequence. A justly famous set piece, this is when the Prince seems to be feeling his age—and to experience feelings of mortality. He perspires, complaining of the heat. When Angelica asks him to dance a mazurka with her, he asks her to wait for a waltz—and as they whirl around the dance floor he seems, for a moment, to be reliving his youth. Afterwards, taking a rest in the library, he contemplates a painting— *La Mort du Juste/*

Death of the Good Man by Jean-Baptiste Greuze—and we realise that he is considering his own mortality. Later, complaining of a headache, he leaves to walk home alone, pausing in the town square to kneel and pray as in the distance gunshots are heard (presumably the soldiers are executing some revolutionaries).

From the beginning of the sound period, foreign films that screened in Italy were dubbed into Italian rather than subtitled; accordingly, the Italian film industry was adept at matching the lips of foreign actors with the unseen Italian actors who provided their voices. *The Leopard* boasts an international cast consisting of Italian, French (Delon, Reggiani), American (Lancaster) and British (Leslie French) actors—and they all speak poetic Italian very convincingly (in the English version originally released abroad the dubbing is far less successful). Burt Lancaster's typically graceful performance transcends the language stumbling block; whether in Italian or English, he brings to life the flawed yet noble nature of this ageing aristocrat.

The main discovery of the restored version was the beauty of Giuseppe Rotunno's photography, both in the lavishly furnished interiors and the beautiful exteriors of the crumbling villages, hillsides and valleys of Sicily. When the shortened 'international' version was released the colour processing by the DeLuxe laboratory in Los Angeles was markedly inferior to the rich colours of the Italian version. Four years before he photographed *The Leopard*, Giuseppe Rotunno had been in Australia photographing Stanley Kramer's *On the Beach* in Melbourne. On a technical level, it should also be noted that Nino Rota's music score is one of his best.

Luchino Visconti (1906–1976) worked as an assistant director (to Jean Renoir, among others) before directing his first feature, *Ossessione* (1942), an unauthorised version of James M. Cain's 1934 novel *The Postman Always Rings Twice*. After the war he made the dramatised documentary *La terra trema/The Earth Trembles* (1948), followed by *Bellissima* (1951), *Senso* (1954), *Le notte bianche/White Nights* (1957) and *Rocco e i suoi fratelli/Rocco and His Brothers* (1960). After *The Leopard* he made *Vaghe stella dell'orsa/Sandra* (1965), *Lo straniero/The Stranger* (1967), *La caduta degli dei/The Damned* (1969), *Morte a Venezia/Death in Venice* (1971), *Ludwig* (1973), *Gruppo di un famiglia in un interno/Conversation Piece* (1974) and *L'innocente/The Innocent* (1976), which was completed just prior to his death.

Charulata

INDIA, 1964

R.D. Bansal Productions. DIRECTOR: Satyajit Ray. 119 MINS.
FIRST SEEN: *Brisbane Film Festival, 30 April 1966.*

Calcutta, 1879. Charulata (MADHABI MUKHERJEE) is married to Bhupati Dutt (SAILEN MUKHERJEE), the owner and editor of political newspaper *The Sentinel.* They live in a large, beautifully appointed house, but Charu is often bored. Bhupati invites his brother-in-law, Umapada (SHYAMAL GHOSHAL), and his wife, Mandakini (GEETALI ROY), to come and live with them and he makes Umapada the newspaper's business manager. One day, Amal (SOUMITRA CHATTERJEE), Bhupati's 23-year-old cousin, arrives unexpectedly, having just completed his university studies. Bhupati asks him to encourage Charu with her interest in literature, and the two form an increasingly close bond. Umapada and Manda leave rather abruptly and soon afterwards Bhupati receives a solicitor's letter from his paper supplier complaining about unpaid accounts; he is shocked to discover that Umapada has robbed him. To Amal he pours out his heart, revealing how much Umapada's breach of trust has hurt him. Amal, realising that his growing feelings for Charu—who has begged him never to leave the house—could similarly hurt his cousin, leaves without saying goodbye. Bhupati takes Charu for a brief seaside holiday where they discuss reviving *The Sentinel* and the possibility of combining political coverage with literary content, the latter to be edited with Charu's help. Elated, they return home, where they discover an uncommunicative letter from Amal. Charu can't contain her grief, and Bhupati, who now realises the depth of feeling his wife has for the younger man, reacts by leaving the house. When he returns, Charu is waiting for him, but he hesitates in the doorway.

Although *Charulata* is one of the most perfect films ever made about unrequited love, it is not the easiest movie for a non-Indian to appreciate, principally because the literary and political references are so integral to the deceptively simple story. Satyajit Ray's screenplay is based on *Nastanirh/The Broken Nest*, a novella written in 1901 by India's literary giant, Rabindranath Tagore (1861–1941). An important element of the film lies in the debt it pays to India's literary tradition: in the opening sequence, Charu takes from the

bookshelf a work by Bankim Chandra Chatterjee (1838–1894), the leading writer in the generation that preceded Tagore, and references to Chatterjee are scattered throughout the movie. In addition, Bhupati, a pipe-smoking, bearded intellectual so absorbed in his obsession with politics—and the alluring smell of newsprint—that he neglects his graceful and intelligent wife, is mesmerised by events in far-off England, believing that the election of a Liberal government under Gladstone will benefit India. Bhupati patronises Charu, promising her that 'one day I'll explain all these political things to you' and wondering how she ever found the time to embroider his initial onto a handkerchief (which she is doing behind the opening credits).

Far more trusting than he should be, Bhupati makes the mistake of bringing Charu's feckless brother, Umapada, into the business, significantly handing over the keys to him, even though his brother-in-law clearly disapproves of the political stance of *The Sentinel* (whose motto is 'Truth Survives'). Bhupati insists that the British government is ruining India, imposing taxes (salt tax, rent tax) over which the Indians have no say because they have no representation. On a practical level, though, the paper is not selling well because it is aimed at the already converted and because its content lacks anything other than politics.

Bhupati clearly thinks that Umapada's wife, Manda, will be a companion for Charu, but she proves to be an airhead and chatterbox, who openly flirts with Amal. It's very clear that Charu is lonely: in the magnificent opening sequence she wanders around the house, with its elegant Victorian-era decor, going from room to room, walking down the long indoor verandahs, and looking down from the windows at the people on the street below—a street musician with a pair of monkeys, a man carrying an umbrella, four porters carrying a palanquin—and when Bhupati walks past her, his nose in a book, not even noticing her, she looks at his departing back through the opera glasses with which she's viewed the people below. Without resorting to any dialogue, in this memorable sequence Ray tells you everything you need to know about the relationship between husband and wife.

Amal's unexpected arrival—he bursts into the house in the middle of a windstorm—provides Charu with a focus. Although he's prone to indolence, Amal has a way with words and he encourages her. The long scene in the garden, where she sits on a swing and Amal starts to write ('Dark of the Sun') in a newly acquired notebook, shows the relationship gradually evolving. Charu, too, begins to write—at first the pompously titled 'The Lament of the Cuckoo' but later the heartfelt 'My Village' (after we

see images of a rural festival), an essay that, to everyone's astonishment, is published in a prestigious magazine.

Amal's decision to leave abruptly after Bhupati is betrayed by Umapada comes soon after Charu has tearfully begged him to promise never to leave. He has to choose between betraying his cousin or the woman he is clearly growing to love, and he chooses the latter course. The film's ending, in which Ray borrows—with acknowledgement—from Truffaut's *Les quatre cents coups/The 400 Blows* (see #53)—concludes in a series of freeze frames, the first of them when Charu holds out her hand to her husband and the image stills just before they touch. There are then still images of Charu, Bhupati and even their servant before a medium still shot of the couple, their hands still not quite connecting. There is no 'The End'—the title of the Tagore novella appears on-screen, ending this magical film.

Music also plays a very important role in *Charulata*. Ray himself composed the plaintive score, and there are a number of songs, perfectly integrated into the drama, that would certainly mean more to a Bengali audience. But even when the film's references and allusions are difficult to access, there are the three main actors—all superb—to enjoy, as well as the great cinematography by Subrata Mitra.

I first met Satyajit Ray in November 1966, at the studio in Calcutta (now Kolkata) where he was working on *Chiriakhana/The Zoological Garden* (1967). At this meeting I invited him to attend the 1968 Sydney Film Festival, which he did—he visited both Sydney and Melbourne, and introduced screenings of his first colour film, *Khanchenjungha* (1962), gave talks about his work, and charmed all who met him. In succeeding years we often met and in January 1977, when I was in New Delhi for the film festival, he arranged for me to attend a reception attended by Prime Minister Indira Gandhi. We also visited the Taj Mahal together, in the company of Akira Kurosawa and Michelangelo Antonioni. In later years Ray was prone to heart trouble and also found it difficult to finance his films without help from outside India, but he always remained cheerful, optimistic and gracious.

Satyajit Ray (1921–1992) was a commercial artist and founder of the Calcutta Film Society before directing his first feature, *Pather Panchali* (1955), the first of a trilogy about a Bengali family that he continued with *Aparajito* (1956) and *Apur Sansar/The World of Apu* (1959). He was one of the few Indian filmmakers whose work was screened in the West. Among his key works are *Jalsaghar/The Music Room* (1958), *Devi/The Goddess*

(1960), *Mahanagar/The Big City* (1963), *Nayak/The Hero* (1966), *Aranyer din Ratri/Days and Nights in the Forest* (1969), *Seemabaddha/Company Limited* (1971), *Ashani Sanket/Distant Thunder* (1973), *Jana Aranya/The Middle Man* (1975), *Shatranj ke Khilari/The Chess Players* (1977), *Ghare Baire/The Home and the World* (1984) and *Agantuk/The Stranger* (1991).

The Umbrellas of Cherbourg
(*Les parapluies de Cherbourg*)

FRANCE/WEST GERMANY, 1964

Parc Film–Madeleine Film–Beta Film. DIRECTOR: Jacques Demy. 91 MINS.
FIRST SEEN: *Pasáž Kino, Prague, Czechoslovakia, 5 November 1966.*

Cherbourg, November 1957. Seventeen-year-old Geneviève Emery (CATHERINE DENEUVE), whose mother (ANNE VERNON), owns an umbrella shop, is in love with Guy Foucher (NINO CASTELNUOVO), a garage mechanic who lives with his sickly godmother, Elise (MIREILLE PERREY). Although she keeps the relationship a secret from her mother, Geneviève spends as much time as possible with Guy; they plan to marry and even discuss what to call their children: they decide they would name a son François or a girl Françoise. Mme Emery is in debt but is thrilled when, following a chance encounter with Roland Cassard (MARC MICHEL), a diamond merchant, she succeeds in selling him a necklace. Guy receives his call-up papers and the night before he leaves for the army he sleeps with Geneviève for the first time. Soon after his departure, Geneviève discovers she is pregnant. Guy's letters become fewer and fewer and, not knowing that he's been wounded during fighting in Algeria, Geneviève reluctantly agrees to marry Roland, who seems happy to raise the child as his own. In March 1959 Guy returns to Cherbourg and is devastated to discover that Geneviève has left the town and that the umbrella shop has been sold. After the death of Elise he becomes closer to Madeleine (ELLEN FARNER), who has cared for her in his absence, and they marry. By December 1963, Guy has his own service station, acquired thanks to a legacy from Elise, and he and Madeleine have a son, François. One snowy night, Geneviève stops to purchase petrol; Guy gets only a glimpse of his daughter, Françoise, in the car. Geneviève drives away.

I would describe Jacques Demy's truly wonderful musical film as pure cinema. It's an operetta, in which every word, even the most banal discussions about grades of petrol, is sung. And the glorious Eastmancolor photography by Jean Rabier, allied to the extraordinary design of Bernard Evein and complementary costumes by J. Moreau, lend the film a unique style, a style enhanced by the great music of Michel Legrand with its famous main theme.

Unlike the Hollywood musical, in which brashness and hyperbole were inevitably key components, Demy's softer, rather melancholy approach succeeds, against the odds, to turn a potentially banal story involving young lovers, an unwanted pregnancy, a marriage of convenience and a final chance re-encounter into something profound and deeply moving.

The magic commences with the opening credits. A silent-era iris out reveals the port of Cherbourg, and the camera rises in a crane shot to look from above at the pedestrians on the street below as it starts to rain: umbrellas of all colours are produced and seen from a bird's-eye perspective. Demy employs a richly detailed colour scheme in which the clothes worn by the characters often match the decor. In one scene, Geneviève's blue maternity dress exactly matches the wallpaper behind her; in another, Madeleine meets Guy in a café wearing orange to match the colour of the café's walls.

The film is divided into three parts, each lasting about half an hour. In the first part, 'The Departure', the lovers spend precious time together before Guy is conscripted; without telling her mother, who wouldn't approve, Geneviève goes with her lover to the opera (*Carmen*), to a nightclub to dance, and to various bars and cafés before agreeing to come to the room in the shabby house where he lives with Elise. Part One ends with the gloriously orchestrated farewell scene at the station.

Part Two, 'The Absence', records Geneviève's increasing anxiety as she realises that she's pregnant and as Guy's letters to her cease. Roland, the

Geneviève (CATHERINE DENEUVE) and her mother (ANNE VERNON) in the umbrella shop in Jacques Demy's *The Umbrellas of Cherbourg*.

wealthy businessman who is constantly flying back and forth to London, Amsterdam and New York, is unfazed by the fact that the woman he wants to marry is pregnant by another man. He explains that, years ago, he had loved, and lost, a woman called Lola. This is a reference to Demy's first feature, *Lola* (1960), in which Anouk Aimée played a Nantes-based entertainer loved by Roland. As Roland is telling Mme Emery about Lola, the camera tracks along through the elevated arcade in Nantes where he and Lola had spent time—and Legrand's theme music from the earlier film is heard on the soundtrack.

Part Three, 'The Return', focuses on Guy. Scarred, unshaven, he has difficulty accepting the fact that Geneviève did not wait for him. He spends his time in bars (one of which reminds him of the time he had spent there with her) and even picks up a prostitute (DOROTHEE BLANK) he insists on calling Geneviève. 'I don't like what you've become,' Madeleine tells him, after he quits his job at the garage following a stupid argument with his boss. Gradually he realises that the loyal Madeleine can be his salvation, and, by the end, he is clearly at peace and completely contented with his life with her and their son—he has always admitted that he is not particularly ambitious. He is momentarily floored to see Geneviève again—a much more sophisticated Geneviève who seems to have become significantly older in the six years since he's seen her. No longer the lovesick teenager from a small town, she looks supremely elegant with her stylish Paris clothes and her smart car. When she asks him if he wants to see his daughter, he refuses. 'Are you doing well?' she asks him. 'Yes, very well,' he replies. As she drives away, Madeleine and their son return from shopping, the music swells and the camera rises on a crane above the garage.

If *Lola* was reality presented almost like a dream, *The Umbrellas of Cherbourg* seems like a dream emerging from reality—from an 'ordinary' world of garages, shops, cafés, harbours and railway stations inhabited by 'ordinary' people who discover that, as Mme Emery remarks early on: 'People only die of love in the movies.'

Jacques Demy (1931–1990) was born near Nantes (in 1991 his widow, Agnès Varda, made a beautiful fiction about his childhood titled *Jacquot de Nantes*). His first feature, *Lola*, was followed by other films set in coastal cities: *La baie des anges* (1962, Nice), *Les parapluies de Cherbourg* (1964), *Les demoiselles de Rochefort* (1967, in which Catherine Deneuve co-starred with her sister, Françoise Dorléac; the film was completed shortly before Dorléac's tragic death in a car accident) and *The Model Shop* (1968, in

which Anouk Aimée's Lola is discovered to be living and working in Los Angeles). He subsequently made fairytales (*Peau d'ane/Donkey Skin*, 1971; *The Pied Piper*, 1972; *L'évenement le plus important depuis que l'homme a marché sur la lune/The Most Important Event Since Man Walked on the Moon*, 1973, about a pregnant man). His remaining films were musicals: *Lady Oscar* (1979), *Une chambre en ville/A Room in Town* (1982), *Parking* (1985) and *Trois places pour le 26/Three Seats for the 26th* (1988). His early death was particularly tragic.

I was lucky enough to meet Demy several times in the late 1960s and 1970s; he was, as you would expect from his films, charming, a bit fey, a little sentimental and thoroughly entertaining.

Thanks to a kind friend, my wife is the proud possessor of an authentic umbrella that was acquired in Cherbourg.

Andrei Roublev

USSR, 1966

Mosfilm. DIRECTOR: Andrei Tarkovsky. 182 MINS.

FIRST SEEN: *Committee for Cinematography screening room, Moscow, USSR, 21 September 1972.*

Russia at the beginning of the 15th century. Part One. Yefim (NIKOLAI GLAZKOV) experiments with a hot-air balloon. For a short time he flies above a riverside town, but the balloon crashes. *The Jester, 1400.* Icon painter Andrei Roublev (ANATOLY SOLONITSYN), who, together with his two companions, Daniil (NIKOLAI GRINKO) and Kirill (IVAN LAPIKOV), has recently left the Andronikov Monastery, arrives at a hostel where a jester (ROLAN BYKOV) is telling a bawdy story about a nobleman and his wife. Emissaries of the Prince (YURI NAZAROV) arrive to take the jester away. *Theophanes the Greek, 1405.* Theophanes (NIKOLAI SERGEYEV), a famous icon painter, invites Roublev to assist him in painting a new church. *The Passion According to Andrei, 1406.* Roublev takes part in a discussion about theology ('Have you ever sinned through ignorance?') and art ('What is praised today is reviled tomorrow'). A re-creation of the crucifixion takes place. *The Holiday, 1408.* Roublev observes a pagan ritual and seems fascinated by the naked women. He is captured, but freed by the beautiful Marfa (NELLI SNEGINA), who later drowns while attempting to escape the Prince's soldiers. *The Last Judgment, 1408.* The Prince's twin brother (also YURI NAZAROV) ambushes and kills Roublev's assistants. Distraught, Roublev splashes paint on the white wall of the church.

Part Two. *The Raid, 1408.* The Prince's brother joins forces with Tartars to ransack the walled town of Vladimir. The ghost of the now dead Theophanes mourns the destruction of church treasures. Roublev saves a deaf and mute girl, Durochka (IRMA RAUSCH), by killing a Tartar soldier. He vows never to speak or to paint again. *Silence, 1412.* A three-year famine is taking its toll. The Tartars return and Durochka willingly leaves with them. *The Bell, 1423.* Roublev is an observer as a boy, Boriska (NIKOLAI BURLYAYEV), only survivor of a family of bell-founders, all of whom have died of the plague, boasts to the Prince's men that he knows the secret of bell-casting. He is given carte blanche to create a great bell, not knowing if, when it is completed and in position, it will actually ring. It does, and

he admits to Roublev that his father did not, after all, tell him the secret of the craft. Roublev breaks his silence, proposing that they work together: 'You cast bells, I'll paint icons.'

Why did Andrei Tarkovsky's extraordinary second feature, *Andrei Roublev*, anger the authorities responsible for Soviet film production in the mid-1960s so much that they banned it for five years? The answer seems to be, at least in part, because the bureaucrats expected a traditional biography of the famous artist. Instead, Tarkovsky made a film in which Roublev is never seen painting but is always a bystander and observer to the frequently tragic events that presumably inspired him and shaped his art. This vision of Russia in the early 15th century is certainly a grim one. When it's not raining, the land is covered with snow. It's muddy and dirty, there is plague and pestilence, the peasants are oppressed by the nobles and by Tartar hordes, who pillage, rape and plunder. Torture (using boiling oil) is employed with impunity, while treachery and deceit thrive. No wonder Roublev loses his faith; though, in the soaring conclusion where he comforts the young bell-caster, he regains it.

Prior to this, Roublev has taken another step in the direction of humanity when he saves Durochka, killing the Tartar soldier who is carrying her off. The girl is an intriguing character. In the *Silence* sequence she willingly agrees to leave with the Tartar chief, although he appears to be taking advantage of her simplicity. But when we see her later she's beautifully dressed in fine clothes and looks extremely happy.

Vadim Yusov's magnificent black and white wide-screen photography brilliantly captures this chaotic world: there's a rich sensuality to the scenes where the naked pagans cavort among the trees holding lighted torches and then dive into the river. One eye-popping moment occurs when the camera is placed high above the town where the Tartars are savagely attacking the populace and a pair of white cranes fly serenely over the carnage. Down below, dogs fight savagely over scraps of food, and the treacherous Prince betrays his country and his brother for short-term gain.

The battle scenes compare favourably to those of any Hollywood epic, but no Hollywood company would have supported a film made on this scale based on such an elliptical screenplay, which was written by Tarkovsky and fellow director Andrei Konchalovsky; the latter subsequently spent some years in exile in Hollywood where he made such films as *Runaway Train* (1985).

The five episodes, plus Prologue, contained in the first half of the film are all relatively brief and the characters they introduce (the jester, the

old Greek painter) are worthy of Chaucer. Theophanes says he admires 'simplicity without gaudiness' in art, and Tarkovsky evokes this quality with the help of Yusov's wonderfully fluid camerawork. The sections in Part Two are longer, with *The Bell* taking up 43 minutes of the total running time.

Perhaps because this is a black and white film, the paintings shown are barely glimpsed: but the film ends with a roughly eight-minute sequence in colour of the original Roublev icons—many of them damaged and showing their age, but still sublimely beautiful. The very last image, though, is of horses standing on an island in the river in the rain.

'I do not understand films that are purely historical, with no relevance to the present,' Tarkovsky said at the time of the film's release, and that statement is perhaps another reason why the authorities took such a dim view of his film. His first feature, *Ivanovo detstvo/Ivan's Childhood* (1962), had been greatly admired in the USSR and had been awarded prestigious prizes. But for five years the authorities attempted to deny access to *Andrei Roublev*, possibly because—as suggested above—it was not the film they expected or wanted but also, perhaps, because it could be seen as an allegory about political oppression. In 1969 an illegal copy turned up in France where it played in a small cinema on the Left Bank for months, establishing its international reputation. In 1971 the film was finally released in the Soviet Union, but the version allowed to screen abroad was cut by almost 40 minutes (this was the version shown at the 1974 Sydney Film Festival); the cuts included the beautiful, but rather mysterious, opening sequence involving the balloon. That sequence ends with a shot of a horse that rolls over, and horses play a key role throughout the film—in one heart-stopping moment, a horse falls down a flight of steps.

Andrei Tarkovsky (1932–1986) followed his first two films with the sci-fi epic *Solaris* (1972), which found favour with the authorities, but next came the very personal and elliptical *Zerkalo/The Mirror* (1974), which also was banned for some time before being grudgingly released. After *Stalker* (1979), his last Russian film, Tarkovsky was forced into exile, a tragedy for a man who loved his country—if not his government—as much as he clearly did. He made *Nostalghia/Nostalgia* (1983) in Italy and *Offret/The Sacrifice* (1986) in Sweden. By the time that film premiered at Cannes in May 1986, he was seriously ill with cancer, but nevertheless came to France to discuss his work; this was the only occasion on which I was privileged to meet him. He died in December that same year, aged only 54.

Accident

UK, 1967

London Independent Producers. DIRECTOR: Joseph Losey. 105 MINS.
FIRST SEEN: *British Empire Films (BEF) screening room, Sydney, 29 August 1967.*

Oxford. A car carrying William (MICHAEL YORK) and Austrian-born Anna (JACQUELINE SASSARD), both students, crashes at 1.45 in the morning outside the home of Stephen (DIRK BOGARDE), their tutor. William is killed. Stephen helps the shocked Anna into his house, calls the police and, as a long flashback commences, recalls how William had first mentioned Anna to him. One long summer afternoon, William, Anna and Stephen's friend, Charley (STANLEY BAKER), came to lunch with Stephen and his pregnant wife, Rosalind (VIVIEN MERCHANT), and stayed to supper. Stephen was attracted to Anna. Rosalind left to stay with her parents. One night, coming home at 3 am after a trip to London, Stephen discovered Charley and Anna had been sleeping in his house. Stephen visited Laura (ANN FIRBANK), Charley's wife. Anna told Stephen she planned to marry William; William asked if he could visit him that evening for a 'man to man' talk. After the accident, Stephen—who has not revealed to the police that Anna was in the car— kisses her. She decides to return to Austria, and Stephen, whose baby son has just been born, returns to life with his family.

Joseph Losey's finest film is based on a book by Nicholas Mosley and was adapted for the screen by Harold Pinter (both Mosley and Pinter have small roles: the former as a sleepy don, the latter as a manic TV executive). *Accident* is about things left unsaid, revelations not made, secrets not shared. Stephen is a teacher of philosophy ('Philosophy is a process of inquiry,' he explains at one point) and has reached that stage in life—about 40—where he has to come to terms with the fact that life will never be very different from what it is now. He has a loving, if critical and judgemental, wife, two kids, a boy and a girl, and a baby on the way, plus a dog and a cat. He has a secure job at one of the world's most prestigious universities and he and his family live in a comfortable house surrounded by fields and woods. The house has several bedrooms, there's a tennis court and it's very peaceful. But Stephen can't take his eyes off Anna's legs, and she seems to be flirting with him. 'Has she made advances to you?' asks Rosalind when

he tells her about his new student. 'I'm too old,' he replies, where upon she replies, pointedly, 'You're not too old for me—and I'm not too old for you.'

Charley is Stephen's best friend, but there's a bitter rivalry between them, partly because Charley, a published author, also appears on a regular TV panel show. Stephen has similar aspirations, but when he goes for an appointment to see a producer at the TV station his meeting is cancelled because the man has been taken ill and Stephen leaves frustrated. During that long, boozy summer afternoon and evening, Stephen starts to believe that Anna is coming on to him: William asks her to go for a walk, but she declines; when Stephen says *he's* going for a walk, she says she'll join him. They stand at a five-barred gate, overlooking a meadow, their hands close together—but the moment passes, they leave, and Gerry Fisher's camera lingers on the gate for a significant moment: *this* is the place where something might have happened, but didn't.

After his frustrating visit to the TV studio, Stephen is reminded of Francesca (DELPHINE SEYRIG), daughter of the provost (ALEXANDER KNOX) and a former flame he hasn't seen for ten years. He phones her and goes to her apartment. 'It can't be ten years,' she says. 'It must be,' he replies. They go out to a restaurant, return to her place and make love ('Have I changed?' 'You're the same').

It's after this interlude that Stephen returns home to find Charley and Anna are there. He's clearly shocked and surprised, yet indulges in stilted small talk ('I'm hungry') while he digests the information. Charley finds an unopened letter from Laura, his wife, addressed to Stephen and insists on reading it: 'You might hint,' she writes, 'that sooner or later he'll be bored to death by her. P.S.—Don't say what I wrote for heaven's sake.' Charley's 'excuse' for his infidelity is almost childlike ('I can't get enough of her. I don't know what to do'), yet Stephen gives him the key to the house for future use. When he tells Rosalind, her response is instant and brutal: 'How pathetic! Poor stupid old man!'

The conclusion is enigmatic. It seems as though Stephen might be about to take advantage of the shocked and frightened Anna; certainly he kisses her on the lips and removes her jacket. But does he go further? Losey and Pinter keep that a secret, and we can only conjecture. At any rate, the scene in which she packs her belongings, with the resigned Stephen and the fretful Charley looking on, is charged with tension. When she extends her hand to Charley to say goodbye, he doesn't take it.

The film ends as it begins, with the exterior of Stephen's house, except that the final shot is in daylight. The children are playing but they go in through the front door; the dog rushes out of the drive—and we hear the sound of another accident.

The acting, especially of Bogarde and Baker—both of whom had worked with Losey more than once before—is exemplary. It's important to remember that this measured, mannered and wholly English film, winner of the Cannes Grand Jury Prize, was directed by an American.

The first time I met Losey was in the 1970s when he came to Australia to discuss the possibility of directing a screen version of Patrick White's *Voss* (he was White's choice for director). I helped him set up some meetings. The last time I saw him was rather unusual: it was 1983 and he was living in Paris. I had been met at Orly Airport by a producer friend who was trying to interest Losey in a screenplay. We stopped by the director's apartment, but he was suffering from a cold and greeted us dressed in red pyjamas; the meeting took place in his bedroom.

Joseph Losey (1909–1984) was a stage director before making his first film, *The Boy with Green Hair*, in 1948. This was followed by *The Lawless* and *The Prowler* (both 1950), a remake of Fritz Lang's *M* and *The Big Night* (both 1951). After establishing himself as a fine director of tough American thrillers, he was blacklisted and relocated to Europe, working sometimes under pseudonyms. In Italy he made *Imbarco a mezzanotte/Stranger on the Prowl* (1952), after which he settled in England where he made *The Sleeping Tiger* (1954), *The Intimate Stranger* (1956), *Time Without Pity* and *The Gypsy and the Gentleman* (both 1957), *Blind Date* (1959), *The Criminal* (1960), *The Damned* (1961), *Eva* (1962), *The Servant* (1963), *King and Country* (1964) and *Modesty Blaise* (1966). After *Accident* he made *Boom!* (1968), *Secret Ceremony* (1969), *Figures in a Landscape* (1970), *The Go-Between* (1971), *The Assassination of Trotsky* (1972), *A Doll's House* (1973), *Galileo* (1974) and *The Romantic Englishwoman* (1975). He moved to Paris in 1975 and made four French productions (*M. Klein*, 1976; *Les routes du sud/Roads to the South*, 1978; *Don Giovanni*, 1979; *La truite/The Trout*, 1982) before his final film, *Steaming* (1984), for which he returned to the UK.

68

The Unfaithful Wife
(*La femme infidèle*)

FRANCE/ITALY, 1968

Les Films la Boetie–Cinegai. DIRECTOR: Claude Chabrol. 94 MINS.
FIRST SEEN: *Little Carnegie, New York, USA, 26 November 1969.*

France. Charles Desvallées (MICHEL BOUQUET), a well-to-do insurance broker, lives near Versailles with his wife of ten years, Hélène (STÉPHANE AUDRAN) and their nine-year-old son, Michel (STÉPHANE DI NAPOLI). Charles, whose office is in central Paris, begins to suspect that Hélène is having an affair and hires a detective, Bignon (SERGE BENTO) to have her followed. The detective reports that Hélène regularly visits the apartment of Victor Pegala (MAURICE RONET), a writer. Without mentioning this to his wife, Charles goes to the apartment and confronts Pegala; they have a seemingly amiable talk—Charles claims his marriage is a 'free and open' one—until, after seeing the bed where his wife committed adultery, Charles suddenly attacks Pegala with a heavy stone bust and kills him. He cleans up the apartment, ties the corpse in sheets and carries it to the boot of his car. Despite a minor but nerve-racking traffic accident, he succeeds in dumping the body in stagnant water. In the succeeding days, Hélène seems upset and unwell. Two police officers, Duval (MICHEL DUCHAUSSOY) and Gobet (GUY MARLY) come to the house and question Hélène about Pegala after finding her name in his address book (his ex-wife has reported him missing). That evening they return and question Charles also. The next day Hélène finds a photograph with Pegala's address in Charles' pocket; she burns it. The police arrive again. '*Je t'aime comme un fou*' ('I love you madly') Charles tells Hélène before leaving with the officers.

One of the original members of the *Cahiers du cinéma* group that founded the French *Nouvelle Vague* (New Wave) in the late 1950s, Claude Chabrol became, in effect, the Alfred Hitchcock of France. Not all of his many films were thrillers, but the best of them were and, like Hitchcock, he avoided the conventional whodunit concept, preferring instead to reveal the identity of the killer to the audience early in the drama. He was also a master at satirising the bourgeoisie, a skill he shared with Luis Buñuel.

La femme infidèle, his masterpiece, could not be simpler. Charles, Hélène and their son live in a beautiful house, surrounded by a large garden, in the outer suburbs of Paris. They are wealthy and secure, and Jean Rabier, Chabrol's regular cinematographer, photographs their idyllic lifestyle through a kind of misty glow. Charles first suspects something when, after a visit from his mother (LOUISE RIOTON), he surprises Hélène making a furtive phone call. From then on, though he says nothing while Hélène talks about her busy days in Paris—at the hairdresser, having a facial, seeing *Dr. Zhivago* for the second time—the seeds of doubt have been sown and are confirmed by the private detective.

One rainy day he follows her and sees her enter Pegala's apartment; when she emerges a couple of hours later he's already gone, and is waiting at home when she arrives back, saying that she missed a train. The following day Charles goes to the apartment and confronts his rival. They sit and chat in the living room, drinking bourbon. Lying, Charles claims that he and Hélène 'tell each other everything'. Pegala expresses surprise ('I didn't imagine you being like that') but also delight ('One worries about unpleasant scenes'). He talks about Hélène's 'gentleness', explains that they first met in a cinema, and shows Charles around the small apartment. In the bedroom, Charles sits on the bed and fondles a lighter he had given his wife for their third wedding anniversary. 'I feel dizzy,' he complains, just before unexpectedly and savagely bludgeoning Pegala to death.

The following, quite detailed, sequence of cleaning up the traces of the killing is clearly inspired by *Psycho*, and the minor collision with a truck—a tense situation given that there's a recently murdered body in the boot— is also pure Hitchcock. The three visits from the two detectives are also handled with maximum suspense, with one of the investigators—Duval— asking all the questions while the other, Gobet, pale and saturnine, says nothing. The very final shot of the film is masterly; as Charles walks away down the drive with the two detectives the camera tracks back, away from Hélène, while at the same time slowly zooming towards her. The disorienting effect evocatively expresses both the end of Charles' freedom and also the pushback represented by his genuine feelings for his wife and son. A very similar shot concludes Arthur Penn's *Alice's Restaurant* (see #70), which was made the following year.

Charles never blames Hélène for her infidelity. If anything, he blames himself for his stuffy, old-fashioned, old-school ways. He is always courteous, always thinking of others, including Paul (HENRI MARTEAU), his womanising

assistant, and Brigitte (DONATELLA TURRI), his scatty, miniskirted secretary. If there's a villain in the film it's Pegala, who brazenly seduces another man's wife and refers to his own ex-wife as a bitch. It's worth remembering that, at the time the film was made, Stéphane Audran—who gives an immensely subtle performance—was married to Chabrol. Michel Bouquet's quiet, intense characterisation—a true case of still waters running deep—is also richly layered; he says little, but speaks volumes.

Adrian Lyne's 2002 Hollywood remake, *Unfaithful*, with Richard Gere as the husband and Diane Lane as the wife, is inferior in every respect.

Hardly a year went by during the period I directed the Sydney Film Festival (1966–1983) when a Claude Chabrol film was not included in the program, yet in all that time I didn't meet him. In 1970, while visiting San Francisco, I drove north to Bodega Bay, where Alfred Hitchcock had filmed *The Birds* eight years earlier. I sent a picture postcard to Chabrol care of his production company, Les Films La Boétie, in Paris, but I didn't include my address. In 2004 Chabrol's *La demoiselle d'honneur/The Bridesmaid*, based on a Ruth Rendell novel, premiered in Venice; the day after the screening I met the director for the first time. I mentioned the postcard I'd mailed 34 years earlier and his face lit up: 'You were the one!' he exclaimed.

Claude Chabrol (1930–2010) was a film publicist, critic and author (of a book on Hitchcock) before directing his first film, *Le beau Serge/The Handsome Serge* (1958); this was the start of the *Nouvelle Vague*. He subsequently directed 53 features, mainly thrillers, as well as short contributions to several multi-part films and television series. His career highlights include: *Les cousins* (1959), *Les bonnes femmes* (1960), *L'oeil du malin/The Evil Eye* and *Ophélia* (both 1962), *Landru* (1963), *Le scandale/The Champagne Murders* (1967), *Les biches/The Does* and *La femme infidèle* (both 1968), *Que la bête meure/Let the Beast Die* and *Le boucher/The Butcher* (both 1969), *La rupture* (1970), *Juste avant la nuit/Just Before Nightfall* and *La décade prodigieuse/Ten Days' Wonder* (both 1971), *Les noces rouges/Red Wedding* (1973), *Nada* and *Une partie de plaisir* (both 1974), *Les Innocents aux mains sales/Innocents with Dirty Hands* (1975), *Violette Nozière* (1978), *Les fantômes du chapelier/ The Hatter's Ghosts* (1982), *Poulet au vinaigre/Chicken with Vinegar* (1985), *Inspecteur Lavardin* (1986), *Le cri du hibou/The Cry of the Owl* (1987), *Une affaire de femmes/A Woman's Affairs* (1988), *Madame Bovary* (1991), *La cérémonie/A Judgement in Stone* (1995), *Au coeur du mensonge/The Color of Lies* (1998), *Merci pour le chocolat/Thanks for the Chocolate* (2000), *La fille coupée en deux/The Girl Cut in Two* (2007) and *Bellamy* (2008).

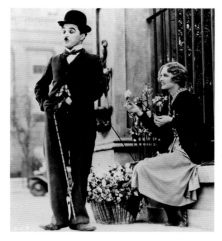

5 *City Lights*

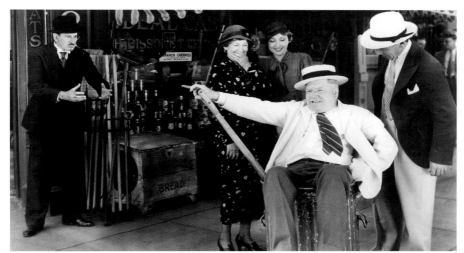

8 *It's a Gift*

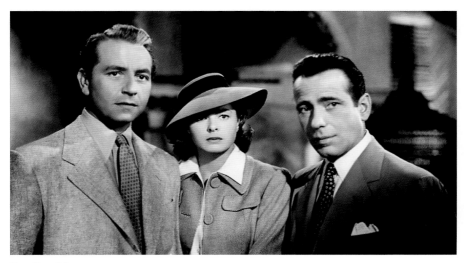

16 *Casablanca*

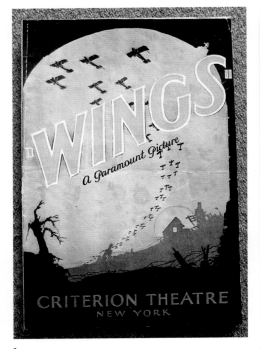

3

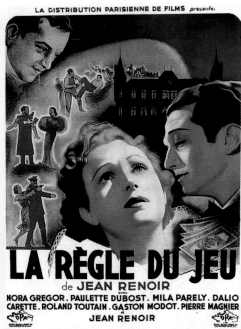

12

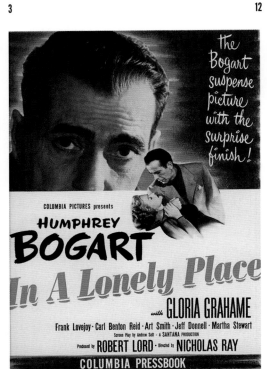

30

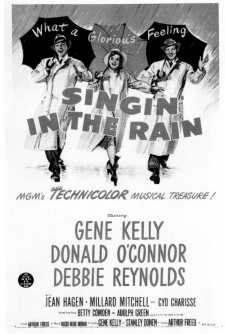

36

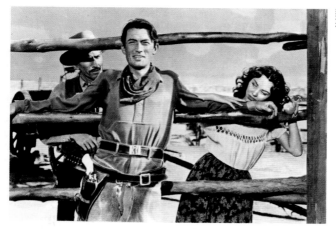

22 *Duel in the Sun*

35 *Shane*

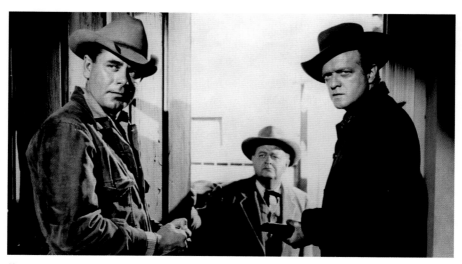

49 *3:10 to Yuma*

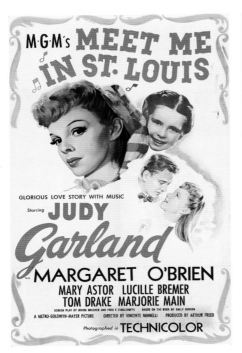

18

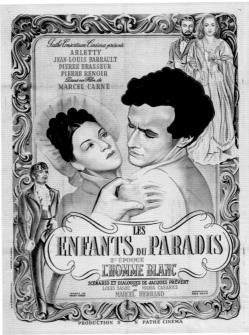

19

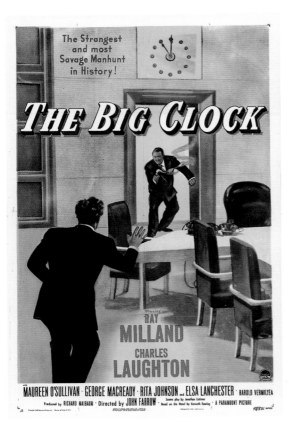

26

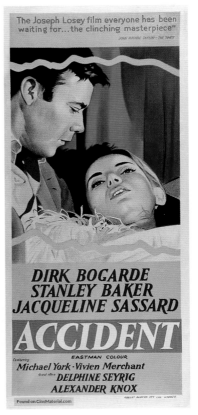

67

63 *The Leopard*

72 *The Conformist*

79 *Jaws*

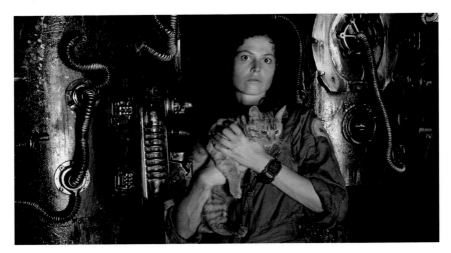

88 *Alien*

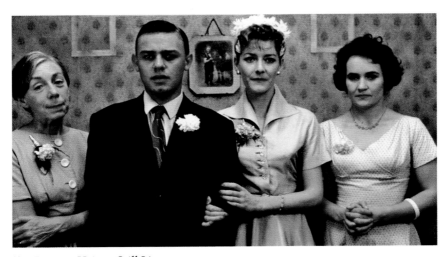

93 *Distant Voices, Still Lives*

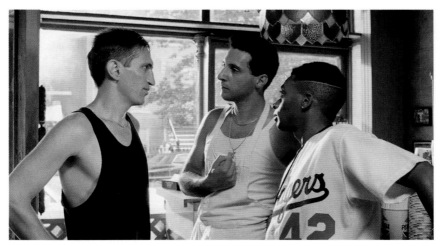

94 *Do the Right Thing*

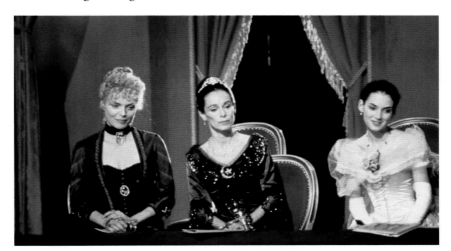

97 *The Age of Innocence*

100 *Love Serenade*

98

102

106

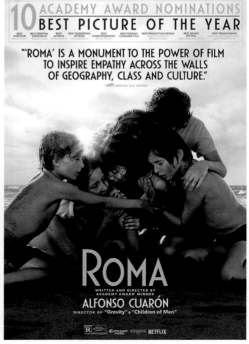

111

69

Z

FRANCE/ALGERIA, 1968

Reganne Films–ONCIC. DIRECTOR: Costa-Gavras. 121 MINS.
FIRST SEEN: *Curzon, Mayfair, London, UK. 8 October 1969.*

A provincial city in an unidentified Mediterranean country. Supporters of a left-wing opposition MP, known as the Doctor (YVES MONTAND), are preparing for a rally to be held in a cinema. The rally organisers, Georges Pirou (JEAN BOUISE), Matt (BERNARD FRESSON) and Manuel (CHARLES DENNER), are warned that an attempt will be made on the Doctor's life. The permits to use the cinema, and another large venue, are cancelled, and the rally is relocated to the first floor of the Employees Union Hall, which seats only 200. A right-wing mob gathers in the square outside the hall and when the Doctor leaves he is hit on the head by Vago (MARCEL BOZZUFFI), who is riding in the back of a van driven by Yago (RENATO SELVATORI); the Doctor later dies in surgery. The public prosecutor (FRANÇOIS PÉRIER) appoints a young examining magistrate (JEAN-LOUIS TRINTIGNANT) to investigate the case. It gradually becomes clear that a secret organisation named CROC (Christian Royalist Organisation against Communism), whose members include several high-ranking police and military officers, is involved. Witnesses are attacked and pressure is placed on the magistrate, but he indicts four senior police officers. A postscript reveals that, sometime later, a military coup overthrew the elected government and that several of the Doctor's supporters subsequently died.

'Any similarity to actual persons or events is deliberate' declares an opening title, but this towering political thriller, winner of two Oscars (Best Foreign Film, Best Editing for Françoise Bonnot) pulls no punches in telling the story of the 1963 murder of Greek deputy Grigoris Lambrakis, which led to the fall of the right-wing Karamanlis government and to the eventual military takeover of Greece where, as the end titles remind us, not only were The Beatles, miniskirts, long hair, homosexuality and strikes banned at the time the film was made, but also Sophocles, Euripides, Aragon, Tolstoy, Harold Pinter and the letter 'Z', which means 'He is Alive' in ancient Greek. Interestingly, the politician played by Yves Montand in the film is only referred to as 'Z' after the attack on

him, and then only when the letter is painted, in white, on a road by a left-wing demonstrator.

Konstantin Costa-Gavras, a Greek expatriate long resident in France, adapted the novel by Vassilis Vassilikos in collaboration with Jorge Semprún and filming took place in Algeria since location filming in Greece itself was clearly impossible.

The narrative itself is straightforward enough. First, the Doctor's supporters are unable to find a suitable venue for his rally. Appeals to the local chief of police, an army general (PIERRE DUX), and to his deputy, the colonel (JULIEN GUIOMAR), fall on deaf ears because—as we soon learn—they are members of a far-right movement that uses under-educated thugs to do their rough stuff for them. The fateful rally takes place on the same night that the Bolshoi Ballet is performing in the city and these bigwigs are in attendance not, as the general hastens to point out, because they're perverts but because they're on the lookout for Reds—a pertinent comment on the way some on the right wing regard lovers of the arts and culture.

From what we see and hear of the controversial politician's speech, his platform is typically left-of-centre. He objects to the fact that schools and hospitals are underfunded while half the country's budget is spent on the military. He is against nuclear testing, both American and Russian. And he demands of his audience: 'Why do our ideas provoke such violence?' On the other hand, the authorities talk about 'an ideological illness' in society, 'a sly enemy pushing us away from God and the Crown'.

The sequence of the assassination is powerfully presented, with an eerily effective performance from Marcel Bozzuffi as the predatory gay killer (a rapist when he was in charge of a scout camp, we later learn). François Périer plays the conflicted, but basically conservative, public prosecutor (DA in American subtitled copies) who, under the country's legal system, is forced to appoint a judge, or examining magistrate, to gather the evidence and recommend how to proceed with the investigation and, if necessary, the subsequent prosecution. In this role, with his tinted glasses and deadly serious but impartial approach, Jean-Louis Trintignant gives one of his best performances. Insisting that the 'assassination' is described for the record as an 'incident' during most of the investigation, this basically honest and seemingly apolitical lawman finally accepts the fact that the politician was murdered and, despite pressure from his boss, who flies in from the capital to lecture him on what the government expects of him, serves the indictments on the angry and incredulous officers who appear before him

wearing arrays of military medals. The other key character is a journalist, played by Jacques Perrin, whose company produced the film; not always behaving in an ethical fashion, the (unnamed) journalist proves a major help in unmasking the culprits.

In the small role of the murdered man's wife, Irene Papas contributes an authentically Greek presence; her role also prevents the dead man from being too idealised, since brief flashbacks reveal that he was an adulterer. The music score by Mikis Theodorakis, which had to be smuggled out of Greece where the composer was confined to a prison camp when the film was made, makes a very powerful contribution to the drama.

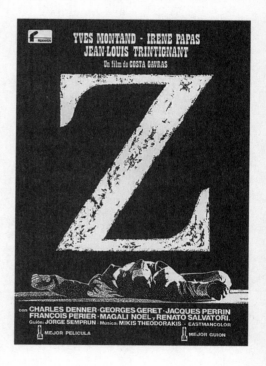

Z was a major international success, won many awards and influenced a great many people. It was, of course, banned in Greece.

Costa-Gavras (b. 1933) studied cinema at IDHEC (the French Film School) and worked as an assistant to several French directors, including Henri Verneuil and Jacques Demy, before directing his first film, *Compartiment tueurs/ The Sleeping Car Murders*, in 1966. This was followed by a film about the wartime resistance, *1 homme de trop* (1967). *Z* was his third film. He next planned to make a film about the Stalinist trials in Czechoslovakia in the early 1950s on location in Prague, but the invasion of Czechoslovakia by Warsaw Pact troops in August 1968 meant that filming of *L'aveu/The Confession* (1970) was forced to take place in Lyon. He subsequently made *État de siège/State of Siege* (1973), *Section spéciale* (1975) and *Clair de femme* (1979) before directing the Hollywood thriller *Missing* (1981), which dealt with an American activist who goes missing in Chile in 1973 after the overthrow of that country's government. Subsequently he moved back and forth between Europe and America with *Hanna K.* (1983), *Conseil de famille* (1986), *Betrayed* (1988), *Music Box* (1989), *La petite apocalypse/The Little*

Apocalypse (1992), *Mad City* (1997), *Amen.* (2002), *Le couperet/The Axe* (2004), *Eden à l'ouest/Eden is West* (2009) and *Le capital* (2012). His last film to date, *Adults in the Room* (2019), is a compelling English-language re-creation of how Greece's Australian-educated Finance Minister, Yanis Varoufakis, stood up to the World Bank during the 2008 global financial crisis and its aftermath.

70

Alice's Restaurant

USA, 1969

--

United Artists–Florin Corporation. DIRECTOR: Arthur Penn. 110 MINS.
FIRST SEEN: *Woods Theatre, Chicago, USA, 11 November 1969.*

--

America. Singer-songwriter Arlo Guthrie (played by himself), facing the unwelcome prospect of being drafted into the military and serving in Vietnam, decides to get 'some of that deferred, preferred, draft-exempted US Government inspected education' and enrols in the Rocky Mountain College, Montana, for a music course; he falls foul of the authorities and the local police and hitchhikes to Stockbridge, Massachusetts, where his friends Ray (JAMES BRODERICK) and Alice Brock (PAT QUINN) have purchased a deconsecrated church as a haven for their drop-out, counter-culture friends. Though occasionally travelling south to visit his ailing father, legendary folk singer Woody Guthrie (JOSEPH BOLEY), in a New York hospital, Arlo helps Alice and Ray establish The Back Room, a restaurant in Stockbridge, and records a singing commercial to publicise the place. At Thanksgiving there is a huge party, after which Arlo and his friend Roger (GEOFF OUTLAW) offer to get rid of the garbage; the tip is closed for the holiday, and the pair dump the rubbish illegally, only to be arrested by Stockbridge Police Chief Obanheim (played by himself) and convicted for littering. This criminal record allows Arlo to avoid the draft. Their friend, Shelly (MICHAEL MCCLANATHAN), a heroin addict, is killed (or possibly commits suicide) and Woody also dies. Ray and Alice decide to remarry in the church and there is a big celebration, after which Arlo and his girlfriend, Mari-chan (TINA CHEN), drive away.

Both a celebration of and a condemnation of the brief era of 'flower power', Arthur Penn's film is a rare case of a screenplay adapted from a song, in this case Arlo Guthrie's 20-minute part-talking blues performance of 'Alice's Restaurant Massacree'. Scripted by the director in collaboration with Venable Herndon, the film is ostensibly about Arlo—who charmingly plays himself—but it is equally about Alice, the Mother Earth figure who embodies universal love, and who is played with great warmth tempered with an inner bitterness by Pat Quinn. Indeed, everything about the film contains this bittersweet quality. Much of it is funny as it mocks authority

figures—the police who make such an event of Arlo's minor crime of littering, the army officers who organise the medical and mental health examinations for young draftees, seen as both deadly serious and incredibly ridiculous (told he has not supplied enough urine for his test, Arlo seeks help from other draftees in the toilet: 'Anybody got any to spare?'). Arlo wryly observes the way in which his 'crime' is exaggerated by the local police, who turn up in force—five cops, three cop cars, a chopper, a police dog— to examine the offending garbage, taking photographs and even making plaster casts of tyre tracks—all eventually useless when the judge in charge of Arlo's trial turns out to be blind and is unable to see the evidence the police have produced.

Like *Easy Rider*, which was released a few weeks earlier, the film examines the attitudes of 'mainstream' Americans towards these long-haired, peace-loving, free-loving hippies. In a Montana diner, Arlo is mocked—for his shoulder-length locks—and thrown through a glass window (after which the police arrest him, of course, and not his assailants). A roadside sign reads: 'Keep America Beautiful: Cut Your Hair'. While travelling cross country, much as his father had done during the Depression some 30 years earlier, Arlo observes various aspects of Middle America, including a revivalist meeting in a tent that features a patently phony miracle maker.

But Penn's film, even more than *Easy Rider*, explores the impossibility of the 'free love' dream. In one particularly sad scene, Arlo is invited to bed by Karin (KATHLEEN DABNEY), who undresses before admitting that she's only 14 years old; when Arlo declines her offer of sex, she reveals that she has already 'made it' with several other singers—plus a political campaign operative—and that she had chosen him because 'You'll probably get to be an album.'

Downbeat, too, is a New York scene in which Arlo has been singing at a club owned by Ruth (EULALIE NOBLE), a contemporary—possibly a lover— of his father's. She lends him the money to retrieve Shelly's possessions from his landlady, but then seeks to have sex with Arlo and becomes angry when he declines. They part on bitter terms.

Alice and Ray both have other lovers and it's Alice trying to help the hapless addict, Shelly, by sleeping with him that inadvertently triggers his death. The last part of the film, indeed, is enveloped in melancholy as first Shelly and then Woody, Arlo's sickly father, die. Shelly's funeral, which takes place during a heavy snowfall, is particularly bleak, with the

young mourners scattered around the graveyard as Joni Mitchell sings the haunting 'Songs for Aged Children'.

Sad, too, are the scenes with a wordless Woody, once the troubadour of the American Depression. Unable to hold the cigarette his wife, Marjorie (SYLVIA DAVIS), places in his mouth, Woody can only look on mutely as Arlo unburdens himself or, in a lovely scene, joins Woody's friend Pete Seeger (played by himself) to sing a couple of songs for the dying man.

Ray and Alice, who are quite a bit older than the kids who flock to them, are failed idealists. Ray, particularly, has a nasty streak to him, and it's a wonder that the ever-loving Alice stays with him. The film's unforgettable last shot occurs after the wedding celebrations have died down and Arlo and Mari-chan have driven away in Arlo's red VW Microbus. Ray and Alice, standing outside the clapboard church, wave them goodbye; Ray goes back into the building leaving Alice, in her white wedding gown, looking wistfully after her departing friends as Michael Nebbia's camera slowly tracks and glides away while gently zooming in towards her—a shot very similar to the final image of Chabrol's *La femme infidèle* from the previous year.

Arthur Penn (1922–2010) worked as a television and theatre director before making his first feature, *The Left-Handed Gun* (1958), in which Paul Newman played Billy the Kid. This was followed by *The Miracle Worker* (1962), *Mickey One* (1965) and *The Chase* (1966). With *Bonnie and Clyde* (1967), which was made very much under the influence of the French *Nouvelle Vague*, Penn scored a tremendous hit. He followed it with *Alice's Restaurant*, *Little Big Man* (1970, with Dustin Hoffman and Faye Dunaway), *Night Moves* (1975, with Gene Hackman) and *The Missouri Breaks* (1976, which starred Marlon Brando and Jack Nicholson). Up until that point Penn had been considered one of the finest directors of his generation, but the critical and commercial failure of the big-budgeted and prestigious *The Missouri Breaks* dented his reputation, and the films that followed—*Four Friends* (1981), *Target* (1985), *Dead of Winter* (1987) and *Penn and Teller Get Killed* (1988) saw him slide into a decline. There was an eight-year gap until 1996 when he made his last, undistinguished film, *Inside*.

When Penn attended the 1970 Venice Film Festival with a documentary made about him (*Arthur Penn 1922-: Themes and Variants*), I was able to conduct a lengthy interview with him about his work up to that time. He was very approachable and informative.

The Wild Bunch

USA, 1969

Warner Bros-Seven Arts. DIRECTOR: Sam Peckinpah. 144 MINS.
FIRST SEEN: *Warner Cinema, Leicester Square, London, UK 4 October 1969.*

San Rafael, South Texas, 1914. Pike Bishop (WILLIAM HOLDEN) and his 'wild bunch'—a gang that includes Dutch (ERNEST BORGNINE), Lyle Gorch (WARREN OATES), Tector Gorch (BEN JOHNSON), Angel (JAIME SÁNCHEZ) and Crazy Lee (BO HOPKINS)—ride into town to rob a railroad office owned by Mr Harrington (ALBERT DEKKER), unaware that Harrington has hired a gang of mercenaries led by Bishop's former partner, Deke Thornton (ROBERT RYAN), to ambush the robbers. Thornton's bounty hunters include the maniacal Coffer (STROTHER MARTIN) and T.C. (L.Q. JONES). As the bunch leaves the bank—carrying bags of 'loot' that, unknown to them, consist of nothing but steel washers—the mercenaries attack from nearby rooftops, their indiscriminate firing mowing down a great many civilians, including members of a parading temperance group. Crazy Lee dies in the battle, but five members of the bunch survive to rendezvous with Freddy Sykes (EDMOND O'BRIEN), who has been left in charge of supplies. Pursued by Thornton and his men, the bunch crosses the river into Mexico where Angel takes them to his village, which has been raided by General Mapache (EMILIO FERNÁNDEZ), a warlord aligned with General Huerta in the struggle against Pancho Villa. Angel learns that his father has been killed and his girl, Teresa (SONIA AMELIO), has become Mapache's mistress.

Mapache, based in the town of Agua Verde, offers Pike and his men $10,000 to rob an American munitions train north of the border. Though closely pursued by Thornton, Pike and the bunch succeed in stealing 16 cases of rifles and ammunition, plus a machine gun. Pike agrees to give Angel one of the cases of rifles in lieu of his share of the payment. Mapache discovers this and has Angel arrested and tortured. Pike, Dutch and the Gorches return to Agua Verde and, Dutch excepted, spend a night at a brothel. When Mapache slits Angel's throat rather than free him as he had promised, Pike kills him and his German adviser (JORGE RADO). A furious battle ensues in which Pike, Dutch and the Gorches are killed, along with most of Mapache's army. Thornton's scavengers retrieve the bodies to collect

their reward but, we later learn, are killed by the rebels. Thornton decides to team up with Sykes and the rebels.

An instant masterpiece, *The Wild Bunch* created something of a sensation in 1969 because of its unusually graphic violence, including the use of explosive blood capsules; when the actors are hit by bullets, blood flies everywhere—though this effect was not seen in the film's initial release in Australia, where the censors removed almost all this material.

The original screenplay by Walon Green and director Sam Peckinpah is, on one level, about righteous men who happen to be on the wrong side of the law. Pike, like the heroes of Peckinpah's *Ride the High Country* (1961), is aware that his days as an outlaw are drawing to a close: 'We gotta start thinking beyond our guns,' he says. 'Those days are closing fast.' Loyalty is an important part of his creed; in one scene Dutch explodes with anger that his former friend, Thornton, is still pursuing them. 'What would you do?' asks Pike. 'He gave his word.' 'That's not what counts,' replies Dutch. 'It's who you give it *to*', but Pike insists, 'It's his *word*!' Yet Pike is also pragmatic; when Angel states the case for helping his people, and his family, Pike counters: '$10,000 cuts an awful lot of family ties.'

Dutch, especially, is quick to sympathise with the plight of the Mexican peasants. His disassociates himself from Mapache ('just another bandit—we ain't nothing like him') and expresses the hope that 'one day these people will kick this scum right into their graves!' And even the Gorch brothers, who initially treat Angel with something close to contempt and express the view that he shouldn't be given an equal share in the (as it turns out, imaginary) loot, presumably because of their racial prejudice, are so incensed by what happens to him that they unhesitatingly join Pike and Dutch in the final confrontation.

Thornton, who, because of his former association with Pike, has been released from Yuma penitentiary to work for the fanatical railroad boss Harrington, is equally unhappy; he despises the 'damned yellow-livered trash' that make up his posse of mercenaries, and no wonder when they're played with such obnoxious relish by Strother Martin and L.Q. Jones, who were members of Peckinpah's unofficial stock company.

The action scenes, stunningly photographed for the wide screen by Lucien Ballard and edited by Louis Lombardo, are justly famous. The 15-minute opening gunfight in the streets of the small Texas town, with the unfortunate civilians caught up in the carnage, is one of the finest scenes of its kind ever filmed. And the climactic battle in the headquarters of

Mapache, with a machine gun causing lethal damage, is also grimly memorable. In both sequences, moments of slow motion are tellingly employed. Yet it's the quiet scenes that are equally impressive: the *looks* that pass between Pike and Dutch, and (from afar) between Pike and Thornton. When Pike decides to do battle with the Mexicans he doesn't have to spell it out to Dutch, who has been waiting outside the brothel where the other three have spent the night—it's hinted that Dutch might be gay.

Children also play important roles in the film, starting with the cheerful but sadistic group of youngsters who are allowing a pair of scorpions to be attacked by ants as the bunch rides past them into town (and who later set fire to scorpions and ants alike), continuing with the little boys who play with toy guns after the smoke has hardly died on the lethal battle, and concluding with the little boy who fires the bullet that kills Pike.

One curious point is worth mentioning. Mapache has acquired a horseless carriage and parades it around (it's used to drag the hapless Angel round the streets). Pike notes that he's heard about machines that can fly, and that they might be used in the war. This is an odd comment in a film apparently set in 1914 (some reviewers say 1913), given that at that time there was no indication that America was going to enter the war in Europe (Pike's shooting of Mapache's German adviser is another example of suspiciously early anti-German sentiment).

It was a good year for westerns: *Butch Cassidy and the Sundance Kid* and *True Grit* were both made in 1969. *The Wild Bunch*, which won no Oscars, towers over both of them. As British critic Philip Strick wrote at the time: 'After this obsessive and elaborate carnage, the Old West, with its tidy, formal duels, will truly be a thing of the past.'

Sam Peckinpah (1925–1984) worked as an assistant to Don Siegel (and played a bit part in *Invasion of the Body Snatchers*—see #46) before making his mark in television. In 1961 he made two features, *The Deadly Companions* and *Ride the High Country*, the latter a magnificent, sombre drama uniting two great western stars, Randolph Scott and Joel McCrea. However, on his next film, *Major Dundee* (1964), Peckinpah experienced considerable difficulties with his producers and he was removed from *The Cincinatti Kid* (to be replaced by Norman Jewison). *The Wild Bunch* was a triumphant comeback and was followed by *The Ballad of Cable Hogue* (1970), the controversial *Straw Dogs* (1971), *Junior Bonner* and *The Getaway* (both 1972), *Pat Garrett and Billy the Kid* (1973), *Bring Me the Head of Alfredo Garcia* (1974), *The Killer Elite* (1975), *Cross of Iron* (1977), *Convoy* (1978) and *The Osterman Weekend* (1983).

72

The Conformist
(*Il conformista*)

ITALY/FRANCE/WEST GERMANY, 1970

Mars Film–Marianne Productions–Maran Film. DIRECTOR: Bernardo Bertolucci. 111 MINS.
FIRST SEEN: *Sydney Film Festival Office screening room, 26 May 1971.*

Paris, 1938. Marcello Clerici (JEAN-LOUIS TRINTIGNANT), an Italian Fascist agent, leaves his hotel at dawn and enters a car driven by Manganiello (GASTONE MOSCHIN). In flashback Clerici remembers how his blind friend Italo (JOSÉ QUAGLIO) arranged for him to be interviewed by an important Fascist minister in Rome some time earlier. At that time Clerici had volunteered to facilitate the elimination of his former lecturer, Professor Quadri (ENZO TARASCIO), an Italian anti-Fascist living in exile in Paris. While making his confession—his first in years—Clerici had told the priest that, when he was aged 13 in 1917, he had shot and killed a paedophile named Lino Seminara (PIERRE CLÉMENTI), who had tried to seduce him. Clerici became engaged to Giulia (STEFANIA SANDRELLI), an inexperienced bourgeois woman, and they travelled to Paris on their honeymoon, with Manganiello watching them from a distance. In Paris, Clerici had contacted Quadri who invited him and Giulia to his apartment where they met the professor's much younger wife, Anna (DOMINIQUE SANDA), who flirted with both of them. Clerici followed Anna to the ballet studio where she teaches, and she told him that she was frightened and begged him not to hurt her or her husband. That night the four ate at a Chinese restaurant, and Giulia became very drunk. The four then visited a dance hall, where the women danced a tango. Clerici had discovered that Quadri was leaving at dawn the next day for his villa in rural France, and had passed this information on to Manganiello. The flashback ends and we discover that at the last minute Anna has decided to join her husband. In an isolated forest, Quadri's car is stopped and he is stabbed to death; Anna pleads with Clerici for help, but he does nothing. She flees and is gunned down. Five years later, in 1943, Mussolini has resigned. While crowds celebrate in Rome, Clerici meets with Italo. By chance he sees Lino Seminara, still alive, and he denounces both him and Italo as Fascists and homosexuals.

Bernardo Bertolucci, only 29 years old when he made *Il conformista*, declared at the time that, for him, cinema meant Sternberg, Ophüls and Welles, and his masterpiece, which he adapted from a novel by Alberto Moravia, lives up to these exceedingly high standards. The creepy story of a dedicated Fascist agent who travels to pre-war Paris to engineer the murder of his old teacher, is—thanks to Vittorio Storaro's exceptional cinematography, Ferdinando Scarfiotti's glorious art deco production design and Bertolucci's command of the medium—visually stunning from the first image to the last. The film opens with the weaselly Clerici, superbly played by Trintignant, bathed in red, as he lies, nattily dressed in a three-piece suit and hat, on a bed in the Palais d'Orsay Hotel while a red neon sign stating '*La vie est à nous*' (the title of a Jean Renoir film made in 1936) illuminates the scene, and it closes as he gazes at the naked body of a youth while light from a street fire gives the scene a hellish glow.

The film is replete with such visual delights. The lateral tracking shots that follow the characters along the streets and into the vast, marble Fascist-era buildings; the tilted camera as Clerici arrives at the rundown villa where his morphine-addicted mother (MILLY) lives with her dogs and her Asian chauffeur/lover while his father (GIUSEPPE ADDOBBATI) is confined to a sparsely inhabited insane asylum. The scene in Giulia's apartment where light seeps through the venetian blinds and complements the stripes on Stefania Sandrelli's black and white dress. The dance hall where Giulia and Anna dance a tango (for the latter this will indeed be her 'last tango in Paris') before they lead a conga line while the men sit at a table and talk, the sinister Manganiello hovering in the background, and the camera glides towards a fogged-up window to focus, bizarrely, on a photograph of Stan Laurel and Oliver Hardy.

The relationships between Clerici and the two women are both guarded and erotic, with Anna baring her breasts to Clerici in a back room at the ballet school, apparently in an attempt to persuade him not to pursue his mission, or with Anna caressing the lower half of Giulia's half-naked body as she purportedly helps her new friend dress for an evening on the town.

With his wolfish grin and stitched-up, meticulously neat and tidy persona, Trintignant's Clerici is a truly unpleasant character. As he makes clear to Italo, he wants to be normal, 'to be the same as everyone else', in other words to conform, and in Fascist Italy that means working for the Party. He is a civil servant with a degree in the classics, and his career looks promising—with the right connections. But his family background is a threat.

Giulia's mother (YVONNE SANSON) receives an anonymous letter claiming Clerici's father is suffering from syphilis, and his mother's relationship with Hemlock, her curiously named chauffeur, has to be stopped (Manganiello proves to be the man to do it). As he confesses to the priest, who is all too eager to hear the details about his boyhood sexual encounter, 'I'm going to build a life that's normal. Mediocre. I intend to construct my normality.'

At the end, on the day that Fascism finally collapses, he tells Giulia that he's unrepentant of his past: 'What have I done? My duty,' and she admits that the engineering of the brutal murders of Quadri and Anna 'was an important step' in her husband's career.

Bernardo Bertolucci (1941–2018) was born in Parma, the son of Attilio Bertolucci, a well-known poet and Marxist. He also became a poet, and served as an assistant to Pier Paolo Pasolini, before directing his first film, *La commare secca/The Grim Reaper*, in 1962. His early films were made under the influence of Jean-Luc Godard: *Prima della rivoluzione/Before the Revolution* (1964) and *Partner* (1968) combined politics with complex relationships. *Il conformista* was a major breakthrough; it was backed by an American distributor (Paramount), was made on a generous budget and reached a worldwide audience. A modest television feature, *La strategia del ragno/The Spider's Strategy*, was also made in 1970. Two years later the director caused a scandal with *Ultimo tango a Parigi/Last Tango in Paris*, in which Marlon Brando gave a riveting performance. The epic *Novecento/1900* (1976) was shown in two parts in Europe but a great deal of footage was removed for the abbreviated English-language release. Spanning the years 1900–1945, the film's cast included Robert De Niro, Gérard Depardieu, Burt Lancaster, Donald Sutherland, Sterling Hayden and the two female stars from *Il conformista*, Dominique Sanda and Stefania Sandrelli. Subsequently Bertolucci moved back and forth between intimate dramas (*La luna*, 1979; *La tragedia di un uomo ridicolo/The Tragedy of a Ridiculous Man*, 1981; *Stealing Beauty*, 1996; *Besieged*, 1998; *The Dreamers*, 2003) and large-scale epics (*The Last Emperor*, 1987; *The Sheltering Sky*, 1990; *Little Buddha*, 1993). His last film, *Io e te/Me and You* (2012), made after a nine-year gap, was a return to the small, personal films that started his career.

I met Bertolucci for the first time in 1970 and we often got together for meals in different parts of Europe (I remember one particularly enjoyable encounter in London). He was a truly charming companion, witty, erudite and passionate. The illness that affected him for the last few years of his life cramped his style without in any way dampening his spirit.

The Last Picture Show

USA, 1971

Columbia–BBS Productions. DIRECTOR: Peter Bogdanovich. 126 MINS.

FIRST SEEN: *Music Corporation of America screening room, Sydney, 15 February 1972.*

Anarene, Texas, 1951. Best friends Sonny Crawford (TIMOTHY BOTTOMS) and Duane Jackson (JEFF BRIDGES) are in their last year at high school. Sonny breaks up with Charlene Duggs (SHARON TAGGART) because she won't permit him to have sex with her; Duane is dating rich, spoilt and attractive Jacy Farrow (CYBILL SHEPHERD). The kids hang out at the diner, where jaded Genevieve (EILEEN BRENNAN) works as a waitress, or the picture show (the Royal), pool hall or café, all owned by Sam the Lion (BEN JOHNSON).

Popper (BILL THURMAN), coach of the unsuccessful football team, asks Sonny to drive his wife, Ruth (CLORIS LEACHMAN), to a clinic in the nearest town; this is the start of a love affair. Jacy wilfully attends a nude swimming party with Lester Marlow (RANDY QUAID), where she meets wealthy, arrogant Bobby Sheen (GARY BROCKETTE). Bobby likes girls who are not virgins, so Jacy accompanies Duane to the Cactus Motel; Duane's first attempt is not a success, but the second time he succeeds in deflowering Jacy, who promptly dumps him for Bobby, while he in turn marries another girl. Duane leaves town and Sonny takes up with Jacy, abandoning Ruth. Sam dies suddenly. Jacy persuades Sonny to marry her across the state line in Oklahoma, but her parents Lois (ELLEN BURSTYN) and Gene (ROBERT GLENN) insist on an annulment. Duane and Sonny fight over Jacy. Duane joins the army and takes his leave of the town just as Billy (SAM BOTTOMS), the sweet, simple boy who loved to sweep the street, is fatally hit by a cattle truck. The Royal closes with Howard Hawks' *Red River*. Sonny returns to Ruth.

Larry McMurtry's novel about broken dreams and lost illusions in a small Texas town could not have found a better filmmaker to bring it to the screen than Peter Bogdanovich, a passionate movie buff who proved with this, his second feature (after the well-received *Targets*, 1968), that he was not only a fine director of actors but also an accomplished visualiser. In this he was given crucial support by cinematographer Robert Surtees who, in an era of colour movies (which had become the norm in American cinema since 1967), made an evocatively beautiful black and white drama.

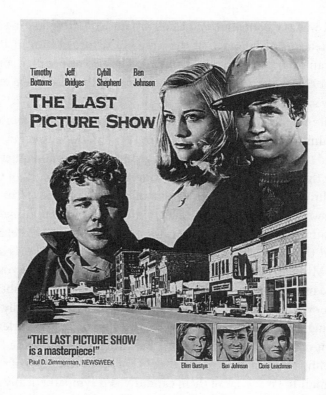

I interviewed Peter Bogdanovich in 1972, in my first such assignment for ABC Television.

Vital, too, was the contribution of Polly Platt, who designed the film; she was married to Bogdanovich at the time but divorced him in 1971 after he began an affair with Cybill Shepherd. The use of popular songs from the early 1950s—performed by Hank Williams, Frankie Laine and many others—was also important.

With its emphasis on the often unsatisfactory sexual lives of its characters, the film could easily have been a kind of sensationalised *Peyton Place*, but instead the material is handled with great tenderness and quiet humour, and more than one critic at the time compared it to the work of Chekhov.

The film opens and closes with a shot of the wide main street of Anarene; the windswept street features a collection of rundown buildings badly in need of paint, among them the Texas Moon Café, the Spur Hotel and Drug Store, and the Royal itself, which, in the opening sequence, is screening Vincente Minnelli's *Father of the Bride* (1950). It's here that the youth of the town head on a Saturday night, with Sonny's eyes fixed on Elizabeth Taylor on screen even as he kisses Charlene (who has first thoughtfully removed her chewing gum). After the show, when they go to park, Charlene wastes no time in removing her top and bra, but draws the line at the frustrated Sonny feeling between her legs. It's the first of many examples of the limitations of small-town sex, all of them candidly and sympathetically recorded.

Only one scene takes place in the classroom these adolescents attend, and even here sex is to the fore—a copy of Mickey Spillane's notorious novel *I, the Jury* is passed around while the teacher (JOHN HILLERMAN) resignedly quotes from Keats. The students are clearly thinking of other things— Jacy, for one, is touching up her make-up. Jacy, superbly played by Cybill Shepherd, is a chillingly calculating young woman who plays one boy off against the other. Her world-weary and clearly unhappy mother, who, we gather, is having a secret affair with oilman Abilene (CLU GULAGER), advises her that 'if you want to find out about monotony, marry Duane' and encourages her to have an affair. 'Everything gets old if you do it often enough' is her mantra.

Ruth, a genuinely sad figure as portrayed by Cloris Leachman (who won a Best Supporting Actress Oscar for the role) is neglected by her husband and childless, and she seizes the chance of happiness with Sonny, despite the fact that, in a town so small, 'you can't sneeze without someone offering you a handkerchief'. The shot in which she waits alone in her bedroom while Sonny goes off with Jacy is heartbreaking.

The other Oscar, for Best Supporting Actor, went to veteran Ben Johnson

whose Sam the Lion epitomises the nobility of past times. In the beautiful scene beside the 'tank', or dam, with Sonny and Billy, the old man talks about how much the country has changed since he first came there 40 years earlier. 'I'm as sentimental as the next fellow when it comes to old times,' he admits, and then tells Sonny how, 20 years earlier, he had enjoyed an affair with a 20-year-old 'wild thing' and how the affair ended when she grew up and got married. The love of Sam's life, we learn, was Lois Farrow and, at his funeral, we discover that the deep feelings were shared between the two of them.

The scene by the tank comes soon after Sonny, Duane and the other high schoolers have taken part in a stupid prank in which they forced the simple Billy, who appears to be an orphan with Sam as his surrogate father, to attempt sex with a blowsy prostitute. This Fellini-like scene ends in tears, and for a while Sam bars all the kids from his three establishments—though he soon relents.

When Duane leaves to fight in Korea, and the Royal closes down, the wide street of Anarene looks truly desolate. Nineteen years later, Bogdanovich and several members of his original cast (Jeff Bridges, Cybill Shepherd, Timothy Bottoms, Cloris Leachman, Eileen Brennan, Randy Quaid) reunited for a sequel, *Texasville*, which proved to be disappointing on almost every level.

Peter Bogdanovich (b. 1939) started in the film industry as an assistant to director Roger Corman and became a highly regarded film critic and writer before he made the thriller *Targets* (1968), with veteran actor Boris Karloff. *The Last Picture Show* was followed by the hilarious screwball comedy *What's Up, Doc?* (1972) and the delightful Depression-era comedy-drama *Paper Moon* (1973). These films were critically praised and performed well at the box office but all that changed with the failure of Bogdanovich's Henry James adaptation, *Daisy Miller* (1974), and the disastrous musical, *At Long Last Love* (1975), that followed it. These failures seriously disrupted the director's career, and subsequently there were long gaps between his films, some of which were a great deal better than others: *Nickelodeon* (1976), *Saint Jack* (1979), *They All Laughed* (1981), *Mask* (1985), *Illegally Yours* (1988), *Texasville* (1990), *Noises Off* (1992), *The Thing Called Love* (1993), *The Cat's Meow* (2001) and the delicious comedy, *She's Funny That Way* (2014).

I met Bogdanovich when he visited Sydney in March 1972 for the opening of *The Last Picture Show* and the ABC asked me to film a discussion with him (it was my first 'celebrity interview'). Subsequently we met often over the years and always enjoyed talking about the movies we both love.

Taking Off

USA, 1971

Universal–Forman–Crown–Hausman Productions. DIRECTOR: Miloš Forman. 92 MINS.
FIRST SEEN: *Sture Cinema, Stockholm, 14 August 1971.*

Fifteen-year-old Jeannie (LINNEA HEACOCK) travels into Manhattan to take part in an audition for a hippie musical without telling her parents, New York suburbanites Lynn (LYNN CARLIN) and Larry Tyne (BUCK HENRY). When she hasn't come home, the Tynes confide their fears about her safety to their friends Margot (GEORGIA ENGEL) and Tony (TONY HARVEY). Larry and Tony go looking for Jeannie and wind up in a bar where they get very drunk. When they arrive home, Jeannie has preceded them; Larry slaps her, and she disappears again. The next day in the city Larry encounters Ann Lockston (AUDRA LINDLEY), mother of another runaway teenager, who encourages him to join SPFC (Society for Parents of Fugitive Children). Lynn has received a call from the police to say that Jeannie has been arrested for shoplifting 300 miles away in upstate New York, but when the Tynes arrive there they discover that the 'criminal' is Jeannie's friend, Corinna Divito (CORINNA CRISTOBAL).

The Tynes attend an SPFC meeting where they meet Ann's husband, Ben (PAUL BENEDICT). Vincent Schiavelli (who plays himself) demonstrates the use of marijuana to the upper-crust attendees and the two couples return to the Tyne house, stoned, unaware that Jeannie has also returned and is in her room. She emerges to see her parents naked after losing at strip poker. Under questioning, Jeannie admits that she has a boyfriend, and is encouraged to invite him to dinner. To Larry's astonishment, Jamie (DAVID GITTLER), a long-haired, bearded hippie, reveals that he earned $290,000 the previous year—before tax.

In the three features and two documentaries that Miloš Forman made in his native Czechoslovakia, a recurring theme for this exceptional filmmaker was the totally different worlds in which children and their parents exist. It may seem like stating the obvious, but rarely has the gulf between adults and teenagers been as beautifully expressed as it is in *Černý Petr/Black Peter* (1964), *Lásky jedné plavovlásky/Loves of a Blonde* (1965) or *Taking Off.*

Forman went into exile after the Warsaw Pact invasion of his country in 1968, but it took three years before he was able to make his first American

film. Working with his gifted Czech cinematographer, Miroslav Ondříček, Forman tells a story about children behaving sensibly and adults behaving badly. Throughout the film there are intercut scenes of teenagers, and some even younger kids, auditioning for a hippie musical. In one scene Forman repeats an idea from his Czech documentary *Audition* (1963) by cutting rapidly from performer to performer during a rendition of 'Let's Get a Little Sentimental'—each hopeful is given just a line of the song, sometimes only a word, before there is a cut to the next aspirant. Most of these kids were genuinely auditioning, and were not professional actors or singers, though there are a couple of exceptions: Carly Simon sings 'The Long Term Physical Effects' and 'Bobo' Bates, aka Kathy Bates, sings her own composition, 'Even the Horses Had Wings'.

Jeannie Tyne is painfully shy and hardly speaks a word throughout the film, but she's determined to try her luck. Her hapless parents, certain she's become one of the very many runaway teenagers of the 'flower power' era, assume the worst. At a time when so many films were made from the point of view of youth (*Easy Rider, Alice's Restaurant*, both 1969, and countless others), *Taking Off* is mainly concerned with their elders.

Larry and Lynn are spending an evening with their friends, Tony and Margot, when Jeannie first disappears. While the men go off in search of the girl, carrying an absurdly large photograph of her in a frame, and wind up getting drunk, Margot regales the astonished Lynn with stories of the sexual appetite of her wimpy husband (apparently when she sings 'Campdown Races' it turns him on). Later, after getting stoned at the absurdly funny meeting of the SPFC, the Tynes lose a game of strip poker played with Ben and Ann Lockston. On both occasions, Jeannie is a bemused witness to her parents' bad behaviour and on both occasions Forman—as he did in *Loves of a Blonde*—switches the mood abruptly and painfully so that the viewer is jolted from laughing at the comical poker game to being shocked into seeing the same scene from the 15-year-old's perspective, when it's decidedly unfunny.

Adults are consistently criticised. A gormless cop ponderously declares to the Tynes: 'This girl is *not* your daughter,' a fine example of stating the bleeding obvious. The Tyne's doctor (ROBERT DRYDEN), woken in the middle of the night to be quizzed about possible drugs Jeannie might have taken, knocks over an ashtray filled with cigarette stubs. The owner of a small diner (RAE ALLEN), when told by Larry that a girl sitting in a booth is featured in a missing persons photograph she keeps beneath her counter, repeats 'I

don't know. That's not my business.' When asked if Jeannie has been fitted with a diaphragm, Lynn replies that her 15-year-old is 'just a baby'. A pair of lecherous characters (ALLEN GARFIELD, BARRY DEL RAE) spot Lynn sitting alone in the nightclub of the hotel where she and Larry are spending the night and one of them follows her to her room, only to be surprised—with his pants down—by Larry. Ann Lockston openly flirts with Larry, who seems willing to go along. And the parents whose children have vanished are mercilessly caricatured as they undergo training in how to smoke a joint from the wonderfully garbed Vincent Schiavelli (a character actor who would reappear in several subsequent Forman films).

Not everyone appreciated the joke. I recall a representative of the film's distributor complaining that a 'Communist from Eastern Europe' had the gall to make fun of American parents. But, of course, Forman's message is a universal one. It's not easy to bridge the gulf between children and teenagers, but he views the situation with compassion, insight and, above all, a wicked sense of humour (the film's screenplay was written by Forman in collaboration with playwright John Guare, John Klein and Jean-Claude Carrière).

I first met Forman when he came to Australia for the premiere of his 1975 film, *One Flew Over the Cuckoo's Nest*, and encountered him on several occasions afterwards. He was a gentle soul, funny and sensitive, like his movies.

Miloš Forman (1932–2018) was born in Čáslav, Czechoslovakia, and his parents died in the Holocaust. He studied at the Prague Film Academy and was a key figure in the establishment of *Laterna Magicka/Magic Lantern*, the multimedia stage presentation that successfully ran in Prague for several years. In addition to the previous films mentioned he made *Hair* (1979), *Ragtime* (1981) and *Amadeus* (1984). Despite the considerable success of these films—he was twice awarded the Oscar for Best Director, for *One Flew Over the Cuckoo's Nest* and *Amadeus*—his career went into a downturn when he made *Valmont* (1989), an adaptation of the 1782 French novel *Les liaisons dangereuses* by Choderlos de Laclos; in an unfortunate coincidence, Stephen Frears simultaneously directed a rival version, *Dangerous Liaisons*, which was released first and overshadowed Forman's equally fine version (see my book *101 Marvellous Movies You May Have Missed*). It was seven years before Forman was able to make *The People vs. Larry Flint* (1996), which was followed by *Man on the Moon* (1999). His last film, *Goya's Ghosts*, made in Spain in 2006, was hardly screened. He made occasional forays into acting, notably in Mike Nichols' *Heartburn* (1986).

75

W.R.: Mysteries of the Organism
(*W.R.: Misterije organizma*)

YUGOSLAVIA/WEST GERMANY, 1971

Neopolanta Film–Telepool. DIRECTOR: Dušan Makavejev. 84 MINS.
FIRST SEEN: *Fasan Bio, Copenhagen, 18 August 1971.*

This film collage is divided into three parts and based on the theories of the Austrian-born psychologist and biologist Wilhelm Reich (1897–1957), the 'W.R.' of the title. Part One consists of a brief documentary on Reich's life and work, and includes interviews with his wife and son, as well as people who knew him in a small town in Maine where he established the Orgone Laboratory. He was charged with the illegal transportation across state lines of 'Orgone Accumulators' and found guilty; he died in Lewisburg Federal Penitentiary and his books were burnt. Part Two, partly filmed in 1968, depicts counter-culture in the USA at the height of the Vietnam War, with coverage of both the anti-war movement and the movement for sexual freedom. Part Three, a fictional story set in Belgrade, features two young women, Milena (MILENA DRAVIĆ) and Jagoda (JAGODA KALOPER), who share an apartment and follow the teachings of Reich. Milena is attracted to Vladimir Ilych (IVICA VIDOVIĆ), a visiting Russian ice-skating star, but he is so terrified by her open sexual approaches that he beheads her with his ice-skate.

Nobody made films like Dušan Makavejev. The Belgrade-born director believed in 'guerrilla' cinema—he said once that he was opposed to 'everything that is fixed, defined, established, dogmatic or eternal'. *W.R.: Mysteries of the Organism*, which premiered at Cannes in 1971, sets out unashamedly to shock, but does so with an infectious sense of humour. The film offended the countries of the Communist bloc, including the director's home country, because of its equation of Communism with Fascism ('Red Fascists' is one of the terms used). The pompous, self-important Soviet People's Artist—who is named after Lenin!—is unable to cope with the politically and sexually liberated Serbian girl, so he kills her. She is too free, just as, three years earlier, the Soviets had crushed Czechoslovakia because it was 'too free'. Makavejev uses sequences from an old Soviet film, *Pitsi/The Vow* (1946),

directed by Mikhail Chiaureli, in which Mikheil Gelovani portrays Stalin, who is adored by a worshipful crowd as he promises to continue in the path set by Lenin—but this sequence is intercut with a counter-culture sequence in which artist Nancy Godrey is making a plaster cast of the erect penis of the editor of *Screw* magazine, Jim Buckley, and the image of Stalin is tinted pink, the same colour as the penis. Similarly when Milena makes a speech about sexual freedom on the third-floor balcony of her apartment building, cheered on by dozens of her neighbours, Makavejev cuts abruptly to Tiananmen Square and Mao Tse-tung being applauded by thousands of people waving his Little Red Book.

The scenes involving Reich, who had been Sigmund Freud's first assistant and who fled both Fascism and Communism in Europe only to be accused of being a Communist in small-town America (where he had voted for Republican Dwight Eisenhower), are totally fascinating, if very weird. His theories on cosmic love led to books like *The Function of the Orgasm*, books that were officially destroyed, on orders of the court, after his death. He designed Orgone Accumulators—small cupboards made of organic material lined with metal—in which patients would sit to collect 'orgone energy'. Kaleidoscopic images of couples having intercourse are accompanied by a female narrator quoting Reich ('Cancer and fascism are closely related. For your health's sake, f**k freely!')

Reich's daughter, Eva, while declaring that 'The American Dream is dead', goes on to tell Makavejev, who is heard but not seen in the interview footage, that, as a citizen from a country 'behind the Iron Curtain', 'if you say what you really think you wouldn't be alive'. She also claims that Russians don't smile because they don't get enough food.

There are interviews with a handful of doctors who were still practising Reichian theories when the film was made, as well as footage of group sex therapy sessions. Milena and Jagoda have an Orgone Accumulator in their apartment.

Some of the counter-culture scenes feature the poet and activist Tuli Kupferberg, who stalks Wall Street with a fake gun and helmet while his song 'Kill for Peace' is heard on the soundtrack. Tupferberg also asks rhetorically: 'Who will judge our police? And who will police our judges?' These American 'underground' sequences also feature sex educator Betty Dodson, who paints women and men enjoying masturbation, and Jackie Curtis, one of Andy Warhol's 'superstars'.

All this material is intercut with the main story. Jagoda, who is almost always naked, is uninhibitedly sexual, frequently coupling with her lover, Ljuba (MIODRAG ANDRIĆ), and obviously enjoying herself immensely. While Milena smokes a cigar and, sitting in front of a poster for a movie titled *The Mating Urge*, reads an article in *The Communist* headed 'How Karl Marx Fell in Love', the two lovers copulate—apparently genuinely—on the floor, on the couch, in bed and under a rug. It's all very cheerful and appears to be mutually pleasurable. Milena, however, is tired of her lover, Radmilović (ZORAN RADMILOVIĆ), a garbage worker, and keeps him at bay while lecturing the men and women in her apartment building on sexual politics.

She's instantly attracted to the Russian skating star, but though 'we pulsated to the vibrations of the universe' he, being 'a genuine Red Fascist' can't cope with her needs and kills her. Even decapitated, she continues to talk and to bemoan all forms of sexual inhibition, while Vladimir Ilych, with her blood on his hands, trudges through the snow singing a plaintive ballad by the Underground poet Bulat Okudjava, 'Ode to François Villon'.

With its radical views on sex and politics, the film may sound heavy going but, like all Makavejev's films, it's frequently hilarious. The unexpected juxtapositions are beautifully timed; the use of music and songs is sublime; and the uninhibited performances from the actors are a joy.

The film was banned in the Communist bloc, including Yugoslavia, and Makavejev was, for a while, forced into exile in Paris. The first time I met him was in 1969 at the Festival of Yugoslav films in Pula (now part of Croatia). We became friends and saw each other often over the years. He came to the Sydney Film Festival with *Sweet Movie* in 1975 and returned a few years later to make *The Coca-Cola Kid* in Sydney. On one occasion we were meeting for dinner in Paris and he asked if I'd mind if we went to see a movie first—the movie he wanted to see was *Cover Girl*, a 1944 musical with Gene Kelly and Rita Hayworth; like me, Makavejev's taste in cinema was eclectic. Once when he was in Australia he came to my house for a TV interview; we filmed it on the deck under a tree and Makavejev was halfway through a reply when my Siamese cat leapt from a tree branch onto his lap; without batting an eye he kept on talking!

Dušan Makavejev (1932–2019) made amateur films and documentaries before his first feature *Čovek nije tiga/Man is not a Bird* (1965). This was followed by *Ljubavni slučaj ili trajedija službenice PTT/Love Dossier, or the Tragedy of a Switchboard Operator* (1967), which, like *W.R.*, is a collage that culminates in the death of a young woman at the hands of her lover. It

was followed by *Nevinost bez zaštite/Innocence Unprotected* (1968), a 'new version' of the first Yugoslav sound feature, and then by *W.R.* In exile, Makavejev made *Sweet Movie* (1974) in Canada; contributed to *Wet Dreams* (also 1974) in the Netherlands; *Montenegro* (1981) in Sweden; *The Coca-Cola Kid* (1985) in Australia; *Manifesto* (1988), an American production filmed in Yugoslavia; and finally *Gorilla Bathes at Noon* (1993), a German–Yugoslav co-production.

Don't Look Now

UK/ITALY, 1973

Casey Productions–Eldorado Films. DIRECTOR: Nicolas Roeg. 110 MINS.
FIRST SEEN: *Odeon, Leicester Square, London, UK 4 October 1973.*

Christine (SHARON WILLIAMS), the younger of two children of John (DONALD SUTHERLAND) and Laura Baxter (JULIE CHRISTIE), accidentally drowns in a pond near their home in rural England while wearing a red plastic raincoat. Sometime later the couple are staying in Venice where John is in charge of restoring a church. In a restaurant they encounter a pair of middle-aged English sisters, Heather (HILARY MASON), who is blind, and Wendy (CLELIA MATANIA); Heather, who claims to have second sight, tells Laura that she can 'see' Christine and that the little girl is happy. John refuses to believe any such thing. Later, Heather tells Laura that John's life is in danger if he remains in Venice. Aware that a series of murders is taking place, Laura urges John to leave, but then leaves herself after a phone call from their son's boarding school in England to say he has been involved in an accident. The hotel in which they are staying closes for the winter and John, as previously arranged, is on his way to move into the residence of Bishop Barbarrigo (MASSIMO SERATO), when he thinks he sees Laura and the two women on a boat on the Grand Canal. He searches everywhere for her, and reports the sisters to the police, but when he phones the school he discovers that Laura is still there. Heather has been arrested, and a chastened John offers to take her back to her hotel when she's released. After he leaves, she has a vision and attempts to get him back, but he has seen a childlike figure in a red coat and followed it; the figure turns out to be a dwarf with a knife.

Daphne du Maurier's short story, on which *Don't Look Now* was based, was originally published in the 1971 anthology, *Not After Midnight*. The screenplay for this exceptionally creepy and effective film, written by Allan Scott and Chris Bryant, follows the original fairly closely, though where it departs from the original it ventures into most interesting territory. In the story, Christine died of meningitis. The film opens with a famous scene in which, following an afternoon rain shower, the little girl is playing near a pond while her elder brother, Johnny (NICHOLAS SALTER), rides his bike.

Beginning a pattern that will be followed throughout the film, the Australian editor, Graeme Clifford—a protégé of Robert Altman's who came to *Don't Look Now* after meeting Julie Christie during the filming of *McCabe & Mrs. Miller* (1971) in Canada—weaves an intricate mesh of images into a powerful whole. He cuts from the pond to (mysteriously) the shuttered window of the hotel room in which the Baxters will stay in Venice, then to Christine in her red raincoat pushing a wheelbarrow, to her red and white striped ball in the pool, to a shot with the house in the background, then to the living room where Laura sits before a fire reading while John projects slide photographs of the Venetian church onto a screen. Rapid cutting back and forth between these elements reaches a climax when Johnny runs over a pane of glass and John spills water onto his slide, whereupon the hooded figure in red sitting in the front pew of the church seems to melt, with red bleeding over the entire image. It's then that John rushes from the house, too late to save his daughter.

After this remarkable opening sequence the action shifts to a wintry Venice; John wears an overcoat and scarf, the tourists are absent and the hotels are closing down for the season. Venice has rarely seemed as sinister as it does in this film. Many scenes take place at night, on side streets and alleys where it's easy to lose yourself. Faces can be seen watching at windows, and in many scenes there is a silent observer who seems slightly sinister—such as in the restaurant toilet where Laura tries to help the sisters, in the police station, the bishop's palace, and in the corridor of the sisters' hotel where John encounters a strange man in a red dressing gown. As it becomes clear that a serial killer is at large—we hear mysterious shouts and screams, a woman's body is unceremoniously dragged out of a canal—the tension rises.

Laura, who has been depressed since her child's death, is thrilled to hear from Heather that Christine is 'happy'. Her happiness leads to another famous—and superbly edited—sequence in which John and Laura (perhaps turned on by a photograph of Uluru in a magazine!) make love—an act that is quite graphically shown—with the lovemaking intercut with a scene in which they later prepare to go out to dinner. Another key sequence is the one in which John, comparing newly manufactured mosaic pieces with the original mosaics high up on the wall of the church he's restoring, almost falls from the swinging platform from which he's working; the scene ends with the bishop's heel crushing the valuable mosaics that have fallen onto the marble floor.

Roeg fills *Don't Look Now* with mysterious moments and details. When Laura faints in the restaurant, knocking over the table, the camera dwells on the merging of wine, vinegar and olive oil on the floor. There's the brief revelation that Laura has brought Christine's ball with her to Venice. The sisters have a curious collection of framed photographs of children ('Nothing can take the place of the one that's gone,' says Heather to Laura). The bishop, asleep in bed, awakens with a start just before John is killed. Police Inspector Longhi (RENATO SCARPA), who has been handed sketches of the sisters and has initiated a search for them, looks out of his office window as they pass by underneath without recognising them. The sisters themselves suddenly, inexplicably laugh as Laura approaches their hotel to talk to them. Then add to these all the haunting scenes of the 'child'—as John supposes the red-cloaked creature to be—flitting around corners, into shadows, down alleys, apparently pursued, perhaps by the killer. When John gently approaches the 'child' he does so with soft words: 'It's okay, I'm a friend, I won't hurt you.' He doesn't know about the knife.

Anthony Richmond's camerawork deserves special praise, both for the misty English winter's afternoon opening sequence as well as throughout the Venice scenes, where there's a constant emphasis on the colour red. The performances of Sutherland and Christie as the grieving parents are very fine, but all the other characters—the sisters, the bishop, the inspector, the hotel manager (LEOPOLDO TRIESTE)—are strangely, vaguely sinister.

I've been to Venice more than 50 times and I know the city well, including the locations for the film. But whenever I go there I still feel slightly uneasy, thanks to the power of Roeg's masterpiece.

Nicolas Roeg (1928–2018) was a highly regarded cinematographer on such films as *Help!* (1965), *Far from the Madding Crowd* (1967) and *Petunia* (1968) before co-directing his first feature, the controversial *Performance* (1970) with Donald Cammell. Subsequently he made the justly memorable *Walkabout* (1971) in Australia. After *Don't Look Now* he directed *The Man who Fell to Earth* (1976), *Bad Timing* (1980) and *Eureka* (1982). The latter was badly distributed and was a commercial failure, and nothing Roeg made afterwards came close to his earlier work. He made *Insignificance* (1985), *Castaway* (1986), *Track 29* (1987), *The Witches* (1989), *Heart of Darkness* (1993, a television feature), *Two Deaths* (1994) and the barely seen *Puffball* (2006).

Chinatown

USA, 1974

Paramount–Long Road Productions. DIRECTOR: Roman Polanski. 130 MINS.
FIRST SEEN: *Cinema International Corporation screening room, Sydney, 24 July 1974.*

Los Angeles, 1937. Private detective J.J. Gittes (JACK NICHOLSON) is hired by Ira Sessions (DIANE LADD), who says her name is Evelyn Mulwray; she tells him she believes her husband has a mistress. Gittes follows Hollis Mulwray (DARRELL ZWERLING), the chief engineer for the city's Water and Power Department. Mulwray is opposing the establishment of a proposed dam and reservoir. Gittes follows Mulwray to a park where he takes a young woman, Katherine (BELINDA PALMER), for a row on a lake; Gittes snaps a photo of the couple later having a meal in the courtyard of the Albacore Apartments. The photo is splashed on the front page of the local paper. Mulwray and Katherine disappear. The real Evelyn Mulwray (FAYE DUNAWAY) threatens to sue Gittes. It seems that her husband was set up by interests supporting the new reservoir. Mulwray's body is found drowned, and his wife withdraws the lawsuit. Gittes discovers that multi-millionaire Noah Cross (JOHN HUSTON), Evelyn's father, had been Mulwray's partner in owner-ship of the area's water supply before it was taken over by the city. Still suspicious of Evelyn, although he spends a night with her, Gittes follows her to a house where she is keeping Katherine safe; the child is her daughter as the result of an incestuous rape by her father. Gittes attempts to enable them to escape, but is thwarted by Lieutenant Lou Escobar (PERRY LOPEZ), his former partner from the time when he was a cop and they worked the Chinatown beat. As Evelyn attempts to prevent her father from gaining access to Katherine, events move to a tragic conclusion.

During the late 1960s and 1970s many of the old private-eye movies of the 1930s and 1940s—starring Humphrey Bogart, Dick Powell and others—were screened on television and found enthusiastic audiences among members of a new generation. Robert Towne's superbly structured original screenplay for *Chinatown*, which has its basis in a particular moment in the history of Los Angeles—a drought-prone city sandwiched between the ocean and the desert—proved to be perfect material for Polish-born Roman Polanski, whose visual invention and craftsmanship were at the peak of

their form. Add the impeccable production design by Richard Sylbert with its rich details (such as Gittes' office with its newly installed venetian blinds and a framed photograph of President Roosevelt next to the drinks cabinet), the period costumes designed by Anthea Sylbert (three-piece suits and natty trilby hats for the men, glamorous garbs for Dunaway), the burnished photography by John A. Alonzo and Jerry Goldsmith's haunting music score, with its mournful trumpet solos, and you have one of the most perfectly packaged movies of the decade.

The backdrop details describing the corruption that is making a fortune for the powerful interests who control the supply of water to the city during a drought gives the twist-laden mystery an unusually authentic edge. But Gittes, ex-cop now super-confident private eye who charges $35 per day plus expenses, is not as smart as he thinks he is. In common with many of cinema's earlier gumshoes, he's cynical, brash and witty—but, tragically, he is also extremely naïve and gets everything wrong. He believes, incorrectly, that Evelyn Mulwray might have been jealous of her husband's 'mistress', whereas, in fact, both Hollis and Evelyn were attempting to protect the tragic Katherine from her evil and terrifying father/grandfather. In this role, John Huston is magnificent: refusing to pronounce Gittes'

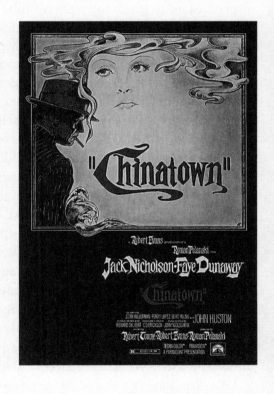

name correctly ('Gitts' instead of 'Gitt-es'), his soft-spoken, old-world malevolence is truly menacing, especially at the climax when he comforts the grief-stricken Katherine who, we assume, may become the wicked old paedophile's next victim.

The earlier scenes in which Gittes meticulously follows up leads, tracking Mulwray as he examines the disputed water sources or quizzing his deputy, Yelburton (JOHN HILLERMAN) about the history of the Water Department,

are beautifully handled by Polanski who makes a famously nasty personal appearance as the diminutive, nattily dressed tough guy who slashes Gittes' nose 42 minutes into the movie—after which Jack Nicholson's face is disfigured first by bandages and later by a bloody scar. 'I cut myself shaving,' he wisecracks to Yelburton, who responds that the wound must smart. 'Only when I breathe,' says Gittes. Later there's a fine scene in which, accompanied by Evelyn, Gittes continues his investigation in an old people's home—where many of the residents, unknown to them, have become 'owners' of valuable real estate. Posing as a couple seeking a place for an ageing parent, Gittes asks the suave manager (JOHN ROGERS) if he accepts people of 'Jewish persuasion,' to which the reply is a firm 'No.'

The film is filled with scenes and incidents that vividly evoke the genre: Gittes discovering that the pond at the Mulwray house contains salt water, or arriving at the house where he expects to meet the mysterious Ida Sessions only to discover her body, and the groceries she was carrying, on the kitchen floor, and Escobar and the cops waiting for him.

There's no excuse for the fact that neither *Chinatown* nor Polanski were recognised with Oscar nominations, even in an exceptional year such as 1974—especially since a routine affair like *The Towering Inferno* was nominated for Best Film. Nicholson and Dunaway were both nominated for their performances but failed to win. However, the film won four Golden Globe Awards: Best Film, Best Director, Best Actor and Best Screenplay, and it was a significant success at the box office. In 1990 Nicholson directed a long-delayed sequel titled *The Two Jakes*.

Roman Polanski (b. 1933), a holocaust survivor, has had an extraordinary and controversial career. A student at the celebrated Polish Film School in Łódź in the early 1950s, he made a number of impressive short films before he came to international fame with his astonishingly good first feature *Nóż w wodzie/Knife in the Water* (1962). He was immediately headhunted by Western producers and made a trio of excellent films in the UK—*Repulsion* (1965), *Cul-de-sac* (1966) and *The Fearless Vampire Killers* (1967, a comedy in which he played the role of a vampire hunter, and his future wife, Sharon Tate, played a vampire's victim). He had a deserved success with his first American film, *Rosemary's Baby* (1968), and was one of the hottest directors in the world when, tragically, Tate, who was pregnant, and her friends were murdered by members of Charles Manson's 'family' in 1969 while Polanski was in London (events given an alternative twist in Quentin Tarantino's *Once Upon a Time in Hollywood*, 2019). After

the tragedy, Polanski made a version of Shakespeare's *Macbeth* (1971) in the UK and the curious comedy *Che?/What?* (1972) in Italy. He returned to the USA for *Chinatown*, followed by *Le locataire/The Tenant* (1976), which he made in France and in which, again, he played a leading role. In 1977 in Los Angeles he was charged with unlawful sexual intercourse with a minor, but left the USA in 1978 and has never returned. He based himself in Paris and became a French citizen. In France he has made *Tess* (1979), *Pirates* (1986), *Frantic* (1987), *Bitter Moon* (1992), *Death and the Maiden* (1994), *The Ninth Gate* (1999), *The Pianist* (2002, which won the Palme d'Or at Cannes and an Oscar for Best Director), *Oliver Twist* (2005), *The Ghost* (2009), *Carnage* (2011), *Venus in Fur* (2013), *D'après une histoire vraie/Based on a True Story* (2017) and *J'accuse/An Officer and a Spy* (2019).

The Conversation

USA, 1974

Paramount–The Directors Company. DIRECTOR: Francis Ford Coppola. 113 MINS.
FIRST SEEN: *Cinema International Corporation screening room, Sydney, 1 May 1974.*

Lunch hour in Union Square in the centre of San Francisco. Under the direction of surveillance expert Harry Caul (GENE HACKMAN), three men are recording a conversation between a young couple, Ann (CINDY WILLIAMS) and Mark (FREDERIC FORREST), as they walk in circles among the crowds. Later in his warehouse workroom, Harry integrates the three tapes and improves the sound quality. He gets the impression that the couple are in danger ('He'd kill us if he had the chance,' Mark whispers) and is troubled because, when working for law enforcement in New York, he had bugged a union official, an act that led to three murders. He refuses to hand the tapes over to Martin Stett (HARRISON FORD), the assistant to his employer, a wealthy businessman, but insists he will only give them to the Director (an uncredited Robert Duvall) personally. After visiting a security convention he invites East Coast rival Bernie Moran (ALLEN GARFIELD), his occasional assistants Stan (JOHN CAZALE) and Paul (MICHAEL HIGGINS), plus two women, Meredith (ELIZABETH MACRAE) and Lurleen (PHOEBE ALEXANDER), back to his workshop for an impromptu party. He sleeps with Meredith but the next morning she and the tapes have gone. Stett acknowledges he has them and tells Harry to come to the office for payment. Later Harry goes to the hotel mentioned during the conversation and discovers (or imagines?) blood welling out of the toilet in the room in which the young couple were to meet. He reads in the paper that the Director has been killed in a car crash. Back in his apartment he realises that he's being bugged ('We'll be listening to you,' says a voice on the phone).

When I first met Francis Ford Coppola, in the summer of 1969 in San Francisco, he showed me a draft screenplay for the film that would become *The Conversation*; by the time the film was released, in April 1974, the Watergate scandal was at its height, so a film about surveillance and secret bugging was timely. It still is in a world of CCTV cameras on the one hand and sophisticated international 'actors' hacking into national computer systems on the other.

Gene Hackman's mesmerisingly interior performance as Harry, 'the best bugger on the West Coast', anchors a quietly disturbing film that seems clearly influenced by Michelangelo Antonioni's *Blow-Up* (1966)—in that film the magnification of a photograph revealed details of a murder, while in *The Conversation* three simultaneously recorded audio tapes are amalgamated and refined to the point that they reveal *some* kind of conspiracy, but not quite the kind that Harry expected—probably because he identifies with the handsome young couple. To be sure, the film cheats a little (the emphasis on the word 'us' in the phrase 'He'd kill us if he could' is subtly altered), but that doesn't diminish its power.

Harry is described at one point in the film as 'lonely and anonymous'. He lives alone, has an unlisted phone number and three locks on his apartment door and is disturbed to find that his landlord has left him a birthday present inside the apartment. He's suspicious on several levels. 'I thought I had the only key,' he tells the landlord on the house phone. 'How did you know it was my birthday?' He also tells the man that he has nothing of value ('I'm happy to have all my things burned in a fire') but, at the end, when he's turning the place upside down to find the elusive bug, he hesitates before breaking open a little plastic statue of the Madonna.

In a poignant scene he goes to the apartment of Amy (TERI GARR), a young woman with whom he's involved; she's already in bed, but he brings a bottle of Chianti and she's obviously pleased to see him. When she starts asking him questions ('I wanna know you') he abruptly leaves, telling her, 'I don't feel like answering any questions.' Meticulous, even obsessive, as far as his work is concerned, Harry is a Catholic who reacts against his colleague, Stan, when he blasphemes. The most we discover about him is when he goes to confession and reveals 'people were hurt because of my work and I'm afraid it will happen again'. But he adds, 'I'm not responsible.' When Stan wonders, 'Who's interested in these two?' Harry claims he doesn't care; his only concern, at least at the start, is to do a professional job. But he takes an instant dislike to the smarmy Stett—an early role for Harrison Ford—who significantly wears an American flag pin in his lapel and who follows Harry to the convention.

The convention sequence allows Coppola to have fun with the most modern inventions, including a pioneering CCTV camera (on which Harry realises that Stett has followed him). Allen Garfield's brash salesman/technician is a memorable character—he even succeeds in planting a bug on Harry in the form of a complimentary pen. Stan is another great character,

as played by John Cazale (who played one of the Corleone brothers in the first two *Godfather* films and who died of cancer in 1978); his evident pride as he explains to Moran the way in which the conversation was recorded (incorporating a high-powered rifle) makes his character genuinely conflicted.

Technically, the film is a marvel with the intricate long-lens photography by Bill Butler and—in the opening sequence—by an uncredited Haskell Wexler, and the ravishing music score by David Shire complemented by the extraordinary achievement in sound montage and refining by Walter Murch. Winner of the Palme d'Or at Cannes a month after it opened in the USA, *The Conversation* was a notable achievement for its director given that it was sandwiched between the first two *Godfather* films; alongside those blockbusters its commercial success was modest but it is, in many ways, dramatically more satisfying than either.

Francis Ford Coppola (b. 1939) worked as an assistant to director Roger Corman and wrote screenplays (*Is Paris Burning?*, 1965; *Patton*, 1969) while at the same time beginning his career as a director. He started with an obscure sex comedy, *Tonight for Sure* (1961), and subsequently made *Dementia 13* (1963), *You're a Big Boy Now* (1966), *Finian's Rainbow* (1968) and *The Rain People* (1969). The commercial failure of the latter film was triumphantly forgotten when he directed *The Godfather* (1972) followed by *The Godfather: Part II* (1974). The troubled but ultimately triumphant Vietnam War epic *Apocalypse Now* (1979) is another of his memorable achievements. Subsequently his work has been uneven and diverse: *One from the Heart* (1982), *The Outsiders* and *Rumble Fish* (both 1983), *The Cotton Club* (1984), *Peggy Sue Got Married* (1986), *Gardens of Stone* (1987), *Tucker: The Man and his Dream* (1988), *The Godfather: Part III* (1990), *Bram Stoker's Dracula* (1992), *Jack* (1996) and *The Rainmaker* (1997). After this there was a ten-year gap before Coppola made his last three, relatively obscure, films: *Youth Without Youth* (2007), *Tetro* (2009) and *Twixt* (2011).

79

Jaws

USA, 1975

Universal–Zanuck–Brown Productions. DIRECTOR: Steven Spielberg. 124 MINS.
FIRST SEEN: *MCA screening room, Sydney, 22 May 1975.*

The coast of Massachusetts. On a summer night in late June, a young woman (SUSAN BACKLINIE) is taken by a giant shark while swimming off a beach near Amity, a small summer resort town located on an island. Martin Brody (ROY SCHEIDER), Amity's recently appointed chief of police, is persuaded by Mayor Larry Vaughn (MURRAY HAMILTON) that the victim died in a boating accident; with the 4th of July holiday approaching, Amity can't afford to lose the holidaymakers on which it depends. Even when Alex Kintner (JEFFREY VOORHEES), a small boy, is killed while paddling on an inflatable float, Vaughn still insists the beaches must stay open. Brody seeks advice from Matt Hooper (RICHARD DREYFUSS), an expert from the Oceanographic Institute who confirms that the woman was killed by a large shark. A man (TED GROSSMAN) in a rowboat is killed in the lagoon and panic ensues. Quint (ROBERT SHAW), a big-game fisherman, is offered $10,000, plus bonuses, to kill the shark. He, Brody and Hooper set off in Quint's boat, *Orca*. The shark proves to be even larger than they at first thought and efforts to kill or capture it fail; after it wrecks the boat, Quint is taken by the creature, but Brody manages to kill it.

Jaws changed the way films were marketed. In the summer of 1975, Universal made the decision to open the film not just in one cinema in each major city, as was the previous strategy, but in over 400 cinemas on the same day. Within a couple of weeks it had grossed over $100 million in the USA and Canada, the start of a worldwide success that would make it, for a while, the biggest grossing film of all time.

Steven Spielberg was only 28 years old. He had made his first television feature, *Something Evil* (1971) at the age of 24 and both *Duel* (1972)—made for TV but expanded into a cinema feature—and *The Sugarland Express* (1974) had been major successes. Peter Benchley's page-turning book, published in 1974 and purchased by the studio at galley stage, proved to be the film that catapulted the young director into the forefront of filmmakers; he became the poster boy for the new generation of 'movie

brats' who, unlike most filmmakers of previous generations, grew up watching movies.

Jaws opens with a bang. At a beach party by a bonfire, a young couple lock eyes. The young woman leads the way to the beach, stripping off her clothes as she runs; the young man is too drunk to follow and collapses on the sand. As the woman swims, the sinister John Williams score heralds the approaching predator, and underwater footage filmed below the swimmer adds to the feeling of dread. The moment the shark strikes is a brutally effective shock.

For a while after this opening sequence the action centres on Brody, the New York cop who came to Amity with his wife, Ellen (LORRAINE GARY), and sons (CHRIS REBELLO, JAY MELLO), expecting a quieter life. His conflict with the mayor—Murray Hamilton, an actor who was second-to-none at playing obnoxious, weaselly characters—over the extent of the crisis ('Amity is a summer town. We need summer dollars') is increased because of his fear for the safety of his own family. Brody is in a bind: if he fails to take action, he is liable for possible shark victims—as Mrs Kintner (LEE FIERRO) accuses him in the case of her son ('You *knew* there was a shark out there, and still my boy is dead')—and if he closes the beaches he threatens the prosperity of his employers. The debate in these early scenes is similar to the dilemma faced by authorities during the 2020 Covid-19 pandemic: which comes first, health and safety or the economy?

This conflict is beautifully expressed in a scene in which Brody is attempting to keep watch at the beach for any possible problem while his view is blocked by an angry local citizen complaining about illegally parked cars. Spielberg packs in plenty of false alarms and suspenseful red herrings in the first half of the film, and then, in the second half, limits the action to the three main characters as he depicts, in almost documentary fashion, the difficulties involved in fishing for an outsized predator.

With a reward on offer some local fishermen catch and kill a tiger shark and put it on display, while tourists begin to crowd back onto the island. This deliberately chaotic early scene is undercut by the arrival of Hooper, the youthful, bearded scientist with a grim sense of humour ('I love sharks,' he admits). He quickly confirms that the captured shark could not have killed the young woman and, with Brody's help, cuts open its stomach, revealing not human remains but a Louisiana licence plate.

Quint brings more grim humour to the drama. Given to singing old sea shanties and telling graphic stories (one of which includes his wartime

experience when he was one of only 316 out of 11,000 men to survive a sunken ship, the rest of whom were taken by sharks), this gnarled character proves to be almost as obsessed with killing a giant sea creature as Captain Ahab in *Moby-Dick*. The three actors make a beautifully contrasted trio of shark hunters.

The film's production difficulties were legendary (the model shark didn't always work, the changeable weather made filming at sea difficult) but Spielberg's sheer skills as a filmmaker paper over the drawbacks. Aided by the fine cinematography by Bill Butler (with Australians Ron and Valerie Taylor providing most of the real shark footage), the film looks magnificent.

Jaws received its European premiere in September 1975, at a film festival in the Spanish city of San Sebastián. The day after the screening I had lunch with Spielberg at one of the town's famously excellent restaurants and we discovered that we shared a great many favourite movies (some of which have already featured in this book). After lunch we returned to our hotel and continued the conversation, and then exchanged personal details. I've often regretted that I never stayed in touch with him; after *Jaws* he became one of the world's most celebrated directors and I suppose I was a bit intimidated by his celebrity status. Also, of course, this was a time when keeping in contact meant writing old-fashioned letters. I have not met him since.

The success of *Jaws* led to three inferior sequels, none of them directed by Spielberg. Roy Scheider, Lorraine Gary and Murray Hamilton returned for *Jaws 2* (1978), directed by Jeannot Szwarc, but there were all-new casts for *Jaws 3-D* (1983), directed by Joe Alves, and *Jaws: The Revenge* (1987), directed by Joseph Sargent.

Steven Spielberg (b. 1946) followed *Jaws* with *Close Encounters of the Third Kind* (1977), *1941* (1979), *Raiders of the Lost Ark* (1981), *E.T.: The Extra-Terrestrial* (1982), *Indiana Jones and the Temple of Doom* (1984), *The Color Purple* (1985), *Empire of the Sun* (1987), *Indiana Jones and the Last Crusade* (1989), *Always* (1989), *Hook* (1991), *Jurassic Park* and *Schindler's List* (both 1993), *The Lost World: Jurassic Park* and *Amistad* (both 1997), *Saving Private Ryan* (1998), *A.I.: Artificial Intelligence* (2001), *Minority Report* and *Catch Me If You Can* (both 2002), *The Terminal* (2004), *War of the Worlds* and *Munich* (both 2005), *Indiana Jones and the Kingdom of the Crystal Skull* (2008), *The Adventures of Tintin: The Secret of the Unicorn* and *War Horse* (both 2011), *Lincoln* (2012), *Bridge of Spies* (2015), *The BFG* (2016), *The Post* (2017), *Ready Player One* (2018) and *West Side Story* (2022).

Nashville

USA, 1975

Paramount–ABC Entertainment. DIRECTOR: Robert Altman. 158 MINS.
FIRST SEEN: *Ritz, London, 23 October 1975.*

Nashville, Tennessee. The paths of 24 characters crisscross over a three-day period. Beloved singer Barbara Jean (RONEE BLAKLEY) flies into the city with her husband/manager Barnett (ALLEN GARFIELD) after recovering from injuries sustained in a fire; she collapses at the airport and is rushed to hospital. John Triplette (MICHAEL MURPHY), a representative of Replacement Party presidential candidate Hal Phillip Walker, meets with the party's local supporter Delbert Reese (NED BEATTY) to plan a benefit concert for the politician that will feature major country and western musical talents. Triplette meets with Haven Hamilton (HENRY GIBSON), who is amenable to appear with Barbara Jean but not with her rival/replacement Connie White (KAREN BLACK). Meanwhile Opal (GERALDINE CHAPLIN), a BBC reporter, turns up uninvited to various events. Tom (KEITH CARRADINE), of the singing trio Bill, Tom and Mary, sleeps with several different women including Mary (CRISTINA RAINES), who is the wife of Bill (ALLAN NICHOLS); Opal; Martha (SHELLEY DUVALL), who has come from California to see her dying aunt but never gets to see her, upsetting her uncle, Mr Green (KEENAN WYNN); and Linnea (LILY TOMLIN), Reese's wife. Kenny (DAVID HAYWARD), who has left home, rents a room from Mr Green. Private Kelly (SCOTT GLENN) visits Barbara Jean in hospital because his mother had made him promise he would see her. Sueleen Gay (GWEN WELLES), who thinks she can sing but can't, performs a humiliating striptease at the fundraiser for Walker. At an open-air concert, at which Walker is to speak, Barbara Jean is shot by Kenny. Untried would-be singer Albuquerque (BARBARA HARRIS) steps in and calms the crowd with a song.

Robert Altman's experiments with multiple characters and overlapping, half-heard sound reached their zenith with this unforgettable insight into America on the cusp of its 200th anniversary ('We must be doing something right to last 200 years,' sings Haven in one of the film's many songs). Filled with intriguing characters, and intricately structured, the film—smartly photographed by Paul Lohmann—is composed of a number of interlocking

set pieces: the recording studio, the airport welcome, the traffic jam (caused by an accident), the hospital, the Grand Old Oprey, the talent contest, the concert where Barbara Jean is replaced by Connie White, dramas that unfold inside various hotel rooms, three different Sunday morning church services, the private outdoor party hosted by Haven and Lady Pearl, the 'smoker' where Sueleen is forced to strip, and the final open-air concert. In all these scenes and locations, the principal characters appear and connect, sometimes only in the background. Typical of Altman's approach is the scene in which Tom sings 'I'm Easy', which he dedicates to 'someone' in the room, and the four women present with whom he's sexually involved covertly check one another out.

Some of the characters are very sketchily portrayed, including the tricycle rider who does magic tricks, played by Jeff Goldblum and, indeed, the character of Kenny, the assassin, although a phone call he has with his demanding mother speaks volumes. The soundtrack, a major achievement in itself, requires some 'work' by members of the audience, once it becomes obvious that the dialogue that is essential can clearly be heard.

Though filmed in Nashville, the movie can't be said to represent an accurate description of the place, given that no major Nashville stars of the period appear in it. Instead, Altman relies on his stock company of character actors and casts them as Nashville stars, among them Henry Gibson's rather sinister Haven, a vain, self-important composer and singer who loses no opportunity to boost his less talented son, Bud (DAVE PEEL). Gibson wrote his own songs, including the wincingly awful 'For the Sake of the Children' (about a man who decides he can't leave his wife for his girlfriend). Also excellent is Keith Carradine as the womanising Tom, who has hardly finished with one attractive conquest before he's on the phone to the next prospect; Carradine wrote the Oscar-winning song 'I'm Easy'.

One or two of the characters are potential stereotypes—Barbara Harris as the scruffy blonde fleeing from her controlling husband (BERT REMSEN) being one—but most of them, as written by Joan Tewkesbury, are given unexpected dimensions. Lily Tomlin's wife, married to an overweight go-getter husband, whose two sons were born deaf (we see her patiently 'talking' to them) and who sings in a church choir, nevertheless agrees to a hotel rendezvous with the superficially charming but desperately shallow Tom. Barbara Baxley's Lady Pearl, a member of Nashville royalty and companion of Haven, whose reminiscences of campaigning for the

Kennedy brothers provides one of the film's most touching moments. Gwen Welles' waitress who deludes herself into thinking she's a singer, and Robert Doqui's Wade, who is quick to give advice to everybody but who seems deeply troubled. Then there is Keenan Wynn's very touching Mr Green, whose wife is dying and whose hippie niece won't stay away from men long enough to visit her aunt in hospital—Wynn's handling of the scene in which he learns of his wife's death is one of the finest achievements of this veteran character actor.

As the paths of these characters intersect over and over again, the political campaign—in the form of a loudspeaker van constantly roaming the streets—is treated with mordant satire. It seems that Hal Phillip Walker's Replacement Party stands for eliminating farm subsidies, taxing churches, removing lawyers from Congress, abolishing the electoral college and changing the national anthem. The world of media is also savagely satirised, not only by the presence of the ubiquitous TV news reporters and commentators, but also by Geraldine Chaplin's hilariously awful Opal 'from the BBC', who crashes every private function, prattles inanely, and, on seeing Elliott Gould, thrusts a microphone in his face seeking a comment (she expects him to remember her after she once interviewed him at a film festival).

The climactic concert demonstrates Altman's ability to create suspense: we *fear* something awful is going to happen, and as the attention of the deranged Kenny is increasingly focused on a giant American flag flying above the stage, we fear the worst—the shooting takes place in long shot, but is no less horrifying for that.

Nashville is a film that requires repeated viewings for full appreciation; despite its length, you feel it could have been improved if it were even longer, so that some of the marginal characters were given more room to breathe. But despite its (minor) faults, it is surely one of the finest American films ever made.

Robert Altman (1925–2006) started his career in television. His first feature, *The Delinquents* (1956), was a minor affair but he came to prominence with *M*A*S*H* (1970), which won the Cannes Palme d'Or. His subsequent films included *Brewster McCloud* (also 1970), *McCabe & Mrs. Miller* (1971), *The Long Goodbye* and *Thieves Like Us* (both 1973), and *California Split* (1974). After *Nashville* his films included *3 Women* (1977), *A Wedding* (1978), *Popeye* (1980), *Come Back to the 5 & Dime, Jimmy Dean, Jimmy Dean* (1982), *Fool for Love* (1985), *The Player* (1992), *Short Cuts*

(1993), *Prêt-à-porter* (1994), *Kansas City* (1995), *Gosford Park* (2001), *The Company* (2003) and *A Prairie Home Companion* (2006).

I first met Altman in 1972 when I visited him at his Los Angeles headquarters and he invited me to a rough-cut screening of *The Long Goodbye*. I met him frequently over the following years in various places, often in Venice where we shared more than one dinner during the film festival.

Picnic at Hanging Rock

AUSTRALIA, 1975

Picnic Productions. DIRECTOR: Peter Weir. 116 MINS (DIRECTOR'S CUT: 107 MINS)

FIRST SEEN: *Lyceum, Sydney, 27 November 1975.*

Victoria, 14 February 1900. Led by teachers Miss McCraw (VIVEAN GRAY) and Mademoiselle de Poitiers (HELEN MORSE), a small party of adolescent girls from Appleyard College travels by coach to the foot of Hanging Rock, a million-year-old volcanic formation near Mt Macedon. Observed from afar by visiting Englishman Michael Fitzhubert (DOMINIC GUARD) and by Albert (JOHN JARRATT), who works for Michael's uncle and aunt, four girls, led by Miranda (ANNE LAMBERT), set out to climb the rock. The watches of both Miss McCraw and coach driver Ben Hussey (MARTIN VAUGHAN) stop at precisely noon. Edith (CHRISTINE SHULER), one of the four girls, experiences something terrifying and flees back down the rock. The other three, and Miss McCraw—who goes in search of them—fail to return. A police search led by Sergeant Bumpher (WYN ROBERTS) is unsuccessful. A couple of days later, Michael persuades Albert to accompany him back to the rock for a further search; Michael stays on the rock overnight and the next day Albert returns to find not only him but also Irma (KAREN ROBSON), one of the missing girls, unharmed except for scratches and bruises. To the dismay of the headmistress, Mrs Appleyard (RACHEL ROBERTS), parents start to withdraw their children from the school. Sara (MARGARET NELSON), an orphan who was close to Miranda, is told she will be sent to an orphanage if her guardian does not pay her fees; later, Mrs Appleyard claims that the guardian has indeed arrived to take the girl away, but her dead body is discovered in the greenhouse. A report reveals that, on 27 March, Mrs Appleyard's body was found at the foot of the rock and that the two missing girls, and their teacher, were never seen again.

This sublimely beautiful, truly haunting film from Peter Weir occupies a vital position in the 1970s resurgence of Australian film production. Before *Picnic*, the Australian revival had consisted of broad 'ocker' comedies (the Barry McKenzie and Alvin Purple films, among others) that were popular but trivial. Weir's film was very different, more akin to a European art-house production. Adapted by Cliff Green from Joan Lindsay's (entirely

fictitious) novel, the film presented an unsolved mystery in such a way that audiences returned to see it again and again in an attempt to solve the puzzle using some of the clues scattered throughout.

For his second feature film, Weir was given major support by producer Patricia Lovell and the McElroy Brothers, Jim and Hal. His principal artistic collaborator was cinematographer Russell Boyd who deliberately set out to emulate the look of 19th-century Australian paintings of the bush, including the work of Frederick McCubbin. The diffused lighting also added to the dream-like atmosphere as the young women, dressed in virginal white, bask in the shadow of the famous rock before four of them embark on their fateful climb.

Prior to this we have seen the influence that the ethereally lovely Miranda has on the other girls, especially Sara, the orphan who adores her (and who later creates a shrine to her). 'You must learn to love someone else apart from me,' Miranda warns her. 'I won't be here much longer,' a prophecy that will soon be fulfilled. Meanwhile, in a scene reminiscent of Mr Bernstein's famous story in *Citizen Kane* (see #14), Michael—Dominic Guard who had played the boy in Joseph Losey's *The Go-Between* just four years earlier—is fixated by his vision of Miranda crossing a stream just before she climbs the rock; like Sara, he equates her with a white swan (to Mademoiselle de Portiers, she's a Botticelli angel) and he will never forget her.

There are other tantalising elements to the film. Sara talks about her childhood in the orphanage, telling Minnie (JACKI WEAVER), the maid, that

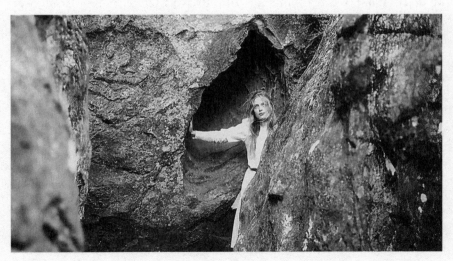

Miranda (ANNE LAMBERT) in Peter Weir's haunting and immensely influential *Picnic at Hanging Rock*.

'I had a brother then.' This 'brother' is presumably Albert who, in keeping with the film's overall unwillingness to provide solutions, never finds his long-lost sister, although she's so close by. After Irma is found and brought to recuperate at the Fitzhubert house, a maid reveals to her mistress that the girl was not wearing a corset, only to be dismissed with the remark, 'It can't possibly be of any interest.' When, later on, Irma, radiant in a red dress and hat, is reunited with her former schoolmates for the first time since the picnic, expecting that they'll be pleased to see her, they react by hysterically turning on her and demanding to know what happened to Miranda (there's never any mention of the other missing girl, Marion, played by Jane Vallis). There are frequent depictions of wildlife: ants busily consuming uneaten cakes after the picnic, birds of various kinds, lizards, a sinister-looking spider in its web, even a koala perched in a tree.

At a dinner with Mademoiselle de Poitiers, Mrs Appleyard—who has by now presumably killed Sara—speaks of her late husband, holidays in Bournemouth, and how angry she is that Miss McCraw, with her 'masculine intellect', 'allowed herself to be spirited away'. Rachel Roberts, excellent as the strange and troubled Mrs Appleyard, was a late replacement for Vivien Merchant, the wife of Harold Pinter, who was originally cast in the role but became, at the last moment, too ill to travel to Australia.

It was a masterstroke to use the panpipe music of Romanian Gheorghe Zamphir (spelt Zamfir in the credits) as the film's haunting and mournful main theme—Zamphir's pipes had also been used to excellent effect in *Pas de deux* (1968), a Canadian short film by Norman McLaren. Composer Bruce Smeaton's contributions are also important, as are the excerpts from Beethoven.

In March 1975, I visited the town of Clare, South Australia, and was present during the filming of the scene in which the girls, packed into their carriage, are driven through Woodend on their fateful journey to the rock. Peter Weir, who I have known since 1967, was among those helping rake the dust on the street to prepare the location for a second take.

Picnic at Hanging Rock was not only a major success in Australia but also around the world. More than any other film, it brought attention to the New Wave unfolding in Australia and it paved the way for the work of other Australian films and filmmakers that followed it.

Peter Weir (b. 1944) made short films at Sydney's ATN Channel 7 TV station before moving to the Commonwealth Film Unit (later Film Australia) where he made several documentaries. He directed one of the

three episodes of *Three to Go* (1970) and the following year made the award-winning short comedy-drama *Homesdale*. His first feature, *The Cars that Ate Paris* (1974), premiered at the Sydney Film Festival and was followed by *Picnic at Hanging Rock*, *The Last Wave* (1977) and *The Plumber* (1978, a TV movie feature). The large-scale *Gallipoli* (1981) and *The Year of Living Dangerously* (1982, both with Mel Gibson) followed. In America Weir made *Witness* (1985), *The Mosquito Coast* (1986), *Dead Poets Society* (1989), *Green Card* (1990), *Fearless* (1993), *The Truman Show* (1997), *Master and Commander: The Far Side of the World* (2003, which deservedly won Russell Boyd an Oscar for Best Cinematography) and an independent feature, *The Way Back* (2010). Weir has not been prolific in recent years but he has an uncompromising approach and refuses to accept film projects in which he does not feel passionately involved. He is one of the finest filmmakers Australia has produced.

Raise Ravens
(*Cría cuervos*)

SPAIN, 1975

Elías Querejeta Producciones. DIRECTOR: Carlos Saura. 110 MINS.
FIRST SEEN: *Hermitage, Paris, 28 July 1976.*

Madrid. Nine-year-old Ana (ANA TORRENT) descends the stairs of her family home one night in time to see Amelia Garontes (MIRTA MILLER) flee the house half-dressed; Ana's father, Anselmo (HECTOR ALTERIO), an officer in the army, is lying dead in bed, and the little girl retrieves a glass from by the bedside and washes it. At the wake, Ana refuses to kiss her father, who lies in an open coffin surrounded by military officers and other dignitaries. Ana's beloved mother, Maria (GERALDINE CHAPLIN), has recently died of cancer. Ana and her sisters, Irene (CONCHI PEREZ) and Maite (MAITE SANCHEZ), are taken in, along with their speechless, wheelchair-bound grandmother, Abuela (JOSEFÍNA DIAZ), and cared for by the children's aunt, Paulina (MONICA RANDALL), who is assisted by the family's long-time servant, Rosa (FLORINDA CHICO). Ana remembers the times she spent with her mother, and a trip to the country villa owned by Amelia's husband, Nicolas (GERMÁN COBOS), her father's best friend and also an army officer. Ana and Paulina frequently quarrel, and after a bitter fight on the last day of the school holidays Ana puts powder from a tin she keeps hidden—and which her mother had told her contained a 'terrible' poison, a spoonful of which would kill an elephant—into her aunt's milk. But next morning, to Ana's surprise, Paulina is perfectly well. The three girls head off to school.

The title of this multi-layered and deeply mysterious film relates to a Spanish proverb: 'Raise ravens and they'll pluck out your eyes.' Saura, working at a time when the dictatorship of General Francisco Franco was nearing its end, is clearly suggesting that the children, growing up in this corrupt and deceitful society, will oversee sweeping changes when they become adults—hence the great significance of the film's final scene when the girls walk into the city streets and enter their school as the camera pans from a distant shot of the school building and continues across the rooftops of the city of Madrid.

Not only is the film a potent political allegory, it's also one of the finest films ever made about the world of children, more than comparable to classics by Réne Clément (*Jeux interdits/Forbidden Games*, 1952), François Truffaut (*Les quatre cents coups/The 400 Blows*—see #53), Abbas Kiarostami (*Where is My Friend's House?*—see #92) and Spain's Victor Erice, whose magnificent *El espíritu de la colmena/The Spirit of the Beehive* (1973) also starred young Ana Torrent. This child, with her huge dark eyes and tremendously expressive face, is the central mystery of *Raise Ravens*: is she a murderess, or are her 'crimes' only taking place in her imagination? Is the powder she believes to be poison really harmless? And if so, why was it that her father died after she had 'poisoned' him but the powder added to Paulina's milk has no effect on her? These are questions the film chooses not to answer.

The 29-year-old Ana (also played by Geraldine Chaplin), facing the camera directly, poses the question: 'Why did I want to kill my father?' and answers it herself: 'At the time I was convinced my father was responsible for all the sadness that embittered the last years of my mother's life. *He* caused her illness and death.'

This is a world in which many of the adults, including Anselmo and Paulina, tell lies. Anselmo deceives Maria with Amelia, and Paulina deceives Amelia with Nicolas, but when Ana tries to tell the truth—that Amelia was in bed with her father when he died—Paulina accuses her of lying. As Maria lies dying, she cries out, 'They lied to me! There's nothing!', but Anselmo is oblivious to her distress ('I won't stand for blackmail,' he tells her. 'I'm fed up with your complaints').

Handsomely photographed by Teodoro Escamilla and precisely edited by Pablo G. del Amo, the film switches back and forth between the present and the past, between truth and memory. Lying in bed, Ana wills her dead mother to come to her room to tell her a story the way she used to; miraculously, she does. Geraldine Chaplin gives her finest performance(s) as both the unhappy wife, Maria, and her daughter, Ana, 20 years into the future, at the age of 29, recalling her 'interminably long, sad childhood [which was] filled with fear'. 'I don't understand why people say childhood is a happy time,' she continues. 'It certainly wasn't for me. I don't believe children are innocent.' Chaplin works beautifully under the direction of Saura, who was then her partner. As Maria, who gave up a career as a concert pianist to marry the misogynistic, predatory Anselmo—who is, significantly, a senior military figure—and who suffers a prolonged and agonising illness from cancer, she is vulnerable and tragic; as the adult Ana, she is

confident, assured and eager to question the events of her childhood that had occurred 20 years earlier.

The past hovers over the huge house in the centre of the city. There are photographs everywhere carrying with them memories of times gone by. The elderly grandmother, who is helpless, is at her happiest when Ana wheels her chair close to a board covered with photos and postcards and reminders of her past.

As for the children, they spend a lot of their time in their room playing a catchy pop song ('*Porque te vas*'/'Because You're Leaving') sung by Jeannette, or dressing up in Paulina's clothes and make-up and re-enacting the arguments they have overheard when their parents were alive, with Irene taking the role of father, Ana (of course) the mother, and Maite the servant. Ana keeps a guinea pig and when it dies she buries it, with due ceremony, in a cardboard box. In one rather chilling scene, Ana, down in the garden, sees her double standing on the roof of the house looking down at herself. On another occasion she claims that her father bequeathed her his Luger and starts brandishing it about, earning a slap across the face from her aunt. From Rosa, she learns that 'men are all the same' and that her father 'chased women like mad'. Yet, despite the pressures of a patriarchal society, these three girls—Spain's future—have moments of pure joy, such as the sublime moment in which they dance with one another to Jeannette's song.

Carlos Saura (b. 1932) directed his first film, *Los golfos*, in 1959. With *La caza/The Hunt* (1966) he became established as a director of great nuance who was able to combine political commentary with realistic stories. He made several films with Geraldine Chaplin (who originally came to Spain in the mid-1960s because *Doctor Zhivago*, in which she had a leading role, was partly filmed there), including *Peppermint Frappe* (1967), *La madriguera/The Honeycomb* (1969), *Ana y los lobos/Ana and the Wolves* (1973) and *Elisa, vida mía/Elisa, My Love* (1977). His films also included *La prima Angélica/Cousin Angelica* (1974), *Los ojos vendados/Blindfolded Eyes* (1976), *Mamá cumple 100 años/Mama Turns 100* (1979), *Deprisa, deprisa/Faster, Faster* (1980), *Dulces horas/Tender Hours* (1982), *El Dorado* (1988), *Goya en Burdeos/Goya in Bordeaux* (1999), *El séptimo día/The Seventh Day* (2004) and *Io, Don Giovanni* (2009). He has made several important music and dance films, notably *Bodas de sangre/Blood Wedding* (1981), *Carmen* (1983), *El amor brujo* (1985), *Flamenco* (1995) and *Tango* (1998).

Kings of the Road
(*Im Lauf der Zeit*)

WEST GERMANY, 1976

Wim Wenders Produktion. DIRECTOR: **Wim Wenders.** 176 MINS.
FIRST SEEN: *Sydney Film Festival, 14 June 1976.*

Germany. For two years, Bruno Winter (RÜDIGER VOGLER) has been driving a converted furniture van along the border between West and East Germany, servicing the projection equipment of small-town cinemas. Robert Lander (HANNS ZISCHLER), a medical researcher who has left his wife in Genoa, drives his VW into a river close to the spot where Bruno's van is parked. Bruno gives Robert a lift and as they move from town to town, sleeping in the van, they become friends. One night Robert is awakened by a noise and encounters a man (MARQUARD BOHM) who is wandering in an abandoned mine; the man explains that his wife had driven into a tree, killing herself. Robert goes to visit his father (RUDOLF SCHÜNDLER), who edits and prints a local newspaper in Ostheim; they haven't seen each other since Robert's mother died eight years earlier. Robert attacks his father for the way he treated his mother; while his father sleeps, he prints a newspaper headline that reads 'How to Respect Women'. Meanwhile Bruno has met Pauline (LISA KREUZER), a cashier at a small cinema; he spends the night with her, but they don't make love. Robert rejoins Bruno and they travel together to an island in the Rhine where they explore the derelict house where Bruno was raised by his mother after his father was killed in the war. They spend the next night in an American military bunker close to the border where they argue—and briefly fight—about their different ways of life. Next morning Robert departs alone, leaving behind a note: 'Everything must change.'

'The Yanks have colonised our subconscious' is a memorable line—spoken by Zischler—in this striking masterwork from a writer-director who always acknowledged his debt to American culture. Despite a running time of almost three hours, there's comparatively little dialogue between the two buddies and yet the film never for a moment feels overextended or undernourished.

It begins with the proud declaration that it is *im schwarz/weiss* (black and white), and titles proceed to inform us when and where it was filmed (over 11 weeks between 1 July and 31 October 1975, between Lüneburg and Hof, along the border with East Germany).

In the opening and closing scenes Vogler's dungaree-clad technician discusses the fate of the movies with small-town cinema owners. In the opening sequence an elderly man recalls the silent era and the music that was used for epics like Fritz Lang's *Die Nibelungen* (1923) and Fred Niblo's *Ben-Hur* (1925). He mentions that, because he joined the Nazi Party under the Third Reich, he was forced to sue to get his cinema back in 1951, and he expresses the hope that in the future there will still be at least one cinema left in every town. In the final sequence, a woman cinema-owner—sitting next to a photograph of Fritz Lang—says it would be 'better to have no cinema' than to have to screen the sort of exploitation films currently offered to her. 'My father always said: "Film is the art of seeing",' she recalls with deep regret.

Between these bookends, with their nostalgia for a long-ago world in which small cinemas screened quality product for appreciative audiences, Wim Wenders—who improvised the film's screenplay on a day-to-day basis during shooting, with input from his actors—explores the bromance between the rootless Bruno and the troubled Robert. The latter makes frequent attempts to phone his wife but is never able to bring himself to talk to her. When Robert, whom Bruno has nicknamed 'Kamikaze', starts to tell his life story, Bruno stops him—he doesn't want to know. Bruno is reading an American pulp-fiction paperback (*Wild Palms*) and plays American EP recordings on a portable player in the truck; he also has a jukebox in the back.

The encounter with the grieving man whose wife has been killed is a rather strange interlude. He tells his story, and then adds: 'The only thing there is, is life', a line repeated later in the film. Another interlude takes place in a small-town cinema where schoolchildren have gathered for a picture show but a faulty speaker needs to be replaced; while working behind the screen, Bruno and Robert are illuminated by a floodlight that casts their shadows onto the screen, and they spontaneously embark on an elaborate slapstick routine in the style of silent comedy, to the delight of the children.

The scene in which Robert confronts his father, refusing to allow him to speak ('Last time I tried to talk to you I had to listen all the time') is intercut with the scene in which Bruno encounters Pauline at a fairground

Robert Lander (HANNS ZISCHLER) in Wim Wenders' *Kings of the Road*.

With Wim Wenders near Alice Springs on the location of *Until the End of the World* in 1991–we appear to be drinking from the wrong coffee mugs.

and she asks him to hold a candle shaped like the head of Hitler, which she had just won. That night he goes to the cinema where she works as a cashier but complains that the picture is out of focus and too dark. He goes to the projection room to complain and discovers that the (temporary) projectionist is masturbating and that rolls of film are piling up on the floor. After the cinema has closed he entertains Pauline by projecting a repeated loop of footage cut from an exploitation picture.

Throughout the film—whose German title translates as 'In the Course of Time'—children play important roles: the men have several encounters with kids, including Robert's final meeting with a boy at a railway station who exchanges his notebook—in which he's written down what he sees—with Robert's dark glasses and empty suitcase.

Rüdiger Vogler had played a character named Phillip Winter in Wenders' *Alice in den Städten/Alice in the Cities* (1974) and would play the same character in *Bis ans Ende der Welt/Until the End of the World* (1991), in which he travels to Australia. Also worth noting is the candid approach to male bodily functions: urination, defecation and masturbation are all shown in the film.

The film is technically bewitching, both for its photography (Robby Müller and Martin Schäfer) and for the haunting, jazzy music score by Axel Lindstädt, which is performed by the band Improved Sound Limited. And there's a lovely concluding joke: the last cinema Bruno visits is named Weisse Wand (White Screen), but some of the neon signage is missing so that the final image of the film reads 'WW E . . . ND'.

I first met Wenders in Munich in 1975, and our paths have crossed many times since; we have met in Berlin, San Francisco (while he was filming *Hammett* there), Cannes and in several parts of Australia, including Alice Springs during the filming of *Until the End of the World.*

Wim Wenders (b. 1945) was one of a group of young West German filmmakers who emerged in the late 1960s and 1970s, including Rainer Werner Fassbinder, Werner Herzog, Volker Schlöndorff and Margarethe von Trotta. Wenders made his first feature, *Summer in the City*, in 1970. He followed it with *Die Angst des Tormanns beim Elfmeter/The Fear of the Goalkeeper* (1971), *The Scarlet Letter/Der scharlachrote Buchstabe* (1972), *Alice in the Cities* (1974), *Wrong Movement/Falsche Bewegung* (1975), *Kings of the Road* (1976) and *The American Friend/Der amerikanische Freund* (1977). *Lightning Over Water* (1980) and *Hammett* (1982) were made in the USA. Thereafter Wenders made films in several different countries,

among them: *Der Stand der Dinge/The State of Things* (1982), *Paris, Texas* (1984), *Tokyo-ga* (1985), *Der Himmel über Berlin/Wings of Desire* (1987) and *In weiter Ferne, so nah!/Faraway, So Close!* (1993). He has also made documentary features, including *Buena Vista Social Club* (1999), *Pina* (2011) and *Pope Francis: A Man of His Word* (2018).

84

Annie Hall

USA, 1977

United Artists–Rollins Joffe Productions. DIRECTOR: Woody Allen. 93 MINS.
FIRST SEEN: *Locarno Film Festival, Switzerland, 14 August 1977.*

New York. Alvy Singer (WOODY ALLEN), a 40-year-old stand-up comic, lives alone in Manhattan. He reminisces about his life: his childhood, his two marriages, and especially his on-off relationship with Annie Hall (DIANE KEATON), and how she eventually moved to Los Angeles.

Prior to *Annie Hall*, Woody Allen had written and directed five scattershot comedies that were often very funny but lacked depth. *Annie Hall*, whose numerous awards included Oscars for Best Film, Director, Original Screenplay and Actress, was different because it was clearly more personal. At the time, publicity was given to the fact that Allen and his wonderful co-star, Diane Keaton, had been in a relationship and that her background was not that different from the character she plays in the film. So watching the couple meet, fall in love, participate in a hot and cold relationship, separate, and finally, some time later, meet again as friends was not only amusing—and frequently hilarious—but also touching. The film is filled with jokes—old and new—but also with caustic commentary on a number of the director's favourite topics: anti-Semitism (he views with suspicion a record shop selling cheap LPs of Wagner), Los Angeles ('A city where the only cultural advantage is that you can make a right turn at a red light'; 'They don't throw away their garbage; they turn it into TV shows') and pretentious intellectuals. Who can forget the famous scene in which Alvy and Annie are standing in line at the New Yorker cinema (waiting to see *The Sorrow and the Pity* yet again) when Alvy becomes irritated by the pompous declarations of the man (ROBERT HORTON) standing behind him in the line complaining to his girlfriend about the latest Fellini film ('incredibly indulgent') and the influence of television and of philosopher and scholar Marshall McLuhan. Breaking the fourth wall, Alvy/Woody produces McLuhan from behind a poster stand, and is delighted when McLuhan tells the hapless intellectual—who says he teaches TV Media and Culture at a university—that 'you know nothing of my work'. 'If life were only like this,' sighs Alvy/Woody to the camera.

Annie Hall opens with a two-minute monologue. Alvy tells a couple of jokes and admits he's going through a crisis. 'Annie and I broke up,' he explains. 'I keep sifting the pieces of the relationship through my mind— when did the screw-up come?' He recalls that, as a child (played by Jonathan Munk), he was neurotically convinced the universe was expanding (*'Brooklyn is not expanding,'* his mother—Joan Newman—assures him). As an adult he sits in the classroom he attended in 1942 and asks some of his erstwhile friends what they achieved as adults: one boy says he became the president of a plumbing company, while another kid claims that he used to be a heroin addict but is now a methadone addict.

As an adult, Alvy has many neuroses and has been under analysis for several years. He can't bear to miss the start of a movie (when Annie arrives late for a screening of Ingmar Bergman's *Face to Face*, he refuses to go in). He remembers meeting Allison (CAROL KANE), his first wife, when he took part in a benefit for Democratic presidential candidate Adlai Stevenson, though he told her that a politician is a notch beneath a child molester. His second wife, Robin (JANET MARGOLIN), was also a short-lived experience. He meets Annie when he and his best friend Rob (TONY ROBERTS), an actor, meet for a game of tennis; she gives him a lift afterwards in her VW, and they wind up at her apartment. Annie, who dresses in a style that quickly became fashionable, wears a hat, waistcoat and tie and uses expressions like 'la de da'. 'Did you grow up in a Norman Rockwell painting?' Alvy asks her soon after they meet. When she takes him home to meet her middle-class family he becomes alarmed by the evident anti-Semitism of her grandmother, Grammy (HELEN LUDLAM), and the delusions of her brother, Duane (CHRISTOPHER WALKEN).

Annie moves in with Alvy, who encourages her to undertake a literature course at college, but then becomes jealous that she might become romantically involved with a teacher. He's contradictory and often infuriating, and after a while she leaves him. One night he sleeps with Pam (SHELLEY DUVALL), a reporter for *Rolling Stone* ('Sex with you is a Kafka-like experience,' she tells him and adds, 'I meant that as a compliment'). But at 3 am Annie calls seeking his help because a large black spider has invaded her bathroom—and they decide to get back together again, at least for a while.

Annie has always wanted to be a singer and when she gets to perform 'Seems Like Old Times' in a club she's approached afterwards by Tony Lacey (PAUL SIMON), an LA-based record producer, who invites her and Alvy to a 'mellow' party for Jack (Nicholson) and Anjelica (Huston), but Alvy won't

let her go ('I don't do "mellow",' he explains. 'I ripen and then rot'). He's a pretty hopeless party guest; on another occasion, invited to snort cocaine valued at $2000 per ounce, he sneezes and blows the powder away.

Although the film is a showcase for Allen's funny/neurotic personality, in the role of director he allows Annie's problems to emerge: in another famous scene, using a split screen, both are talking to their shrinks and both are asked how often they have sex together. 'Hardly ever. Three times a week,' says Alvy; 'Too often. Three times a week,' says Annie. At the end, after meeting Annie again following a long separation, Alvy admits how much fun it was knowing her and ends on another joke about a guy whose brother behaves like a chicken. 'Why don't you turn him in?' he's asked. 'I would, but I need the eggs,' comes the reply. 'That's how I feel about relationships,' says Alvy (to camera). 'They're irrational, crazy, absurd—but most of us need the eggs.'

Woody Allen (b. 1935) was a stand-up comedian and writer (his play, *Play It Again, Sam*, was filmed by Herbert Ross in 1972) before he directed his first film, *Take the Money and Run*, in 1969. It was followed by a quartet of broad comedies: *Bananas* (1971), *Everything You Always Wanted to Know About Sex but Were Afraid to Ask* (1972), *Sleeper* (1973) and *Love and Death* (1974). Following the commercial and critical success of *Annie Hall* he made the non-comedic *Interiors* (1978), the first of a handful of dramas he would write and direct (the others: *September*, 1987; *Another Woman*, 1988; *Alice*, 1990; *Match Point*, 2005; *Cassandra's Dream*, 2007). Mostly his films have been comedy-dramas, or dramatic comedies, and have included: *Manhattan* (1979), *A Midsummer Night's Sex Comedy* (1982), *Zelig* (1983), *Broadway Danny Rose* (1984), *The Purple Rose of Cairo* (1985), *Hannah and Her Sisters* (1986), *Radio Days* (1987) and *Crimes and Misdemeanours* (1989). In 1992 Allen's marriage to Mia Farrow, his third wife, came to an abrupt end with the revelation that he was involved with Soon-Yi Previn, the adopted daughter of Farrow and André Previn. For a while his films went into an artistic slump (*Husbands and Wives*, 1992; *Manhattan Murder Mystery*, 1993) from which he has arguably never fully recovered, though he has continued to make a film a year, including *Bullets over Broadway* (1994), *Deconstructing Harry* (1997), *Sweet and Lowdown* (1999), *Melinda and Melinda* (2004), *Vicky Cristina Barcelona* (2008), *Midnight in Paris* (2011), *Blue Jasmine* (2013), *Café Society* (2016) and *Wonder Wheel* (2017). Serious accusations against him made by his daughter Dylan, never brought to court, have had an impact on the distribution of his two most recent films, *A Rainy Day in New York* (2018) and *Rifkin's Festival* (2020).

85

The Chant of Jimmie Blacksmith

AUSTRALIA, 1978

The Film House. DIRECTOR: Fred Schepisi. 122 MINS.
FIRST SEEN: *Riverside Studio, Melbourne, 21 March 1978.*

The eve of Federation in Australia, 1900. Jimmie Blacksmith (TOMMY LEWIS), the child of a white father and an Aboriginal mother, is educated by the stern but decent Rev. Neville (JACK THOMPSON) and his wife, Martha (JULIE DAWSON). He leaves to find work, but is poorly treated by Healey (TIM ROBERTSON), an Irish immigrant, for whom he builds fences, and later by Lewis (ROB STEELE). Jimmie finds work as an assistant to drunken police officer Farrell (RAY BARRETT), but leaves when he is unwittingly responsible for the hanging death of an Aboriginal prisoner in his cell. He is next employed by Jack Newby (DON CROSBY) whose wife, Heather (RUTH CRACKNELL), encourages him to bring Gilda (ANGELA PUNCH), a white girl he believes he has made pregnant, to live on the Newby property in a makeshift hut. But when Jimmie's relatives, Mort (FREDDY REYNOLDS) and Tabidgi (STEVE DODDS), turn up also, Newby has a strong negative reaction to what he sees as the establishment of a 'black camp'. Gilda's baby, a son, looks entirely white and Mrs Newby attempts to persuade her to leave Jimmie. Denied grocery supplies, Jimmie and Tabidgi appeal to Mrs Newby but are roughly refused; Jimmie strikes Mrs Newby with an axe, and the two men then slaughter the Newby daughters and Petra Graf (ELIZABETH ALEXANDER), their governess. They flee, pursued by a posse led by Newby's sons (MATTHEW CROSBY, MARSHALL CROSBY). Tabidgi is arrested and brought to trial. Jimmie and Mort arrive at the Healey farm where Jimmie shoots and kills Mrs Healey (JANE HARDERS) and her baby while Mort kills another woman on the property. They kidnap McCready (PETER CARROLL), a schoolteacher, but he persuades Jimmie to let him escape; Mort returns McCready and is later shot dead by the posse. Jimmie is wounded and is eventually found sheltering in a nunnery.

Thomas Keneally's novel, his seventh, was 'based on real events' and provided the basis of one of the great films of the 1970s revival thanks to an intelligent and faithful adaptation by Fred Schepisi, the superlative wide-screen photography of Ian Baker, and Schepisi's powerful direction of what was only his second feature. The film opens with an Aboriginal initiation

ceremony in which Jimmie goes through a variety of rituals and is taught traditional ways and values. This sequence is intercut with a scene in which Rev. Neville chafes over young Jimmie's absence ('He knows I needed him'). The boy's white education in the home of the minister is contrasted with the purity of traditional ritual experiences and with the wretchedness of the nearby Aboriginal camp, where drunkenness is endemic.

But outside the closeted world of the Nevilles, life is tough for a lad like Jimmie as Australia takes cautious steps towards Federation. 'Federation will be a good thing,' says Jimmie. 'Free trade between the States.' 'But no difference for black bastards,' he's assured. 'You'll still have the same rights— none!' Jimmie is constantly demeaned and insulted by the men from whom he seeks work. 'Do you have any religion other than nigger?' he is asked by one employer, while another refuses to employ him because, he says, 'How do I know you won't bugger off?' Healey, who pays him a pittance, thinks his work is fine at the start but when the time comes to pay him finds fault with it. Jimmie is actually better educated than Healey, who won't give him a reference because he can't read or write.

The constant put-downs ('You know your place') and outright exploita- tion (Farrell, given a cash reward for capturing an alleged killer, pays Jimmie just a fraction of the sum they were supposed to share) eventually lead to the horrendous acts of violence that occur: 'What did I ever do wrong?' asks Jimmie before the final provocation. 'Why do they keep doing this to me?' The last straw comes when the seemingly enlightened Newbys refuse Jimmie food unless he sends his black family away; the unpremeditated axe attack on the Newby women, starting with Mrs Newby in the doorway of her home, is one of the most shocking scenes in cinema, though handled with as much tact as possible by Schepisi. Nevertheless, blood spattering over a mug filled with milk as the hapless governess falls backwards into the crockery is the stuff of nightmares.

This savage set piece occurs almost exactly halfway through the film and is followed by the long and increasingly desperate manhunt that culminates in reports that 20,000 people, including soldiers, are searching for the fugi- tives. At times the film evokes Charles Laughton's *The Night of the Hunter* (see #44) by introducing the state hangman, a butcher named Hyberry (BRIAN ANDERSON), who is in the running for an MBE but is unimpressed by the gratuitous quizzing he receives from a tactless customer (ARTHUR DIGNAM) who gets his information from scandal sheets and sporting newspapers.

'They took away our way of life. What for?' asks Jimmie at one point, to be reminded that white 'civilisation' introduced the Aboriginal people to such things as 'alcohol, religion, influenza, schools and syphilis—a whole host of improvements'.

The film is filled with interesting characters in quite small roles: Bryan Brown as a shearer who talks about the Boer War and its implications; Robyn Nevin as McCready's wife, who shows Jimmie and Mort an article in *The Bulletin* that refers to them; and Thomas Keneally himself, who has a cameo as the cook at the shearers' shed.

But the film succeeds as brilliantly as it does thanks to the performances of the Aboriginal actors, and especially Tommy (later Tom E.) Lewis as Jimmie; Lewis convincingly portrays a young man torn between two conflicting cultures and lifestyles, a youth trying to better himself but who is faced with the most implacable racism wherever he turns. As the good-natured Mort, Freddy Reynolds is also superb, and his tragic fate is especially affecting.

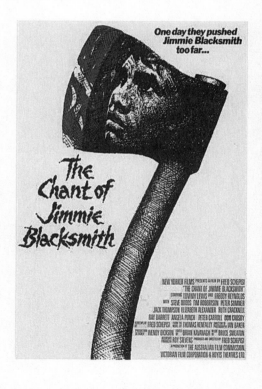

At the time, the budget of *The Chant of Jimmie Blacksmith* was at the high end of the scale for an Australian production, and though it was given a comprehensive cinema release it was not an immediate commercial success. However, its stature has only increased over the years and it's now seen as a landmark achievement.

Fred Schepisi (b. 1939) was well established in the advertising business before turning to cinema with an episode from the portmanteau film, *Libido* (1973). His first feature, *The Devil's Playground* (1976), was a fine, controversial film set in a Catholic boys boarding school. After *Jimmie Blacksmith* Hollywood came calling and Schepisi embarked on a very

varied series of films: *Barbarosa* (1982), *Iceman* (1984), *Plenty* (1985) and *Roxanne* (1987). He returned to Australia to make a magnificent film about the Lindy Chamberlain scandal, *Evil Angels* (*A Cry in the Dark* overseas, 1988), and then made the excellent John Le Carré adaptation, *The Russia House* (1990). After this came some lesser films: *Mr. Baseball* (1992), *Six Degrees of Separation* (1993), *I.Q.* (1994) and *Fierce Creatures* (co-directed with Robert Young, 1997). There was a significant return to form with the deeply poignant *Last Orders* (2001) and then in Australia a fine adaptation of the Patrick White novel *The Eye of the Storm* (2011), followed by the made-in-Canada *Words and Pictures* (2013), which, like many of Schepisi's films, explores the world of art and education.

86

Coming Home

USA, 1978

United Artists–Jerome Hellman Productions–Jayne Productions. DIRECTOR: Hal Ashby. 128 MINS.
FIRST SEEN: *United Artists cinema, Westwood, Los Angeles, USA, 25 October 1978.*

Los Angeles, 1968. Captain Bob Hyde (BRUCE DERN) farewells his wife, Sally (JANE FONDA), and departs for a tour of duty in Vietnam. Sally befriends Vi (PENELOPE MILFORD), the girlfriend of Bob's buddy, Dink (ROBERT GINTY); Vi's brother, Billy (ROBERT CARRADINE), who has been mentally affected by the war, is confined to an under-staffed veterans' hospital, and Sally decides to work there as a volunteer, moving out of officers' quarters and renting a house near the ocean. On the ward she is reunited with Luke Martin (JON VOIGHT), a high-school contemporary, who has returned from the war an embittered paraplegic. The two become friends. Sally flies to Hong Kong to meet Bob, who is on R and R with Dink; Vi refuses to come because she and Dink are not married. Dink is furious and Bob sides with his friend. Sally finds her husband greatly changed. Back in LA she begins an affair with Luke, unaware that they are being spied on by the FBI because Luke has taken part in an anti-war demonstration. When Bob comes home, after accidentally shooting himself in the foot, FBI agents inform him of his wife's infidelity. He confronts Sally and Luke with a loaded rifle, but backs down and, the next day, strips naked and swims out to sea. Meanwhile Luke talks to high-school kids about the grim reality of the war.

The end of the 1970s saw the release of a number of important American films that examined the legacy of the recently ended Vietnam War, most notably *The Deer Hunter* (1978) and *Apocalypse Now* (1979). Rather than depict the war on the ground, Hal Ashby's profoundly moving *Coming Home* looks at the effect of the war on both the men who returned, physically or mentally wounded, and the women who waited for them. Filming took place in a real hospital and wounded veterans played minor roles, which resulted in considerable authenticity.

The pre-credit sequence consists of an unscripted conversation among disabled veterans in which they discuss the war. 'Nobody's got the right to tell [the South Vietnamese] to do something against their will,' says one. 'That's why I went to fight.' It's pointed out to him that drafting kids

against their will into the army falls into the same category. 'Some of us need to justify what we did,' another guy says. 'How many guys can say what I did was wrong?' comes the reply.

Despite the politics of the war, *Coming Home* is in the main a touching love story. 'I don't think she really understands it all, but she accepts it,' Bob tells a friend before leaving for Vietnam. And at the start of the film we see that Sally, an ex-cheerleader with carefully arranged hair and a super-ficially conservative attitude, is much like the other officers' wives. In her school yearbook she had written that the one thing she wanted if she was stranded on a desert island was a husband. Her life begins to change when she meets the wounded men in the veterans' hospital, especially Luke who is angry and frustrated at his immobility; they first meet when he, propel-ling his mobile stretcher at great speed, collides with her in the corridor and his urine spills out of a colostomy bag all over the floor—surely the most unusual meeting of eventual lovers in cinema history.

The love affair evolves slowly but when the pair finally go to bed together the scene is passionate and frankly presented, comparable to the Julie Christie–Donald Sutherland love scene in *Don't Look Now* (1973) in its intensity. Sally experiences orgasm, possibly for the first time, and after-wards is visibly transformed; she exchanges her old sedan for a convertible, changes her hairstyle, and suddenly looks fresher and younger.

Luke, too, becomes gentler, more human; he starts to smile and to enjoy life. Bob's coming home will change everything, of course; the lovers accept that Sally will stay with her husband, but the interference of the FBI (after Luke has chained himself to the gates of the recruiting office and given an anti-war interview on TV) ruins any chance of the matter being handled with discretion or delicacy. Bruce Dern's performance in the scene in which he confronts his wife is quite astounding—his voice rises to a shrill pitch as he tries to articulate how he feels ('What I'm s-a-a-a-ying is, I don't belong here').

Ultimately the film's anti-war message—underlined by the involvement of Jane Fonda, who was a notable anti-Vietnam activist—comes across in many ways; among them are the sad spectacle of the wounded, troubled veterans, the divisions that in 1968 were beginning to disrupt the fabric of American society, and the impassioned speech Luke gives the high schoolers in the final scene: 'It's not like in the movies. I *wanted* to kill for my country. I have, and I don't feel good about it. All you see [in war] is a lot of death.' Ashby intercuts this school scene with the sequence of Bob

stripping and swimming, presumably to his death, and with Sally and Vi shopping and leaving the supermarket by a door bearing a sign that reads, simply, 'OUT'.

The intense photographic style of Haskell Wexler, a famous cinematographer who had directed an anti-Vietnam War film, *Medium Cool*, in 1968, lends the film a strong sense of realism, and the soundtrack is peppered with great songs from the era, songs that often play across more than one scene—artists such as The Beatles, The Rolling Stones, Bob Dylan, Jefferson Airplane, Steppenwolf, Jimi Hendrix and others are all represented, and the film opens and closes with The Stones' great 'Out of Time'.

Fonda and Voight deservedly won Oscars for their roles in the film, as did Waldo Salt, Robert C. Jones and Nancy Dowd for their original screenplay. Voight also won Best Actor at the Cannes Film Festival, and the film was showered with accolades awarded over the following year.

Hal Ashby (1929–1988) came to prominence as an editor; he worked frequently with Norman Jewison, editing such films as *The Russians are Coming, the Russians are Coming* (1966), *In the Heat of the Night* (1967) and *The Thomas Crown Affair* (1968). Jewison produced the first film Ashby directed, *The Landlord* (1970). Thereafter Ashby achieved a major cult success with the Spring–December romance, *Harold and Maude* (1971), and directed strong vehicles for the top stars of the era, Jack Nicholson (*The Last Detail*, 1973) and Warren Beatty (*Shampoo*, 1975). Ashby, who often made a cameo appearance in his films (in *Coming Home* he can be briefly glimpsed as a man driving a car on the freeway), began to experience personal difficulties that led to his messy next feature, *Second-Hand Hearts* (1979), which was little seen. He made a comeback, though, with the acclaimed *Being There* (also 1979, which features Peter Sellers in his last great role), but there were more problems with his succeeding films *Lookin' to Get Out* (1981), *Let's Spend the Night Together* (1982) and *The Slugger's Wife* (1985). His final film, *8 Million Ways to Die* (1986), was an uncharacteristic thriller.

Newsfront

AUSTRALIA, 1978

Palm Beach Pictures. DIRECTOR: Phillip Noyce. 108 MINS.
FIRST SEEN (IN 123 MIN ROUGH CUT): *APA screening room, Neutral Bay, Sydney, 20 January 1978.*
FINAL VERSION FIRST SEEN: *Village Cinema, Double Bay, Sydney, 11 July 1978.*

Sydney, 1948. Rival teams of newsreel cameramen representing Cinetone and Newsco record the arrival of a migrant ship from Europe and a speech by Prime Minister Ben Chifley. Cinetone cameraman Len Maguire (BILL HUNTER) and his assistant, Chris Hewitt (CHRIS HAYWOOD), a new arrival from the UK, show their footage to Cinetone boss A.G. Marwood (DON CROSBY), his assistant, Amy McKenzie (WENDY HUGHES), and the editing team, Geoff (BRYAN BROWN) and Bruce (DREW FORSYTHE). *Spring 1949.* Len marries Fay (ANGELA PUNCH), a strict Roman Catholic; Len's brother, Frank (GERARD KENNEDY), a former Cinetone cameraman who has been dating Amy, decides to leave for America. *November 1949.* Len's friends help him build an extension to his house. Menzies wins the Federal election, defeating Labor. Frank departs on a liner bound for the USA. *Winter 1951.* Menzies calls a referendum on banning the Communist Party; at the christening of his third child, Len gets into an argument with his in-laws and the priest (JOHN FLAUS) over politics ('I'm a democrat,' he claims). Len leaves home. *Winter 1953.* A.G. collapses and dies; Cliff Brennan (JOHN CLAYTON) succeeds him. While covering the Redex round-Australia trial in the small town of Dunnydoo, Chris spends the night with local girl Ellie (LORNA LESLEY), who becomes pregnant. She follows him to Sydney and they marry. Len and Amy get together. *February 1954.* Chris is drowned while covering the Maitland floods. *Spring 1956.* Television news is impacting the cinema newsreels; Cinetone and Newsco merge. Frank returns from the USA with a job offer for Len, who opts to stay on and film the Melbourne Olympic Games. Frank offers him $50,000 for footage of the Hungary–Russia clash in the semi-final of the water polo event—Len refuses.

For me, *Newsfront* was love at first sight, perhaps because I didn't grow up in Australia and the film's witty and hugely informative screenplay (by director Phillip Noyce, based on an original screenplay by Bob Ellis and a concept by producer David Elfick and—uncredited—Philippe Mora) says so

much about this country in the post-war period. The whip-smart dialogue, the impeccable performances from a quite exceptional cast composed of the finest Australian actors of the period, and the sense of national pride in achievement, make the film a richly emotional experience.

Newsfront is also important for its acknowledgement of and admiration for the rich and diverse work of the country's newsreel cameramen, who are listed as the first credit at the end of the film. Based loosely on fact (there were two rival newsreel companies), the film also pays tribute to pioneers such as Ken G. Hall, who was the inspiration for A.G. Harwood (though Hall, also the director of many feature films in the 1930s, was alive and well when Newsfront was made).

The choice of the newsreel excerpts is admirable, starting with a terrific opening montage consisting of Chico Marx entertaining an audience of Australian men in uniform with a rendition of 'Waltzing Matilda', to the final shots of prime ministers, ending with Gough Whitlam. Footage of planes flying in formation when two of them collide is amazing, as is the front-line material photographed by Damien Parer in New Guinea during World War II, an assignment that cost him his life.

Integral to this tribute to Australian newsreel cameramen are the characters of Len and Charlie (JOHN EWART), friends and rivals who are seeing profound changes in their profession. Early in the film the 'House Full' sign goes up outside the State newsreel cinema in central Sydney; near the end the cinema has been transformed into an art-house screening And God Created Woman/Et Dieu . . . créa la femme (1956) with Brigitte Bardot. Len, who is proudly left wing (he reveres John Curtin as Australia's finest prime minister, with Ben Chifley as runner-up) and who is for the most part idealistic and certainly patriotically Australian, is contrasted with his opportunistic brother, Frank, who embraces the Americanisation of Australia that proceeds apace after the war. The film editor, Geoff, is a cynic whose views are even further to the left than those of Len and who gets into trouble for editing a sequence involving Menzies in such a way as to make the new PM look idiotic. These 'true' Australians are contrasted with better educated men like Harwood and Ken (JOHN DEASE), the narrator of the newsreels, who speak a form of English from which Australian slang and idioms are absent and who adopt a more conservative line. And then there's the eager newcomer, Chris, who came to Australia 'because there's more chances in a new, young country' and who proudly reveals that he voted for Winston Churchill. The film reserves its derision

for Frank, who 'shoots through' to America and sells his soul for a dollar; who dumps Amy after a six-year relationship, but opportunistically links up with her again when he returns, even though she's now living with his brother.

The women are also beautifully realised. Wendy Hughes' Amy is a superbly self-confident professional woman who is well aware of her considerable sexual allure. Angela Punch's Fay, on the other hand, is a bitter, deeply conservative wife and mother who suspects her husband of infidelity and whose faith rejects the use of contraception. And Lorna Lesley's Ellie is a naïve, small-town girl who loses her virginity to an 'exotic' stranger and (presumably) lives to regret it.

Technically, the film is a marvel. Alternating between black and white and colour to integrate the newsreels convincingly into the action, the film looks far bigger than its modest budget would have suggested. The sequence of the Maitland flood is particularly impressive; a facsimile of the town was constructed in the Narrabeen Lagoon north of Sydney, and the scenes in which the hapless Chris is swept to his death are edited, with complete conviction, into existing footage of the catastrophe.

There's an unintended reference to a later Phillip Noyce film when we see newsreel coverage of the construction of a rabbit-proof fence ('Rabbits are Public Enemy No. One', we're advised, although for much of the film the chief threat seems to be a real or perceived Communist influence on the country).

Phillip Noyce (b. 1950) was part of the first intake into Australia's Film and Television School in 1973 and made several prize-winning short films between 1969 and 1976. His first feature was the ultra-low-budget *Backroads*, which premiered at the 1977 Sydney Film Festival. *Newsfront* followed and then came *Heatwave* (1981), *Shadows of the Peacock* (1987) and *Dead Calm* (1988). Like many other Australian directors, Noyce was headhunted by Hollywood producers. He made *Blind Fury* (1989), *Patriot Games* (1992, with Harrison Ford), *Sliver* (1993), *Clear and Present Danger* (1994, again with Ford), *The Saint* (1997) and *The Bone Collector* (1999, with Denzel Washington). He returned to Australia to make *Rabbit-Proof Fence* and *The Quiet American* (both 2002). He made *Catch a Fire* (2006) in South Africa and then returned to America for the Angelina Jolie thriller *Salt* (2010). *Mary and Martha* (2013) was a UK-produced drama about the fight against malaria in Africa, while *The Giver* (2014) was based on the

first book in a series of young adult adventures set in a dystopian future and was commercially unsuccessful. *Above Suspicion*, made in 2017 but not released until 2020, is set in Kentucky in 1988 and deals with the first FBI officer ever to be convicted of murder.

Alien

UK, 1979

20th Century-Fox–Brandywine Productions. DIRECTOR: **Ridley Scott.** 116 MINS.

FIRST SEEN: *United Artists cinema, Pasadena, California, USA. 3 November 1979.*

The Future. A commercial towing vehicle, *Nostromo*, carrying 20 million tonnes of mineral ore, has travelled halfway on a return journey to Earth from deep space with a crew of seven: Dallas (TOM SKERRITT), the captain; Kane (JOHN HURT), his deputy; warrant officer Ripley (SIGOURNEY WEAVER); Ash (IAN HOLM), the science officer; Lambert (VERONICA CARTWRIGHT), the navigator; and engineers Parker (YAPHET KOTTO) and Brett (HARRY DEAN STANTON). 'Mother', the ship's computer, awakens the sleeping crew and orders them to trace the source of what appears to be a distress signal coming from a nearby planet. Dallas reluctantly orders the ship to land on the rocky, windswept planet and he, Kane and Lambert disembark. They trace the signal—which looks less like an SOS and more like a warning, Mother now informs the crew on board—to an abandoned alien craft where Kane, investigating what appear to be eggs, is attacked by Something. When Dallas and Lambert arrive back at *Nostromo* with the injured Kane, Ripley, nominally in command, refuses them entry on quarantine grounds, but Ash—whom she doesn't trust—overrides her. Kane has an octopus-like creature clinging to his face, which, when investigated, drips acidic 'blood' that cuts through two decks of the ship. Later the creature disappears, and Kane appears to make a recovery, but while he enjoys a celebratory meal a sharp-toothed alien bursts out of his chest, killing him. As the crew members search for the creature—which is growing larger and larger—they are killed off one by one. Ripley discovers that the spacecraft's mission was always to bring home the alien and that the crew members were considered expendable. After Ash is revealed to be an android, Ripley is left alone to face the vicious alien.

The scene, about 55 minutes into *Alien*, in which the creature bursts out of John Hurt's chest will not be easily forgotten, especially if seen on the big cinema screen (early screenings in the USA were projected in 70mm, and that is the format in which I first saw it). Ridley Scott's celebrated thriller became an instant classic, mainly for this scene but also for the fact that, for once, a woman—Ripley, wonderfully incarnated by Sigourney

Weaver in her first major screen role—is the hero who prevails at the end. Dan O'Bannon, the screenwriter, had already provided the basis for John Carpenter's jokey sci-fi movie *Dark Star* (1974), and his script for *Alien*, with its echoes of Howard Hawks' *The Thing* (1951), unfolds not on the sort of glamorous exploratory spaceship usually found in movies (*2001: A Space Odyssey*, 1968, being the prime example) but on a commercial craft carrying minerals and crewed by a cross-section of believable characters, including blue-collar workers who bicker about wages, bonuses and conditions; the jaded, seen-it-all captain; and the emotionless, charmless scientist—a role in which Ian Holm excels. 'He has a funny habit of shedding his cells,' he observes of the alien, 'which gives him a prolonged resistance to environmental conditions.' Weaver's Ripley is, at first, an unlikely hero, though she's the only one who—wisely—seeks to obey some very basic quarantine rules. There's a moment of drily prophetic humour when Parker, complaining about the delay that the unexpected stopover will cause, is advised by Ripley that if there's any booty on the mystery planet, 'You'll get what's coming to you. You're guaranteed to get a share.' Indeed he does.

The film starts very slowly with Derek Vanlint's camera prowling through the corridors of the spacecraft before the lights turn on; the crew members are awakened by Mother and slowly emerge from their pods. Visually the film is highly impressive with the extraordinary sets, designed by Michael Seymour—filmed in studios near London—and, of course, the alien itself. This nasty creature, with its tentacles, domed head and cavernous, slobbering mouth—boasting two sets of shiny, sharp teeth—was the concept of H.R. Giger, while Carlo Rambaldi worked specifically on the creature's head. O'Bannon is also credited 'Visual Design Consultant' while Ron Cobb was 'Concept Artist'. All did an amazing job.

This was only Ridley Scott's second feature and it made his reputation—*Blade Runner*, another great sci-fi thriller, came next, three years later. Scenes like the one in which Brett, searching for the ship's elusive cat, Jones, is stalked and eventually attacked by the alien are textbook exercises in suspense. The scene takes place in silence (Jerry Goldsmith's score is muted throughout), with only dripping water and the soft clanking of hanging chains to be heard as Brett moves closer to the camera, then away, then close again—until the creature strikes. There's also a great scene in which Ash, who has been decapitated, keeps on talking—the robot attempting to justify his actions to the humans he has betrayed.

The tension generated in the last 20 minutes of the film, as Ripley finds herself facing the alien alone, is riveting. Dressed only in her underwear, and determined not to leave Jones the cat behind, Ripley proves her mettle when she discovers that the ghastly creature has infiltrated the shuttle in which she's desperately trying to escape from the *Nostromo*.

It's true that the concept is far from original, and probably dates back to that classic of British sci-fi, *The Quatermass Xperiment* (1955)—and the TV series that preceded it—in which an alien enters the body of an astronaut who becomes a killer on his return to Earth. In fact, it all goes further back than that: the *Nostromo* could easily stand in for the traditional 'old dark house' in which a killer stalks the hallways murdering guest after guest until he is eventually exposed.

When *Alien* was screened for the trade press in America (on 16 May 1979) it was eight minutes longer than the final release version. Comments from trade-paper reviewers suggest that the deleted footage involved nudity.

Alien was an enormous success and, for good or ill, was followed by several sequels of which James Cameron's apocalyptic *Aliens* (1986) was the best. What became an unplanned franchise reached a low point when 20th Century Fox combined two of its movie monsters in the dismal *Alien vs. Predator* (2004). Scott himself returned to the theme with a pair of prequels, *Prometheus* (2012) and *Alien: Covenant* (2017). There have been a great many imitators, one of the better ones being the Russian *Sputnik* (2020, directed by Egor Abramenko).

Ridley Scott (b. 1937) became established as one of Britain's leading directors of TV commercials before making his first feature, *The Duellists* (1977). His two sci-fi classics were succeeded by a number of thrillers (*Someone to Watch Over Me*, 1987; *Black Rain*, 1989; *Hannibal*, 2001; *American Gangster*, 2007 and *The Counselor*, 2013). He has also achieved great success with period epics (*1492: Conquest of Paradise*, 1992; *Gladiator*, 2000; *Kingdom of Heaven*, 2005; *Robin Hood*, 2010; and *Exodus: Gods and Kings*, 2014) as well as the feminist drama *Thelma and Louise* (1991), the military drama *Black Hawk Down* (2001) and a rather different example of the space movie, *The Martian* (2015). In 2021 he released two films, *The Last Duel* and *House of Gucci*. All his films have been distinguished by an unusually strong visual approach to his chosen material.

89

Breaker Morant

AUSTRALIA, 1979

South Australian Film Corporation. DIRECTOR: Bruce Beresford. 103 MINS.
FIRST SEEN: *Roadshow screening room, Sydney, 22 January 1980.*

Pietmaritz, Transvaal, South Africa, November 1901. Three members of
the Bushveldt Carbineers, a special unit formed to fight Boer guerrillas,
are court-martialled. British-born lieutenants Harry 'Breaker' Morant
(EDWARD WOODWARD), who has spent most of his adult life in Australia, Peter
Handcock (BRYAN BROWN) and George Witton (LEWIS FITZ-GERALD) are charged
with the killing of Boer prisoners as well as Hesse (BRUNO KNEZ), a German
missionary. Major Thomas (JACK THOMPSON), a lawyer from Tenterfield, NSW,
is assigned to defend them against the charges laid by prosecuting officer
Major Bolton (ROD MULLINAR). Bolton has been advised by Lord Kitchener
(ALAN CASSELL) and his aide Colonel Johnny Hamilton (VINCENT BALL) that
convictions are required to prevent Germany taking advantage of the case
to enter the war on the Boer side. The President of the Court, Lieutenant
Colonel Denny (CHARLES TINGWELL), constantly frustrates Thomas' efforts to
prove that Morant's superior, Captain Hunt (TERENCE DONOVAN), had, before
he was mutilated and killed by Boers, passed on to Morant Kitchener's
orders not to take prisoners. During the trial a Boer force attacks the base
and the three accused men help drive them off, but their heroism is not
taken into account. Despite a powerful closing speech from Thomas, all
are found guilty of the killings of the Boer prisoners; Witton is sentenced
to life imprisonment (an end title reveals that he served only three years)
while Morant and Handcock are shot by a firing squad.

Another key film in the Australian revival of the 1970s, *Breaker Morant*
tapped into the increasingly republican mood of the period—a movement
that was soon to be frustrated by defeat in a referendum. The film offers a
powerful critique of the British officer class and their appallingly patron-
ising treatment of Australian soldiers during the Boer War (two years later,
Peter Weir's *Gallipoli* would take a similar approach).

An opening title briefly contextualises the events that follow. By 1901, the
year Australia became an independent member of the Commonwealth,
the Boer War (1899–1902) was at the mid-point; British forces were occupying

most of the Boer territory but had difficulty gaining an outright victory because of the activity of mobile Boer forces, or guerrillas.

In essence this is a true story, though some of the facts are disputed and the case is far from clear-cut. According to the screenplay, by Bruce Beresford, Jonathan Hardy and David Stevens, based on material that formed the basis of a play by Kenneth Ross and the 1973 novel *The Breaker* by Kit Denton, Morant *did* order the killings of Boers who had surrendered under a white flag, and Handcock *was* guilty of killing Hesse, though he claimed to be having sex with a pair of Boer wives at the time. The film takes the view that 'soldiers at war are not to be judged by civilised rules' and that 'the horrors of war are committed by normal men in abnormal situations', both points made by Major Thomas in his final address to the court, but, with the atrocities committed by US Lieutenant William Calley in the My Lai massacre during the Vietnam War still fresh in the minds of many, these principles hardly seemed justification for the killings. The film is on firmer ground in exploring the duplicity of the British officer class and their obvious disdain for the Australians who fought in the 'special ops' division known as Bushveldt Carbineers. Ultimately, *Breaker Morant* is manifestly a significant anti-war movie, and a very powerful one.

This 'sideshow of war', as Colonel Hamilton calls the court-martial, will soon be forgotten, the British believe, and if it helps keep the Germans out of the conflict then the ends more than justify the means. Throughout, though, the film makes the Vietnam parallel clear ('It's a new kind of war,' says Morant. 'The enemy isn't in uniform. They're farmers—some of them are women and some of them are children').

Breaker Morant was produced for an estimated budget of $800,000, and Beresford and his team were forced to take ingenious steps to make the film as convincing as it is. In the scene of the Boer raid on British HQ, extras on horseback played both Boers and English with Donald McAlpine's camera filming first the attackers and then, with mostly the same actors, the defenders. David Copping's production design skilfully makes the South Australian town of Burra, and the area around it, look convincingly like the Transvaal. The bleak, spartan space that becomes a courtroom is convincingly functional.

The film is suffused with grim humour, much of it to be found in the laconic dialogue given to Bryan Brown. His character, Handcock, who enlisted because Australia was in the grip of a depression and he had a wife and child to support, responds to the information that Thomas' legal

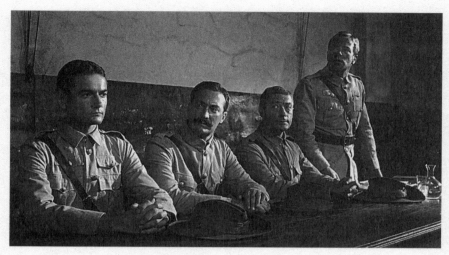

The court-martial in Bruce Beresford's *Breaker Morant*: (left to right) Lewis Fitz-Gerald, Bryan Brown, Edward Woodward and Jack Thompson.

experience is mostly confined to preparing wills, quipping, 'Might come in handy.' He mutters that one of the prosecution witnesses, Drummond (RAY MEAGHER), 'couldn't lie straight in bed' and, when he hears the coffins being constructed outside his cell, he comments ruefully that 'they could have had the decency to measure us first' (in fact, his coffin proves to be far too small, which results in a bleak final joke). 'This is what comes of empire building,' remarks Morant on the eve of his execution, and he calls out to the firing squad, 'Shoot straight, you bastards! Don't make a mess of it.' Beresford researched the film extensively, and the touching scene in which the doomed men walk to the place of execution holding hands really occurred and was not invented for the film.

Beresford has always been a fine director of actors, and every member of the *Breaker Morant* cast, down to the smallest cameo (Chris Haywood as Sharp, an observant and vindictive sentry), are pitch perfect. Jack Thompson won the Best Actor award at Cannes in 1980, as well as Best Actor in the 1980 Australian Film Awards. Other AFI Awards included Best Film, Best Director, Best Adapted Screenplay, Best Supporting Actor (Bryan Brown), Best Photography, Costumes (Anna Senior), Editing (William Anderson), Production Design and Sound.

In 2013, during the Cannes Film Festival, I was having a conversation with American actor Bruce Dern who told me that in his opinion *Breaker*

Morant was the best film of the 1970s; he particularly praised the performance of Jack Thompson.

Bruce Beresford (b. 1940) was a lover of film from childhood and he knows his cinema history. After working with a film unit in Nigeria and a brief spell as Head of the British Film Institute's Production Board, he directed his first feature, *The Adventures of Barry McKenzie,* in 1972, which was followed by a sequel, *Barry McKenzie Holds His Own* (1974). As the 70s wore on he became a leading director in the Australian film revival with *Don's Party* (1976), *The Getting of Wisdom* (1977) and *Money Movers* (1978). After the enormous success of *Breaker Morant* he divided his time between filming in Australia and the USA. In the USA he made *Tender Mercies* (1982), *Crimes of the Heart* (1986), the Oscar-winning *Driving Miss Daisy* (1989), *Rich in Love* (1992) and many others. Australian productions have included *The Fringe Dwellers* (1986), *Black Robe* (1991—a co-production with Canada, where it was filmed), *Paradise Road* (1997), *Mao's Last Dancer* (2009) and *Ladies in Black* (2018).

90

Manhunter

USA, 1986

Dino de Laurentiis Entertainment Group. DIRECTOR: Michael Mann. 120 MINS.
FIRST SEEN: *Lowes, Cinema 2, Montreal, 29 August 1986.*

Will Graham (WILLIAM PETERSON), a former FBI investigator who quit his job after capturing the notorious serial killer Dr Hannibal Lecktor (BRIAN COX), is persuaded by his old boss, Jack Crawford (DENNIS FARINA), to help track down the killer of two entire families, one in Atlanta, the other in Birmingham, Alabama. The killer seems to be on a lunar cycle and there is a little over three weeks before the next full moon. Despite the concerns of Molly (KIM GREIST), his wife, Will agrees. By exploring in detail the shocking crime scenes, he tries to enter into the mind of the killer police have nicknamed 'Tooth Fairy' because he bites his victims. He visits Lecktor in his tightly controlled prison cell seeking insights into his quarry. The police discover a letter sent by the killer to Lecktor setting up a coded correspondence via small ads in *The National Tattler*, a scandal sheet whose lead journalist, Freddie Lounds (STEPHEN LANG), features an article about Will on the front page. The killer kidnaps Lounds and murders him. Will deduces that the murderer must have seen the home movies that the families filmed, both of which were processed in the same laboratory in St Louis, Missouri. The killer, Francis Dollarhyde (TOM NOONAN), works at the lab and has become involved with Reba McClane (JOAN ALLEN), a blind employee. Wrongly thinking that Reba kissed another man, Dollarhyde kills his rival and kidnaps Reba. He is about to kill her when Will, Jack and a SWAT team attack his house.

Though Jonathan Demme's Oscar-laden *The Silence of the Lambs* (1990) is much better known, Michael Mann's pulsating film version of an earlier Thomas Harris novel, *Red Dragon*, is in most ways superior; though, with its little-known cast and, at the time, little-known director it was a major flop at the box office (it was nearly three years after its US release before it opened in some key territories, including the UK).

In some ways the film is exploring a fairly familiar film noir theme, that of the links between the cop and the criminal, a concept best represented by films like Robert Siodmak's *Cry of the City* (1949). But Mann—thanks to the

taut screenplay he wrote himself; the unusual use of colour (predominantly green) in Dante Spinotti's excellent photography; the intensity of the acting; and the pounding music score by Michael Rubini and The Reds, with its intriguing use of songs like 'Strong as I Am' and 'Heartbeat'—brings to the material a rare complexity as well as a truly creepy ambience.

These attributes are present from the very start, a first-person shot, lit by torchlight, as the killer ascends the stairs of the Leeds family house, past children's toys and into the master bedroom where Mrs Leeds awakens and stares at the camera before the screen goes black and the title of the film appears in green lettering. Later Will makes the same journey up the same stairs, but this time the bedroom is empty, the bed sheets and much of the walls covered in blood. There's a powerful moment when the phone rings and we hear the recorded voice of the murdered Mrs Leeds asking the caller to leave a message.

At frequent intervals, Will talks to the unknown killer as if he were present. 'You rearrange the bodies,' he says. 'What is it you think you're becoming?' and, later, 'It's just you and me now.' Already traumatised by his earlier experience with the frighteningly intelligent Lecktor—like Anthony Hopkins who played the character later on, Brian Cox's British accent is somehow chilling—Will is determined not to be taken over again by the thoughts of a psychopath. The scene in Lecktor's white-painted cell, in which the serial killer greets him warmly ('Glad you came! Do you have any problems?') and then reminds him that 'the reason you caught me, dear Will, is that we're alike', ends when Will literally flees the cell, down the winding galleries and out into the fresh air.

Will's painstaking investigation, his sifting of the most obscure clues and his long periods of reflection are interspersed with his reports to Jack: 'The Tooth Fairy will go on until we get smart or we get lucky,' he tells his boss. 'He's got a genuine taste for it.' He obsessively examines the photographs of the families, both before and after the murders and, while on a flight to Birmingham, he inadvertently causes a disturbance on the plane when a little girl sitting near him sees the images of the horrible crime scene. But his patience pays off and he discovers the evidence that links the killer to a mahjong symbol: the Red Dragon.

In crime films journalists are often sympathetically presented and are of assistance to the investigators, but not here. Lounds is a pretty repulsive character ('How does this investigation affect your sex life?' he asks Will, who is properly infuriated). Yet we naturally sympathise with the

man when he falls into the killer's clutches and Dollarhyde inserts in his mouth a formidable pair of false teeth before bending over the newspaper man to perform an act that, mercifully, Mann does not permit us to see.

At approximately the hour and a quarter mark Mann has the killer, Dollarhyde, take centre stage. Tom Noonan is chillingly good in this role: very tall, balding, with a scarred lip and an intense expression. Dollarhyde's courtship of the vulnerable but self-confident Reba is almost unbearable to experience, and their love scene one of the creepiest ever filmed. Prior to this is an extraordinary scene in which Dollarhyde, promising a 'surprise', takes Reba to see a sleeping tiger, a beast presumably drugged prior to a surgical procedure. He watches as the blind woman strokes the predator, fondling its ears and lifting its lip to bare its teeth.

Four years later, Demme's film *The Silence of the Lambs* rather unexpectedly won Oscars for Best Film, Director, Screenplay, Actor (Hopkins) and Actress (Jodie Foster). It was followed by *Hannibal* (2001) directed by Ridley Scott, with Hopkins reprising his role and, the following year, by a quite unnecessary remake of Mann's film. *Red Dragon* (2002), directed by Brett Ratner, and photographed by Mann's cinematographer, Dante Spinotti, otherwise has little in common with the earlier film and is in every way less effective despite a cast that includes Anthony Hopkins as Lecter (spelt differently this time), Edward Norton as Will, Emily Watson as Reba and Ralph Fiennes as Dollarhyde.

Michael Mann (b. 1943), though born in Chicago, studied at the London Film School in the mid-1960s, which is possibly why he has such a distinctive visual style. After making commercials and documentaries he directed his first made-for-TV feature, *The Jericho Mile* (1979). This was followed by *Thief* (1981) and *The Keep* (1983). He achieved some fame for his work on the popular TV series *Miami Vice* (1984–1989). *Manhunter* was followed by *The Last of the Mohicans* (1992), the very impressive thriller *Heat* (1995), *The Insider* (1999), *Ali* (2001), *Collateral* (2004, another excellent thriller with Tom Cruise cast against type as a ruthless contract killer), the big-screen version of *Miami Vice* (2006), *Public Enemies* (2009) and *Blackhat* (2015).

High Tide

AUSTRALIA, 1987

Hemdale Film Group–FGH–SJL Productions. DIRECTOR: Gillian Armstrong. 100 MINS.
FIRST SEEN: *Cannes Film Festival (Market screening), 14 May 1987.*

Eden, NSW. Lilli (JUDY DAVIS), one of three back-up singers supporting
Elvis imitator Lester (FRANKIE J. HOLDEN), is fired after a performance and
is stranded in the small coastal town when her car breaks down. She rents
accommodation at the Mermaid Caravan Park where she meets 13-year-old
Ally (CLAUDIA KARVAN), who shares a caravan with her paternal grandmother,
Bet (JAN ADELE). Only when she also meets Bet does Lilli realise that Ally is
her daughter, who she left with Bet as a baby after the death of John, her
husband. Bet suspects Lilli has come to claim Ally, and is very unhappy to
see Lilli and her as yet unsuspecting daughter become friends. Lilli has a
fling with Mick (COLIN FRIELS), a local fisherman and would-be artist, and
leaves town with him, but his idea of their shared future drives her back
to Eden. Mick responds by telling Ally the truth about her mother. After
paying off her car repairs Lilli spontaneously invites Ally to come away with
her; there is a tearful farewell between Ally and her grandmother before
mother and daughter drive away. They stop that night at a roadside diner
where Lilli contemplates leaving Ally behind, but she changes her mind.

It's difficult to think of another Australian film that comes close to being
as emotionally draining as *High Tide.* Thanks to a trio of simply wonderful
performances from three great actors, Gillian Armstrong's film, based on
an original screenplay by Laura Jones, is arguably the most touching explo-
ration of female relationships ever filmed in Australia.

Ironically, the project originally featured a male character in the central
role, but at some point the brilliant decision was made to transform a story
about yet another rootless, unreliable male (the sort of character, presumably,
Jack Nicholson played in *Five Easy Pieces*, to name one of many examples
from the 1970s and early 1980s) into one featuring a woman. With Judy
Davis reunited with her *My Brilliant Career* (1979) director, the result is an
exceptional portrait of a confused and troubled woman. Freedom, for Lilli,
has always been important ('Taking off. Going somewhere. Best feeling in
the world,' she tells Mick), though when she's left behind in Eden by Lester

and the other two girls (TONI SCANLON, MONICA TRAPAGA), her response is to get blind drunk, and she winds up on the floor of the shared shower and toilet amenities singing a Bob Dylan song. This is how she first encounters Ally who, together with her friend Jason (MARC GRAY), helps the drunken woman back to the caravan she's rented. Before she realises who Ally is, Lilli is quick to offer the young girl some dubious advice: 'Don't let anyone tell you you're too young,' she tells her. 'People [who tell you that are] old and ugly and jealous.'

Lilli is in a pretty desperate situation when she discovers that repairs to her car she thought would cost $300 have cost double what she expected. For a moment she seems to be seriously considering offering sexual favours to the handsome garage mechanic (MARK HEMBROW), but she changes her mind and takes a job as a stripper ('After all, it's all show business, isn't it?' the sleazy club manager—played by Barry Rugless—assures her).

We gradually discover that, though at least 13 years have passed, Lilli is still grieving over the (unexplained) death of John ('Why didn't you help me?' she asks Bet. 'Where were you when John died?') and she feels guilty about abandoning her daughter ('I gave you away,' she admits to Ally. 'It wasn't simple. I felt angry, useless. I couldn't cope with you'). On the other hand, she seems to have no qualms when Mick abandons *his* small daughter to the care of her grandmother to leave town with Lilli.

The adult characters are complicated. There's an air of desperation about both Bet and Lilli. Bet not only works in the local fish-packing factory, but also runs a mobile ice-cream van with Ally's help. She has a lover, Col (JOHN CLAYTON), but doesn't hesitate to spend a night with Joe ('COWBOY' BOB PURTELL), an itinerant country and western singer. Lilli, despite her principles, agrees to perform a striptease at a buck's night at the Eden Fishermen's Recreation Club, and, though the mother–daughter bond proves to be strong, it's not easy to imagine a happy future for mother and daughter.

Davis' intense, unhappy Lilli is a wonderfully realised character, matched by Jan Adele's demanding yet caring Bet and by Claudia Karvan's unforgettable Ally. In only her second featured role (after playing a little girl in *Molly* in 1983) 15-year-old Karvan gives a performance of remarkable depth. Something of a tomboy, Ally loves to surf—on her dad's old surfboard—and hangs out with Jason, a boy her own age. In one scene she persuades Bet to tell her about her parents. ('When I was a baby, did my mother and father love me? Did they love each other?') Despite her love for her grandmother, her loneliness shows through and she instinctively latches on to

Lilli when she discovers she is the mother she had only dreamed about. Neither child nor yet woman, Ally, first seen in her wetsuit floating in a rock pool, is bright, aware, funny and, in her own way, independent. It's an unforgettable portrayal.

In addition to the fine direction, lucid screenplay and sensational acting, *High Tide* is distinguished by Russell Boyd's location cinematography and by the editing of Nicholas Beauman. More than once, the camera glides away from the action and imperceptibly the backdrop changes to a highway as cars roar down narrow coastal roads. The resort town is shutting up for the winter, and the end-of-season atmosphere is beautifully captured in the subtle lighting of the exteriors of beach, port and village, with its shabby restaurants and shops. The lingering close-ups of the three main actors, especially in the highly emotional climax to the film, are exquisitely judged.

Gillian Armstrong (b. 1950) was, like Phillip Noyce, a member of the first intake of students when the Australian Film and Television School was established in 1973. After making some outstanding short films she became, with *My Brilliant Career* (1979), only the second woman to direct a feature in Australia since 1933 (the first was pioneering Turkish immigrant Ayten Kuyululu with her 1975 film *The Golden Cage*, on which Russell Boyd was also cinematographer).

As well as making a number of probing documentaries such as *Smokes and Lollies* (1976)—which was followed, like Michael Apted's Up series, by four more documentaries featuring the same women—Armstrong has worked on feature films in Australia, Britain and the USA. The trail-blazing *My Brilliant Career* was followed by *Starstruck* (1982), an off-beat musical, after which Armstrong travelled to the USA to make *Mrs. Soffel* for MGM; despite strong performances from Mel Gibson and Diane Keaton, the film proved a difficult experience for all concerned and was under-appreciated, but it deserves to be reassessed. Her subsequent features have included *Fires Within* and *The Last Days of Chez Nous* (both 1991), a fine adaptation of *Little Women* (1994), an adaptation of the Peter Carey novel *Oscar and Lucinda* (1997), *Charlotte Gray* (2001) and *Death Defying Acts* (2007). She has also made the well-regarded partly fictionalised documentary features *Unfolding Florence* (2005), about designer Florence Broadhurst, and *Women He's Undressed* (2014), about the life of Australian-born Hollywood costume designer Orry-Kelly.

92

Where is My Friend's House?
(*Khaneh-je Doost Kojast?*)

IRAN, 1987

Institute for the Intellectual Development of Children. DIRECTOR: Abbas Kiarostami. 83 MINS.
FIRST SEEN: *SBS Television, 9 August 1994.*

Koker, Northern Iran. In the village school, a stern teacher (KHEDA BARECH DEFAI) scolds eight-year-old Mohamed Reza Nematzadeh (AHMED AHMED POOR) for writing his homework on sheets of paper and not in his notebook. Reducing the child to tears, the teacher warns him that if this happens again, he will be expelled, while Ahmed (BABEK AHMED POOR), who sits next to Mohamed Reza, looks on in sympathy. Returning home that evening, Ahmed realises that he has mistakenly taken Mohamed Reza's notebook. Determined to return it, Ahmed finds an excuse when he is sent on an errand to buy bread. He runs to the next village, Poshteh, where his friend supposedly lives, but no one seems to know which is his house, and Ahmed returns disconsolately to Koker. He sees his grandfather (RAFIA DIFAI) talking to a craftsman (MOHAMED HOCINE ROUHI) who has the same surname as his friend. When the craftsman leaves, riding on his donkey, Ahmed pursues him back to Poshteh, but loses him. As night falls, an old man (HAMDALLAH ASKAR POOR) offers to show Ahmed the house where Mohamed Reza lives, but still Ahmed cannot find his friend. He returns home. The next day he arrives at school and quietly hands over his friend's notebook—having done his homework for him.

The cinema of Iran is not as well documented as it might be, and since the establishment of a strict Muslim government the film industry has been carefully controlled. The best directors—Mohsen Makhmalbaf, Jafar Panâhi and others—have often had to disguise their themes to avoid censorship, and even so, many of them have found themselves in trouble with the authorities. Abbas Kiarostami, after making several documentaries, came to international attention with *Where is My Friend's House?*, which is, on the surface, a children's film, though it's far more than that. Among the finest films made anywhere in the world about children, it's an intimate and deeply touching story of an eight-year-old boy's tenacity and his efforts, against the odds, to help his friend.

Koker, where the film was made, is about 320 kilometres north-west of Tehran, in a mountainous region. There were no sealed roads, and the two villages where the story is set—the other being Poshteh—have narrow, hilly streets with a great many stone steps leading up the hillsides.

The opening image of the film is of a door that doesn't close properly; this is the entrance to the schoolroom where the young protagonists are taught by an irritable teacher who, arriving late, is furious that the kids are being noisy. He berates the hapless Mohamed Reza for not doing his homework in his notebook, asking the boy repeatedly how many times he'd been told the same thing. He has no sympathy for the fact that Mohamed Reza, and other children in the class, have to walk from Poshteh and that consequently some of them arrive late—'Get up ten minutes earlier,' he orders them.

When Ahmed arrives home—a two-level house with a large courtyard— he quickly realises he has picked up his friend's notebook by mistake. His mother (IRAN OUTARI), who is busy doing the washing and looking after a small baby, isn't interested in the boy's problem; she keeps telling him to do his homework when she isn't giving him chores to do. When the boy finally gets the message through to her about Mohamed Reza's book, she's unsympathetic. 'Serves him right,' she says. 'Give it back tomorrow.'

The bulk of the film consists of Ahmed's determined efforts to find his friend. Adults are, for the most part, no help. Either they ignore the boy, or they give him half-hearted and often misleading directions. Like a little detective, the child follows clues: his friend lives in a house with a blue door; the man who might, or might not, be his friend's father, or uncle, rides a donkey with a bell; a pair of shorts hanging on a line to dry outside a house look like those of Mohamed Reza—but they're not. All these 'clues' prove useless as night falls and the poor child becomes increasingly distressed.

Earlier his grandfather had sent him on an errand to buy cigarettes, even though he didn't really need them. In conversation with his friends, the grandfather expresses the view that children should be beaten regularly to make them behave. The film also digresses at this point for a debate between the old men of Koker and the visiting craftsman about replacing old doors with new ones, a discussion that leads to a conversation about the good old days.

The only adult willing to help Ahmed in his search is an old man who lives alone and has no family. He makes the stained-glass windows that feature in many of the local houses. He offers to take Ahmed to his friend's

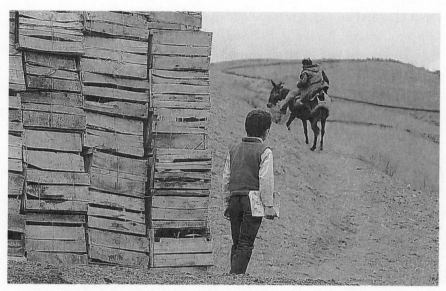

The boy, Mohamed Reza Nematzadeh, on his quest, in Abbas Kiarostami's *Where is my Friend's House?*

house, but he walks very slowly, and time is running out. The old man stops to refresh himself at a tank filled with spring water and gives Ahmed a flower that was growing nearby. The next day, that flower is found by the teacher in Mohamed Reza's schoolbook, alongside the homework Ahmed has completed for him—and the image of the flower concludes the film.

All the actors in the film were non-professionals who lived in the area; Ahmed and his friend are actually played by brothers. Kiarostami's skill at extracting unforgettably real performances from child actors has been rightly compared to that of François Truffaut in *The 400 Blows* (see #53) and to Satyajit Ray in his first film, *Pather Panchali* (1955). The narrative of *Where is My Friend's House?* could not be simpler, but through this very basic story of a good little kid who defies the adults around him in his determination to do the right thing by his friend, we are afforded amazing insights into this isolated, ultra-traditional world and the people who live there.

Three years after the film was made, a massive earthquake struck the region, killing about 50,000 people. Deeply saddened by the catastrophe, Kiarostami made the hazardous journey, accompanied by his son, back to the area to see if his 'actors' had survived. Subsequently he made a film

about his quest, in which actors stood in for the filmmaker and his son; the film was *Zendegi Edame Darad/And Life Goes On*, aka *Life, and Nothing More* (1992) and was in turn followed by *Zire Darakhtan Zeyton/Through the Olive Trees* (1994); the three films comprise what is now known as The Koker Trilogy.

Abbas Kiarostami (1940–2016) started his career in cinema making documentaries. *Where is My Friend's House* was his first feature. He also directed *Nema-ye Nazdik/Close-Up* (1989), *Ta'm e Guilass/The Taste of Cherries* (1997, winner of the Palme d'Or at Cannes) and *Bad Ma Ra Khahad Bord/The Wind Will Carry Us* (1999). He subsequently made non-fiction portraits (*Ten*, 2002; *Five*, 2004) before working abroad. He made *Copie conforme/Certified Copy* (2010) in France and *Like Someone in Love* (2012) in Japan.

I interviewed him a couple of times, although he spoke no English. He reminded me of Satyajit Ray; the gentleness, the warmth and the humanity of the man shone through, and his death at the age of 76 came far too soon.

93

Distant Voices, Still Lives

UK, 1988

BFI Productions. DIRECTOR: Terence Davies. 84 MINS.

FIRST SEEN: *Cannes Film Festival (Directors' Fortnight), 14 May 1988.*

Liverpool. This film features incidents and memories from the lives of members of the Davies family from the mid-1940s to 1959. During World War II the children, Eileen, Maisie and Tony, sell bundles of wood chopped by their stern father (PETE POSTLETHWAITE); they flee an air raid but when they arrive in the shelter Father slaps Eileen for keeping him waiting, before making her sing 'Roll Out the Barrel'. At Christmas, Father fondly observes the children sharing a bed, but later, in a burst of temper, wrecks the Christmas table setting. While Mother (FREDA DOWIE) perches on the sill to clean the outside of an upstairs window (as, on the soundtrack, Ella Fitzgerald sings 'Taking a Chance on Love') the children watch, fearful she will fall; the song continues as Father brutally bashes her.

Later, Father makes Maisie (LORRAINE ASHBOURNE) scrub the cellar floor when she seeks permission to go to a dance. Her friend Micky (DEBI JONES), however, is able to extract concessions from 'Mr D'—up to a point. Father is taken ill and the family visits him in hospital, Tony (DEAN WILLIAMS) having sought compassionate leave from the army. Father checks himself out of hospital and arrives home, having walked all the way; soon afterwards he dies. In the following years, Eileen (ANGELA WALSH) marries Dave (MICHAEL STARKE), and they have a child, and Maisie marries George (VINCENT MAGUIRE). The women find that their husbands actively discourage former friendships and one of their circle, Jingles (MARIE JELLIMAN), seems actually frightened of her husband. Tony marries Rose (ANTONIA MALLEN). Maisie and George live with Maisie's grandmother ('Gran') (ANNIE DYSON), who insists they don't stay out late. Eileen and Dave's baby is christened, and family and friends gather for the celebration.

Terence Davies' sublime remembrance of his early life is divided into two more or less equal parts of about 40 minutes each. The first, *Distant Voices*, unfolds in the 1940s and early 1950s, and much of the attention is on Mr Davies, brilliantly played by Pete Postlethwaite, a man who could be both tender and charming—there's a glorious moment when his three children,

upstairs in a loft, look down on him as he lovingly grooms a horse while singing 'Irish Eyes are Smiling'. But Davies exhibits frighteningly abrupt mood changes, subjecting his wife and his children to irrational violence. As a result he is both hated ('If I ever get a gun I'll blow your brains out,' says Maisie, who was beaten with a broom by Father when she asked him if she could go to a dance) and loved ('I'm wishing Dad was here,' sighs Eileen, on her wedding day). 'Why did you marry him?' one of the girls asks her mother, who replies, 'He was nice. He was a good dancer.' Sadly the attitude towards women is inherited by the next generation, so that the girls, and their friends—except for the perennially cheerful and cheeky Micky—live in fear of their husbands. Only Tony, presumably the director's surrogate up to a point, is presented as being a thoroughly decent man, yet even he tells his father: 'I wouldn't give you daylight', no doubt because his dad had rejected him more than once—as a child when he shut him out of the house for the night, and as a soldier when his dad refuses to have a drink with him, presumably because he's gone AWOL. The irony is that the family members are devout Catholics, who attend Mass and, apparently, confession on a regular basis.

Distant Voices, Still Lives was originally made as two medium-length films shot two years apart and with different production crews; Postlethwaite's Father is completely absent from Part 2, but his presence is still strongly felt. There is no linear narrative; scenes from the past and the present intertwine and collide freely, but the overall impression—of a time and a place—is immensely strong. In several scenes, especially in *Distant Voices*, the family members are filmed as though their portrait is being painted; they look directly at the camera, their expressions conveying a multitude of emotions.

The film takes place in a time before television, a time when families listened to the BBC on the radio. Many indelible programs from the period are included on the soundtrack: fragments of weather forecasts, football match results and clips from popular shows like *Family Favourites*, *The Man in Black*, *The Billy Cotton Band Show*, *Beyond Our Ken* and *Take it from Here*. It was also a time when stories were handed down from one generation to another. 'If you look into a mirror after midnight,' Gran tells the children solemnly, 'you'll see the Devil.'

Songs are also of vital importance, because sing-alongs formed a major component of family get-togethers. Everyone, from Gran on down, knows the words of favourites like 'Barefoot Days', 'The Finger of Suspicion', 'That

Old Gang of Mine' and 'Lazy River'. Going to the pictures was a popular event; at one point the camera rises up the wall of the Futurist Cinema, past posters of *Guys and Dolls* and *Love is a Many-Splendored Thing* (both 1955), to reveal a packed auditorium thick with cigarette smoke as the latter film's famous theme music, composed by Alfred Newman, is heard.

The film begins with Father's funeral on a rainy day: Mother sings 'I Get the Blues When it's Raining', and the plaintive ballad 'There's a Man Going Round Taking Names' is heard as the camera slowly tracks through the front door of the Davies' terraced house into the shabby hallway and the memories, the distant voices, begin. Much later, on the day of his wedding, Tony is reduced to tears when he hears the song 'Oh My Papa', and all the memories it brings with it.

Terence Davies assembled an exceptional cast of mostly little-known performers for this richly evocative film, most notably the unforgettable Freda Dowie, whose long-suffering character is modelled after the director's own mother. Also notable is Debi Jones' Micky whose affectionate put-downs of her diminutive husband, Red (CHRIS DARWIN), provide the film's most optimistic vision of marriage.

The two cinematographers, William Diver and Patrick Duval, create a drab, almost sepia-toned look back at post-war Liverpool with its rows of identical houses in which so many lives are being lived, sometimes happy, sometimes definitely not. Apart from moments in Woody Allen's most personal films (for example, *Radio Days*, 1987) no filmmaker has ever handled nostalgia so astringently and so realistically as Davies does with this rich, deeply felt family drama.

Terence Davies (b. 1945) grew up in Liverpool. From the mid-1970s he commenced a trilogy of medium-length films about the life of a man: childhood (*Children*, 1976), youth (*Madonna and Child*, 1980) and old age (*Death and Transfiguration*, 1983). The success of *Distant Voices, Still Lives* was followed by an almost equally fine sequel, *The Long Day Closes* (1992). After this, Davies abandoned personal reminiscence for a while to make two literary adaptations, *The Neon Bible* (1995) and *The House of Mirth* (2000). He returned to Liverpool with the affectionate documentary feature *Of Time and City* (2008), before his adaptation of Terence Rattigan's play *The Deep Blue Sea* (2011) and a pair of biographies, *Sunset Song* (2015) and *A Quiet Passion* (2016).

Do the Right Thing

USA, 1989

Universal–40 Acres and a Mule Filmworks. DIRECTOR: Spike Lee. 120 MINS.
FIRST SEEN: *Cannes Film Festival, 19 May 1989.*

Brooklyn. Established for a quarter of a century, Sal's Famous Pizzeria occupies a corner in the Bedford–Stuyvesant district. The owner, Sal (DANNY AIELLO), runs the place with his two sons, bitterly racist Pino (JOHN TURTURRO) and undemanding Vito (RICHARD EDISON). Pizza deliveries are assigned to Mookie (SPIKE LEE), who lives with his sister, Jade (JOIE LEE), and occasionally visits his girlfriend, Tina (ROSIE PEREZ), and their baby son. During the course of a swelteringly hot day, local activist Buggin' Out (GIANCARLO ESPOSITO) becomes obsessed with removing the photographs of famous Italian-Americans (Frank Sinatra, Al Pacino, Liza Minnelli and others) from the walls of the pizzeria and replacing them with black heroes. Radio Raheem (BILL NUNN) annoys Sal by playing his ghetto-blaster at top volume in the restaurant; Sal smashes it, starting a riot that ends with the burning down of the restaurant and the death of Radio Raheem, who is choked to death by a police baton. Next day, outside the ruined restaurant, Mookie and Sal argue over pay, while the local radio station reports that there will be a commission of inquiry into the riot.

When Spike Lee's devastating third feature (or 'joint' as he prefers to call them) premiered in competition at Cannes the atmosphere was electric. Here was a film that seemed utterly of the moment, a film that captured with unflinching honesty the racial tensions to be found in most large American cities. Seen again 32 years later it is even more pertinent, with the death of the giant Radio Raheem at the hands of the police painfully reminiscent of more recent black deaths, such as George Floyd's, at the hands of law enforcement officers: Raheem doesn't gasp 'I can't breathe!' but he might just as well have.

The film is extraordinarily even-handed. Many different sides to the problem are explored in this microcosm of urban America. Pino, who has a very short fuse, admits that he 'detests' the area and that he 'hates niggers' and tells his brother 'they're not to be trusted'. 'We should stay in our own neighbourhood,' he tells Sal, 'and niggers in theirs.' His father,

on the other hand, 'never had trouble with these people. They grew up on my food, and I'm very proud of that'. Sal is so fond of Jade that Mookie, probably wrongly, suspects his motives.

Sal is, in many ways, the film's key character. Unlike his sons, the aggressive, hostile Pino and the feeble Vito, he's genuinely proud of what he's achieved in this predominantly black part of the city. He gives Da Mayor (OSSIE DAVIS) a pittance to sweep the pavement in front of the restaurant, and he upbraids Pino for sending the hapless Smiley (ROGER GUENVEUR SMITH) away. Is he a genuinely decent man, or is he a patronising representative of the 'power' to which Radio Raheem's ghetto-blaster keeps referring? Is he delighted to see Jade because he's genuinely fond of a young woman who's been a customer all her life, or does he have (as Mookie suspects) a darker motive? Or is it that, in this heightened climate, it's much too easy to suspect the worst of people?

Buggin' Out represents the radical face of Black Power; he abuses a white man (JOHN SAVAGE) for living in the area (the man responds that he was born in Brooklyn). In one grim montage, insults are exchanged ('Go back to Africa!' 'Fuck Michael Jackson!') while everyone hates the cops and resents the Korean family whose convenience store is on the opposite corner across from the pizzeria.

This slice of New York is filled with colourful characters, all of them vividly brought to life. The film's opening credits play against a backdrop of terrace houses (not so very unlike those in *Distant Voices, Still Lives*, see #93) while Rosie Perez performs a wild dance routine in a variety of costumes, including boxing shorts, to the tune of 'Fight the Power', sung by Public Enemy. Tina's prickly relationship with Mookie is understandable given his unreliability, though he's able to win her over in one beautifully intimate scene. Da Mayor is an alcoholic veteran and committed mediator, the polar opposite of Buggin' Out; he is secretly in love with the ageing Mother Sister (RUBY DEE). Smiley, a mentally impaired stutterer, spends his day hawking copies of a photograph of Martin Luther King Jr and Malcolm X; significantly, it's he who strikes the match that starts the fire during the climax. Radio Raheem wears knuckle-dusters stamped with the words Love and Hate, and he even emulates Robert Mitchum in *The Night of the Hunter* (see #44) by telling the story of these two opposing emotions, though in a decidedly more forceful way. There is a quartet of young black men who frequent the pizzeria on a regular basis but whose mood can shift with the wind; and a trio of middle-aged 'characters' who

sit on the street under an umbrella and chew the fat. The events of the day are observed and commented on by Love Daddy (STEVE JACKSON), who operates a radio station from his front room overlooking the street. In one poignant moment he reads out a list of black entertainers, including Ella Fitzgerald, Louis Armstrong, Little Richard, Dexter Gordon and very many others, thanking them 'for making our lives just a little brighter'.

As the blisteringly hot day wears on and the tensions rise, it's little wonder that the film ends in violence. As Sal's place burns, the mob turns towards the Korean store, the presence of which many of them resent; the storekeeper defends his property. 'You, me—the same,' he cries, and the rioters back off and leave the place alone.

Lee ends the film with two lengthy quotations. One is from Martin Luther King Jr, which reads in part, 'Violence is immoral because it thrives on hatred rather than love . . . Violence ends by defeating itself. It creates bitterness in the survivors and brutality in the destroyers.' The other quote is from Malcolm X and it reads in part: 'I'm not against using violence in self-defence. I don't even call it violence when it's self-defence. I call it intelligence.'

Spike Lee (b. 1957) is the son of a jazz musician and he studied film with Martin Scorsese. His first feature, *She's Gotta Have It* (1986), was independently made but had an immediate impact. He has since had what is best described as an uneven career, having made a significant number of powerfully important films as well as a few that were far less successful. He has also made a number of documentaries and has often interpolated documentary footage into his feature films, as he did so powerfully at the end of *BlacKkKlansman* (2018) when he showed footage of the alt-right violence against blacks in Charlottesville, Virginia, in 2017 as a reminder that racism remains a powerful evil in the USA and other parts of the world.

His films include: *School Daze* (1988), *Mo' Better Blues* (1990), *Jungle Fever* (1991), *Malcolm X* (1992, a biography of the black radical leader), *Crooklyn* (1994), *Clockers* (1995), *Girl 6* and *Get on the Bus* (both 1996), *4 Little Girls* (1997), *He Got Game* (1998), *Summer of Sam* (1999), *Bamboozled* (2000), *25th Hour* (2002), *She Hate Me* (2004), *Inside Man* and *When the Levees Broke* (both 2006), *Miracle at St. Anna* (2008), *Bad 25* (2012), *Oldboy* (2013) and *Da 5 Bloods* (2020).

Sweetie

AUSTRALIA, 1989

Arena Film. DIRECTOR: Jane Campion. 100 MINS.
FIRST SEEN: *Hoyts screening room, Sydney, 8 March 1989.*

Sydney. Kay (KAREN COLSTON), who has a fear of trees, is told by Mrs Schneller (JEAN HADGRAFT), a fortune-teller, that a man with a question mark will offer her 'deep love'. Soon afterwards Cheryl (LOUISE FOX), who works in the same office as Kay, announces her engagement to Louis (TOM LYCOS), who—the startled Kay observes—has a tuft of hair that, combined with a mole, looks something like a question mark. A self-described serial monogamist, Kay arranges to meet Louis in the office's underground parking station and, despite the fact that he's been engaged for less than an hour, they have sex. Thirteen months later they are living together in the suburbs, but Louis upsets Kay by removing the Hills hoist clothesline from the concrete-covered backyard and replacing it with a sickly elder tree. She secretly removes the tree and hides it under the bed. Later the couple begin to experience sexual problems; they seek help in meditation, but Kay moves into the spare room. One night they return home to find the front door smashed and that Kay's sister, Dawn, aka Sweetie (GENEVIEVE LEMON), has moved in with her seedy, drugged-out 'producer', Bob (MICHAEL LAKE). Sweetie's bad behaviour includes seducing Louis. Gordon (JON DARLING), the sisters' father, moves in after Flo (DOROTHY BARRY), their mother, leaves him for a month's trial separation. Gordon takes Bob to a café to have a talk about Sweetie's singing career, but Bob passes out and is not seen again. Gordon, Kay and Louis decide to drive to the outback property where Flo is working as a cook and, with difficulty, trick Sweetie into staying behind. Gordon and Flo are reconciled. When eventually they all return, Sweetie is behaving like a dog. Louis finds the remains of the tree and departs. Back at her parents' home, Sweetie strips naked, paints her body, and occupies the tree house covered with fairy lights that Gordon had built for her when she was a child. Kay brings Clayton (ANDRE PATACZEK), the little boy who lives next door, to try to persuade Sweetie to come down, but she refuses. The tree house collapses and Sweetie is fatally injured.

Jane Campion's first feature, after a number of impressive, award-winning shorts and an exceptional TV feature, is quite unclassifiable. On a very basic level it's a family drama about rivalry between sisters, one 'normal', the other 'eccentric', but in this film nobody and nothing is exactly normal. Even the presence of the title character is delayed until almost a third of the way into the movie. The bizarre original screenplay, written by Campion and Gerard Lee, takes place in Australian inner suburbia and gives the setting a thorough shake-up; 'normality'—the little inner-city houses with their tiny backyards and Hills hoists, the rose-patterned carpeted floors, the drab kitchens—is here made to look like something alien. Kay has a morbid fear of trees that proves to be prescient: her sister dies after falling out of a tree and a tree root has to be removed before her coffin can be lowered into the ground. However, their mother, Flo, loves trees ('I can't imagine living without my trees,' she says. 'They give me hope').

Unusual events are handled with a casual matter-of-factness as, for example, Kay's 'stealing' of the newly engaged Louis from her workmate, and Gordon's reaction to meeting his daughter's 'producer'. He sees nothing odd about the man's weird behaviour. ('Dawn's never held a position in the theatre world,' he explains to the somnolent, drooling Bob. 'Has she got a chance?') At the outback property (filmed near Warren, NSW), the jackaroos take part in a strange dance as if they're rehearsing for a slow-paced western musical (one of them, incidentally, is played by Andrew Traucki who would go on to direct horror films about crocodiles and sharks). And Flo unexpectedly breaks into song ('We Can Begin Again'), proving that she has a lovely singing voice. Elsewhere much of the film's music is performed by the Café of the Gate of Salvation Choir.

Kay's most cherished possession is a set of china horses, chipped and broken, and Sweetie's great act of defiance is to try to swallow one of them. When ensconced in the home of Kay and Louis, Sweetie and Bob spend their time stuffing papers into envelopes to no apparent end. Sweetie also plays with Clayton, the little boy next door, though her childlike behaviour is flawed by her frequent flashes of temper and her sulky demeanour. She tells Louis she's been in a coma for a year ('She's had bad luck,' he tells Kay), but Kay, the superstitious one, sees her sister as 'a dark spirit' and reckons 'she's never even been unconscious!'

Throughout this darkly comic combination of the natural and the unnatural lies Kay's vision of trees as having 'hidden powers'. Of the tree

in which Sweetie had her tree house, she says, 'I used to imagine the roots of that tree crawling right under my bed.'

Visually the film is richly textured with outstanding production design by Peter Harris and inventive camerawork by Sally Bongers, who often frames her characters in strikingly curious ways, showing only their legs in several scenes. A scene in which Kay and Louis decide to try 'sex by appointment', undress, and lie on top of the bed without actually doing anything is filmed in this unusual style and succeeds in being both sad and funny ('Some animals won't mate in captivity,' speculates Louis), especially as the noises coming from the bedroom occupied by Sweetie and Bob leave no doubt as to what's going on there. 'Have you ever been licked all over?' Sweetie asks Louis as they hang out on a beach bordered by what looks like an industrial factory. 'I'm a good licker.' But when Louis tries licking Kay's leg, she recoils: 'I thought a big snail was sliding up my nightie.' After some time in which Kay has refused him sex, Louis says to her, 'Good night, big sister.' 'Don't call me that,' she responds. 'I'm your girlfriend!' There's a flash of jealousy when Melony (DIANA ARMER), a woman at the meditation centre, shows Louis a book filled with

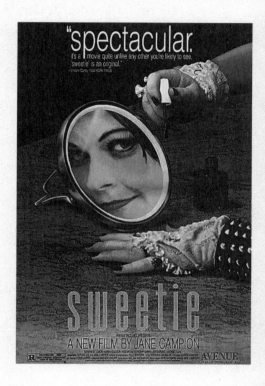

sexually explicit illustrations. 'It's just a meditation book,' Louis lies, confidently, to Kay. For moments like these, and so many others, *Sweetie* is one of the strangest, yet most compelling, love stories ever filmed.

Jane Campion (b. 1954) was born and raised in Wellington, New Zealand, but studied at the Australian Film, Television and Radio School where she made her acclaimed early short films, *Peel* (1982), *A Girl's Own Story* (1983) and *Passionless Moments* (1984). While working for ABC Television in Sydney she directed the small-screen feature *Two Friends* (1986), in which the friendship of two young women unfolds in reverse chronological order.

Her next film, *Sweetie*, was invited to compete in Cannes in 1989, and its reception there, mainly positive but with some vocal dissenters, led to the beginning of an international recognition that was only enhanced by her subsequent work: *An Angel at my Table* (1990, originally made as a three-part series for Television New Zealand), *The Piano* (1993, Oscar winner for Campion's screenplay, for Best Actress, Holly Hunter, and Supporting Actress, Anna Paquin, and also Cannes Palme d'Or winner [shared]), *The Portrait of a Lady* (1996), *Holy Smoke* (1999), *In the Cut* (2003) and *Bright Star* (2009). For the last decade Campion has worked in television, making two series of *Top of the Lake*.

96

Lorenzo's Oil

USA, 1992

Universal. DIRECTOR: **George Miller.** 130 MINS.

FIRST SEEN: *Greater Union Cinemas, George Street, Sydney, 14 January 1993.*

July 1983. World Bank economist Augusto Odone (NICK NOLTE) is completing an assignment in the Comoros Islands, off the coast of East Africa, with his wife, Michaela (SUSAN SARANDON), and their five-year-old son, Lorenzo (ZACK O'MALLEY GREENBURG). Soon after their return to Washington, Lorenzo starts behaving violently and erratically, destroying the drawings of other children at kindergarten because 'they annoyed me'. Several doctors are consulted (the possibility that he picked up a parasite in Africa is one theory) before the child is diagnosed with adrenoleukodystrophy (ALD), a hereditary degeneration of the nervous system passed on through the female chromosome that only affects boys and is usually fatal within a couple of years. Dr Judalon (GERRY BAMMAN) refers the case to Dr Nikolais (PETER USTINOV), a specialist in the field who is working on an experimental protocol based on food intake. His suggestion that saturated fats be eliminated from Lorenzo's diet proves only marginally successful. The Odones, with the help of Michaela's sister, Deirdre (KATHLEEN WILHOITE), decide to nurse Lorenzo at home and to carry out research in the hope of finding alternative cures. They also connect with the ALD Foundation, which is run by Ellard Muscatine (JAMES REBHORN) and his wife, Loretta (ANN HEARN), but they prove to be too cautious and conservative for the Odones.

Eventually a laboratory in Cleveland produces a refined form of olive oil that reduces the level of fats in Lorenzo's body by half but fails to prevent further damage. After much agony and research, the Odones contact elderly biochemist Don Suddaby (played by Suddaby himself), who is based in London and has worked on face cream and cosmetics hitherto, but who quietly produces a type of pure oil. Deirdre insists on acting as a guinea pig, and in September 1986, the new oil is given to Lorenzo. Three months later his blood samples are normal. But his brain has been damaged and for the rest of his life he is able to communicate only by winking an eye or moving a finger. However, 'Lorenzo's Oil' has proved to be a successful treatment

for ALD if diagnosed at an early stage (the film ends with photographs of survivors) and Augusto Odone is awarded an honorary medical degree.

George Miller achieved lasting fame for his action-packed *Mad Max* films but *Lorenzo's Oil* deals with a different kind of conflict. It begins with the words of a Swahili warrior song: 'Life has meaning only in the struggle. Triumph or defeat is in the hands of the Gods ... so let us celebrate the struggle.' Miller, who graduated in medicine and was working as an intern before leaving the profession to make films, is clearly deeply fascinated by the courage and tenacity of Augusto and Michaela Odone and their lengthy struggle to keep their beloved son alive and to find a cure for the terrible disease—a disease that was unknown just a decade before Lorenzo was afflicted by it—so that other sick children and their parents might benefit. The result is that what seems on the surface to be Miller's least typical film is clearly his most deeply felt; the battles fought by Mad Max seem mild when compared to the struggles undertaken by the Odones.

It's a challenging film for an audience in many ways, not least because of the numerous scenes in which the dialogue revolves around fairly complex medical and scientific terms but also because of the candour with which the debilitating effect of the illness is shown in the boy that we saw in the opening scenes as a cheerful, intelligent, happy child, able to speak a little Swahili and friendly with the amiable Omouri (MADUKA STEADY). There's a particularly grim scene in which the sickly Lorenzo, hardly able to walk unaided, is paraded in front of a class of students and doctors and presented as a sort of specimen. 'This morning I could still understand him,' says a shattered Michaela as her son's ability to speak dwindles to nothing, while Augusto, at one point, lies in the stairwell of an office building, weeping uncontrollably.

Challenging, too (especially when seen in the context of the Covid-19 pandemic), are the debates between the cautious scientists and medical professionals, personified in Peter Ustinov's layered performance, and the parents who are desperate to find a cure for their children and are willing, if necessary, to cut corners to do so. At the centre of the film are career-best performances from Susan Sarandon and Nick Nolte—some reviewers at the time criticised Nolte's Italian accent, but those who saw and heard the real Augusto Odone would realise just how accurate Nolte's portrayal was. Sarandon's flashes of temper reflect a woman under enormous stress, and when she turns against nurses—one of them played, in an early role, by Laura Linney—or on her sister, you can understand the pain and frustration

beneath her anger. One of the film's most delightful characters is that of Don Suddaby, who appears in a couple of simple, beautifully understated scenes.

The film's Australian content includes a small role for Sandy Gore as a member of the Odone family, the fine cinematography by John Seale, and the post-production work, which was carried out in Sydney.

To its enormous credit, the film completely rejects the standard Hollywood formula for this kind of movie. Lorenzo does not make a complete recovery, although at the end he is able to communicate again, albeit in a very minimal way. The real Lorenzo died in 2008, the day after his 30th birthday; his mother pre-deceased him, dying of cancer in 2000, while his father, who returned to his Italian birthplace after his son's death, died in 2013.

George Miller (b. 1945), the son of Greek migrants, grew up in rural Queensland before studying medicine. (He is not to be confused with another Australian director named George Miller, whose best-known film is *The Man from Snowy River*, 1982.) Miller formed a creative partnership with producer Byron Kennedy—who died in a helicopter accident in 1983— that resulted in the hugely influential *Mad Max* (1979), which made a star of Mel Gibson. *Mad Max 2* (aka *The Road Warrior*) followed in 1981, after which Miller was invited to Hollywood to direct an episode of *Twilight Zone: The Movie* (1983); his episode, *Nightmare at 20,000 Feet*, was the most successful of the four segments. Subsequently Miller returned to Australia to make *Mad Max Beyond Thunderdome* (1985), on which he collaborated with stage director George Ogilvie. *The Witches of Eastwick* (1987), made in America, was a troubled production, and it was five years before Miller made *Lorenzo's Oil*. Meanwhile Kennedy Miller Productions also produced some significant TV series (*The Dismissal*, 1983; *The Cowra Breakout* and *Bodyline*, both 1984; *Vietnam*, 1987; *The Dirtwater Dynasty*, 1988; *Bangkok Hilton*, 1989) and feature films (John Duigan's *The Year My Voice Broke*, 1987 and *Flirting*, 1991; Phillip Noyce's *Dead Calm*, 1989; Chris Noonan's *Babe*, 1995). Miller also directed a personal history of Australian cinema, *40,000 Years of Dreaming* (1997), for the TV series *Century of Cinema*. He returned to feature films with *Babe: Pig in the City* (1998) and two animated features, *Happy Feet* (2006) and *Happy Feet Two* (2011), before making the fourth in the *Mad Max* franchise, *Mad Max: Fury Road* (2015), which was acclaimed as one of the best action films of the period.

The Age of Innocence

USA, 1993

Columbia Pictures. DIRECTOR: Martin Scorsese. 138 MINS.
FIRST SEEN: *Venice Film Festival, 6 September 1993.*

New York City, the 1870s. Newland Archer (DANIEL DAY-LEWIS), a socially connected young lawyer, is engaged to May Welland (WINONA RYDER), whose grandmother, Mrs Mingott (MIRIAM MARGOYLES), is one of the city's most influential socialites. When May's cousin, Ellen Olenska (MICHELLE PFEIFFER), returns from Europe she brings with her a whiff of scandal since she has left behind her husband, Count Olenska, and is apparently planning to divorce him. Newland is drawn to Ellen, and attempts to forestall his impulses by persuading May to bring forward the wedding—but her mother (GERALDINE CHAPLIN) will not agree. Newland sees Ellen in the company of a wealthy philanderer, Julius Beaufort (STUART WILSON). While May is away, Newland and Ellen become closer and they confess they love one another, but Ellen tells him she will not hurt May. The wedding of Newland and May goes ahead.

Sometime later Newland learns that Ellen is returning to Europe. However, she changes her mind and stays in New York to care for Mrs Mingott, who has suffered a stroke. Ellen and Newland agree to meet for a secret rendezvous, but before this can occur she leaves the country abruptly. May tells Newland she is pregnant, and reveals that she had shared this information with Ellen prior to her departure. Years pass and Newland, now almost 60, travels to Paris with his son, Ted (ROBERT SEAN LEONARD), who has decided to visit his distant cousin, Ellen.

Martin Scorsese's reputation as a director of superbly crafted crime movies is second to none, but his range is far wider than that as is exemplified by *The Age of Innocence*, a beautiful and moving story of unrequited love in the second half of the 19th century. The director, in collaboration with Jay Cocks, adapted Edith Wharton's 1921 Pulitzer Prize–winning novel with considerable fidelity, even giving the author a voice in the form of the comprehensive narration, which is spoken by Joanne Woodward. The story itself is slight but few films have been richer in detail. Visually this is a masterpiece, with a major contribution from cinematographer Michael

Ballhaus, who made his reputation in Germany with the very different and more modest films of Rainer Werner Fassbinder. Also of vital importance are the contributions of production designer Dante Ferretti and costume designer Gabriella Pescucci and their teams.

The eye feasts on the rich interiors of these upper-crust New York families; the camera lingers on the wall coverings, the curtains, the flower arrangements (flowers play a crucial role in the drama, and the opening credits are printed over not only calligraphy but also flowers gradually opening), the paintings, the cutlery, the crockery, the furniture, the lavish meals themselves. The apparel worn not only by the women but also by the men in this supremely elegant era is simply sumptuous.

The film's main concerns are with the way the social order works in this rarefied world. The all-important interpersonal connections and the family relationships that open doors which would otherwise be shut are closely explored. This is a society 'so precious its harmony could be shattered by a whisper', a society where 'everybody knows everybody', a society where the rumours about the Countess Olenska—chiefly that she was involved with her husband's secretary—could be terminally damaging if she were not given the full support of her grandmother and, through her, the topmost pillars of society, the Van Luydens (MICHAEL GOUGH, ALEXIS SMITH). In this environment it's not enough for Ellen to have rented a little house in a 'respectable' street if that street is not also 'fashionable'. In New York, we are assured, 'every*thing* is labelled but every*body* is not'.

It's through this closeted, snobbish, watchful world that the incipient love affair between Newland and Ellen takes place; no wonder that it's so difficult and so intimidating. There are gossips, male as well as female, everywhere, among them Richard E. Grant's Larry Lefferts. Even Newland's elderly employer, Mr Letterblair (veteran NORMAN LLOYD), as he treats the younger man to the most extravagant meal, is at pains to insist that he dissuade the Countess from anything as sordid as a divorce. It's also notable that Newland is suffocated by a *matriarchal* society in which all the major decisions are taken not by men but by women, who are totally in charge of ensuring that the social order is in no way compromised.

Scorsese takes his time to explore this hothouse environment, employing along the way many well-tested tricks of the cinematic trade: the use of irises (the gradual opening or closing of the camera lens), rare since the silent era; the gradual blocking in of an image to emphasise a point; fades not to black, as is usual, but to red or, after Newland sends Ellen an anonymous

bunch of yellow roses, to yellow. There are moments that evoke Impressionist paintings (Ellen standing on a pier at sunset, her back to the camera—and to Newland—as she gazes across a red-hued lake).

The three main actors give flawless performances. The same year that Day-Lewis appeared in Jim Sheridan's *In the Name of the Father*, portraying a lad from Belfast wrongly accused of an IRA bombing, the versatile actor imbues Newland Archer with a troubled, tentative charm. Michelle Pfeiffer's Ellen, the catalyst whose return to her roots causes such a stir and the makings of a scandal, is achingly vulnerable yet sophisticated in ways that seem alien to these New Yorkers. And Winona Ryder's innocent May, who, in the end, proves to be not quite as innocent as she appeared to be, is equally touching. There is not one false note in a film that is soaringly beautiful without being superficial, moving without being sentimental.

Martin Scorsese (b. 1942) grew up in New York in an Italian-American family. In common with Steven Spielberg, Brian de Palma, Francis Ford Coppola, Jonathan Demme and other directors of his generation, he is a movie buff who frequently pays tribute to earlier movies (*The Age of Innocence* contains more than a hint of Orson Welles' *The Magnificent Ambersons*, 1942). After the independently made *Who's That Knocking at My Door?* (1969) and the Depression-era crime film *Boxcar Bertha* (1972), he scored a major success with *Mean Streets* (1973), a semi-autobiographical drama that co-starred two men who would become his favourite actors, Robert De Niro and Harvey Keitel. Subsequently his monumental epics about the criminal underworld (*Taxi Driver*, 1976; *Goodfellas*, 1990; *Casino*, 1995; *The Departed*, 2006; *The Irishman*, 2019) have been interspersed with movie-influenced dramas (*Alice Doesn't Live Here Anymore*, 1974; *New York, New York*, 1977; *The Color of Money*, 1986; *Cape Fear*, 1991; *The Aviator*, 2004; *Hugo*, 2011), literary adaptations (*The Last Temptation of Christ*, 1988; *Shutter Island*, 2009; *Silence*, 2016) and music documentaries featuring Bob Dylan, George Harrison, Mick Jagger and The Band. A movie collector and historian, he has also made feature-length documentaries and TV series about the history of both American and Italian cinema. He sometimes appears, Hitchcock-like, in cameo roles in his own films: in *The Age of Innocence* he is briefly glimpsed as a photographer employed to take May's wedding portrait.

Fargo

USA, 1995

Polygram–Working Title. DIRECTOR: Joel Coen. 98 MINS.

FIRST SEEN: *Greater Union screening room, Sydney, 11 March 1996.*

Fargo, North Dakota. Jerry Lundegaard (WILLIAM H. MACY), executive sales manager at his father-in-law's car dealership in Minneapolis, meets criminals Carl Showalter (STEVE BUSCEMI) and Gaear Grimsrud (PETER STORMARE) in a bar. He offers to provide them with a new car, plus $40,000, if they kidnap his wife, Jean (KRISTIN RUDRÜD), and demand an $80,000 ransom, of which he will pocket half. He explains that he needs the money and that, though his father-in-law, Wade Gustafson (HARVE PRESNELL), is very wealthy, he will never help him financially.

Jean is kidnapped from her house, but as the kidnappers are driving near the town of Brainerd (home of Paul Bunyon) they are stopped by a state trooper, who is killed by Gaear, along with a young couple who, unfortunately for them, drive past the scene. Brainerd's police chief, Marge Gunderson (FRANCES MCDORMAND), who is seven months pregnant, leads the investigation into the killings and deduces that the trooper had stopped a car driving with dealers' licence plates, which leads her to the Gustafson dealership. Meanwhile Jerry, who tells Wade that the ransom demand is for $1 million, is unable to prevent Wade delivering the money personally; Wade confronts Carl with a gun and shoots him in the face, seriously injuring him, before being shot dead. Gaeard, who has casually murdered Jean while waiting for Carl to return, argues with his partner over money; he kills Carl with an axe and is feeding the body into a woodchipper when he is apprehended by Marge.

The Coen Brothers were born in Minneapolis, so with *Fargo*, their sixth feature, they were working close to home. An opening title assures us that 'This is a true story', and goes on to explain that the events depicted in the film took place in Minnesota in 1987 but that, at the request of the survivors, the names have been changed 'out of respect for the dead'. The title continues, 'the rest has been told exactly as it occurred'. It's certainly a bizarre and violent tale that commences by establishing the character of the venal Jerry who has got himself into serious financial difficulties. Two

phone conversations with (presumably) a bank official reveal that he has been swindling his father-in-law in some way—and the brand-new Ford Sierra that he delivers to the two criminals in Fargo has clearly been stolen from his father-in-law's company.

That first meeting in the King of Clubs bar establishes the mood of the film. While Gaear, a cigarette dangling from his mouth, appears to be asleep, Carl complains that Jerry is an hour late for their appointment and queries the sense of the crime for which they're being hired. ('You want your *own wife* kidnapped?') Back home, Jerry is annoyed to find that Wade, his father-in-law, has invited himself to dinner, but he uses the occasion to try, again, to interest the old man in the purchase of a parking lot for which Jerry urgently requires $750,000. Wade eventually agrees that the deal 'looks pretty sweet' but he and his ruthless business partner, Stan Grossman (LARRY BRANDENBURG), offer the hapless Jerry only a finder's fee, not the cash investment he had sought (Jerry's argument that the project would benefit his wife and son falls on deaf ears: 'Jean and Scotty need never worry about money,' points out the overbearing Wade). Meanwhile Carl and Gaear are constantly bickering, with Carl complaining about being subjected to his partner's cigarette smoke and the fact that Gaear rarely says a word.

The scene of the kidnapping of Jean is brilliantly handled; the men, wearing black hoods, smash into the house and pursue her into the bathroom. This is followed by the even more chilling sequence that takes place on the road at night when Gaear kills the trooper and pursues and ruthlessly executes the unfortunate young couple who have witnessed the murder.

At this point, a third of the way into the film, the central character of Marge Gunderson is introduced, with Frances McDormand, wife of Joel Coen, giving a career-best performance as the intuitive, small-town cop whose artist husband, Norm (JOHN CARROLL LYNCH), cooks her breakfast before she heads out to solve a series of brutal murders. Like most of the characters in the film, Marge speaks with a strong Minnesota accent and uses expressions like 'Thanks a bunch', 'You got that right', 'Real good', 'How the heck are you?' and 'Hi you all'. Despite her happy, if probably rather dull, marriage, Marge, while visiting the Twin Cities (Minneapolis–St Paul) to further her investigations, dolls herself up to meet Mike (STEVE PARK), an old friend from her school days, in a bar. He becomes tearful when he tells her about the girl he married (in a class a year before them at school) who died of leukaemia and, despite the fact that Marge is pregnant, he's

clearly angling for a sexual encounter, which she firmly refuses; only later does she discover that everything he told her was a fabrication.

Director Joel Coen builds considerable suspense from depicting the ruthlessness of both of the criminals (Carl empties his gun into Wade when the ransom payment goes wrong) and contrasting it with the vulnerability of his heroine as she painstakingly goes about the investigation, talking to the 'hookers' who had sex with Carl and Gaear (Carl is described as 'funny-looking' and not circumcised) or to the dissembling Jerry, who—in William H. Macy's memorable performance—becomes increasingly unconvincing as he stumbles over his side of the story. In retrospect the saddest of the characters is Scotty (TONY DENMAN), the young son of Jerry and Jean, a sweet youngster who loses both his parents during the course of the film. But there's a great deal of humour, too, especially in the affectionate depiction of some of the more eccentric locals, like the witness (BAIN BOEHLKE) who takes an interminably long time to tell his story.

The film ends with a lovely coda in which Norm, an amateur painter, informs Marge that one of his bird paintings has been acquired for the three-cent stamp. 'I love you,' they tell one another, and then, in reference to the pregnancy, 'Two more months.'

Fargo is distinguished by Roger Deakins' photography, especially in the scenes on the misty, snow-lined roads where these brutal events unfold. Also impressive is the fine music score by the Coens' regular composer, Carter Burwell.

(In 2014, a television series, *Fargo*, executive produced by the Coen Brothers, was launched and ran for three seasons. I have not seen it, but it appears that, apart from the setting and a certain mood, it has no direct links with the film.)

Joel (b. 1954) and Ethan (b. 1957) Coen have written, produced and directed all their films, although only Joel received directorial credit for the films up to and including *Intolerable Cruelty*. They have alternated between thrillers with strong comedic elements and comedies with strong suspense elements; their first feature, *Blood Simple* (1984), fell into the first category and their second, *Raising Arizona* (1986), into the other. Their films have included *Miller's Crossing* (1990), *Barton Fink* (1991), *The Hudsucker Proxy* (1994), *Fargo* (1995), *The Big Lebowski* (1998), *O Brother, Where Art Thou?* (2000), *The Man who Wasn't There* (2001), *Intolerable Cruelty* (2003), *The Ladykillers* (2004, a misguided remake of the Ealing Studios comedy classic and the Coens' weakest film by far), *No Country for Old Men* (2007, an

exhilarating return to form), *Burn After Reading* (2008), *A Serious Man* (2009), *True Grit* (2010, a remake of the 1969 film), *Inside Llewyn Davis* (2013), *Hail, Caesar!* (2016) and *The Ballad of Buster Scruggs* (2018, a mild western anthology made for Netflix).

99

Drifting Clouds
(*Kauas pilvet karkaavat*)

FINLAND, 1996

Sputnik Oy. DIRECTOR: Aki Kaurismäki. 93 MINS.
FIRST SEEN: *Cannes Film Festival, 16 May 1996.*

Helsinki. Ilona Koponen (KATI OUTINEN) is head waitress at Dubrovnik, a downtown restaurant, while her husband, Lauri (KARI VÄÄNÄNEN), is a tram driver. Lauri loses his job when the tram routes are revised and, because he is deaf in one ear, he also loses his licence to drive public transport. A restaurant chain acquires Dubrovnik from its owner, widow Mrs Sjöholm (ELINA SALO), and all the staff are dismissed. After some difficulty, Ilona finds a job at a snack bar owned by the shady Forsström (MATTI ONNISMAA), but tax inspectors close the place down. Broke and unable to pay their bills, the Koponens resort to drastic measures: Lauri sells his vintage Buick and gambles the proceeds—he loses. A chance encounter between Ilona and Mrs Sjöholm, who is bored with her retirement, leads to the latter bankrolling a new restaurant, Ravintola Työ (Workers' Restaurant), which proves to be successful.

Aki Kaurismäki is one of the finest exponents of minimalist cinema. His films, which invariably deal with working-class characters and outcasts struggling to survive against the odds stacked against them, are unemphatically 'ordinary'; they are photographed in muted colours (when they're not in black and white) and filled with plaintive musical numbers (or vintage rock 'n' roll hits).

Drifting Clouds, his masterpiece, tells the simplest of stories. During a recession both husband and wife lose their jobs and, after much difficulty and hardship, finally get back on their feet. The slightness of the plot is offset by the film's deadpan humour, the truthfulness of its depiction of everyday struggles in hard times and the radiantly happy ending. The director has described it as a cross between *It's a Wonderful Life* (1946) and Vittorio De Sica's neorealist classic *Ladri di biciclette/Bicycle Thieves* (1949), and the influences are clear to see.

When the film begins, Ilona's quiet strength becomes immediately apparent. The Dubrovnik's chef, Lajunen (MARKKU PELTOLA), has gone on

a drunken rampage and has accidentally cut another member of staff, Melartin (SAKARI KUOSMANEN), with a butcher's knife. Ilona calms him down and tends to Melartin's wound; next day a chastened Lajunen pays for the stitches Melartin required and the pair share a cigarette. There are no lasting recriminations.

At home, Ilona and Lauri live very modestly in their small apartment with their floppy-eared dog—there's always a dog in a Kaurismäki film. Lauri has just acquired a colour TV set—though the entertainment content appears to be minimal and the news programs the couple view are full of scenes of violence and killings in Africa. There are few books on the bookshelf, but there is a photo of a small boy who, we gather, died young (the photograph is actually of Matti Pellonpää, the actor who starred in most of Kaurismäki's early films, often opposite Kari Outinen; he died from a heart attack caused by his alcoholism in 1995, and *Drifting Clouds* is dedicated to him). When times are hard, not only the TV but also items of furniture are carted away by the debt collectors.

Lauri's sister, Leena (OUTI MÄENPÄÄ), is the cashier at a cinema, and she gets them into movies free of charge. Lauri, however, can be extremely critical; the couple walk out of a screening (it sounds like a western with deafening gunfire heard but not seen, though it was supposed to be a comedy) and then he has the gall to ask for his money back, even though he didn't pay. Leena takes this in her stride and, when Lauri is savagely beaten up by Forsström and his goons after he attempts to obtain Ilona's unpaid wages, she allows him to stay with her until he's recovered sufficiently to return to his worried wife. Lauri is not, clearly, an ideal husband, but he's honest and stoic.

It's no wonder that Dubrovnik failed to survive in hard times. A decidedly old-fashioned establishment, with a traditional menu and an ageing clientele, it features on some nights an African-American pianist (SHELLEY FISHER), who, during the opening credit titles, sings (in English) a sentimental song ('The Wonderful Girl I Love'). On other nights there's an orchestra, but the musicians and their repertoire are hardly up-to-the-minute. 'It was the best restaurant in town,' sighs Ilona after the place has closed for the last time. 'Yes, after the war,' comes the reply.

In their quest for work, the Koponens come across a number of hard-boiled characters—bank managers, tax inspectors, transport company bosses, shady operators—all of them hostile towards the increasingly desperate couple. Although he spends a fair amount of time drinking

The final image of Aki Kaurismäki's *Drifting Clouds*: Lauri (KARI VÄÄNÄNEN) and Ilona Koponen (KATI OUTINEN) outside the Workers' Restaurant with the inevitable Kaurismäki dog, Pietari.

strong spirits, Lauri manages to remain philosophical during these difficult times ('The trees still grow,' he proclaims at an especially low ebb). One particularly disagreeable restaurant owner (ESKO NIKKARI) interviews Ilona for a job as a dishwasher, but tells her she's too old (she's 38): 'You could drop dead at any time,' he warns her. Life is a struggle for these working-class heroes but for Lauri, schnapps is short-term compensation ('Life is short and miserable—be merry while you can' is his motto).

Kaurismäki clearly loves his main characters. They're unglamorous, not beautiful, not brilliant—but they're great people to meet and to spend time with. The ending of the film is too good to be true, but since seeing *Drifting Clouds* I've never been able to visit a restaurant without thinking of the struggles that went into establishing it in the first place and the day-to-day problems faced, especially in hard times when the staff wait, sometimes in vain, for diners to occupy the empty tables. The director has said that he invariably writes a sad conclusion for his films but by the time he's finished shooting he feels so sympathetic towards his characters that he turns it into a happy ending.

Apart from his regular cinematographer, Timo Salminen, Kaurismäki is practically a one-man band. He not only directed *Drifting Clouds* but was also the screenwriter, editor and producer. The dog featured in the film, Pietari, belonged to him.

I met Kaurismäki several times over the years at festivals. He is not the easiest person to talk to, being disposed to give monosyllabic replies to questions. His weary sense of humour is, however, very appealing.

Aki Kaurismäki (b. 1957) directed his first feature, an updating of Dostoyevsky's *Crime and Punishment* (*Rikos ja rangaistus*), in 1983. For many years, despite his avowed addiction to alcohol, he succeeded in making a series of minimalist classics: *Varjoja paratiisissa/Shadows in Paradise* (1987); *Hamlet liikemaailmassa/Hamlet Goes Business* (1987); *Ariel* (1988); *Tulitikkutehtaan tyttö/The Match Factory Girl* (1990); *La vie de Bohème* (1992); *Pidä huivista kiinni, Tatjana/Take Care of Your Scarf, Tatiana* (1993); *Mies vailla menneisyyttä/The Man Without a Past* (2002); *Laitakaupungin valot/Lights in the Dark* (2006); *Le Havre* (2011); and *Tolvon tuolla puolen/The Other Side of Hope* (2017). He also created the crazy Russian rock band Leningrad Cowboys, who featured in his films *Leningrad Cowboys Go America* (1989) and *Leningrad Cowboys Meet Moses* (1994). His brother, Mika, also directs films. For many years the siblings helped organise the Midnight Sun Film Festival, which is held in June, north of the Arctic Circle in the town of Sodankylä.

Love Serenade

AUSTRALIA, 1996

Jan Chapman Productions. DIRECTOR: Shirley Barrett. 101 MINS.
FIRST SEEN: *Atlab screening room, Artarmon, Sydney, 25 April 1996.*

Sunray, Victoria. Ken Sherry (GEORGE SHEVTSOV), a jaded, middle-aged DJ, drives into the small Murray River town ('Several Times a Tidy Town Runner-up', a sign proclaims) where he is to take over the local radio station, 3SR (The Sounds of Sunray). Sisters Vicki-Ann (REBECCA FRITH) and Dimity Hurley (MIRANDA OTTO), who share a house located next door to the house Sherry is renting, are excited that this celebrity—fresh from Brisbane—is moving in. Sherry seduces both sisters and then rejects them both. In revenge, they lure him to the top of a grain silo and push him off, later dumping his body in the river.

The plot of Shirley Barrett's arresting first feature makes it sound like a banal love-triangle story but it's far from that. From the very start Barrett's beautifully understated screenplay hints at all manner of dubious things going on just below the surface of this fictitious rural Victorian backwater—filming actually took place mostly in the town of Robinvale. Sherry, with his permanently sleepy expression and flat, unemotional way of speaking, is a refugee from three marriages and divorces. He has come to Sunray, he says, 'to escape the hustle and bustle' of city life, though he's dismayed to discover the low level of technology in the radio station ('At least we'd heard of compact discs in Brisbane'). Still, he plays his vinyl tracks (Glen Campbell, Dionne Warwick and the like) and reads passages from 'Desiderata' while confiding to his listeners that he barely sleeps but lies awake 'reflecting on my life's journey'.

Dimity is a shy, 20-year-old virgin who works as a waitress in the local Chinese restaurant run by prickly Albert Lee (JOHN ALANSU), who practises nudism at home, sings 'Wichita Lineman' for no particular reason, and takes offence when Sherry only ever orders beef with black bean sauce from his menu. Dimity has never even been kissed, but she's forward enough to inform Sherry that her sister is looking for a boyfriend ('What about you?' he asks her). She spends her days idly cycling around the almost-deserted town, usually joining her sister for a sandwich lunch in the rundown Rotary

Park. She quickly falls for Sherry's laid-back line ('Luckily for you, virgins are my specialty') but after stripping—in front of the giant stuffed marlin that hangs on Sherry's wall—her first experience of sex is thwarted when Vicki-Ann bangs on the door demanding that she comes home. Later encounters prove more successful, although Dimity describes sex as 'like going to the dentist, but you've got to take all your clothes off', and she is quietly devastated when Sherry turns his attention to her sister.

Vicki-Ann owns the unisex 'Hairport' in town and is at first glance more outgoing than her sister. The night Sherry moves in next door, after warning Dimity not to 'hang around gawking at him' because 'celebrities are human beings, too', she fronts up with a present of a freshly caught carp—fishing seems to be the sisters' main pastime—which he declines ('I don't eat fish'). She then attempts to gain his attention by offering him other dishes, including chicken casserole and ox-tail stew. She's lonely—we see her looking forlornly through her salon window at her assistant hanging out with her boyfriend and at a mother with a clutch of children—and she bemoans the fact that her only previous boyfriend met an unfortunate end when he fell on his chainsaw.

The film is sharp and witty. Barrett finds humour in the most mundane events, such as Dimity's difficulties with opening Sherry's bottle of wine during his first evening at Albert's, or the droll argument over whether the prawns served in the restaurant are fresh, given that Sunray is more than a thousand kilometres from the ocean.

All the actors are superb. Shevtsov's strikingly unusual presence is perfect for the role of the weary, sexually self-confident Sherry whose shameful treatment of the two vulnerable sisters receives unusually severe punishment. Otto's painfully shy Dimity visibly blossoms as the film progresses (the expressions that pass across her face in the scene on top of the silo are a joy to behold) while Frith's insecure Vicki-Ann, who has an endearing habit of referring to people as 'silly old duffers', is a performance of considerable subtlety, so much so that you wonder why this fine actor has been so underused in subsequent Australian films.

One of the intriguing elements of this most unusual film is its fish theme. A large fish circling a bait on a hook is seen during the opening credits; a faded roadside sign directed at anglers greets Sherry as he drives into town; the sisters are first seen in their boat on the river fishing; they have a discussion about whether or not their missing dog was consumed by a giant carp; when Albert talks about marriage, Dimity observes that

'many species of fish mate for life'; there's that sinister-looking marlin, of which Sherry is so proud, dominating his lounge room; and, most bizarrely, Sherry possesses gills, from which bubbles emanate as Dimity discovers when she sees him gargling in his bathroom. 'I think he's part-fish,' she tells her sister, to which Vicki-Ann retorts, 'How dare you cast aspersions on my fiancé?' Vicki-Ann has, by this time, decided to marry Sherry and she shows up at his house in a wedding dress, only to be brutally rejected. It's after this that she climbs the silo as part of what might, or might not, be a joint plan to do away with this louche seducer.

Sherry's attitude to relationships is not uncommon. 'I'm unable to give myself to one person,' he tells the sisters. 'Love is not some abstract concept—love is like the birds circling overhead. What's special about them is their freedom. In order to love somebody, first you must set them free.' These words prove to be his epitaph.

A tragic accident marred the film's production. During the filming of the silo scene, stuntman Collin Dragsbaek was killed when he fell onto a faulty airbag, and the film is dedicated to him.

With this, her first feature, Shirley Barrett proved to be an accomplished filmmaker both as a writer of smart, funny, edgy dialogue and as a visual artist. Mandy Walker's wide-screen photography of the shabby little town is superb and is matched by the film's clever production design (by Steven Jones-Evans) and costume design (by Anna Borghesi)—all pinks and mauves for Vicki-Ann. The vibrant soundtrack features several Barry White songs, including the title track 'Love Serenade'.

The film was selected to screen in the Directors' Fortnight at the 1996 Cannes Film Festival and it won the Caméra d'Or, the prize for the best feature film debut in any section of the festival. As a result it was picked up by Harvey Weinstein's Miramax company for North American distribution.

Shirley Barrett (b. 1961) has made only two features since this most impressive debut and, sadly, neither film has made as much impact as *Love Serenade*, though both contain considerable qualities. *Walk the Talk* (2000) is featured in my book *101 Marvellous Movies You May Have Missed*; *South Solitary* (2010) was selected to open that year's Sydney Film Festival and I had the pleasure of conducting a Q&A with the director afterwards. At the 2019 festival I programmed *Love Serenade* as part of a retrospective of films by Australian women directors and hosted a lively discussion with Barrett and producer Jan Chapman following the screening.

Jackie Brown

USA, 1997

Miramax–A Band Apart–Mighty Mighty Aphrodite Films. DIRECTOR: Quentin Tarantino. 148 MINS.
FIRST SEEN: *Roadshow screening room, Sydney. 29 January 1998.*

Los Angeles. Jackie Brown (PAM GRIER), a flight attendant who works for a small airline, smuggles cash in from Mexico on behalf of illegal arms dealer Ordell Robbie (SAMUEL L. JACKSON). Another of Ordell's employees, Beaumont Livingston (CHRIS TUCKER), is arrested for carrying a concealed weapon; Ordell secures the $10,000 bail from bondsman Max Cherry (ROBERT FORSTER) and then callously shoots Beaumont. Arriving at LA International Airport, Jackie is searched by agents Ray Nicolette (MICHAEL KEATON) and Mark Dargus (MICHAEL BOWEN) who find $50,000 and a small amount of cocaine in her bag. Again, Ordell negotiates a bond from Cherry, who becomes smitten with Jackie. Jackie strikes a deal with Ordell, swearing she won't inform on him. But she secretly plans to rob him of his entire Mexican stash, with Cherry's help. A complicated heist takes place in a dress shop located in a large shopping mall, with identical bags, one containing $500,000, the other with $50,000, being exchanged in a fitting room. Fooled into taking the bag with the smaller amount, Louis Gara (ROBERT DE NIRO), Ordell's ex-con partner, kills Melanie (BRIDGET FONDA), Ordell's girlfriend, because she annoys him. Ordell kills Louis and is in turn shot down by Nicolette. Jackie leaves for Madrid.

Quentin Tarantino's third feature proved to be rather different from his confronting and hugely popular first two films, *Reservoir Dogs* (1991) and *Pulp Fiction* (1994). *Jackie Brown* is based on a book, *Rum Punch*, by crime writer Elmore Leonard, which was published in 1992, and the attraction for Tarantino was presumably Leonard's typically colourful gallery of criminals. At the same time, Tarantino, the dedicated movie buff, is paying homage to the Blaxploitation action films of the 1970s, especially *Coffy* (1973) and *Foxy Brown* (1974), both of which starred Pam Grier. So complete is the writer-director's homage that the principal character in this murky tale, who was named Jackie Burke in the book (which was set in Miami), is given the same surname as Grier's Foxy.

Tarantino has demonstrated time and time again his affection for a relaxed approach in which scenes where characters deliver his salty dialogue last far longer than most other filmmakers would permit. Not one of the thrillers from past decades that he admires so much would stretch to a two-and-a-half-hour running time as this one does, and yet, in the hands of this most distinctive director, the suspense is somehow heightened rather than diminished as the film rambles on.

It helps, of course, to have top-quality actors in every role. Pam Grier's Jackie, first seen behind the opening credits as the camera closely follows her on a moving walkway at the airport, is a great character, beautiful, resourceful, independent and wily. Grier plays her to perfection.

Samuel L. Jackson's Ordell, with his long ponytail and weird little chin pigtail, is a consummate villain. Snappily dressed, and given to wearing a series of smart-looking berets, Ordell lives by the mantra 'Never do business with people you ain't done business with before without back-up'. He has established an apartment with a view of the ocean for Melanie, his blonde surfer girlfriend, whose only ambition, she admits, is to get high and watch daytime television. Among the movies Melanie watches is *Dirty Mary, Crazy Larry* (1974), which starred Bridget Fonda's father, Peter. Usually dressed in a bikini-top and shorts, the long-limbed, handsomely tanned beauty seems to be little more than a trophy for Ordell, who admits he doesn't

Pam Grier at LA International Airport in the opening scene of Quentin Tarantino's *Jackie Brown*.

trust her. 'You can always trust Melanie to be Melanie,' he warns Louis. His attitude proves correct as Melanie thinks nothing of inviting the listless Louis to have sex with her the moment Ordell leaves on business and then casually suggests that the pair double-cross Ordell—a proposal that Louis immediately relays to his friend. Smoking from a curious collection of pipes, Melanie is in a world of her own—until the unexpected moment in a parking lot when the exasperated Louis, sick of her nagging, shoots her twice.

Robert De Niro's Louis is a shabby, rather dense criminal who is very much in the shadow of the garrulous Ordell. In contrast to his friend, Louis says very little and never quite works out exactly what's going on. He's dangerous, but not as dangerous as Ordell, who dispatches him with a couple of bullets at close range as he sits behind the wheel of a parked van.

Robert Forster's Max Cherry is the film's moral centre. Unlike the character in the book he's not unhappily married, but he's lonely and his face lights up when he sees Jackie for the first time. He tells her later that, after 19 years, he decided—when he first met her—that he was tired of the bail bond business. Tarantino leads us to believe that there will be a romantic happy ending for Jackie and Max, but, after a chaste kiss, Jackie leaves to fly to Spain and Max is left alone to cope with the problems of the next client who needs the services of a bail bondsman. Forster's subtle, interior performance affords a neat contrast with the more ebullient characters in the drama, like Michael Keaton's tenacious federal agent or Chris Tucker's doomed Beaumont ('An employee I had to let go,' Ordell explains, though 'letting go' involved shutting him in the trunk of his car and then pumping bullets into him).

Typical of the scenes of unhurried dialogue is the one in which Max and Jackie discuss whether to upgrade from vinyl recordings to CDs, or ruminate on growing old ('It's not something I think about,' says Max). The lengthy sequence in the shopping mall, seen from three different perspectives, is a tour de force, and—unlike the director's other films—the violence is never shown explicitly, though the sudden killing of Melanie comes as a considerable shock. A mordant sense of humour permeates the film: Ordell talks casually about the advanced weaponry he's able to supply to criminals while watching a video titled *Chicks who Love Guns*. Adding to the 'coolness' is a splendid soundtrack of songs including Bobby Womack's 'Across 110th Street' (heard over the credits at the beginning and end), The Supremes' 'Baby Love' and Johnny Cash's 'Tennessee Stud'.

Among the routine thankyous listed in the end credits, one stands out: a prominent dedication to one of Hollywood's greatest directors of hard-boiled dramas, Sam Fuller, who died in 1997 just before the film was released. It reads, simply, 'Thanks for <u>Everything</u>'.

Quentin Tarantino (b. 1963) famously managed a video store before directing the cult success *Reservoir Dogs* (1991). The first time I met him was at Cannes that year, where the film received its world premiere. Before his next film, *Pulp Fiction*, screened at Cannes in 1994, he had written the screenplays for Tony Scott's *True Romance* (1993) and Oliver Stone's *Natural Born Killers* (1994). *Jackie Brown* was followed by *Kill Bill: Volume 1* (2003) and *Kill Bill: Volume 2* (2004), after which Tarantino directed the *Death Proof* sequence from *Grindhouse* (2007) and *Inglourious Basterds* (2009— Tarantino invited me to introduce him when he appeared at Sydney's State Theatre for the Australian premiere of this film), *Django Unchained* (2012), *The Hateful Eight* (2015) and *Once Upon a Time . . . in Hollywood* (2019).

All About My Mother

(*Todo sobre mi madre*)

SPAIN/FRANCE, 1999

El Deseo–Renn Productions. DIRECTOR: **Pedro Almodóvar.** 101 MINS.
FIRST SEEN: *Cannes Film Festival, 15 May 1999.*

Madrid. Manuela (CECILIA ROTH), who works as the coordinator for organ transplants in a city hospital, lives with her son, Esteban (ELOY AZORÍN). On Esteban's 17th birthday Manuela takes him to the theatre to see the famous actor Huma Rojo (MARISA PAREDES) playing Blanche DuBois in a production of Tennessee Williams' *A Streetcar Named Desire.* After the play, Esteban tries to obtain Huma's autograph, but while running after her car he is hit by another car and killed. The devastated Manuela decides to go to Barcelona to seek out Lola (TONI CANTÓ), Esteban's trans father. She locates La Agrado (ANTONIA SAN JUAN), Lola's friend, who introduces her to Sister Rosa (PENÉLOPE CRUZ), a young nun whose life's mission is helping sex workers and transgender people. The production of *Streetcar* has now moved to Barcelona, and Manuela, who has introduced herself to Huma, helps the actor find Nina (CANDELA PEÑA), her heroin-addicted co-star and lover, and the grateful actor employs her as her assistant for a while. But Rosa, who has been diagnosed HIV positive and is pregnant by Lola, needs help and Manuela becomes her full-time carer, with La Agrado filling in as Huma's assistant. Rosa dies in childbirth and Lola attends the funeral. Manuela tells him about their son. She returns to Madrid with Rosa's baby but two years later, back in Barcelona, she sees Huma and La Agrado again.

Pedro Almodóvar's multi-award-winning masterpiece ends with a lengthy dedication: 'To Bette Davis, Gena Rowlands, Romy Schneider; to all actresses who have played actresses; to all women who act; to men who act and become women; to all people who want to be mothers; to my mother.' The film's title channels Joseph L. Mankiewicz's *All About Eve*, which Manuela and Esteban watch on television—dubbed into Spanish—in an early scene; Esteban complains about the fact that the Spanish title, *Eva Unveiled*, is incorrect; that it should be 'Todo sobre Eva', which Manuela says would sound funny—just as the new film's title, *Todo sobre mi madre*,

appears on the screen. We then see the scene in which Bette Davis' Margo Channing complains about 'fans' before being introduced to the biggest fan of all, Eve Harrington.

Not a moment is wasted in this exquisitely made and acted film. One memorable scene follows another: Esteban's death in the rain, the camera tilting down with him as he falls on to the road so that it finally rests on its side; La Agrado entertaining a young theatre audience with raunchy stories about his life after *Streetcar* is cancelled one evening; the deeply moving moment when Sister Rosa encounters her senile father (a cameo role for the great Spanish actor Fernando Fernán-Goméz) who fails to recognise her.

Almodóvar's screenplay quotes directly from both Mankiewicz's film and Williams' play. 'I've always depended on the kindness of strangers,' Huma tells Manuela when the latter offers to help her find Nina—the same line that is spoken by Blanche in *Streetcar*. And when Manuela temporarily becomes Huma's personal assistant (and, for one performance, Nina's understudy as Stella), Nina accuses her of behaving like Eve Harrington. There's another amusing reference to classic cinema when La Agrado arrives at Manuela's apartment to find Sister Rosa and Huma already there, spaced out across the width of the Scope screen; it reminds her, she says, of *How to Marry a Millionaire* (1953), which was the second film to be released in the wide-screen system, CinemaScope.

Another significant quote comes from Truman Capote's book *Music for Chameleons*, which Manuela reads to her son: 'When God hands you a gift he also hands you a whip: and the whip is intended solely for self-flagellation.' And there are troubling contemporary references, not least to the AIDS epidemic; Sister Rosa has been planning to travel to El Salvador to take the place of a nun who was murdered there.

Although the film is, in a very real sense, a love letter to mothers, it's interesting to note that two of the mothers we encounter—Manuela and Sister Rosa—lack anything in the way of a sexual life; the former left her husband Esteban, now Lola, behind in Barcelona 18 years earlier and seems to have no sexual relationship in Madrid. We see her only with her son and with her colleagues at the hospital. Sister Rosa, ostensibly a nun living a life of chastity, somehow allowed herself to be impregnated by Lola, the transgender sex worker she was supposedly trying to help. Huma and Nina are lesbian women in a partnership, though La Agrado spitefully reveals to Manuela at the end that Nina has married and given birth to a 'fat, ugly, horrible baby'. And Sister Rosa's mother, also named Rosa (ROSA MARÍA

SARDÁ) is a bitter, angry woman who has difficulty coming to terms with her daughter's lifestyle and who seems perfectly happy to 'lose' her grandson to Manuela—who, in the end, winds up with a second son named Esteban. Almodóvar's affectionate treatment of all these characters, the 'good' and the 'bad', allows us to understand them and to like and admire them.

With its spectacular use of areas of Barcelona—handsomely photographed by Affonso Beato—the film has a very different feel from the director's previous films, which were all set in Madrid. In a sense, this film pointed the way to a new direction for Almodóvar, and everything about it, from the beautifully designed credit titles to the haunting Alberto Iglesias music score, distinguish it as the work of a great filmmaker.

I first met Almodóvar in 1980 in San Sebastián. He was 31, and his debut feature, *Pepi, Luci, Bom y otras chicas del montón/Pepi, Luci, Bom and the Other Girls*, had just received its world premiere. He seemed younger than his years, nervous, excited and eager to shock. I've interviewed him several times since and have seen him transform into the wise, insightful auteur he has become. His early films featured elements of sexual content—straight and gay—that would never have been permitted in Spanish films while General Franco was still alive, and these films—which introduced important actors like Javier Bardem, Penélope Cruz and Antonio Banderas—brought him to world attention. As his work progressed he evidenced a new level of maturity.

Pedro Almodóvar (b. 1949) followed his first feature with *Laberinto de pasiones/Labyrinth of Passion* (1982), *Entre tinieblas/Dark Habits* (1983), *Qué he hecho yo para merecer esto?/What Have I Done to Deserve This?* (1984), *Matador* (1985), *La ley del deseo/The Law of Desire* (1986), *Mujeres al borde de un ataque de nervios/Women on the Verge of a Nervous Breakdown* (1988), *Átame!/Tie Me Up, Tie Me Down* (1989), *Tacones lejanos/High Heels* (1991), *Kika* (1993), *La flor de mi secreto/The Flower of My Secret* (1995), *Carne trémula/Live Flesh* (1997), *Hable con ella/Talk to Her* (2002), *La mala educación/Bad Education* (2004), *Volver* (2006), *Los abrazos rotos/Broken Embraces* (2009), *La piel que habito/The Skin I Live In* (2011), *Los amantes pasajeros/I'm So Excited* (2013), *Julieta* (2015) and the partly autobiographical *Dolor y gloria/Pain and Glory* (2019).

103

Lantana

AUSTRALIA, 2001

MBP–Jan Chapman Films. DIRECTOR: Ray Lawrence. 120 MINS.
FIRST SEEN: *Palace 2, Leichhardt, Sydney, 7 June 2001.*

Sydney. Leon Zat (ANTHONY LAPAGLIA), a detective, has a rendezvous with Jane O'May (RACHAEL BLAKE), a woman he met at a dance school, in a motel. Leon's wife, Sonja (KERRY ARMSTRONG), is seeing celebrity psychiatrist Valerie Somers (BARBARA HERSHEY), whose patients also include Patrick Phelan (PETER PHELPS), a gay man who talks about his married lover. Leon and Jane have sex again, this time in the house where she had been living with her husband, Pete (GLENN ROBBINS), before his departure. Next-door neighbour Nik (VINCE COLOSIMO), who is unemployed, sees Leon leave late at night. Valerie and her husband, John (GEOFFREY RUSH), an academic, are still in mourning after the murder of their 11-year-old daughter, Eleanor, two years earlier. Driving home one night Valerie crashes her car; she calls John but there is no reply and she leaves a message. She stops a passing car, and never returns home. John reports her missing the next day and Leon and his partner, Claudia (LEAH PURCELL), are placed in charge of the investigation. In Valerie's office, Leon sees his wife's file and takes a taped recording of her latest interview with Valerie, along with one of Phelan's. Jane sees Nik throw something into the bushes across from her house and retrieves a woman's shoe. She reports this to the police, who discover the shoe belonged to Valerie. Nik confesses that he had given Valerie a lift but, when he took a short cut, she panicked and fled. Her body is discovered in a gorge.

Ray Lawrence's second feature, made 16 years after his first, *Bliss* (1985), opens with Mandy Walker's camera delving deep into a bank of lantana; beneath the attractive flowers on the surface lie prickly thorns— a perfect metaphor for the events that will follow. Under the lantana lies a woman's body, and at first it seems as though the film will be a murder mystery. Instead, this exceptional adaptation by Andrew Bovell of his play, *Speaking in Tongues*, is a completely cinematic exploration of relationships where trust has been replaced by secrets and lies. Bovell, incidentally, also collaborated on the screenplay for another extraordinarily fine Australian film, *Blessed* (Ana Kokkinos, 2009), which was also

based on a play, though again you'd never guess it from the cinematic approach taken by the director and writers.

The second sequence depicts Leon and Jane having sex for the first time. We don't know exactly how this came about, but we quickly realise the extent of Jane's loneliness and neediness after the break-up of her marriage. Discovering Jane's missing pearl earring lodged in his underpants as he drives guiltily away from the liaison, Leon realises that his work is suffering—Claudia, his partner, is alert to the fact that something is wrong, especially when Jane contrives a second meeting with Leon outside the police station. Sonja, meanwhile, mother to two teenaged sons, confides to Valerie during a session that she wants marriage to be 'passionate, challenging, honest'. Later she tells her psychiatrist that she thinks her husband is being unfaithful; asked what she would do if this was proved to be correct, she replies: 'I would leave. I would survive,' and adds, 'Not telling me would be the betrayal.' In the same room, Patrick discusses the fact that his lover 'comes encumbered with a wife'. Asked if the wife knows about him, he responds: 'Depends on how good he is at deceiving her—or how good she is at deceiving herself.' The words impress Valerie because her husband, John, is acting in a cold and distant way towards her. She's unaware that, as part of his grieving for their dead daughter, he is visiting the place where their child was killed and spending long periods of time there. During a speech Valerie gives at a gallery, she talks about trust: 'Trust is as vital to human relationships as bread is to life.' The problem is that none of the women in the film trusts their men. If Valerie had not been suspicious of Nik, who was trying to be a Good Samaritan when he gave her a lift, she would not have died.

The lives of these interrelated characters, twined together like the lantana plant, are rigorously explored in a film in which a great deal is left unsaid—an interesting achievement for a stage adaptation. In addition, there are a number of curious, only partly explained, incidents and encounters that add to the richness of the drama. In one scene Leon is jogging near his home when he collides, violently, with a stranger (RUSSELL DYKSTRA)—both are bloodied, but the stranger bursts unexpectedly into tears and Leon finds himself holding and comforting the man. Only much later do we discover that this stranger frequents the Chinese restaurant where Claudia dines alone. In a similar scene, Leon is drinking alone in a bar when he strikes up a conversation with Pete, who is also drinking alone after being shouted at by Valerie on the street. The men have no idea that there is a strong connection between them: that Leon is having an affair with Pete's wife.

The immaculate production, with outstanding camerawork and production design (the latter by Tony Campbell), is handled with meticulous skill by the director. Marginal characters, like the two sons of Leon and Sonja—played by Nicholas Cooper and Mark Dwyer—are given unusual attention (the 16-year-old is caught by his father smoking dope, and it's the younger one who usually does all the talking). The deteriorating relationship between Jane and her neighbours is also subtly handled; at first they are so close that Jane sits in a deckchair with her legs across Paula's (DANIELA FARINACCI), but after Paula realises that it was Jane who called the police about Nik's disposal of the shoe, the relationship quickly sours.

The film ends with a series of brief scenes depicting how all these characters behave in the aftermath of the police investigation. Jane is dancing alone in her house. Pete, rejected, is driving away. Claudia is finally meeting the man she has admired from a distance in the restaurant. Patrick is tearfully watching from afar as his lover sits in a café with his wife and child. Nik and Paula are enjoying life with their kids. John, alone, is staring across the waters of a pristine bay. Sonja and Leon are lying down beside one another. With its superlative ensemble cast, this intelligent, richly evocative contemporary urban drama rates among Australia's finest productions.

At the 2001 AFI Awards, *Lantana* was awarded Best Film, Director, Actress (Kerry Armstrong), Actor (Anthony LaPaglia), Supporting Actress (Rachael Blake), Supporting Actor (Vince Colosimo) and Adapted Screenplay (Andrew Bovell).

Ray Lawrence (b. 1948) has, incredibly, made only three feature films. The fact that each one has been outstanding makes it all the more regrettable that this director—who has consistently worked on the production of television commercials—has not had more opportunities to bring credit to the Australian film industry. Lawrence's first feature, *Bliss* (1985), was a near-flawless adaptation of a complex novel by Peter Carey. Unhappily, the North American launch of *Lantana*, which took place at the Toronto Film Festival in September 2001, was badly affected by the attacks on September 11 in nearby New York. Lawrence's third feature, *Jindabyne* (2006), is based on the same Raymond Carver short story that featured in Robert Altman's *Short Cuts* (1993), though Lawrence takes a very different approach. Comparisons between the two directors are interesting; with its ensemble cast of intersecting characters, *Lantana* is, in many respects, an Altmanesque kind of movie.

Million Dollar Baby

USA, 2004

Warner Bros–Lakeshore–Malpaso Production. DIRECTOR: Clint Eastwood. 132 MINS.

FIRST SEEN: *Roadshow screening room, Sydney, 18 January 2005.*

Los Angeles. Frankie Dunn (CLINT EASTWOOD) owns the rundown Hit Pit boxing gym, which he operates with the help of Scrap (MORGAN FREEMAN), an ex-boxer Frankie once managed but who lost an eye after a fight. Frankie is approached by 32-year-old Maggie Fitzgerald (HILARY SWANK), who has a burning ambition to be a boxer, but he rejects her ('I don't train girls'); Scrap quietly encourages her and eventually Frankie reluctantly agrees to manage her. She wins a number of early fights, suffering a broken nose in one of them. She buys her ungrateful mother, Earline (MARGO MARTINDALE), a small house. After a successful European tour, Frankie and Maggie return to the USA for a title fight in Las Vegas against Blue Bear (LUCIA RIJKER), a German known for fighting dirty. At the end of a round, Blue Bear throws a foul punch and Maggie falls on her stool, breaking her neck. Frankie stays by her hospital bedside. Maggie develops gangrene and a leg is amputated. She tries to kill herself by biting her tongue and when that fails asks Frankie to help her die.

Clint Eastwood's extraordinary career, both as an actor and, more importantly, as a director, marks him as one of the last of the great classical Hollywood filmmakers, able to make complex storytelling look effortless. I could have chosen any one of a dozen of his films as a favourite for this book, but *Million Dollar Baby* is special for several reasons. Although there have been a number of fine films about boxing (including *Golden Boy*, 1939; *Body and Soul*, 1947; *Champion* and *The Set-Up*, both 1949; *The Harder They Fall*, 1956; *Raging Bull*, 1980), there's no boxing film quite like this one, partly because the fighter is a woman but also because Eastwood, working from a screenplay by Paul Haggis based on stories from the collection *Rope Burns* by E.X. Toole (boxing trainer Jerry Boyd), makes abundantly clear the terrible toll the sport can take on those who participate, not only in the ring but also outside it.

'If there's magic in boxing, it's the magic of fighting beyond endurance,' intones Scrap in his voice-over. 'The magic of risking everything for a dream nobody sees but you.' But it's a pretty bleak and dismal kind of magic.

Frankie Dunn (CLINT EASTWOOD) with the courageous Maggie (HILARY SWANK) in *Million Dollar Baby*.

In 1988, I interviewed Clint Eastwood at Cannes about his film *Bird*.

Frankie has never recovered from feelings of guilt over the injury that lost his old friend Scrap an eye. The two men constantly bicker, but they are the closest of friends. Because of Scrap's bad experience in the ring, Frankie is reluctant to allow his latest fighter, Big Willie (MIKE COLTER), to participate in a title fight; Willie leaves him for another manager and wins the title. Similarly, Frankie hesitates to put the ambitious Maggie at

risk, and in this case his caution is proved correct when she suffers a life-threatening injury. 'I don't want my fighters spending the second half of their life cleaning spit,' Frankie comments at one point, referring to Scrap who uncomplainingly performs all the menial tasks in the gym, including cleaning the toilets.

A more conventional film might have included a romance between the female boxer and her manager; in *Million Dollar Baby* the relationship is more like that of a father and daughter (Frankie's letters to his own, long-estranged daughter are returned unopened, and the film is structured around a letter Scrap is sending to her—'I thought you'd like to know what kind of man your father really was').

A more conventional film would probably have depicted Maggie's mother as a kind of hard-working, long-suffering Ma Joad instead of the slatternly, greedy, selfish woman she turns out to be ('[Maggie] grew up knowing one thing: she was trash'). Instead of being grateful for the house her daughter gives her, Earline Fitzgerald complains that being a home-owner will compromise her welfare and demands more money from her daughter as compensation. Before becoming a fighter, Maggie works as a waitress, stealing leftover scraps to feed herself. When Frankie visits her apartment he finds her living in the most basic of circumstances without even a television set. 'My brother's in prison, my sister's on welfare, my dad is dead,' she tells Frankie. 'I'm too old for this, and I've got nothing.' When she *does* have something, she spends it on her ungrateful family.

A more conventional film might not have included scenes in which Frankie goes daily to church to pray, and engages in debates with his priest, Father Horvak (BRÍAN O'BYRNE), a context that makes his final decision to assist Maggie to die even more challenging.

'Winners are simply willing to do what losers won't' reads a sign on the wall of the gym, and Eastwood depicts the rather shabby premises and its regulars with offhand realism. Most of the men who train there, it's clear, are never going anywhere; they include jittery, loud-mouthed 'Danger' (JAY BARUCHEL) and tough Shawrelle Berry (ANTHONY MACKIE). But at least they have hope and a goal. 'Always protect yourself' is Frankie's mantra, and he usually follows his own advice by not getting too involved. But Maggie is different ('Damn woman won't do a thing I tell her,' Frankie complains) and by becoming a father-figure to her he lets down his guard, and pays the price. As Scrap says, 'He did something he hated doing: he took a chance.'

The boxing sequences are superbly staged, photographed (by Tom Stern) and edited (by Joel Cox), and the film deservedly won Oscars for Best Picture, Director, Actress and Supporting Actor (Freeman). It is one of the most accomplished works of a fine director.

Clint Eastwood (b. 1930) worked as a logger and in a steel factory before becoming a screen actor—his debut was an uncredited bit part in *Revenge of the Creature* (1955). Numerous small roles followed until he found fame as Rowdy Yates in the TV series *Rawhide* (1959–1965). In the meantime he had become a star playing The Man with No Name in three Italian westerns directed by Sergio Leone (*A Fistful of Dollars*, 1964; *For a Few Dollars More*, 1965; *The Good, The Bad and the Ugly*, 1966). Other acting roles included *Coogan's Bluff* (1968); *The Beguiled* and *Dirty Harry* (both 1971); *Thunderbolt and Lightfoot* (1974) and *In the Line of Fire* (1993).

I met him at the world premiere, in San Francisco, of the first film he directed, *Play Misty for Me* (1971), and I was invited to the location where he was filming *Breezy* (1973) in Los Angeles. We have met several times over the years, mostly at festivals. Eastwood starred in many, but not all, the subsequent films he directed: *High Plains Drifter* (1972), *The Eiger Sanction* (1975), *The Outlaw Josey Wales* (1976), *The Gauntlet* (1977), *Bronco Billy* (1980), *Firefox* and *Honkytonk Man* (both 1982), *Sudden Impact* (1983), *Pale Rider* (1985), *Heartbreak Ridge* (1986), *Bird* (1988), *White Hunter, Black Heart* and *The Rookie* (both 1990), *Unforgiven* (1992), *A Perfect World* (1993), *The Bridges of Madison County* (1995), *Absolute Power* (1996), *Midnight in the Garden of Good and Evil* (1997), *True Crime* (1999), *Space Cowboys* (2000), *Blood Work* (2002), *Mystic River* (2003), *Million Dollar Baby* (2004), *Flags of our Fathers* and *Letters from Iwo Jima* (both 2006), *Changeling* and *Gran Torino* (both 2008), *Invictus* (2009), *Hereafter* (2010), *J. Edgar* (2011), *Jersey Boys* and *American Sniper* (both 2014), *Sully* (2016), *The 15:17 to Paris* and *The Mule* (both 2018), *Richard Jewell* (2019) and *Cry Macho* (2021).

He has written the music scores for several of his films, including *Million Dollar Baby*, and in 2003 directed the jazz documentary *Piano Blues*.

105

Brokeback Mountain

USA, 2005

Focus Features–River Road Entertainment. DIRECTOR: Ang Lee. 134 MINS.
FIRST SEEN: *Venice Film Festival, 1 September 2005.*

Signal, Wyoming, 1963. Joe Aguirre (RANDY QUAID) hires two young men, Ennis Del Mar (HEATH LEDGER) and Jack Twist (JAKE GYLLENHAAL), to care for a flock of sheep on Brokeback Mountain during the summer months. One night the men have sex. The intimate relationship continues until brought to an abrupt end when Aguirre orders that the flock be brought down from the mountain because of impending bad weather. Ennis marries Alma (MICHELLE WILLIAMS), his sweetheart, they settle in Riverton, Wyoming, and raise two daughters. In Texas, Jack meets Lureen (ANNE HATHAWAY), daughter of L.B. Newsome (GRAHAM BECKEL), an overbearing businessman, and they marry. Jack drives to Wyoming to meet Ennis, and Alma sees them kissing before they leave to spend the night in a motel. Over the following years the pair regularly meet for 'fishing trips', and Jack frequently tries in vain to persuade Ennis to leave his family and join him in running a small ranch. Ennis, whose father had taken him, when he was nine years old, to see the mutilated body of a murdered gay man, always refuses. Alma divorces Ennis, but he stays close to his daughters. At the conclusion of a final 'fishing trip', Ennis and Jack quarrel. A card Ennis sends to Jake is returned with 'Deceased' stamped on it. Ennis phones Lureen who tells him Jake died in an accident, but Ennis is certain he was killed because he was gay. He visits the modest home where Jake lived as a child; his mother (ROBERTA MAXWELL) tells him that Jack wanted his ashes scattered on Brokeback, but that his father (PETER MCROBBIE) refused. Ennis leaves with a shirt he had worn during that first summer, which Jack had kept in his wardrobe. Alma Jr (KATE MARA), Ennis' 19-year-old daughter, comes to tell him she's getting married, and he agrees to attend the wedding.

Annie Proulx's short story has been intelligently and emotionally expanded by Larry McMurtry (author of *The Last Picture Show* and *Lonesome Dove*) and Diana Ossana for the profoundly moving *Brokeback Mountain*, which is the finest film to date from director Ang Lee. Assigned to guard sheep from preying coyotes in a spectacular but remote location,

the two young protagonists spend months in one another's company before, one cold night, they engage in sex almost accidentally. 'You know I ain't queer,' insists Ennis afterwards. 'Me neither,' Jack assures him. But neither will ever forget what happened on Brokeback, and the ramifications of it will follow them for the remainder of their lives.

As 20 years or more fly by, the different worlds that Ennis and Jack inhabit are intricately explored. Importantly, the film never makes the mistake of portraying their wives as unsympathetic. Alma, touchingly played by Michelle Williams, says nothing to Ennis about his 'fishing trips', even though they clearly deeply distress her. Lureen, a superb Anne Hathaway, is clearly proud that Jack stands up to her bullying father. When Alma decides to divorce Ennis it's because he makes it clear that he wants no more children. He later dallies with Cassie (LINDA CARDELLINI), a girl he meets in a bar, but his heart isn't in it. Jack, on the other hand, is strongly drawn to gay men, and even crosses the border into Mexico to satisfy his desires.

Homophobia proves the chief threat to the love affair. Ennis has never forgotten the awful sight of the castrated body his father forced him to see when he was a child, and because of this argues against Jack's repeated suggestions that they live together on a ranch. The reaction of Aguirre, who refuses to hire Ennis a second time ('You sure found a way to spend the time up there,' he mutters accusingly, before telling Ennis to 'Get the hell out of my trailer') is typical, and, even though the official story of Jack's death is that he died of an injury while attempting to change a wheel on his car and drowned in his own blood, Ennis imagines—correctly, we assume—that what actually happened was that he was beaten to death in a gay-hate crime.

The exceptionally versatile Australian actor Heath Ledger, whose tragically early death in 2008 at the age of only 28 was a profound loss, gave his best performance as the taciturn, introverted Ennis, while Jake Gyllenhaal revealed unexpected depths in his role as the needier of the two men. Both have unhappy backgrounds. Jack, who loves rodeo, is troubled by the fact that his father, a rodeo rider himself, 'never taught me and never once came to see me ride'. The repressed Ennis reveals to Jack that his parents were killed in a car accident when he was still at school ('One curve in 45 miles and they missed it!') and that, when his sister moved away and his brother married, he was forced to look after himself. 'That's how I ended up here,' he concludes, adding, 'That's the most I've spoken in a year.'

Scenes of the two men living and working on the mountain, chopping wood, killing game to eat, bathing and chatting beside the campfire, facing outside threats—Ennis has a startling encounter with a bear—are handsomely photographed by Rodrigo Prieto and represent some of that fine craftsman's best work.

Ang Lee handles the emotional scenes with exceptional skill. The last couple of sequences, especially, are deeply affecting. The visit of Ennis to the rundown home of Jack's parents is remarkable for its restraint. Jack's surly father insists that his son's ashes, against Jack's specific wishes, are to be buried in the family plot while the teary-eyed mother, without saying a word, quietly fetches a bag in which to put the shirt that her son had secretly kept for more than 20 years as a souvenir of the summer that changed his life.

This wonderful scene is followed by another that is equally impressive, involving a grown-up Alma Jr who comes to ask her father to come to her wedding and who also leaves behind the shirt, which Ennis clutches as the film concludes.

Brokeback Mountain won the Golden Lion at Venice and Oscars for Lee's very accomplished direction, for the screenplay and for the haunting, guitar-based music score by Gustavo Santaolalla.

Ang Lee (b. 1954) made his first films, *Pushing Hands* (1992), *The Wedding Banquet* (1993) and *Eat Drink Man Woman* (1994) in his native Taiwan. He then made a remarkable leap into international filmmaking with his excellent adaptation of Jane Austen's *Sense and Sensibility* (which was adapted for the screen by actor Emma Thompson). Subsequently Lee has made films in a variety of genres: *The Ice Storm* (1997, a family drama), *Ride with the Devil* (1999, a Civil War western), *Crouching Tiger, Hidden Dragon* (2000, Chinese martial arts), *Hulk* (2003, comic-book superhero), *Brokeback Mountain* (2005), *Lust, Caution* (2007, intrigue in China in the 1930s), *Taking Woodstock* (2009), *Life of Pi* (2012), *Billy Lynn's Long Halftime Walk* (2016) and *Gemini Man* (2019).

After several encounters with Lee over the years, including hosting a public Q&A session for *Taking Woodstock* in Sydney, I have always found him to be modest, self-effacing, tenacious and, self-evidently, supremely talented.

106

The Host

(*Gue-mool*)

REPUBLIC OF KOREA, 2006

Chungeorahm Film. DIRECTOR: Bong Joon-ho. 119 MINS.
FIRST SEEN: *Cannes Film Festival (Directors' Fortnight). 22 May 2006.*

Seoul, 2000. At the Yongsan military base, Douglas (SCOTT WILSON), a US army scientist, orders Mr Kim (KIM HAK-SUN) to pour hundreds of bottles of poisonous waste material into a laboratory sink from which it finds its way into the Han River that flows through the centre of the city. Sometime later, two men fishing in the river find a tiny mutant with a long tail that quickly swims away. On a summer day in 2006, picnickers are thronging the banks of the river when an enormous, fast-moving, amphibious monster emerges from the water and attacks the crowd. Park Gang-du (SONG KANG-HO), a lazy single dad who runs a riverside kiosk with his father, Hee-bong (BYUN HEE-BONG), lets go of the hand of his young daughter, Hyun-seo (KO A-SUNG), in the panic and she is taken by the monster. While Gang-du is mourning for the little girl together with his father, his alcoholic brother, Nam-il (PARK HAE-IL), and his sister, Nam-joo (BAE DOO-NA), who has just won a bronze medal in archery, he receives a phone call—Hyun-seo is still alive, hiding in a sewer where the creature has deposited some of its victims. The family sets out to rescue her, but the US military, convinced that the monster is spreading a virus, has demanded a lockdown and is preparing to cover the area with Agent Yellow, an anti-viral powder. Gang-du, who, because he came into contact with some of the monster's blood, has been forcibly taken to hospital for experiments, succeeds in escaping. Meanwhile Hyun-seo has befriended an orphaned boy, Se-ju (LEE DONG-HO), in the monster's lair. On the rescue mission, Hee-bong is killed by the creature, and the three siblings approach the sewer—too late to save Hyun-seo, who has been swallowed alive. With the combination of fire, a well-placed arrow and a sharpened pole, the creature is killed and Hyun-seo's lifeless body recovered. Se-ju, miraculously, has survived and is adopted by Gang-du. In winter the river is frozen, but something seems to be moving just under the surface . . .

As we've seen, the era of the 'creature' movie—rampaging monsters terrifying viewers in *Godzilla*, *The Beast from 20,000 Fathoms*, *Them*, *Tarantula* and a dozen others—was the mid-1950s when nuclear testing and the aftermath of the bombing of Hiroshima and Nagasaki created an environment in which mutant behemoths were somehow plausible. Monsters like these had been pretty much neglected in movies until Korea's master-director, Bong Joon-ho, succeeded in breathing new life into a moribund genre.

With technical assistance from visual and special-effects experts in San Francisco, Sydney and Wellington, the monster in Bong's exciting third feature is as convincing as it's possible for these things to be. It's not enormous, in the Godzilla tradition, but it's pretty big; it has a scaly body, an awesome mouth with several sets of sharp teeth, and a long tail it uses to swing from the arches of the bridges that cross the Han River—and sometimes also to grab hold of a hapless victim.

Its first appearance, seen hanging from a river bridge before dropping into the water ('It's an Amazonian river dolphin,' somebody surmises) and then emerging to gallop along the riverbank chomping on the hapless picnickers, is one of the most convincing sequences ever created for this kind of film. The eyewitnesses can't believe what they're seeing; they take photographs and gape—until they realise the extent of the danger and flee for their lives, many of them too late. One girl is listening to music on headphones and never knows what hits her. An American attempts to hit the thing with a portable street sign, to no avail.

The film's none-too-subtle prologue sheets the blame for this monster to wilfully careless American scientists—and, indeed, the American military comes out of the film very badly. Wrongly convinced that the creature is carrying a virus to rival SARS, the Americans persuade the Korean authorities to hold half the city in isolation. They then carry out some very nasty experiments—using needles—on anyone who got too close to the monster, and subsequently permit the pumping of the highly dubious Agent Yellow into the atmosphere.

Essentially, *The Host*—in common with the best of Bong's impressive work—is about a family and how it faces a crisis. Gang-du, the nominal hero, is first seen snoozing behind the counter of the kiosk he operates with his dad. With his dyed blond hair and his laid-back attitude, he's considered lazy and even useless by the other members of his family, and also pretty irresponsible, since he encourages his small daughter to drink beer. But when his daughter is taken by the creature he unleashes unexpected

reserves of energy and courage—though tragically his heroism comes to nothing. In the central section of the film—which, admittedly, is a shade on the long side—the dysfunctional family finds ways in which they can combine their forces to fight this existential threat and, by the end, with Gang-du's adoption of little Se-ju, the family is—almost—complete again. In one bleakly amusing scene they pay an opportunistic criminal to help them escape mandatory quarantine and to smuggle them past the police and military lines only to be told that the charge will come to $11,400, plus $500 for a map of the sewers ('We accept cards,' says the smuggler cheerfully).

Bong's skills as a director are amply displayed in the suspense scenes in the sewer in which the resourceful Hyun-seo cautiously tries to find ways to escape. The creature's sudden appearances are timed for maximum impact, and there's a cheerful gruesomeness to scenes such as the one in which it regurgitates bones and other human parts, along with a can of beer.

After all the suspense and tension it's sad that the resourceful Hyun-seo doesn't survive her encounter with the creature. Not too many Hollywood films would allow such a potentially bleak ending, but Bong's 'life goes on' approach ensures that the film's ending, if not exactly happy, is at least bittersweet.

Bong Joon-ho (b. 1969) directed his first film, *Flandersui gae/Barking Dogs Never Bite*, a comedy about a couple infuriated by the barking of neighbours' canines, in 2000. This was followed by the mystery thriller, *Salinui chueok/Memories of Murder* (2003) and, after *The Host* in 2006, by *Madeo/Mother* (2009), a thriller in which a mother tries to prove that her son, accused of murder, is innocent. The large-scale *Snowpiercer* (2013), an end-of-humanity thriller filmed in the Czech Republic, followed; the English-language territory rights were acquired by Harvey Weinstein who allegedly ordered considerable re-editing, so that the release of the film was delayed for some time. *Okja* (2017) was about a little girl and a giant experimental pig, though its theme mainly explored animal rights issues. Bong's trail-blazing, Oscar-winning *Gisaengchung/Parasite* (2019) again deals with a resourceful family, and though, despite its title, it is not really a horror film it has its moments, and is rich in mordant humour. No other Korean director has come close to Bong's achievements.

Animal Kingdom

AUSTRALIA, 2009

Porchlight Films. DIRECTOR: David Michôd. 113 MINS.
FIRST SEEN: *The Reel Room, Sydney, 10 February 2010.*

Melbourne. When his mother dies of a heroin overdose, 17-year-old schoolboy Joshua ('J') Cody (JAMES FRECHEVILLE) seeks help from Janine, aka Smurf (JACKI WEAVER), the grandmother he's hardly ever seen because, as he muses in voice-over, 'Mum kept me away from her family because she was scared [of them].' Invited to live in the Cody house, J soon discovers why his mother was concerned. The Codys are members of a criminal gang (black and white photographs during the film's credit titles show hooded, armed robbers in action). Noting that 'this was a while ago now, and the Armed Robbery Squad [of police] was out of control,' J explains that 'they'd been after my family for months'. On arrival at the Cody house in a quiet suburban street, J meets his uncles Craig (SULLIVAN STAPLETON), an edgy drug dealer, and Darren (LUKE FORD), who is suspected by his siblings of being gay. He also meets family friend Barry 'Baz' Brown (JOEL EDGERTON), a reformed bank robber who is thinking of going straight and is dabbling in the share market. It doesn't take long for J to appreciate the situation he's in; when a couple of hoons in another car shout at Craig, who is driving J, the boy is ordered to point a gun at them 'to let them know who's king'. Soon after this the eldest uncle, Andrew, aka Pope (BEN MENDELSOHN), who is hiding out from the police, makes a furtive appearance at the Cody house. Baz taunts the cops watching the house in a car parked outside with a bunch of flowers. Randall Roache (JUSTIN ROSNIAK), a corrupt detective, warns Craig to 'pull his head in'. Baz is shot by a cop while he is sitting in his car; Pope sees the killing and swears vengeance. J is ordered to steal a car that is used to ambush two cops, who are then killed by the gang. Police pick up Pope, Craig and Darren and question them. J is interrogated by Senior Sergeant Nathan Leckie (GUY PEARCE) but gives noncommittal replies. Pope becomes suspicious when J is kept at the police station longer than the others. J spends a night with his girlfriend, Nicky Henry (LAURA WHEELRIGHT), at the home of her parents (CLAYTON JACOBSON, SUSAN PRIOR). Craig is ambushed by police and killed. The family lawyer, Ezra White (DAN WYLLIE), advises Pope to

'keep an eye on' J. Nicky arrives at the Cody house looking for J; Pope kills her. In court, coached by the family barrister, Justine Hopper (ANNA-LISE PHILLIPS), J gives evidence that allows Pope and Darren to go free. But once he is back at the Cody home he takes his own revenge.

David Michôd's mesmerising first feature is up there with the very best crime films from any source, not only because of the skill with which the writer-director establishes an intense degree of suspense but also because of the powerful emotional pull of a drama that is seen from the point of view of a 17-year-old who is suddenly brought face to face with members of his ruthless and murdering family.

The film is loosely inspired by the criminal activities that rocked Melbourne in the 1980s, a period in which members of the underworld carried out brazen crimes, including police shootings. The real-life character of 'Granny Evil' Pettingill was clearly the inspiration for Jacki Weaver's truly alarming Smurf.

It may be no accident that the lethal clan bears the name Cody, which was also the name of the gangster played by James Cagney in Raoul Walsh's *White Heat* (1949); the Cody in that film also had a mother to whom he was perversely attached, and the mother figure in *Animal Kingdom*, portrayed with chilling normalcy by Jacki Weaver, proves to be the most memorable character in a film that has many. Cheerfully pottering about in the family kitchen, sipping tea, hugging and kissing her criminal boys, professing love for the son of her only daughter (with whom she quarrelled years earlier in a dispute over the rules of a card game), Smurf shows her true colours when she suspects her grandson might be informing on the family. 'J has got to go,' she tells Ezra, the corrupt lawyer; when he asks how she discovered the address of the safe house where the boy has been placed, she answers

simply: 'I've been around.' She also blackmails the crooked cop, Roache, into helping to kill the boy ('He knows you've done some bad things, sweetie').

In a film filled with fine actors seen at their best, Ben Mendelsohn is chilling as the paranoid Pope; Joel Edgerton is briefly charming as the reformed crim (his unexpected murder, just 23 minutes into the film, is a true shocker); Guy Pearce upholds law and order with intelligence and style; and there are vivid portraits of corruption from Dan Wyllie and Anna-Lise Phillips, the latter playing a barrister adept at manipulating the law in the service of the criminals.

The younger actors are superb: Sullivan Stapleton as the unstable Craig; Laura Wheelright as the tragic Nicky, a schoolgirl killed because it's suspected that she knows too much; and James Frecheville, in his first major role, as the character around whom the whole diabolical plot revolves. Among members of the supporting cast it's worth noting that Mirrah Foulkes, who plays Catherine, the wife of Baz, subsequently directed the well-received feature film *Judy & Punch* (2018). Michôd himself can be briefly glimpsed playing a TV reporter.

Thanks to the film's success in the USA—it was warmly received and won prizes at its world premiere at Sundance Film Festival in 2009—many doors were opened for the principals involved. The careers of Mendelsohn, Edgerton and Weaver were enormously boosted, and Stapleton and Frecheville were also cast in roles in international productions.

On a technical level the film also rates highly for Adam Arkapaw's suffocating wide-screen photography—in which he brilliantly films these dangerous and fidgety criminals as if they were, indeed, caged animals. Impressive, too, is Antony Partos' memorable music score; it was one of six winners at the 2010 AFI Awards, the other accolades being given for Best Film, Director, Actor (Mendelsohn), Actress (Weaver), Supporting Actor (Edgerton) and Editing (Luke Doolan).

David Michôd (b. 1972) edited *Inside Film* magazine for three years, during which period he also made short films and documentaries. Following the success of *Animal Kingdom* he made *The Rover* (2013), a dystopian thriller, and two features for Netflix, *War Machine* (2017), an impressive and ambitious—and, sadly, seriously underrated—critique on America's involvement in Afghanistan, and *The King* (2019), a magnificent re-imagining of the events leading up to the Battle of Agincourt, with superb performances from Timothée Chalamet as Henry V, Joel Edgerton as Falstaff and Ben Mendelsohn as Henry IV.

Samson & Delilah

AUSTRALIA, 2009

Scarlett Pictures–Caama Productions. DIRECTOR: Warwick Thornton. 96 MINS.
FIRST SEEN: *Adelaide Film Festival. 20 February 2009.*

Northern Territory. Delilah (MARISSA GIBSON) lives with her aged grand-mother, Kitty (MITJILI GIBSON), in an isolated, impoverished Aboriginal community. The old woman creates bark paintings that are taken away by a white agent to be sold in Alice Springs. Samson (ROWAN MCNAMARA) lives in the same community; addicted to glue and petrol sniffing, he is almost totally inarticulate, but he attempts to capture Delilah's attention, mainly by throwing stones at her. After a while he moves his swag to her house, despite her objections. Kitty dies and the women of the community blame Delilah for not caring for her properly. They beat her, just as Samson had also been beaten for annoying the three musicians who played outside his room. The pair steal the community vehicle and head for Alice, abandoning the car when it runs out of petrol and continuing on foot. In Alice they find a place to stay under the bridge spanning the dried-up Todd River, a space they share with Gonzo (SCOTT THORNTON), a garrulous character who offers them some of his modest food. Delilah is kidnapped, raped and beaten by some white men and later is hit by a car and suffers a broken leg. Samson, whose petrol sniffing has increased, is too stoned to register much, but when Delilah recovers she succeeds in making contact with their community. The pair are transported back, but immediately made to feel unwelcome. They leave and head further into the desert, making a home for themselves in an abandoned tin shed.

A love story in which the lovers never exchange a word with one another is pretty unusual. Warwick Thornton's outstanding feature film debut—which followed a number of highly regarded short films and the director's work as a cinematographer on, among other films, Rachel Perkins' *Radiance* (1997)—won the coveted Caméra d'Or for Best First Feature at Cannes as well as a host of other awards, and deservedly so.

Thornton, a Kaytetye man, was born and raised in the Alice Springs area, and he has intimate knowledge of the way people live in the neglected communities that are to be found all over Central Australia.

For white audiences, *Samson & Delilah* proved an eye-opener, not only for its unflinching depiction of the extreme poverty in which so many of Australia's Aboriginal people exist, but also for the callous ways in which they're exploited by white Australians. The old grandmother's beautiful bark paintings, which she sells for a pittance to a middleman, are—Delilah discovers—on sale in an Alice Springs gallery for $22,000. In addition to this intellectual rape of Australia's Aboriginal people by whites, the film depicts (albeit off-screen) the literal rape of the (presumably virginal) Delilah by some white thugs who beat her up before releasing her.

The saddest element of the story centres on Samson's gradual descent into oblivion thanks to his addiction to substance abuse. We first meet him in the community where he seems to have no family—unless he's related to one of the three musicians who play outside his window but won't let him join them. His shy courtship of Delilah, a marginally more sophisticated young woman, is both touching and wrenching; we eventually discover, when he attempts to say his name, that he has a bad stutter. 'Samson' is the only word he speaks during the entire movie, but his looks and smiles and silences are eloquent. Delilah isn't exactly loquacious—unlike the ratty but friendly Gonzo, who is played by the director's brother—but in brief conversations with her grandmother she demonstrates her love and compassion. When the old woman dies, Delilah cuts off her own long hair with a knife—just as, later, Samson shears his hair off when he thinks Delilah has been killed. Yet she's accused by some of the women in the community of neglecting her; the scene in which she is beaten by these women is truly a puzzling one for the uninitiated.

The film is divided into three parts. The first part describes life in the community and amusingly depicts how the eponymous lovers get together. The community basically consists of a few graffiti-covered shacks, a tin church, a shop and a mobile health centre. There is also a public phone that occasionally rings, but no one bothers to answer it. Part two is set in Alice Springs, where the pair are forced to steal from a supermarket or to share meals (noodles or spaghetti) with the generous, but homeless, Gonzo, who seems a bit deranged. 'I was in love once,' he tells the couple. 'It was bloody lovely.' He also gives Samson some good advice: 'Cut that shit [petrol sniffing] out. It'll fuck up your brain!' In a confronting scene when Delilah attempts to sell some of her own art to tourists sitting outside cafés in the town, she is rudely rejected and told not to be a bother by a blonde waitress.

In the Alice Springs scenes Delilah clings to her shabby yellow blanket as though it were a lifesaver, while Samson will not be parted from his plastic bottle filled with petrol, siphoned from cars or motorbikes.

Part three finds the couple surviving alone in a shack in the middle of nowhere. Now it's Samson, who fooled around in a wheelchair in the community in the first part of the film, who is incapacitated and is cared for by Delilah. She goes hunting and shoots a kangaroo, she makes the fire, she cares for the man who is now genuinely confined to a wheelchair. Delilah bathes him in brown water collected in a trough presumably designed for cattle to drink from. 'No more,' she tells him, when he attempts to sniff more petrol. She is going to be his salvation.

And now they can indulge in the music they love: for Delilah, that represents the songs of Mexico's Ana Gabriel, and for Samson the ballads of African-American country and western singer Charley Pride. The film ends as the scruffy but beautiful pair sneak looks at one another while, on the soundtrack, we hear Pride's 'All I Have to Offer You is Me'. It's a richly evocative conclusion to a great Australian movie.

Warwick Thornton (b. 1970) followed the international success of *Samson & Delilah* with an impressive episode for the multi-part film *The Turning* (2013). The same year he made *The Darkside*, a series of stories of the supernatural, which were related by actors directly to the camera. *We Don't Need a Map* (2017), an ambitious semi-documentary about Australian racism, was selected to open the Sydney Film Festival. The same year the director won the Jury Prize at the Venice Film Festival for *Sweet Country*, a very powerful film about racism and injustice in outback Australia in the period after World War I. As a member of the festival jury that year I was delighted to be able to present the award to Thornton on the stage of the Sala Grande on the closing night of the very prestigious event.

109

Nebraska

USA, 2013

Paramount–Bona Fide Productions. DIRECTOR: Alexander Payne. 115 MINS.
FIRST SEEN: *Cannes Film Festival, 23 May 2013.*

Billings, Montana. Woody Grant (BRUCE DERN), an elderly, confused alcoholic and Korean War veteran, wrongly believes that he's won $1 million in a sweepstake even though his exasperated wife, Kate (JUNE SQUIBB), and sons, David (WILL FORTE) and Ross (BOB ODENKIRK), assure him that he's been deceived by a marketing company. After he has set out several times to walk to Lincoln, Nebraska—where the headquarters of the sweepstake company is located—David, whose live-in girlfriend of two years has just walked out on him—offers to drive him there, a distance of some 1450 kilometres. After a small detour to see Mount Rushmore, father and son stay the night at a motel where Woody falls and cuts his head. He spends a night in hospital and David, who has taken sick leave from his job as a salesman of home theatre equipment, realises that his original plan, which was to be back home before the weekend, is no longer viable. They decide to stop in Hawthorne, Woody's home town, and stay with his brother, Ray (RANCE HOWARD). The family reunion is completed when Kate decides to join them, taking the bus from Billings, and other local relatives eagerly show up to meet the man who has supposedly won a million dollars. Woody looks up Ed Pegram (STACY KEACH), his former business partner who, he believes, stole his compressor. But Ed, believing Woody is rich, claims money is owed to him, as do other members of Woody's family. After another night in hospital, Woody and David arrive at the office of the marketing company in Lincoln to be told that he hasn't won anything; he is given a baseball cap with 'Prize Winner' printed on it in compensation. David exchanges his car for the truck his father always wanted and buys him a compressor. He allows his dad to drive the truck down the main street of Hawthorne, to the amazement of Ed and the locals.

Alexander Payne's exquisite black and white road movie is, quite simply, about a father and son who have never been close but who get to know one another a little better when they embark on an odyssey to collect an imaginary $1 million. Woody, first seen trudging along beside a busy main road

in winter, is a crotchety old geezer who is confused but who has moments of lucidity. He exasperates his no-nonsense wife ('You dumb cluck,' she calls her husband), but she is clearly very fond of him, and concerned about him.

The first setback on the journey takes place when Woody mysteriously mislays his teeth; after a search by the railway track they're found and restored to their proper place. Woody is unimpressed by a visit to see the carved heads of four US presidents at Mount Rushmore ('It's just a bunch of rocks,' he complains. 'Doesn't look finished').

Most of the film takes place in Hawthorne (filming actually took place mainly in Plainview, Nebraska) where Woody's brother, Ray, his wife, Martha (MARY LOUISE WILSON), and their obese, oafish sons Bart (TIM DRISCOLL) and Cole (DEVIN RATRAY) live and where Woody's nemesis, Ed, holds court each night in the local bar. The first night at Ray's house is a numbingly awful experience for David as the dim-witted brothers, when they aren't glued to the television, chortle over the fact that it took David two days to drive from Billings and drop heavy hints about getting a share of the alleged money. Cole, it transpires, is doing compulsory community service after a rape conviction.

Escaping to the local bar, David begins to discover things about his father he never knew ('Ever wish you hadn't married Mum?' he asks. 'All the

David Grant (WILL FORTE) with his father, Woody (BRUCE DERN), in Alexander Payne's *Nebraska*.

time' is Woody's deadpan response). Later, when asked why he became an alcoholic, he replies, 'You'd drink, too, if you were married to your mother!'

The next day Kate arrives on the bus and wants to be taken to the cemetery, where she is typically forthright about those buried there. ('That's Woody's mother. She hated me!') She also claims that Woody's sister, who died at 19 in a car crash, was 'a whore and a slut'. Stopping at the grave of one man she once knew, the old woman lifts her skirts: 'See what you could have had!' she tells the tombstone.

In a forlorn attempt to hose down the speculation about Woody's good fortune, David visits the local newspaper, *The Republican*, where the editor, Peg Nagy (ANGELA MCEWAN), reveals that she had once dated Woody, a touching admission that is quickly followed by her assurance that she subsequently had a happy marriage. Peg surprises David by showing him an old newspaper story in which his father is featured as a hero returning home from Korea.

Bob Nelson's original screenplay is filled with marvellously observed examples of everyday Nevadan banality. The brothers discuss a car one of them used to drive. 'They don't make cars like that anymore. They run forever. What happened to it?' 'Stopped running.' 'They'll do that.' Kate mutters 'Just about how your mother left it,' as they make a detour to visit the abandoned homestead where Woody grew up. When David's older brother Ross, a minor media celebrity in Billings, arrives to take part in the impromptu family reunion and gets into a fistfight with Cole (or Bart), he cries: 'Watch my face! I'm on TV!'

There's a priceless scene in which, touring the neighbourhood, David, Ross and their parents arrive at a house that Kate claims belongs to Ed. No one is home, and the brothers decide to retrieve their father's long-lost compressor from the shed, only to be told by Woody: 'That's not mine. Mine doesn't look anything like that.' They then realise that they're at the wrong house.

Payne was born and raised in Nebraska and he knows these people well. All the characters in the film are beautifully observed, with—one assumes— a number of local people appearing as extras. The mellow monochrome photography by Phedon Papamichael emphasises the desolation of these sad little communities where financial hardship has brought devastation to local businesses.

The performances are simply wonderful. June Squibb's Kate is marvel-lously feisty and combative, while Will Forte's gentle David blossoms as he

becomes increasingly fond of his crazy old dad. The ecstatic look on Bruce Dern's face at the end when his son allows him a triumphal drive in the new truck through the streets of Hawthorne is a marvel. Dern deservedly won the Best Actor prize at the Cannes Film Festival.

Alexander Payne (b. 1961) made a couple of no-budget independent films (*The Passion of Martin*, 1991; *Citizen Ruth*, 1996) before scoring a major success with his first mainstream feature, *Election* (1999). This was followed by *About Schmidt* (2002), in which Jack Nicholson gives one of his finest performances; *Sideways* (2004), a lovely comedy set in the Napa Valley; *The Descendants* (a comedy-drama set in Hawaii); *Nebraska* (2013); and the sci-fi comedy-drama *Downsizing* (2017). He is a keen film buff who attends niche international events, like the festival of film restorations in Bologna, where he can be guaranteed to take part in enthusiastic conversations about some recently rediscovered masterpieces.

I, Daniel Blake

UK/FRANCE/BELGIUM, 2016

Sixteen Films–Why Not Productions–Wild Bunch–Les Films du Fleuve. DIRECTOR: Ken Loach. 96 MINS. FIRST SEEN: *The Barn, Leura, 5 November 2016.*

Newcastle, England. Daniel Blake (DAVE JOHNS), a carpenter by trade and recently widowed, has suffered a heart attack. His doctor has told him he can't work, but in order to claim welfare benefits he has to complete a 'fit for work' test, which he fails. He must now sign on for Jobseeker's Allowance, which requires him to look for work. At the Jobseeker office he meets Katie (HAYLEY SQUIRES), the single mother of Daisy (BRIANA SHANN) and Dylan (DYLAN PHILLIP MCKIERNAN); recently arrived from London, she is also struggling to negotiate the welfare bureaucracy. Daniel helps her by doing odd jobs in her rundown flat, but his frustrations increase. Unable to find work, Katie takes a job with an escort service and is humiliated when Daniel tracks her down there. On the day of his appeal against the bureaucratic refusals to pay him benefits, Daniel dies of a heart attack. At the funeral, Katie reads the speech Daniel had planned to give before the appeals board.

Ken Loach (sometimes Kenneth on the credits) has had a long, illustrious and consistent career. Since he made his first television film, *Cathy Come Home* (1966), he has championed the underdogs, the working classes and the marginalised. *I, Daniel Blake*—his second Cannes Palme d'Or winner—represents the culmination of his life's work. An angry, impassioned attack on the legacy of Thatcherism and what it's done to the British working class, the film is, on the surface, the simple story of a sick man battling the system. But it's far more than that, thanks to a truly wonderful performance from Dave Johns—better known in Britain as a comedian—as the battler who refuses to be defeated by a soulless labyrinth of Kafkaesque bureaucracy.

Loach's regular screenwriter Paul Laverty has clearly done his research. The opening sequence, heard but not seen behind the simple credit titles, has Daniel attempting to answer the inane questions put to him by an unseen female interrogator. He keeps insisting that his doctor has told him that his heart condition prevents him from working, yet

the inquisitor—a self-described 'healthcare professional' employed by an outsourced company—bombards him with questions that have nothing to do with his circumstances. ('Can you press a button? Do you experience loss of control leading to evacuation of the bowel?') 'Forget about my ass—it works a dream!' explodes the exasperated Daniel, and it's probably in that instant he fails the test.

In order to obtain welfare, the lifetime taxpayer now has to negotiate the telephone system ('Please continue to hold . . .' while the same passage from Vivaldi plays over and over again). He is also forced to struggle with the internet: the forms he has to complete for Jobseeker must be completed online, but Daniel has never owned a computer or a smartphone. Understandably he has trouble completing the required forms on a computer at the public library, and though kindly people try to help him, his frustration and stress increase. 'There's a special number to phone if you're dyslexic,' he's told. 'You can find it online.'

In the Jobseeker office most of the staff are arrogant and rigidly unhelpful—the exception being the sympathetic Ann (KATE RUTTER), who helps Daniel but is disciplined for it. It's here that Daniel meets Katie and her kids. She was late for her appointment because, freshly arrived from London, she'd alighted at the wrong bus stop, but that cuts no ice with the bureaucrats. She explains that she's moved north because there was no free housing available to her in the London area, where she has always lived and where her mother—who could have provided support for her—lives. It's almost incomprehensible that such things could occur in England's green and pleasant land, but clearly they do.

Daniel, who is already on very friendly terms with his neighbours, China (KEMA SIKAZWE) and Piper (STEVEN RICHENS)—who are involved with some dodgy merchandising of Chinese-made footwear—embraces Katie and the children as the family he doesn't have. In one moving scene they visit a food hall where essentials are provided free of charge—and the starving Katie chokes on a can of baked beans she attempts to eat unobserved. Later she's detained for stealing sanitary products from a supermarket; the kindly manager lets her go, but the security guard, who works for an escort agency, sees her as prime fodder for the sex industry.

Ordered to attend a lecture on how to prepare a CV, which he does with great reluctance, Daniel and the other attendees are advised that 'You must stand out from the crowd.' The demand for jobs, the smartly dressed lecturer unsurprisingly declares, far exceeds the number of jobs

actually available. The idiotic part of the whole system is that Daniel is *obliged* to seek work in order to receive welfare, but if he's actually offered a job—as he is, once—he can't take it because his doctor has told him he's medically unfit.

Near the end of the film, Daniel—to the cheers of onlookers—spray-paints a message on the exterior of the Jobseeker building: 'I, Daniel Blake, demand an appeal date before I starve,' he writes, and adds: 'And change the shite music on the phone.'

'It's a monumental farce,' Daniel sadly tells Ann at yet another Jobseeker appointment. 'You're sitting opposite a sick man who is looking for a non-existent job he can't take anyway. You're wasting your time, my time—all to humiliate me and grind me down.'

The speech he intended to give to the appeals board, movingly read by Katie in the film's final scene, is a cry from the heart in which Loach and Laverty express their solidarity with the Daniel Blakes of this world and their contempt for the system that has driven them, in this case, to an early grave. 'I am not a client, a customer or a service user. I'm not a shirker, a scrounger, a beggar or a thief. I don't accept or seek charity. I paid my dues. I demand my rights. I demand you treat me with respect. I, Daniel Blake, am a citizen, nothing more, nothing less.'

This intense, passionate drama is, like all Loach films, directed in a straightforward and unfussy way. He is a wonderful director of actors, often using non-professionals who shine under his guidance. Indeed the consistency, the courage and the passion of his films make him Britain's leading director of realist cinema.

Kenneth Loach (b. 1936) joined the BBC in 1961 and directed pioneering work in television drama before making his first feature, *Poor Cow* (1967). This was followed by *Kes* (1969), *Family Life* (1971) and *Looks and Smiles* (1981). He has frequently tackled very political material, for example *Fatherland* (1986, about an East German protest singer), *Hidden Agenda* (1990, about militant anti-Catholics in Ireland), *Land and Freedom* (1996, the Spanish Civil War) and *The Wind that Shakes the Barley* (2006, Loach's other Cannes winner, a film about the post–World War I Irish uprising). Usually, though, his films deal with the struggles of the working class in Scotland, Ireland or regional England, and these include *Riff-Raff* (1991), *Raining Stones* (1993), *Ladybird, Ladybird* (1994), *My Name is Joe* (1998), *Sweet Sixteen* (2002), *The Angels' Share* (2012) and *Sorry We Missed You*

(2019). His superb documentary about the aftermath of the first post-war general election, *The Spirit of '45* (2012), is a major achievement.

I have known Loach since 1972 and I am a great admirer of his dedication and commitment to explore on film the concerns that mean so much to him.

Roma

MEXICO, 2018

Netflix–Esperanto Filmoj Production. DIRECTOR: Alfonso Cuarón. 135 MINS.
FIRST SEEN: *Venice Film Festival. 30 August 2018.*

Colonia Roma, a suburb of Mexico City, 1970. Cleo (YALITZA APARICIO), a Mixtec woman, works for Antonio (FERNANDO GREDIAGO), a doctor, and his wife, Sofía (MARINA DE TAVIRA). The couple have four children, Toño (DIEGO CORTINA AUTREY), Sofi (DANIELA DEMESA), Paco (CARLOS PERALTA) and Pepe (MARCO GRAF); they all adore Cleo who, in addition to doing the cooking and cleaning—with help from Adela (NANCY GARCÍA)—is almost a mother to them. Antonio announces he is going away for a two-week conference in Quebec, but he does not return. Cleo allows herself to be seduced by Fermín (JORGE ANTONIO GUERRERO), a martial arts enthusiast, but when she tells him she is pregnant he abruptly leaves her. Cleo shamefacedly reveals her condition to Sofía, who is understanding and takes her to see a doctor at the hospital where Antonio works (while she is there a minor earthquake occurs). In the absence of Antonio, Sofía takes the children and Cleo to spend Christmas and New Year at a hacienda owned by friends, where Cleo overhears discussions about land disputes and killings.

1971. While taking the children to the cinema, Cleo sees Antonio passing by on the street in the company of an attractive young woman. Cleo travels out of town to find Fermín, but he angrily rebuffs her. Sofía's mother, Teresa (VERÓNICA GARCÍA), takes Cleo into the city to buy a cot from a department store. In the street outside the store, demonstrations turn violent and a young couple flee into the store pursued by armed vigilantes who kill the young man; one of the gunmen is Fermín. Cleo's waters break but the frantic attempts by Teresa to get her to the hospital are delayed by the crowds. Antonio is at the hospital and comforts her, but the baby is born dead. Sofía decides to take the children and Cleo on a holiday to Tuxpan, near Veracruz, while Antonio, in their absence, collects his belongings from the house. Over dinner at the resort Sofía tells her tearful children that their father is not coming back. Next day they go for a final paddle in the sea, but Sofi ventures out too far, Paco tries to help her, and they almost drown. They are saved by Cleo, who cannot swim, but who wades

into deep water to rescue them. They return to the city to find the house has been rearranged. Cleo's routines continue.

Set at a specific moment in the recent history of Mexico—when director Alfonso Cuarón was nine or ten years old—this very personal film is quite breathtaking in its subtle depiction of a fractured society seen from the perspective of a troubled middle-class family and their servant. Both deeply touching and slyly humorous, the film—superbly photographed in black and white by the director, who also scripted and co-edited—seems measured at first as it gradually explores the intimate details of the domestic arrangements of the household, but, as time goes by—and there are instances of several months passing by without comment—the accumulation of information and revelations about the state of the country at the time (pretty dire) and the sad lives of the two women—the employer and the employee—at the centre of the drama come into sharp focus.

Cleo is indispensable. She works from dawn till late at night. She starts her day cleaning the patio, where the family's cars are parked, of the poo left in copious amounts by the household dog. Later she wakens and dresses the children, and performs most of the domestic chores (her fellow servant, Adela, really doesn't appear to be pulling her weight). A sweet, naïve woman who is living far from her home in the countryside, Cleo is only dimly aware of the political events enveloping the country. There are discussions about killings (Toño reports that a man who threw a balloon at an army truck was shot in the head) and land grabs. Soldiers march in the streets and police are everywhere. When Cleo ventures out into a distant suburb in search of the man who seduced and abandoned her, she encounters a different world—muddy, pot-holed streets, dilapidated buildings, and the country's President Echiverría's voice booming over loudspeakers promising the people that 'We will move above and beyond.' After watching Fermín training in martial arts, Cleo asks him 'Is it for the Olympics?' 'Something like that,' he replies, but we soon discover he's a member of an armed right-wing vigilante group that supports the government against the people demonstrating for justice and civil rights. The scene in which Fermín points a gun at Cleo and the elderly Teresa in the department store is quite shocking.

So, too, is the sequence in which Cleo gives birth. The baby is born and taken away to be treated: Cuarón frames Cleo in the foreground of the Scope-size screen while in the background we see the doctors fighting

in vain for the child's life. The little corpse is then handed to the shocked mother to allow her to say a brief farewell.

The sequence on the beach is handled in a masterly way, with the camera tracking backwards and forwards into and out of the water as the children wade in too far and the plucky Cleo plunges into the sea to save them. The scene ends with Cleo, Sofía and the children clinging together as the sun sets in the background—this is the film's emotional high point.

On several occasions members of the family venture out into the crowded city that lies beyond their suburban street. Cuarón's camera films them in long, lateral tracking shots as they cross crowded roads (with cars sometimes stopping only just in time to avoid hitting one or other of them) and mingle with the throng. There are two visits to the cinema, once when Cleo and Fermín go to see a French comedy about World War II (*La grande vadrouille,* Gérard Oury, 1966) and Fermín walks out after Cleo tells him that she's pregnant, and once when the family goes to see *Marooned* (John Sturges, 1969); the scene we see of men (GENE HACKMAN, RICHARD CRENNA) floating in space serves as a reminder that the film Cuarón made immediately prior to *Roma* was the 3D space epic, *Gravity* (2013).

Roma won the Venice Film Festival's Golden Lion and went on to be awarded many accolades, including Oscars for Best Foreign Language Film (a first for Mexico), Best Director and Best Cinematography.

Alfonso Cuarón (b. 1961) made several short films before his first feature, *Sólo con tu pareja/Love in the Time of Hysteria* (1991). He followed this with two films made in the USA: *A Little Princess* (1995) and *Great Expectations* (1997), a modernisation of the Dickens novel. He returned to Mexico to make *Y tu mamá también* (2001) and then directed the third of the Harry Potter films—*Harry Potter and the Prisoner of Azkaban* (2004). *Children of Men* (2006) was a futuristic thriller set in the UK, and was followed by *Gravity* (2013) and *Roma* (2018). He is one of a group of filmmakers, which includes Guillermo del Toro, Alejandro González Iñárritu and Michel Franco, who have recently put Mexican cinema on the international map.

Where you can find the movies

My favourite movies, as well as the many others to which I refer in this book, can be found on the commercial streaming sites and retailers listed below. They can also be borrowed from public libraries or rented from a commercial film library.

Because of issues with rights and commercial arrangements with film-makers, classic movies will be available from different streaming platforms at different times, and they may not always be available from retailers. You may need to check a number of sources to track down the movie you want to watch.

The sources listed here are for readers in Australia and New Zealand.

Streaming sites

Amazon Prime
Apple's iTunes
Foxtel
Google Play
HBO
Netflix
Stan
YouTube Movies

DVD and Blu-ray retailers

Amazon
AroVideo (New Zealand)
Booktopia
Film Classics
Fishpond
JB Hi-Fi
Readings
Sanity Entertainment

Libraries

Many public libraries have movies available to borrow. If the movie you want isn't in your local library's catalogue, you may be able to order it through an interlibrary loan.

Film Club is a Sydney-based specialist film rental library with a large catalogue of classic movies.

Index

References to images are in *italics*